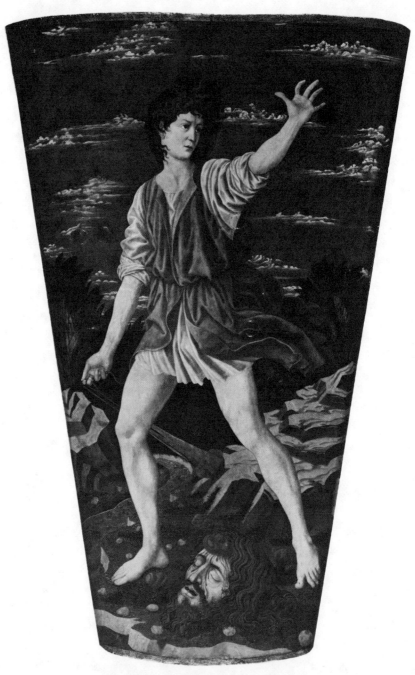

The Youthful David; Andrea del Castagno; National Gallery of
Art, Washington; Widener Collection (Date: ca. 1450; Leather;
1.156 x 0.769 to 0.410 [$45\frac{1}{2}$ x $30\frac{1}{4}$ to $16\frac{1}{8}$in.])

Central Italian Painting, 1400-1465

an annotated bibliography

A
Reference Publication in
ART HISTORY
Marilyn Aronberg Lavin, Editor

Central Italian Painting, 1400-1465

an annotated bibliography

MARTHA LEVINE DUNKELMAN

REFERENCE PUBLICATIONS
IN
ART HISTORY

G. K. Hall & Co, 70 Lincoln Street, Boston, Massachusetts

Library of Congress Cataloging-in-Publication Data

Dunkelman, Martha Levine.
 Central Italian painting, 1400–1465.

 (A Reference publication in art history)
 Includes indexes.
 1. Art, Italian—Italy, Central—Bibliography.
 2. Art, Renaissance—Italy, Central—Bibliography.
 I. Title. II. Series.
 Z5961.I8D86 1986 016.7595'6 86-7530
 [N6919.C46]
 ISBN 0-8161-8546-8

This publication is printed on permanent/durable acid-free paper
MANUFACTURED IN THE UNITED STATES OF AMERICA

Contents

Contents

The Author

Martha Levine Dunkelman received her Ph.D. from the Institute of Fine Arts at New York University. She has written articles on Italian Renaissance art for the Art Bulletin, Drawing, and Perceptions and contributed to the exhibition catalog Italian Renaissance Sculpture in the Time of Donatello. She was Associate Professor of Art History at Wright State University in Dayton, Ohio, where she received an award for excellence in teaching.

Editor's Preface

No period in the history of postclassical art has been studied as much as the Italian Renaissance. Yet, in recent years, no other period has undergone so much reevaluation. In the early nineteenth century when Passavant was eulogizing Raphael, and Crowe and Cavalcaselle wrote the first edition of their History of Painting in Italy (1864), the favored technique was stylistic analysis, and the goal was attribution. By tacit agreement, experts followed the predilections of Giorgio Vasari (Lives of the Most Eminent Painters, Sculptors, and Architects [2d ed., 1564]) and deemed the High Renaissance in Florence and Rome as the pinnacle of art.

By the mid-twentieth century, efforts to struggle free of these historical preconceptions were succeeding. The later sixteenth century (the period of "Mannerism") was saved from oblivion. Studies of iconography stood on the podium next to those of style. Ferrara and Brescia, Naples and Bologna were recognized as centers of culture along with Florence and Rome. Miniature painting, printmaking, garden architecture, liturgy, patronage, and other historical phenomena entered the art scholars' purview. In short, Italian art history has been placed in its sociocultural context and extended from the confines of the connoisseur to the realm of the art historian.

This broadened outlook is the basis for the organization of the Italian Renaissance series of bibliographies. About twenty in all, the volumes are defined by a kind of grid based on medium, topography, and chronology. There are volumes devoted to painting (and drawing), to sculpture, to architecture, to printmaking, to decorative arts, and to ephemera, theater, and urbanism. Topographical regions form the subdivisions: central italy (Tuscany, Lazio, Umbria, and the Marches); north Italy (Lombardy, Piedmont, Liguria, Emilia-Romagna, and the Veneto); south Italy, and Sicily. These subdivisions are further grouped chronologically by portions of centuries (1400-65, for example), whole centuries, or more than a century, as in the case of the volume on the decorative arts. A few of the major artists have volumes of their own: Leonardo, Raphael, Michelangelo, Titian, and Palladio, who are therefore excluded from the usual categorization by medium, region, and period.

The authors have reviewed all of the works cited; their annotations are descriptive and are meant to point out the lasting values or specific limitations of each item. The intent has been to provide concise but well-rounded references (about 1,500 to 2,000 per volume) to books, articles, and reviews from the early days of the history of art through current works that take their place alongside the classics of Renaissance art historiography.

Marilyn Aronberg Lavin
Princeton University

Preface

The scholarly literature on painting in the central regions of Italy (Tuscany, the Marches, Umbria, and Lazio) in the first two-thirds of the fifteenth century is greater in quantity than for any other time or place in Western art. Praise and analysis of Tuscan painting in particular has appeared in an almost unbroken stream from the time of its creation to the present day and, since the middle of the nineteenth century, has risen steadily to almost explosive proportions. The intention of this volume is to define, within the vast expanse of the literature in the field, an essential corpus of those works that have made the most important scholarly contributions.

This goal has resulted in a bibliography that emphasizes the literature of the last thirty or forty years. The writing done in this more recent time period includes a broadening of interests to include discussions of the iconography and historical contexts of works and reflects an increasingly scientific and objective approach to stylistic analysis and questions of attribution. The appearance of substantial monographs, complete with catalogues raisonnées, documentation, and extensive bibliographies, is evidence of the scholarly, rather than subjective, approach of the last and current generations of art historians.

The gathering of the material included here has also revealed other trends in the development of scholarly writing on fifteenth-century Italian painting. It is clear, for example, that from the very beginning, as seen even in the early sources and documents, attention to Florentine art has dominated the literature, followed at a short distance by the study of the art of Siena and the whole of Tuscany, and at a somewhat later time and in lesser quantity by writings about the outlying regions of Umbria, the Marches, and Lazio. Thus the cataloging of collections, discussions of attributions, and interest in minor works, all of which characterize the study of Florentine art in the late nineteenth and early twentieth centuries, do not appear until a decade or so later for Umbro-Marchigian works. It can also be seen that the more scholarly approach characteristic of recent literature, as mentioned above, has

led to an increase in the study of drawings, on which many publications date from the last quarter century. Other even more recent trends include numerous exhibitions of restored works, articles with detailed scientific discussions of medium and technique, and a scattered interest in semiotics.

The citations included in the volume were gathered by a lengthy combing of the standard art reference indexes, including the Art Index, the Répertoire d'art et d'archéologie, and RILA. This search was supplemented by a constant checking of the bibliographies in recent publications, particularly monographs on individual artists, and by consulting the catalogs of the libraries of the Frick Art Reference Library, Harvard University, and the Kunsthistorisches Institut in Florence. Of the items thus compiled, almost all of which were examined, approximately two-thirds are included in the present volume. Citations of works that could not be examined firsthand are designated by an asterisk preceding the entry number. Purely popular publications, brief announcements, and passing mentions of artists or works have, for the most part, been eliminated. Decisions regarding inclusions and exclusions have unavoidably been based upon the author's personal judgments. For example, among the many articles published by museums upon the acquisitions of works, a selection has been made based on the perceived scholarly depth of the discussions. The same selective process has been applied to those museum and exhibition catalogs in which fifteenth-century works play a relatively minor role.

When multiple editions of a publication exist, usually only the most recent is cited, with some further information about other editions often noted in the text of the entry. Additional editions are occasionally cited separately if they have special scholarly importance. If a work has been published in more than one language, the original language edition is cited and only translations into English noted.

The organization of the bibliography has been determined as much as possible by the nature of the material covered. The majority of the citations is found under Artists, which is arranged alphabetically by name of artist. In each of these sections, books and dissertations have been listed separately from articles, pamphlets, and sections of books, in the hope that it will be useful to see at a glance the existing booklength publications on a given artist. The reader will notice that the dividing line between a book and a pamphlet is not always based upon the length of the publication, but that items have been categorized according to their scope rather than strictly by the number of pages. Thus a short book in which a qualified scholar examines the range of an artist's career will be found among the books on the artist, while one similar in length that deals with one work or one problem, in the manner of an article, has been classified with the articles.

In investigating an individual artist, the user of this volume should remember that individual artists are also mentioned in the

general and regional surveys listed in the first chapters. The index should be conulted for additional publications in which the artist figures prominently.

The portion of the bibliography on individual artists is preceded by a variety of chapters covering material that studies aspects of art in the area as a whole, in the various provinces, or in the two major cities of Florence and Siena. As a glance at the table of contents will indicate, the regional studies have been further subdivided into sections on documents and sources, overviews of the period, writings that concern specific aspects of a region or center, and exhibitions of the art of the area. The regional sections are followed by a chapter on specific topics important enough in the art of the period to merit a literature of their own. Catalogs of museums and private collections are included in this chapter. Book-length publications have not been separated from articles in these chapters on regional areas or special topics.

The final organization of this bibliography follows what seemed the most logical of several reasonable possibilities. As would be true with any arrangement, however, numerous items can be found that could logically be included in two or more sections. An article on Brunelleschi's perspective experiments, for example, might be seen to belong in Special Topics, under Perspective, or in Artists, under Brunelleschi. An article on Sienese drawings might be classified within Siena, under Books and Articles on Aspects of Sienese Painting, or within Special Topics, under Drawings. In general, when such dual allegiances appeared, priority was given first to artists (thus writings on Brunelleschi's perspective are included with the rest of the literature on Brunelleschi), next to the special topics (thus Sienese drawings are found with the literature on drawings), and finally to the regional groupings. Common sense has led to a few exceptions to this approach. Iconographic analyses of single anonymous works, for example, are located in the material on the region from which they originate, rather than in the section on iconographical studies, which is reserved primarily for studies of iconographical themes. In a similar manner, articles concerning works in various museums and collections, written as analyses of specific works rather than as cataloging of the collection, are again located in the regional sections, rather than among the museums. In some cases where an item seems to have an equal rationale for two or more locations, cross-references have been indicated.

In compiling this volume I have been aided by grants from the Wright State University Research Incentive and Research Development Fund and College of Liberal Arts Research Committee, to whom I would like to express my gratitude. My warmest thanks go also to Lauren Meyers, Wendy Whealdon, Genetta Gardner, and Marc Vincent for their assistance at various stages of the project, and to Heather Hall for a heroic contribution in typing and editing the original draft. To my immediate and extended family, all my appreciation for the many varieties of help and support that were so constantly provided.

General Material

Documents

1 CHAMBERS, D[AVID] S[ANDERSON]. Patrons and Artists in the
 Italian Renaissance. Columbia: University of South Carolina
 Press; London: Macmillan, 1971, 245 pp., 5 illus.
 Gathers a range of documentary records regarding patron-
 age and working practices. Organizes by type of patrons.
 Review: Rab Hatfield, Art Bulletin 55, no. 4 (1973):630-33.

2 GAYE, GIOVANNI. Carteggio inedito d'artisti dei secoli XIV,
 XV, XVI. Vol. 1, 1326-1500. Florence: Giuseppe Molini,
 1839, 600 pp. Reprint. Turin: Bottega d'Erasmo, 1961.
 Major reference work, including a large variety of docu-
 ments, from several civic archives. Arranged chronologically.
 Index. Facsimiles of forty-five items appended.

3 GUALANDI, MICHELANGELO. Memorie originali italiane
 riguardanti le belle arti. 6 vols. Bologna: Jacopo
 Marsigli, 1840-45.
 Important reference work, including a series of volumes
 compiling various documents of ca. 1300-1700.

4 GUHL, ERNST, and ROSENBERG, ADOLF. Künstlerbriefe. 2d ed.
 Berlin: J. Guttentag, 1879, 382 pp.
 Collection of letters written by artists 1400-1700, with
 annotations. Includes Nelli, Lippi, Alberti, Gozzoli, Domenico
 Veneziano, and others.

5 MANZONI, LUIGI. Statuti e matricole dell'arte dei pittori
 delle città di Firenze, Perugia, Siena nei testi originali
 del secolo XIV. Rome: Ermanno Loescher & Co., 1904, 181
 pp., 3 illus.
 Transcribes regulations and lists of matriculants of
 painters' guilds, continuing through fifteenth and sixteenth

Source Material

 centuries. Explanatory introduction and notes. Appends other
 documents. Index of artists mentioned.

6 ROSSI, ADAMO. "Spogli vaticani." <u>Giornale</u> <u>di</u> <u>erudizione</u>
 <u>artistica</u> 6, no. 9-10 (1877):262-84.
 Gathers material from Vatican archives concerning various
topics. Includes section on Gentile, Angelico, and Gozzoli at
Vatican and in Orvieto with documents mostly from 1420s and
1440s, and another on references to painters and miniaturists
from 1419 to 1550.

See also entries 10 and 11.

Sources <u>up</u> <u>to</u> <u>1700</u>

7 BALDINUCCI, FILIPPO. <u>Notizie de' professori del disegno da</u>
 <u>Cimabue in qua</u>. 7 vols. Florence: Batelli, 1845-47.
 Reprint. Florence: Studio per edizione scelte, 1972-75,
 with appendix and notes by Paola Barocchi. Index by Antonio
 Boschetto.
 Modern edition of account that traces a progressive de-
velopment in art, in decades. Told mostly through careers of
artists. Originally published in Florence, 1681-1728.

8 FICARRA, ANNAMARIA, ed. <u>L'anonimo magliabechiano</u>. Naples:
 Fiorentino editore, 1968, 204 pp., 1 illus. [Also published
 as Carl Frey, <u>Il codice magliabechiano</u> (Berlin:
 G. Grote'sche Verlagsbuchhandlung, 1892). Reprint.
 Farnborough: Gregg, 1969, 404 pp.]
 Important early source work, here dated ca. 1536-46,
compiling various writings. Includes a history of art from
Cimabue through early seventeenth century. Editor's introduc-
tion discusses manuscript's use and modification of early
sources. Index.

9 FILARETE [ANTONIO DI PIERO AVERLINO]. <u>Filarete's Treatise</u>
 <u>on Architecture</u>. Translated with introduction and notes by
 John R. Spencer. 2 vols. New Haven and London: Yale
 University Press, 1965, 378 pp., 214 illus.
 Annotated translation of seminal treatise written 1451-64
for Francesco I Sforza, which includes brief mentions of impor-
tant painters of time. Edition includes volume of facsimiles
of manuscript.

10 GILBERT, CREIGHTON E. <u>Italian Art, 1400-1500: Sources and</u>
 <u>Documents</u>. Englewood Cliffs, N.J.: Prentice-Hall, 1980,
 254 pp.
 Presents and explains selected passages from prominent
early sources. Arranged by types of authors, including art-
ists, patrons, clergy, and chroniclers. Index.

11 HOLT, ELIZABETH G. "The Renaissance, Italy." In A Documen-
 tary History of Art. Vol. 1, The Middle Ages and the Ren-
 aissance. Garden City, N.Y.: Doubleday Anchor Books, 1957,
 pp. 151-296, 24 illus. [Originally published as Literary
 Sources of Art History (Princeton: Princeton University
 Press, 1947).]
 Compilation of excerpts of original documents on the
 arts, in English translation, with introduction to each selec-
 tion. Includes selections by Ghiberti, Manetti, Vespasiano da
 Bisticci, Bartolomeo Fazio, Alberti, Filarete, Piero della
 Francesca.

12 SANTI, GIOVANNI. Cronaca rimata delle imprese del duca
 Federigo d'Urbino. Edited by H. Holtzinger. Stuttgart,
 1893, 234 pp.
 Rhymed chronicle eulogizing duke, written after his death
 in 1482. Includes disputation on painting, praising Gentile
 and numerous Florentine artists. See also entry 334.

13 SCHLOSSER, JULIUS VON. Materialen zur Quellenkunde der
 Kunstgeschichte. II: Frührenaissance. Sitzungsberichte
 der kaiserliche Akademie der Wissenschaften in Wien, 179,
 no. 3. Vienna: Hölder, 1915, 72 pp.
 Surveys fifteenth-century theory. Separates historical,
 theoretical, and romantic approaches. Extensive bibliography.

14 SCHLOSSER-MAGNINO, JULIUS. "Il primo rinascimento" and "La
 storiografia dell'arte prima del Vasari." In La letteratura
 artistica. Translated by Filippo Rossi. Notes by Otto
 Kurz. 3d ed. Florence: La nuova Italia, 1977,
 pp. 101-223.
 Basic source, originally published 1924, regarding writ-
 ings on art from medieval times. Information on editions,
 discussion of historians and theorists, cultural background.
 Bibliography for each section.

15 TANTURLI, GIULIANO. "Le biografie d'artisti prima del
 Vasari." In Vasari storiografo e artista. Atti del
 Congresso internazionale nel IV centenario della morte,
 1974. Florence: Istituto nazionale di studi sul
 rinascimento, 1976, pp. 275-98.
 Studies writings on or mentions of artists before 1500.
 Covers Fazio, Ghiberti, Manetti, Billi, the Anonimo
 Magliabecciano, Gelli, and Paolo Giovio. Considers methods of
 organization and attitudes to art in each.

16 VASARI, GIORGIO. Lives of the Most Eminent Painters, Sculp-
 tors, and Architects. Translated by Gaston du C. de Vere.
 10 vols. London: Warner, 1912-14.
 Reliable English translation of 1568 version of lives.
 Not annotated.

Source Material

17 . Le vite de' più eccellenti pittori, scultori et
architettori italiani. Edited by Gaetano Milanesi. 9 vols.
Florence: Sansoni, 1878-85. Reprints. 1906 and 1973.
 Standard edition of the 1568 version of this classic work
of biography and history, major source of information for all
subsequent scholarship. Volumes 2 and 3 (1406 pp. total) and
index volume (265 pp.) cover numerous fifteenth-century paint-
ers, who are seen as part of a progressive development begin-
ning with Cimabue and ending with Michelangelo. Milanesi adds
extensive notes and commentaries based on documentary
information.

18 . Le vite de' più eccellenti pittori, scultori et
architettori nella redazioni del 1550 e 1568. Edited by
Rosanna Bettarini and Paola Barocchi. 4 vols. Florence:
Sansoni, 1966-71.
 Edition of famous lives, paralleling texts of two edi-
tions of original. Includes editors' notes regarding text.
Useful and lengthy index.

19 VENTURI, LIONELLO. "La critica d'arte in Italia durante i
secoli XIV e XV." L'arte 20 (1917):305-26, 5 illus.
 Discusses art criticism before Vasari. In fifteenth
century considers primarily views of Ghiberti, Alberti,
Filarete, Landino, and Manetti.

SURVEYS OF ITALIAN PAINTING

20 BAXANDALL, MICHAEL. Giotto and the Orators: Humanist Ob-
servers of Painting in Italy and the Discovery of Pictorial
Composition 1350-1450. Oxford: Oxford University Press,
1971, 198 pp., 16 illus.
 Describes humanist attitudes to painting and development
of humanist criticism. Emphasizes idea of "composition" as
coming from a set of linguistic ideas. Includes humanist texts
in Latin and English. Bibliography. Index.
 Review: Myron P. Gilmore, Art Bulletin 55, no. 1
(1973):148.

21 . Painting and Experience in Fifteenth Century Italy:
A Primer in the Social History of Pictorial Style. Oxford:
Oxford University Press, 1972, 173 pp., 81 b&w and 4 color
illus.
 Studies continuous relationship between social history
and artistic styles. Chapters on the picture trade, the devel-
opment of the artist's visual skills, and concepts of visual
judgment used in the period, particularly by Cristoforo Landino.
Index.

22 BECK, JAMES. Introduction and "The First Generation." In
 Italian Renaissance Painting. New York: Harper & Row, Icon
 Editions, 1981, pp. 1-154, 120 illus.
 Surveys period, dividing into generations and into "monu-
 mental" and "lyric" categories. Index, bibliography, diagram,
 appendix of artists not discussed.

23 BERENSON, BERNARD. Italian Painters of the Renaisance.
 London: Phaidon, 1952, 501 pp., 400 b&w and 17 color illus.
 Reprints. New York: Phaidon, 1968 (paper). Oxford:
 Phaidon; Ithaca: Cornell University Press, 1980.
 Republication of fundamental essays concerning regional
 schools of Italian art ca. 1300-1600, originally published
 1894-1907, and of essay on decline of art, written 1930. Anal-
 ysis based on tactile values of works.
 Review: [Charles J. Holmes], Burlington Magazine 58, no.
 336 (1931):151-52.

24 ____. Italian Pictures of the Renaissance: Central and
 North Italian Schools. Introduction by Luisa Vertova. 3
 vols. London: Phaidon, 1968, 3 vols., 559 pp., 1988 b&w
 and 3 color illus.
 Illustrated edition of lists originally published in 1897
 and 1907. Lists artists in central Italian schools, including
 Tuscany (except for Florence), Umbria, Marches, Lazio. For
 each painter, lists works by location with brief bits of infor-
 mation regarding dates and signatures. Index of locations.

25 BRANDI, CESARE. "Il secolo XV." In Disegno della pittura
 italiana. Turin: Einaudi, 1980, pp. 117-280, 48 illus.
 Introduction to period in a volume surveying thirteenth
 through nineteenth centuries. Includes general section on
 century, then a series of discussions of individual illustra-
 tions of major works.

26 BURCKHARDT, JACOB. The Cicerone: An Art Guide to Painting
 in Italy. Translated by A.H. Clough. New York: Scribners;
 London: T. Werner Laurie, 1908, 305 pp., 16 illus. Re-
 print. New York: Garland, 1979. [German ed. Cornelius von
 Fabriczy and Wilhelm Bode, eds. (Leipzig: E.A. Seeman,
 1910).]
 English translation of an early, brief, wide-ranging
 guidebook originally published in 1855. Pp. 52-68 concern
 early fifteenth-century painters.

27 CROWE, J.A., and CAVALCASELLE, G.B. A History of Painting
 in Italy: Umbria, Florence and Siena from the Second to the
 Sixteenth Century. Vol. 4, Florentine Masters of the Fif-
 teenth Century, edited by Langton Douglas, assisted by G. de
 Nicola. London: John Murray; New York: Scribners, 1911,
 387 pp., 54 illus. Vol. 5, Umbrian and Sienese Masters of
 the Fifteenth Century, edited by Tancred Borenius. London:

Surveys of Italian Painting

John Murray, 1914, 528 pp., 74 illus. Reprint. New York:
AMS Press, 1975.
Important early survey of the period, arranged into mono-
graphic chapters on major artists. Indexes.

28 ESCHER, KONRAD. "Die erste Hälfte des Quattrocento" and
"Die Malerei um die Mitte und in der zweiten Hälfte des
Quattrocento." In Malerei der Renaissance in Italien: Die
Malerei des 14. bis 16. Jahrhunderts in Mittel- und
Unteritalien. Edited by Fritz Burger. Handbuch der
Kunstwissenschaft. Berlin: Akademische Verlagsgesellschaft
Athenaion MBH, 1922, pp. 26-214, 185 b&w and 2 color illus.
An early, rather thorough study, examining general issues
in each era and interrelationships between schools. Bibliogra-
phy, indexes of artists and places.

29 GENGARO, M[ARIA] L[UISA], and D'ANCONA, P[AOLO].
"Masaccio," "Le scuole regionale: Toscana: Pittura," and
"Le scuole regionale: Marche-Umbria-Romagna: Pittura." In
Umanesimo e rinascimento. 4th ed. Storia dell'arte
classica e italiana, 3. Turin: Unione tipografico editrici,
1958, pp. 59-78, 171-260, 273-98, 128 b&w and 3 color
illus.
Survey of art and humanist environment. Fully illus-
trated, with lengthy bibliography and indexes.

30 HARTT, FREDERICK. "The Quattrocento." In History of
Italian Renaissance Art: Painting, Sculpture, Architecture.
2d ed. Englewood Cliffs, N.J.: Prentice-Hall; New York:
Abrams, 1979, pp. 145-434, 335 b&w and 40 color illus.
Chapters in a survey directed primarily to students.
Fully illustrated. Glossary, bibliography, index.

31 HAUSER, ARNOLD. "The Concept of the Renaissance," "The
Demand for Middle Class and Courtly Art in the Quattrocento,"
and "The Social Status of the Renaissance Artist." In The
Social History of Art. Translated by Stanley Godman. Vol.
2, Renaissance, Mannerism, Baroque. New York: Vintage
Books, 1957, pp. 3-83, 4 illus. [Original English ed. New
York: Alfred A. Knopf, 1951. Reprinted in Meditations on a
Hobby Horse (New York: Phaidon, 1963), pp. 86-94.]
Sections in a longer study of art history as a reflection
of social history, based on dialectical materialism.
Review: E[rnst] H. Gombrich, Art Bulletin 35, no. 1
(1953):79-84.

32 HEYDENREICH, LUDWIG H. Italienische Renaissance: Anfänge
und Entfaltung in der Zeit von 1400 bis 1460. Munich: C.H.
Beck, 1972, 430 pp., 316 b&w and 91 color illus.
Surveys artists in early period of Renaissance. Chronol-
ogy, maps, bibliography.

Review: Erich Steingräber, Pantheon 31, no. 3.
(1973):334-36.

33 MÜNTZ, EUGÈNE. Histoire de l'art pendant la renaissance.
Vol. 1, Italie: Les primitifs. Paris: Librairie Hachette,
1889, 744 pp., 561 b&w and 13 color illus.
Frequently cited survey. Includes sections on historical
setting and on general character of period, and a chapter on
painting from Masaccio to Mantegna. Index.

34 PERATÉ, ANDRÉ. "La peinture italienne au XVe siècle." In
Histoire de l'art. Edited by André Michel. Vol. 3, pt. 2.
Paris: Librairie Armand Colin, 1908, pp. 589-715, 77 b&w
and 2 color illus.
Early survey, much quoted by later writers. Considers
regional differences.

35 SALVINI, ROBERTO. Pittura italiana. Vol. 2, Il
quattrocento. Milan: Martello, 1960, 206 pp., 105 color
illus.
General survey of whole century, organized by regional
schools. Useful set of color illustrations.

36 SISSON, JACQUELINE D. Index to Adolfo Venturi, Storia
dell'arte. 2 vols. Nendeln: Kraus-Thomson, 1975, 1461 pp.
Volume 1 includes a location index that combines, cor-
rects, expands, and reorganizes those of Venturi's individual
volumes (entry 39). Volume 2 contains an artist index that
lists works and then locations, and also reproduces Venturi's
tables of contents. Many cross references supplied.
Review: Creighton Gilbert, Art Bulletin 58, no. 3
(1976):468-70.

37 THIEME, ULRICH, and BECKER, FELIX, et al. Allegemeines
Lexikon der bildenden Künstler: von der antike bis zur
gegenwart. 37 vols. Leipzig: E.A. Seemann, 1907-50.
Basic reference work including well known and obscure
names. Entries review careers, list works, and provide de-
tailed bibliography.

38 VAN MARLE, RAIMOND. The Development of the Italian Schools
of Painting. 19 vols. The Hague: Martinus Nijhoff, 1923-
38. Reprint. New York: Hacker, 1970.
Major, multivolumed reference work, with extensive illus-
trations. Volumes cover various regional schools. Vols. 8-11
and 14-16 include central Italian artists. Each volume has
geographical index and index of artists. Vol. 19 is comprehen-
sive index.

39 VENTURI, ADOLFO. "La pittura del quattrocento." In Storia
dell'arte italiana. Vol. 7, pts. 1-2. Milan: Hoepli,
1911-13, 1780 pp., 1152 illus.

Surveys of Italian Painting

A major reference work surveying period, primarily by
regional schools. Comments upon and illustrates innumerable
works, mentions major and many minor figures. Bibliography in
notes. Geographical and name indexes. See entry 36.
Review: Tancred Borenius, Burlington Magazine 29, no.
160 (1916):161-64.

BOOKS AND ARTICLES ON ASPECTS OF ITALIAN PAINTING

40 BONNEFOY, YVES. "Le temps et l'intemporel dans la peinture
du quattrocento." Mercure de France 335, no. 1146
(1959):193-213.
Philosophical discussion of sense of "temps" in works of
art, of existence outside of time. Discusses perspective.
Tuscan examples, including Masaccio and Uccello as opposite
poles, and Piero.

41 CASTELFRANCHI-VEGAS, LIANA. International Gothic Art in
Italy. Translated by B.D. Phillips, revised by D. Talbot
Rice. Rome: Editori riuniti, 1966, pp. 42-55, 29 color
illus.
Sections on Umbria, the Marches, and Tuscany in a lav-
ishly illustrated survey of works in the International Style.
Attempts to establish its homogeneity of style throughout
Europe. Bibliography.

42 CLARK, KENNETH. "Architectural Backgrounds in Fifteenth-
Century Italian Painting II." Arts 2 (1947):33-42,
13 illus.
Discusses role of architecture in creation of harmonious
space. Importance of antiquity and perspective. Emphasizes
Piero's work, discusses Baltimore and Urbino panels, and
Barberini panels.

43 COCKE, RICHARD. "Masaccio and the Spinario, Piero and the
Pothos: Observations on the Reception of the Antique in
Renaissance Painting." Zeitschrift für Kunstgeschichte 43,
no. 1 (1980):21-32, 10 illus.
Discusses slow absorption of the antique into Renaissance
art. Notes specific sources of inspiration for Masaccio and
Piero.

44 DANILOVA, I.E. "Iskusstvo i zritel' v Italii 15 veka" [Art
and the viewer in fifteenth-century Italy]. Sovetskoe
Iskusstvoznanie 1 (1979):88-103.
In Russian, with English summary. Discusses new dialogue
between artist and viewer in fifteenth century, when viewer and
pictures both regarded as ideal "models." Ideas of Alberti,
Piero, and others.

Books and Articles on Aspects of Italian Painting

45 _____. Ot Srednih vekov k Vozroždeniju: Složenie
hudožestvennoj sistemy kartiny kvatročento [From the Middle
Ages to the Renaissance: The artistic structure of quattro-
cento paintings]. Moscow: Iskusstvo, 1975, 127 pp.,
1 illus.
 In Russian. Studies compositional methods of fifteenth-
century painting. Chapters on role of iconography, Alberti,
light and shadow, and other aspects.

46 DUNKELMAN, MARTHA LEVINE. "Donatello's Influence on Italian
Renaissance Painting." Ph.D. dissertation, New York Univer-
sity, 1976, 187 pp., 308 illus.
 Surveys impact of Donatello's individual works and types
of works on painting 1400-1600. Bibliography.

47 FRANCASTEL, PIERRE. La figure et le lieu: L'ordre visuel
du quattrocento. Paris: Gallimard, 1967, 362 pp., 30
illus.
 Study of new systems of visual order in the quattrocento
as systems of signs that determine understanding of work.
Examines social and historical conditions.

48 _____. Peinture et société: Naissance et destruction d'un
espace plastique. De la renaissance au cubisme. Lyon:
Audin, 1951, 300 pp., 70 illus.
 Traces spatial concepts from quattrocento to early 1900s
as reflecting state of society. Analyzes works of early
fifteenth-century manuscripts. Appendixes on Brunelleschi's
dome and on linear perspective.

49 FREDERICKSEN, BURTON B., and ZERI, FEDERICO. Census of Pre-
nineteenth-century Italian Paintings in North American Pub-
lic Collections. Cambridge, Mass.: Harvard University
Press, 1972, 700 pp.
 Detailed reference tool, organized into a variety of
sections, with many cross references. Section 1 lists artists
alphabetically and for each artist lists works, by location,
with reference to sources of reproductions. Section 2 organized
by subject; 3 by collections. Appendixes on paintings not
included, works in Kress Collection, locations, bibliography.
Attention given to questions of attribution, closeness to art-
ist's hand indicated.
 Review: Bruce Cole, Art Bulletin 57, no. 4 (1975):
600-601.

50 GOLDBERG, JONATHAN. "Quattrocento Dematerialization: Some
Paradoxes in a Conceptual Art." Journal of Aesthetics and
Art Criticism 35, no. 2 (1976):153-68.
 Sees fifteenth-century artists and theorists searching
for transcendent meaning as well as illusionistic form. Dis-
cusses, among others, Masaccio, Uccello, Domenico Veneziano,
Piero, and Alberti.

Books and Articles on Aspects of Italian Painting

51 MARCHESE, VINCENZO. Memorie dei più insigni pittori,
 scultori ed architetti domenicano. 2d ed. 2 vols. Florence:
 Felice Le Monnier, 1854, 830 pp.
 Discusses careers of Fra Angelico, Fra Carnevale, and
 some miniaturists, especially Fra Benedetto del Mugello.

52 MEISS, MILLARD. The Great Age of Fresco: Discoveries,
 Recoveries, and Survivals. New York: George Braziller in
 association with the Metropolitan Museum of Art, 1970, 251
 pp., many plates (unnumbered), mostly color.
 Discusses and illustrates major works from Great Age of
 Fresco exhibition (entry 70) plus seventy-five additional
 works, mostly Tuscan, thirteenth to sixteenth centuries. In-
 cludes works newly discovered and restored. General introduc-
 tion concerning technique, comments on each plate. Glossary,
 index, selected bibliography.

53 PERKINS, F. MASON. "Note su alcuni quadri del 'Museo
 Cristiano' in Vaticano." Rassegna d'arte 6, no. 7 (1906):
 106-8, 3 illus.; no. 8 (1906):120-23, 2 illus.
 Lists a variety of works, with attributions to many
 different fifteenth-century artists.

54 POSEQ, A.W.G. "The Lunette, A Study in the Role of the
 Arch-outlined Format in the Design and Content of Italian
 Murals of the Renaissance." Ph.D. dissertation, Hebrew
 University, Jerusalem, 1974, 1016 pp., 107 illus.
 Investigation into works in the lunette format from a
 variety of points of view. Categorized into types. Sections on
 portals, tombs, vaults, cloisters, murals, etc., and their
 varying significance. Chapters on various specific cycles
 including Piero's at Arezzo and Gozzoli's at Montefalco and San
 Gimignano. Appends classified list of Renaissance lunettes.
 Bibliography.

55 ROZYCKA-BRYZEK, ANNA. "Nowe atrybucje kilku obrazów
 wloskich w zbiorach czartoryskich" [New attributions for
 Italian paintings in the Czatoryski Collection]. Biuletyn
 historii sztuki 22, no. 2 (1960):203-18, 20 illus.
 In Polish. Publication of revised attributions to works
 in Czatoryski Collection, Cracow. Includes numerous early
 fifteenth-century paintings.

56 RUDEL, J. "Schèmes plastiques et structures symboliques
 dans la peinture du quattrocento: Quelques remarques." In
 Symboles de la renaissance. Paris: Presse de l'école
 normale supérieure, 1976, pp. 89-104, 139-45, 13 illus.
 Deals with spatial constructions of works and their sym-
 bolic sense. Includes Lippi's Annunciation, Spoleto.
 Diagrams.

Books and Articles on Aspects of Italian Painting

57 SALVINI, ROBERT, and TRAVERSO, LEONE. The Predella from the
 Thirteenth to the Sixteenth Centuries. London: Faber &
 Faber, 1960, 320 pp., 213 b&w and 100 color illus. [Italian
 ed. Florence: Vallecchi, 1959.]
 Surveys type of work. Arranged chronologically and by
 artist with descriptive text for plates. Indexes.

58 SCHLOSSER, JULIUS VON. Kunstlerprobleme der
 Frührenaissance. Akademie der Wissenschaften in Wien:
 Philosophisch-historisch Klasse. Sitzungsberichte, 214.
 Vol. 5. Abhandlung. Vienna and Leipzig: Holder-Picher-
 Tempsky A.-G., 1933, 47 pp., 4 illus.
 Discusses issues of double interests in artists who are
 also theoreticians. Sections on Piero, Uccello, and Alberti.

59 SIRÉN, OSVALD. "Notizie critiche sui quadri sconosciuti nel
 Museo Cristiano Vaticano." L'arte 9 (1906):321-35, 9 illus.
 Deals with a variety of works, including some quattrocento
 attributions. Identifies Gentile's scenes from life of Saint
 Nicolas of Bari as predella to the Quataresi altarpiece. Also
 considers works by Masolino, Sano di Pietro, Sassetta, and
 Giovanni di Paolo.

60 VENTURI, A[DOLFO]. Studi dal vero: Attraverso le raccolte
 artistiche d'Europa. Milan: Hoepli, 1927, 415 pp., 285
 illus.
 A survey of Italian art, fourteenth to eighteenth cen-
 turies, no longer in Italy. Organized by regional styles.
 Index.

61 VENTURI, LIONELLO. Italian Painting in America. Translated
 by Countess Van den Heuvel and Charles Marriott. Vol. 2,
 Fifteenth Century Renaissance. Milan: Hoepli; New York:
 E. Weyhe, 1933, 440 illus. with accompanying text.
 Expansion of a project originally published in 1931 to
 present a large selection of works collected by Americans.
 Each plate has large illustrations, description, and discussion
 of pertinent issues, such as attributions. Lists provenance,
 exhibitions and bibliography.

62 WERNER, EVA FRIEDERIKE. "Das italienische Altarbild
 vom Trecento bis zum Cinquecento; Untersuchungen zur
 Thematik italienischer Altargemälde." Ph.D. dissertation,
 University of Munich, 1971, 123 pp.
 Reviews development, considering earlier sources and new
 types. Catalogs 222 selected works by main subject (Mary,
 Christ, Saints). Bibliography.

EXHIBITIONS

63 CERTALDO. PALAZZO PRETORIO. Arte in Valdelsa dal sec. XII
 al sec. XVIII. Catalog by Paolo dal Poggetto. Certaldo:
 1963, 136 pp., 130 illus.
 Exhibition of works in area, not necessarily by native
 artists, and often in little-known locations. Each entry in-
 cludes biography of artist, bibliography.
 Review: Federico Zeri, Bollettino d'arte 48, no. 3
 (1963):245-58, 21 illus.

64 CRACOW. MUSEE NATIONAL. La peinture italienne des XIVe et
 XVe siécles. Cracow: Druk. Wyd., 1962, 106 pp., 117 b&w
 and 3 color illus.
 Exhibition, primarily from Polish collections, of 103
 paintings, each with descriptive catalog entry, bibliography.

65 LONDON. ROYAL ACADEMY, BURLINGTON HOUSE. A Commemorative
 Catalogue of the Exhibition of Italian Art Held in the
 Galleries of the Royal Academy, Burlington House, London,
 January–March 1930. Edited by Lord Balniel and Kenneth
 Clark in consultation with Ettore Modigliani. Introduction
 by Roger Fry. 2 vols. London: Humphrey Milford; Oxford:
 Oxford University Press, 1931, 377 pp., 252 b&w and 1 color
 illus.
 Catalog of loan exhibition of over 1100 objects covering
 all media. Arranged by medium, then by artist. Entries on
 drawings contributed by A.E. Popham. Includes paintings, draw-
 ings, manuscripts, and cassoni.
 Review: Carlo Gamba, Dedalo 11, no. 9 (1931):570-99, 25
 b&w and 1 color illus.

66 _____. Italian Art and Britain. Winter Exhibition, 1960,
 247 pp.
 Exhibition illustrating collecting of Italian art by the
 British. Six hundred forty-eight works, including numerous
 fifteenth-century paintings and drawings, each with a scholarly
 and descriptive entry.
 Review: Roberto Longhi, Paragone 11, no. 125 (1960):
 59-61.

67 NEW HAVEN. YALE UNIVERSITY ART GALLERY. Rediscovered
 Italian Paintings. New Haven: Yale University Press, 1952,
 39 pp., 28 illus.
 Exhibition of fourteen recently cleaned Italian paint-
 ings, 1300-1500. Includes before and after photos, details.
 Entries emphasize condition of works.

68 NEW YORK. DUVEEN GALLERIES. A Catalogue of Early Italian
 Paintings Exhibited at the Duveen Galleries, New York, April
 to May 1924. Catalog by W.R. Valentiner. New York: pri-
 vately printed, 1926, unnumbered pages, 48 illus.

Illustrates forty-eight works acquired by Duveen and sold to American collectors, each with page of text giving biography of artist, description, and bibliography.

69 NEW YORK. KLEINBERGER GALLERIES. Catalogue of a Loan-Exhibition of Italian Paintings in Aid of the American War Relief. Catalog by Osvald Sirén and Maurice W. Brockwell. New York: Kleinberger Galleries, 1917, 260 pp., 102 illus.
Catalog of 102 works from private collections, ca. 1200-1600. Each with a general description and some bibliography and comments. Arranged by geographic school.

70 NEW YORK. METROPOLITAN MUSEUM. The Great Age of Fresco: Giotto to Pontormo. Catalog by Ugo Procacci, Paolo dal Poggetto, Umberto Baldini, Luciano Berti, and Millard Meiss. New York: Metropolitan Museum, 1968, 233 pp., 12 color and many b&w illus.
Catalog of exhibition of detached paintings and monumental preparatory drawings. Arranged chronologically. Each entry includes discussion and bibliography. Introduction discusses technique and methods of conservation. Glossary, indexes. See entry 52.

71 PARIS. ORANGERIE. De Giotto à Bellini, les primitifs italiens dans les musées de France. Catalog by Michel Laclotte. Introduction by André Chastel. Paris: Edition des musées nationaux, 1956, 146 pp., 205 illus.
Exhibition of works from numerous French collections. Detailed entries with lengthy bibliography.
Review: Millard Meiss, Revue des arts 6 (1956):139-48, 15 illus.

72 STUTTGART. WURTTEMBERGISCHEN STAATSGALERIE. Frühe italienische Tafelmalerei. Catalog by Robert Oertel. Stuttgart: Galerieverein, 1950, 64 pp., 125 illus.
Loan exhibition of 125 objects, 1300-1500, from collections in Germany, Austria, and Switzerland.

73 VIENNA. KUNSTHISTORISCHES MUSEUM. Europäische Kunst um 1400. Vienna: 1962, 536 pp., 160 illus.
Catalog of exhibition of art in all media, centering on the International Style of around 1400. Introductory sections and entries are by various scholars.

74 VITERBO. MUSEO CIVICO. La pittura viterbese dal XIV al XVI secolo. Catalog by Italo Faldi and Luisa Mortari. Viterbo: Agnesotti, 1954, 100 pp., 84 illus.
Exhibition of eighty-four works, mostly painting, located in Viterbo and surrounding area. Includes section on influential non-native work, as well as section on Viterbese artists.

Tuscany: Regional Surveys and Material on Smaller Centers

Documents (See also General Material: Source Material: Documents)

75 DEL VITA, ALESSANDRO. "Notizie e documenti su antichi artisti aretini." L'arte 16 (1913):228-32.
Collection of documents, mostly fourteenth century, but including some mention of Giovanni d'Angelo di Balduccio, Parri Spinelli, and others.

76 GAMURRINI, G.F. "I pittori aretini dell'anno 1150-1527 (aggiunte all'articolo di V. Pasqui)." Rivista d'arte 10, no. 1-2 (1917-18):88-97.
Transcribes documents from the papers of the Magestrato della Fraternità mentioning various painters. See also entry 80.

77 GLASSER, HANNELORE. "Artists' Contracts of the Early Renaissance." Ph.D. dissertation, Columbia University, 1965, 422 pp., 59 illus. New York and London: Garland, 1977.
Studies contracts made with fifteenth-century Tuscan artists. Examines documents and discusses common procedures. Includes Piero's S. Agostino altarpiece (with documents appended) and works by Fra Angelico and Gozzoli.

78 MILANESI, GAETANO. Nuovi documenti per la storia del'arte toscana dal XII a XV secolo. Florence: n.p., 1901, 176 pp. Reprint. Soest: Davaco Publishers, 1973.
Gathers documents printed in Il Buonarroti 1881-88 in a volume to be used with author's edition of Vasari's Vite. Includes 198 documents arrayed chronologically from 1165 to 1499, drawn from a wide variety of archival sources. Gives brief summary at beginning of each and adds some annotations.

Source Material

79 _____. "Documenti inediti dell'arte toscana dal XII al XVI
 secolo." Il Buonarroti, 3d ser. 2, no. 3 (1885):73-85;
 no. 4 (1885):109-21; no. 5 (1885):141-51.
 Sections in a long series of publications of documents
 that deal with years 1401-59, and include Lorenzo di Niccolo,
 Mariotto di Nardo, Meo d'Andrea, Martino di Bartolommeo,
 Gozzoli, Piero, Bocchi, Mariotto di Cristofano, Domenico
 Veneziano, and Lippi. Annotated.

80 PASQUI, UBALDI. "Pittori aretini vissuti dalla meta del
 sec. XII al 1527." Rivista d'arte 10, no. 1-2 (1917-18):
 32-87, 1 illus.
 Compiles and annotates documents on a variety of painters
 from area. See entry 76.

81 TANFANI-CENTOFANTI, L. Notizie di artisti tratte dai
 documenti pisani. Pisa: Enrico Spoerri editori, 1897,
 581 pp.
 Documents on artisans working in Pisa, 1100-1700.
 Entries arranged alphabetically by artist's name. Chrono-
 logical list of artists. Index.

Sources up to 1700 (See also General Material: Source Material:
Sources up to 1700)

82 MURRAY, PETER. An Index of Attributions Made in Tuscan
 Sources before Vasari. Florence: Olschki, 1959, 163 pp.
 Compiles works cited by various sources writing before
 1550, arranged by artist and then location. Includes some
 references to more recent sources to clarify locations, condi-
 tions, and historical changes.
 Review: Werner Cohn, Kunstchronik 12 (1959):343-46.

SURVEYS OF TUSCAN PAINTING
(See also General Material: Surveys of Italian Painting)

83 ANTAL, FRIEDRICH. "Gedanken zur Entwickluing der Trecento-
 und Quattrocentomalerei in Siena und Florenz." Jahrbuch für
 Kunstwissenschaft 3 (1924):207-39, 28 illus.
 Traces survival of Gothic spirit and influence of North-
 ern ideas. Particular attention to Gentile.

84 BORSOOK, EVE. The Mural Painters of Tuscany: From Cimabue
 to Andrea del Sarto. 2d ed. Oxford: Clarendon Press,
 1980, 215 pp., 182 illus.
 Introduction concerns mural techniques and general his-
 tory. Catalogs more than thirty major projects. Amply illus-
 trated with details and sites. Glossary, bibliography, and
 index.

Surveys of Tuscan Painting

Review: Julian Gardner, Burlington Magazine 124, no. 947
(1982):104-6.

85 FIOCCO, GIUSEPPE. La pittura toscana del quattrocento.
Novara: Istituto geografico De Agostini, 1945, 34 pp.
introduction, 132 illus.
Surveys primarily first half of century, with brief
essays introducing extensive group of photographs.

BOOKS AND ARTICLES ON ASPECTS OF TUSCAN PAINTING

86 BALDASS, LUDWIG. "Toskanische Gemälde des Internationalen
Stiles in der Wiener Galerie." In Festschrift Eberhard
Hanfstaengl zum 75. Geburtstag. Munich: Bruckmann, 1961,
pp. 35-36, 7 illus.
Presents examples of International Style in predella
panels by Bicci di Lorenzo, Madonna and Child by Master of the
Bambino Vispo, and Madonna and Child by Mariotto di Nardo.

87 BALDINI, UMBERTO. "Note brevi su inediti toscani."
Bollettino d'arte 40, no. 1 (1955):79-83, 6 illus.
Includes Crucifix by Lorenzo Monaco, Sta. Marta, Florence;
Madonna and Saints, by unknown Florentine artist, La Ferruzza,
Fuecchio.

88 BERENSON, BERNARD. Homeless Paintings of the Renaissance.
Edited by Hanna Kiel. Introduction by Myron P. Gilmore.
Bloomington: Indiana University Press, 1970, 256 pp., 442
b&w and 1 color illus. [British ed. London: Thames &
Hudson, 1969.]
Reissues publications of 1929-32 on Florentine and
Sienese works whose whereabouts were unknown to Berenson. Some
articles here published for first time in English. List of
illustrations with later changes in attributions and present
whereabouts given when known. Index.
Review: David Wilkins, Art Quarterly 1, no. 2
(1978):117-21.

89 BOSQUE, A. DE. Artistes italiens en Espagne du XIVme siècle
aux rois catholiques. Paris: Editions du temps, 1965, 493
pp., hundreds of unnumbered illus.
Surveys presence in Spain of Tuscan artists. Includes
sections on Master of the Bambino Vispo, Starnina, and Dello
Delli, and on other items, such as manuscripts. Reviews works
and scholarly research. Very amply illustrated. Detailed
bibliography.

90 BROCKHAUS, HEINRICH. "Der Gedankenkreis des Campo Santo in
Pisa und verwandter Malerein." Mitteilungen des
Kunsthistorischen Institutes in Florenz 1 (1908-11):237-54,
10 illus.

Surveys of Tuscan Painting

Study of the program of three cycles, including Chiostro
Verde in Sta. Maria Novella, Florence; Campo Santo, Pisa; and
little-known works in parish church in Cercina, ca. 1460.
Death-related iconography.

91 BRUNETTI, GIULIA. "Gli affreschi della Cappella Bracciolini
in San Francesco a Pistoia." Rivista d'arte 17 (1935):221-
44, 9 illus.
Publishes frescoes, early fifteenth century. Artist
unknown.

92 CALLMANN, ELLEN. "Thebaid Studies." Antichità viva 14, no.
3 (1975):3-22, 30 illus.
Reviews visual and literary sources of theme. Discusses
panel in Uffizi, Florence, of ca. 1425-35, frescoes in Campo
Santo, Pisa, attributed to Traini, fresco in Sta. Marta, Siena,
by Gualtieri di Giovanni, and in Sant' Andrea, Cercina.

93 CHIASSERINI, VERA. La pittura a Sansepolcro e nell'alta
valle tiberina prima di Piero della Francesca. Edited by
Dante Gennaioli. Collana di monografie storiche e artistiche
altotiberine. Florence: Olschki, 1951, 95 pp., 9 illus.
Overview of area where Tuscan and Umbrian trends merge.
Appendix of unpublished documents, bibliography.

94 DEL VITA, ALESSANDRO. "Contributi per la storia dell'arte
aretina." Rassegna d'arte 13, no. 11 (1913):185-88, 2
illus.
A variety of information, including documents regarding
several Aretine painters.

95 FIOCCO, GIUSEPPE. L'arte di Andrea Mantegna. 2d ed.
Venice: Neri Pozza editore, 1959, 129 pp., 174 b&w and 8
color illus.
Contains important material on the activity of Tuscan
artists in the Veneto. Chapters on Uccello, Domenico Veneziano,
Dello Delli, Castagno, Lippi, and others.

96 GAI, LUCIA. "Rapporti tra l'ambiente artistico pistoiese e
fiorentino alla fine del trecento ed ai primi del quattro-
cento: riesame di un problema critico." In Egemonia
fiorentina ed autonomie locali nella Toscana nord-
occidentale del primo rinascimento: Vita, arte, cultura.
Convegno internazionale, 1975. Pistoia: 1978, pp. 325-26,
12 illus.
Investigates decline in artistic activity in Pistoia
under Cosimo de' Medici. Comments by Enzo Carli.

97 GORI-MONTANELLI, LORENZO. Architettura e paesaggio nella
pitture toscane: Dagli inizi alla metà del quattrocento.
Pocket Library of Studies in Art, 11. Florence: Olschki,
1959, 239 pp., 26 illus.

Review of "ambiente" in painting of period (rather than figures). Surveys works by major artists through Piero.

98 KALLAB, WOLFGANG. "Die toscanische Landschaftsmalerei im XIV. and XV. Jahrhundert, ihre Enstehung and Entwicklung: Section VII: Die toscanische und umbrische Landschaftsmalerei im XV Jahrhundert. Part 1: Masaccio and die Naturalisten." Jahrbuch der kunsthistorischen Sammlungen des allerhöchsten Kaiserhauses 21 (1900):51-69, 8 illus.
 Survey of landscapes in figured scenes by various artists. Emphasizes issues of developing naturalism, perspective, and various motifs.

99 PROCACCI, UGO. "Opere sconosciute d'arte toscana I." Rivista d'arte 14 (1932):341-53, 6 illus.
 Includes a fresco, S. Martino, Vespignano, by an anonymous hand, early fifteenth century. Rejects attribution to Paolo Schiavo.

100 PROTO PISANI, R.C. "Tre casi d'intervento nel territorio toscano." Bollettino d'arte 67, no. 15 (1982):99-108, 12 illus.
 Publishes frescoes in houses. Includes attributions to Cenni and Bicci di Lorenzo.

101 RAGGHIANTI, CARLO L[UDOVICO]. "Argomenti lippeschi e uccelleschi." In Miscellanea minore di critica d'arte. Bari: Guis. Laterza & figli, 1946, pp. 69-76, 7 illus.
 Attributes Madonna, Duveen, New York (now National Gallery, Washington) to Domenico di Bartolo. Makes other attributions, discusses relationship of Lippi to Domenico di Bartolo. Also discusses some attributions to Uccello, and one to Giovanni di Francesco of Madonna, Blumenthal Collection.

102 SALMI, MARIO. "Paolo Uccello, Domenico Veneziano, Piero della Francesca e gli affreschi del Duomo di Prato." Bollettino d'arte 28, no. 1 (1934):1-27, 30 illus.
 Examines frescoes in Cappella dell'Assuntà. Rejects various earlier attributions in favor of an unknown hand.

103 _____. "Spigolature d'arte toscana." L'arte 16 (1913):208-27, 9 illus.
 Selection of unpublished or little-known works by various artists who bridge fourteenth and fifteenth centuries. Lists works by each hand. Includes, among others, Mariotto di Nardo, Bicci di Lorenzo, Giovanni dal Ponte, Master of the Bambino Vispo, and Rossello di Jacopo Franchi.

104 SANESI, ANNA. "Gli affreschi della cappella dell'Assunta del Duomo di Prato." Archivio storico pratese 32, no. 1-4 (1956):44-62, 8 illus.

Surveys of Tuscan Painting

Examines frescoes done in second quarter of fifteenth
century in two phases, first group in style close to Uccello
and Domenico Veneziano; second, later group attributed to
Andrea di Giusto.

105 SEMENZATO, CAMILLO. "Un polittico di Paolo da Brescia."
 Arte veneta 9 (1955):24-28, 8 illus.
 Attributes tondi in polyptych of 1458 by Paolo da
Brescia, Galleria Sabauda, Turin, to a Tuscan artist.
Believes panels were taken from another work and inserted
into polyptych.

106 SIRÉN, OSVALD. "Alcune note aggiuntive a quadri primitivi
 nella galleria vaticana." L'arte 24 (1921):24-28, 97-102,
 16 illus.
 Comments on, among others, works by Turino Vanni, Lorenzo
di Niccolo, and Lorenzo Monaco.

107 _____. "Tre Madonnine nel Fitzwilliam Museum di Cambridge."
 Rivista d'arte 3, no. 12 (1905):245-52, 3 illus.
 Discusses works by Lorenzo Monaco, Parri Spinelli, and
Giovanni dal Ponte.

108 _____. "Two Early Quattrocento Pictures." Burlington
 Magazine 46, no. 267 (1925):281-87, 3 illus.
 Publishes works, Nemés Collection, Munich: cassone with
story of Lucretia, attributed to Giovanni di Paolo, and Madonna
Adoring the Child, Lippi School, possibly an early work by the
Master of the Castello Nativity.

109 SOULIER, GUSTAVE. Les influences orientales dans la
 peinture toscane. Paris: Laurens, 1924, 450 pp., 180
 illus.
 Deals with historical background and evidence of Oriental
influence outside painting. Then examines specific borrowings
and general stylistic affinities seen in paintings. Finally
suggests sources of inspiration and possibilities of contact.
 Review: Louis Hourticq, Journal des savants (1926):
58-70.

110 THIEM, GUNTHER, and THIEM, CHRISTEL. Toskanische Fassaden-
 Dekoration in sgraffito und fresko 14. bis 17. Jahrhundert.
 Italienische Forchungen von Kunsthistorischen Institut in
 Florenz, 3. Munich: Bruckmann, 1964, 158 pp., 233 illus.
 Surveys exterior architectural decoration. Introductory
essays on various periods. Catalog by type of building.

111 VAVASOUR-ELDER, IRENE. "Alcuni dipinti ed oggetti d'arte
 nei dintorni di Firenze." Rassegna d'arte 16, no. 9
 (1916):179-86; no. 11-12 (1916):256-64, 23 illus.
 Publishes various works in churches near Florence. In-
cludes items by Bicci di Lorenzo, Neri di Bicci, and Mariotto
di Nardo.

112 ZERI, FEDERICO. "Due ipotesi di primo quattrocento a Lucca
 e due dipinti a Parma." In Diari di lavoro 2. Turin:
 Einaudi, 1976, pp. 39-46, 15 illus.
 Reconstructs activity of a Master of S. Davino, based on
 triptych, Galleria Nazionale, Parma. Active ca. 1395-1420.
 Also reconstructs activity of a Master of Barga, related to
 Master of the Bambino Vispo. Both artists from Lucca.

113 _____. "Sul catalogo dei dipinti toscani del secolo XIV
 nelle gallerie di Firenze." Gazette des beaux arts 71,
 no. 1189 (1968):65-78, 17 illus.
 Review of various items, mostly from trecento (arising
 from book by Luisa Marcucci, I dipinti toscani del secolo XIV
 nelle gallerie nazionale di Firenze (Rome: Libreria dello
 stato, 1965). Includes reconstruction of career of an artist
 active in quattrocento, whom author names Master of 1416.

 EXHIBITIONS

114 LONDON. WILDENSTEIN. The Art of Painting in Florence and
 Siena from 1250 to 1500. Catalog by St. John Gore. Intro-
 duction by Denys Sutton. London: Wildenstein & Co., 1965,
 91 pp., 95 b&w and 4 color illus.
 Loan exhibition of 102 paintings from public and private
 collections.
 Review: Federico Zeri, Burlington Magazine 107, no. 746
 (1965):252-56, 11 illus.

115 PRATO. PALAZZO PRETORIO. Due secoli di pittura murale a
 Prato: Mostra di affreschi, sinopie e graffiti del sec. 14
 e 15. Catalog by Giuseppe Marchini. Prato: Azienda
 autonoma di turismo di Prato, 1969, 158 pp., 81 b&w and 10
 color illus.
 Exhibition catalog with sections on technique and on
 terminology of fresco painting. Illustrates sinopie, diagrams
 giornate. Major section on Cappella dell'Assunta, Duomo, by
 Andrea di Giusto and possibly Uccello.
 Review: Miklòs Boskovits, Arte illustrata 3, no. 25-6
 (1970):32-47, 133-37, 21 b&w and 4 color illus.

116 ROME. PALAZZO VENEZIA. Mostra di dipinti restaurati:
 Angelico, Piero della Francesca, Antonella da Messina.
 Introduction by Umberto Baldini. Rome: Tipografia istituto
 tiberino, 1953, 15 pp.
 Pamphlet with rather complete descriptions of works by
 Fra Angelico and Piero, recently restored.

Florence

Documents (See also General Material: Source Material: Documents, and Tuscany: Source Material: Documents)

117 CIASCA, RAFFAELE, ed. Statuti dell'arte dei Medici e Speziali, editi a spese della camera di commercio e industria di Firenze. Florence: Vallecchi, 1922, 677 pp.
Publishes rules and regulations of Florentine guild from 1314 to 1769. Includes notices of some artists' activities, such as matriculation.

118 COHN, WERNER. "Notizie storiche intorno ad alcune tavole fiorentine del '300 e '400." Rivista d'arte 31 (1956): 41-72, 7 illus.
New documentary information concerning works of a variety of artists. Arranged by location.

119 CORTI, GINO, and HARTT, FREDERICK. "New Documents Concerning Donatello, Luca and Andrea della Robbia, Desiderio, Mino, Uccello, Pollaiuolo, Filippo Lippi, Baldovinetti and Others." Art Bulletin 44, no. 2 (1962):155-67.
Publishes entries in books of Cambrini bank, ca. 1450-77, including numerous commissions made by Bartolommeo Serragli.

120 DEL PIAZZO, MARCELLO, and GUIDORIZZI, LAURA. "Gli artisti fiorentini del quattrocento nei catasti contemporaneii." Commentari 1, no. 3 (1950):189-92; 1, no. 4 (1950):250-58; 2, no. 1 (1951):56-61; 2, no. 2 (1951):127-29; 2, no. 3-4 (1951):236-41.
Publishes, with explanatory introduction, several catasto decorations, including those of Baldovinetti and Castagno.

121 ESCH, ARNOLD. "Florentiner in Rom um 1400. Namensverzeichnis der ersten Quattrocento-Generation." Quellen und Forschungen aus italienischen Archiven und Bibliotheken

Source Material

(Herausgegeben vom Deutschen Historischen Institut in Rom) 52 (1972):476-525.
Names of 200 Florentines in Rome in 1388-1413, gleaned from various archival sources. Discusses historical situation, lists names with information. Italian summary. Includes some artists.

122 FILIPPINI, FRANCESCO. "Notizie di pittori fiorentini a Bologna nel quattrocento." Miscellanea di storia dell'arte in onore di Igino Benvenuto Supino. Florence: Olschki, 1933, pp. 417-28, 3 illus.
Documents regarding Angeli di Lippi and Zanobi del Migliore.

123 FREMANTLE, RICHARD. "Tre note dell'archivio fiorentino." Antichità viva 16, no. 3 (1977):69-70.
Alphabetical list of artists mentioned by Filippo di Cristofano, notary in Florence. Includes Bicci di Lorenzo, Lippi, Mariotto di Nardo, Neri, Pesello, Uccello, and a number of others.

124 MACK, CHARLES R. "A Carpenter's Catasto with Information on Masaccio, Giovanni dal Ponte, Antonio di Domenico, and Others." Mitteilungen des Kunsthistorischen Institutes in Florenz 24, no. 3 (1980):366-69.
Record of debts owed to a carpenter in 1427 by Masaccio and Giovanni dal Ponte. Includes text of document.

125 MATHER, RUFUS GRAVES. "Documents Mostly New Relating to Florentine Painters and Sculptors of the Fifteenth Century." Art Bulletin 30, no. 1 (1948):20-65.
Publishes catasto declarations of twenty fifteenth-century artists, as well as available guild matriculations, entrances into compagnie, and death notices.

126 MÜNTZ, EUGÈNE. Les collections des Medicis au XVe siecle; le musée, la bibliothèque, le mobilier. Paris: Librairie de l'art, 1888, 112 pp.
Publishes inventories of collections, gathered primarily by Piero di Cosimo and Lorenzo. Amplifies with historical background. Covers important objects in all media. Index.

127 POGGI, GIOVANNI. "Appendice di documenti." Rivista d'arte 2, no. 10-11 (1904):225-44.
Collection of documents ca. 1350-1500, for various Florentine locations. Mentions Ambrogio di Baldese, Mariotto di Nardo, Bicci de Lorenzo, Lapo di Francesco, Ventura di Moro, Rossello di Jacopo Franchi, Neri di Bicci, and others.

128 _____. Il Duomo di Firenze: Documenti sulla decorazione della chiesa e del campanile tratti dall'archivio dell'opera. Italienische Forschungen, herausgegeben vom Kunsthistorischen

Institut in Florenz, 2. Berlin: Bruno Cassirer, 1909, 427
pp., 89 illus.
Fundamental collection of documents concerning the cathe-
dral of Florence. Analysis of each followed by transcription.
Arranged by location.

Sources Up to 1700 (See also General Material: Source Material:
Sources up to 1700, and Tuscany: Source Material: Sources up to 1700)

129 ALBERTINI, FRANCESCO. "Memoriale di molte statue e pitture
 della citta di Firenze." In Five Early Guides to Rome and
 Florence. Edited by Peter Murray. London: Gregg Inter-
 national Publications, 1972.
 Brief early guide to works of art in city, arranged by
 location. First published in Florence in 1510.

 BAXANDALL, MICHAEL. "Alberti and Cristoforo Landino." See
 entry 579.

130 BILLI, ANTONIO. Il libro di Antonio Billi esistente in due
 copie nella Biblioteca Nazionale di Firenze. Edited by Carl
 Frey. [Also pub. as Cornelius von Fabriczy, "Il libro di
 Antonio Billi e le sue copie nella Biblioteca Nazionale di
 Firenze," Archivio storico italiano 7 (1891):299-368. Re-
 print. Farnborough: Gregg, 1969.]
 Important early source, with notes on various Florentine
 artists from Cimabue to early sixteenth century. Edition pre-
 sents and annotates two known versions of text.

131 BOCCHI, FRANCESCO. Le bellezze della città di Fiorenza.
 Introduction by John Shearman. England: Gregg Inter-
 national Publishers, 1971, 290 pp.
 First detailed guidebook of Florence, written in 1591.
 Important source for works in a variety of locations. Long
 index of names and subjects.

132 BORGHINI, RAFFAELLO. Il riposo. Edited by Mario Rosci. 2
 vols. Milan: Edizioni labor, 1967, 828 pp.
 Reprints text first published in Florence in 1584.
 Lengthy work discussing theory of art and surveying its
 history. Includes brief summaries of careers of major
 Florentine artists. Second volume includes editor's bib-
 liography and analytic index.

133 FABRICZY, C[ORNELIUS] DE. "Huomini singhularj in Firenze
 dal MCCCo innanzi." Archivio storico dell'arte 5 (1892):
 56-60.
 Reviews contents in Codice Miscellane of Codex
 Magliabecchiano XVII, 1501, in Biblioteca Nazionale, Florence.
 Questions Manetti's authorship of section on fourteen famous
 men, which discusses several painters. See also entries 138
 and 140.

Source Material

134 GELLI, GIOVANNI BATTISTA. Vite de' primi pittori di
 Firenze. In Scritti scelti. Edited by Aurelio Ugoline.
 Milan: Vallardi, 1906. [Also published as Girolamo
 Mancini, ed., "Vite d'artisti," Archivio storico italiano 17
 (1896):32-62.]
 Manuscript written in mid-sixteenth century but unpub-
 lished until modern times. Includes biographies of Masolino,
 Starnina, Lippi, and Delli.

135 GHIBERTI, LORENZO. I commentari. Edited by Ottaviano
 Morisani. Naples: Riccardo Ricciardi editore, 1947,
 247 pp.
 Standard edition of Ghiberti's three commentaries, writ-
 ten 1447-55. The first concerns ancient artists, the second
 Florentine artists, the third art theory, especially optics.
 One of first texts to consider development of art, as well as
 biographies of artists.

136 GILBERT, CREIGHTON. "The Archbishop on the Painters of
 Florence, 1450." Art Bulletin 41, no. 1 (1959):75-87, 2
 illus.
 Analyzes chapter on painters in Summa theologica (1446-
 59) by Archbishop Antoninus of Florence. Deals with questions
 of social status of artist, ethics of various representations,
 role of painter in choosing iconography, and position of
 sculpture. See entry 217.

137 LANDINO, CRISTOFORO. "Fiorentini eccellenti in pittura e
 scultura." In "Commento sopra la Comedia." In Scritti
 critici e teorici. Edited by Robert Cardini. Rome:
 Bulzoni, 1974, pp. 123-25.
 Important early text, written in 1467, in which author
 mentions most significant artists of his century, including
 Masaccio, Lippi, Castagno, Uccello, Fra Angelico, and
 Pesellino, as representatives of a new style that had begun
 with Cimabue. See also entry 140.

138 MANETTI, ANTONIO. Operette istoriche. Edited by Gaetano
 Milanesi. Florence: Le Monnier, 1887, 213 pp.
 Standard Italian edition of works attributed to Manetti's
 authorship in late fifteenth century. Introduction traces
 author's life and family tree. Volume includes life of
 Brunelleschi and "XIV Uomini Singolari in Firenze," recounting
 lives and works of several Florentine artists, including
 Brunelleschi, Masaccio, Fra Angelico, Lippi, and Uccello. See
 also entries 133 and 141.

139 MILANESI, GAETANO. "Le vite di alcuni artefici fiorentini
 scritte da Giorgio Vasari, corrette ed accresciute
 coll'aiuto de' documenti." Giornale storico degli archivi
 toscani 4, no. 3 (1860):177-210; 6, no. 1 (1862):3-18.
 [Also published in Sulla storie dell'arte Toscana: Scritti

vari (Siena, 1873), pp. 263-324. Reprint. Soest: Davaco
Publishers, 1973.]
 Edits and annotates Vasari's lives of Lorenzo di Bicci,
Dello Delli, Pesellino, Giovanni Toscani, Masolino, Masaccio,
Castagno, Domenico Veneziano, and Piero, among others. Lists
works and adds new documents.

140 MORISANI, OTTAVIO. "Art Historians and Art Critics-III:
 Cristoforo Landino." Burlington Magazine 95, no. 605
 (1953):267-70.
 Discussion of attitudes of Landino, in introduction to
 Dante's Divine Comedy. Includes texts of versions from 1481
 through 1564 in which cites great artists of Florence. See
 also entry 137.

141 MURRAY, PETER. "Art Historians and Art Critics-IV."
 Burlington Magazine 99, no. 655 (1957):330-36, 2 illus.
 Discusses codex, Biblioteca Nazionale, Florence, of XIV
 uomini singhularii in Firenze. Dates 1494-97. Suggests
 Manetti as the author; includes Italian text and English trans-
 lation. See also entries 133 and 138.

SURVEYS OF FLORENTINE PAINTING, INCLUDING DICTIONARIES AND GUIDEBOOKS
 (See also General Material: Surveys of Italian Painting,
 and Tuscany: Surveys of Tuscan Painting)

142 ANTAL, FREDERICK. "Art of the Early Fifteenth Century." In
 Florentine Painting and its Social Background: The
 Bourgeois Republic Before Cosimo de' Medici's Advent to
 Power: XIV and Early XV Centuries. London: Kegan Paul,
 1948, pp. 288-380, 61 illus. Reprint. New York: Harper &
 Row, 1975.
 Historical survey of era with emphasis on influence of
 social and political changes on developments of style and
 iconography. Bibliography, index of names.
 Review: Millard Meiss, Art Bulletin 31, no. 2
 (1949):143-50.

143 BERENSON, BERNARD. Italian Pictures of the Renaissance:
 Florentine School. 2 vols. London: Phaidon, 1963, 236
 pp., 1478 b&w and 2 color illus.
 Authoritative list of painters ca. 1250-1600, originally
 published in 1896. Arranges artists alphabetically, and for
 each gives works by location with notations concerning date,
 signatures, and authenticity. Topographical index.

144 COLNAGHI, DOMINIC ELLIS. A Dictionary of Florentine Paint-
 ers from the Thirteenth to the Seventeenth Centuries.
 London: John Lane, Bodley Head, 1928, 286 pp.
 Useful reference work. Each entry includes brief career
 survey, references to documents and literature. Very brief
 bibliography.

Surveys of Florentine Painting

145 CRUTTWELL, MAUD. <u>A Guide to the Paintings in the Churches</u>
<u>and Minor Museums of Florence: A Critical Catalogue with</u>
<u>Quotations from Vasari</u>. New York: E.P. Dutton & Co., 1908,
286 pp., many illus.
 Guide to works not in major museums, with useful refer-
ences and illustrations, index.
 Review: Alessandro Chiappelli, in <u>Arte del rinascimento</u>
(Rome: Casa editrice Albert Stock, 1925), pp. 119-32.

146 FREMANTLE, RICHARD. <u>Florentine Gothic Painters from Giotto</u>
<u>to Masaccio: A Guide to Painting in and near Florence,</u>
<u>1300-1450</u>. London: M. Secker & Warburg, 1975, 690 pp.,
1335 b&w and 1 color illus.
 Large reference tool covering fifty-four artists, with
biographical notes and bibliographies. Numerous lists and
appendices, including: review of 220 additional artists from
region; list of unattributed paintings; glossary; index of
Saints and symbols. Concordance to Berenson (entry 143), maps,
and indexes.
 Review: Allan Braham, <u>Apollo</u> 103, no. 170 (1976):340.

147 _____. <u>Florentine Painting in the Uffizi: An Introduction</u>
<u>to the Historical Background</u>. Florence: Olschki, 1971, 159
pp., 64 illus.
 Discusses history of building and collection, history of
Florence, and significance of Florentine painting. Presents
in-depth look at numerous works in collection.

148 LANZI, LUIGI. "Pittori fiorentini che vissero dopo Giotto
fino al cadere del secolo XV." In <u>Storia pittorica della</u>
<u>Italia dal risorgimento delle belle arti fin presso al fine</u>
<u>del XVIII secolo</u>. Vol. 1. Bassano: Remondini, 1789, pp.
47-94. Reprint. Edited by Martino Capucci, with extensive
notes. Florence: Sansoni, 1968, 690 pp. [English ed.
Translated by Thomas Roscoe. London: Bohn, 1852.]
 Important early survey, divided into regional schools.
Emphasizes evolution of styles and connoisseurship. Elaborate
bibliography including guidebooks and early sources.

149 LOTHROP, STANLEY. <u>A Bibliographical Guide to Cavallini and</u>
<u>the Florentine Painters before 1450, Including Lists of</u>
<u>Documents and the More Important Pictures</u>. Rome: American
Academy in Rome, 1917, 58 pp.
 Reference work with short sections on important artists,
each with brief biography, list of works and bibliographies.
Geographic index.

150 PAATZ, WALTER, and PAATZ, ELIZABETH. <u>Die Kirchen von</u>
<u>Florenz: Ein kunstgeschichtliches Handbuch</u>. 6 vols.
Frankfurt am Main: Vittorio Klostermann, 1940-54.
 Fundamental guide to Florentine religious structures.
For each building, gives detailed description of architecture,

Books and Articles on Aspects of Florentine Painting

history, and contents including information on paintings. In-
cludes plans, notes with bibliography. Index volume with
names, places, and maps.

151 RICHA, GIUSEPPE. Notizie istoriche delle chiese fiorentine
 divise ne' suoi quartieri. 10 vols. Florence: Stamperia
 di Petro Gaetano Viviani, 1754-62. Reprint. Rome: Soc.
 multigrafica editrice, 1972.
 Major guide to Florentine churches with description of
 contents, including paintings. Also discusses history, early
 writings. Indexes of names, objects, and family tombs.

152 ROSSI, SERGIO. Dalle botteghe alle accademie: Realtà
 sociale e teorie artistiche a Firenze del XIV al XVI secolo.
 Preface by Maurizio Calvesi. Milan: Feltrinelli, 1980,
 198 pp.
 Studies evolution of artist from medieval artisan to
 Renaissance intellectual. Considers social and theoretical
 issues. Includes chapters on (1) corporate system (sistema
 corporativo) and workshops in Florence and (2) on Alberti.
 Bibliography. Index.

153 SANDBERG-VAVALÀ, EVELYN. Uffizi Studies: The Development
 of the Florentine School of Painting. Florence: Olschki,
 1948, 320 pp., 115 illus.
 Survey of Italian Renaissance art through works in the
 Uffizi. Chapters on major artists. Indexes.

154 WACKERNAGEL, MARTIN. Der Lebensraum des Künstlers in des
 Florentinischen Renaissance: Aufgaben und Auftraggeber,
 Werkstatt und Kunstmarkt. Leipzig: E.A. Seemann, 1938,
 387 pp. [English ed. The World of the Florentine Renaissance
 Artist: Projects and Patrons, Workshop and Art Market,
 trans. Alison Luchs (Princeton: Princeton University Press,
 1981), 477 pp.]
 Study of Florentine art from 1420 to 1530 with particular
 attention to its context. Sections on commissions, patronage,
 and studio and business procedures. Bibliographies and index.
 Review: Randolph Starn, Art Bulletin 65, no. 2
 (1983):328-35.

BOOKS AND ARTICLES ON ASPECTS OF FLORENTINE PAINTING

155 ANSANO FABBI, D. "Artisti fiorentini nel territorio di
 Norcia." Rivista d'arte 34 (1959):109-22, 8 illus.
 Publishes works in little-known places, including some in
 Abeto by Neri di Bicci.

156 BACCI, PÈLEO. "Il Pesellino, Fra Filippo Lippi, Domenico
 Veneziano, Piero di Lorenzo, Fra Diamante, Domenico discepolo
 di Fra Filippo, etc., e la tavola pistojese della 'Trinità'

Books and Articles on Aspects of Florentine Painting

nella Galleria Nazionale di Londra." Arti 3, no. 5
(1941):353-70, 5 illus.; no. 6 (1941):418-34, 9 illus.
Publishes documents (1455-68) regarding Pesellino and
Lippi's Trinity, National Gallery, with extensive commentary
regarding earlier literature.
Review: Mary Pittaluga, Rivista d'arte 26 (1950):233-39,
3 illus.

157 BECHERUCCI, LUISA. "Donatello e la pittura." In Donatello
e il suo tempo. Atti dell'VIII Convegno internazionale di
studi sul rinascimento, 1966. Florence: Istituto nazionale
di studi sul rinascimento, 1968, pp. 41-58.
Discusses relationship between Donatello and Masaccio,
particularly ca. 1425-27. Also notes Donatello's influence on
Uccello and Lippi and others.

158 BERTI, L[UCIANO]. "Sequace di Lorenzo Monaco." Bollettino
d'arte, 37, no. 2 (1952):175, 1 illus.
Publishes Annunciation from S. Michele, Carmignano.

159 BERTOLINI, LICIA. "Opere d'arte toscane ignote o poco
note." Annali della scuola normale superiore di Pisa 23
(1954):144-50, 7 illus.
Publishes Crucifixion, Sta. Lucia, Montecastello, attrib-
uted tentatively to Filippo Lippi, ca. 1430, and Madonna and
Saints, S. Giusto, Volterra, 1452, earliest dated work of Neri
di Bicci.

160 BORENIUS, TANCRED. "The Fifteenth Century." In Florentine
Frescoes. London: T.C. & E.C. Jack, 1930, pp. 43-83, 146
b&w and 12 color illus.
Surveys works in medium in a general manner.
Review: T.C., Burlington Magazine 57, no. 329 (1930):96.

161 _____. "Notes on Various Works of Art." Burlington
Magazine 40, no. 228 (1922):134-39, 4 illus.
Includes Crucifixion, School of Lorenzo Monaco, Ashmolean
Museum, Oxford.

162 _____. "Three Panels from the School of Pesellino."
Burlington Magazine 33, no. 189 (1918):216-21, 3 illus.
Publishes scenes, Ross Collection, probably from a
cassone, illustrating story of Joseph.

163 CALLMANN, ELLEN. "A Quattrocento Jigsaw Puzzle."
Burlington Magazine 99, no. 650 (1957):149-55, 7 illus.
Nineteen small panels in National Gallery Scotland; Yale
University, New Haven; Kunsthaus, Zurich; and Christ Church
Library, Oxford. Here reconstructed into a single work repre-
senting the Thebaid. Relates to other representation of theme.
Identifies as Florentine, after 1450.

Books and Articles on Aspects of Florentine Painting

164 CAVIGGIOLI, AURÉ. "Due capolavori del XV sec." Arte
 figurativa antica e moderna 10 (July-August 1954):19-21, 4
 b&w and 2 color illus.
 Publishes St. Anthony, attributed to Giovanni di
 Francesco, and St. Francis, attributed to Domenico Veneziano,
 both in Brivio Collection, Milan.

165 COMSTOCK, HELEN. "Florentine Annunciation Newly Brought to
 Light." Connoisseur 97, no. 418 (1936):338-39, 1 illus.
 Publishes Annunciation by unknown artist recently
 acquired by Griggs Collection. Dates ca. 1440.

166 COVI, DARIO. "The Inscription in Fifteenth Century
 Florentine Painting." 4 vols. Ph.D. dissertation, New York
 University, 1958, 721 pp., 184 illus.
 Discusses tradition. Catalogs 449 inscriptions, indicat-
 ing locations for each. Bibliography, appendix.

167 _____. "Lettering in Fifteenth Century Florentine Paint-
 ing." Art Bulletin 45, no. 1 (1963):1-17, 45 illus.
 Traces growth of use of Roman capitals and new
 humanistica script in pictures, beginning ca. 1420. Discusses
 sources in writing and carving, and suggests possible criteria
 for selection of letter style in individual cases.

168 DUPONT, JACQUES. "A propos d'un tableau aux armes de
 Jacques Coeur." Bulletin de la société de l'histoire de
 l'art français (1935):17-19, 1 illus.
 Notes that Annunciation, Munich, attributed to Lippi
 school, with arms of Jacques Coeur, may have been rare example
 of Italian work in France before time of Charles VIII.

169 EDGERTON, SAMUEL Y., Jr. "Florentine Interest in Ptolemaic
 Cartography as Background for Renaissance Painting, Archi-
 tecture, and the Discovery of America." Journal of the
 Society of Architectural Historians 33, no. 4 (1974):274-92,
 17 illus.
 Relationshp of ideas of Florentine physician Toscanelli
 (1397-1482) to those of Alberti and Brunelleschi. Concepts of
 space and order, linear perspective.

170 _____. "'Mensurare Temporalia Facit Geometria Spiritualis':
 Some Fifteenth-century Italian Notions about When and Where
 the Annunciation Happened." In Studies in Late Medieval and
 Renaissance Painting in Honor of Millard Meiss. Edited by
 Irving Lavin and John Plummer. New York: New York Univer-
 sity Press, 1977, pp. 115-30, 6 illus.
 Examines Saint Antonine's views on the Annunciation.
 Sees them as influencing the compositions and perspective of
 Florentine paintings in the fifteenth century. Examples in-
 clude Fra Angelico and Domenico Veneziano. Indicates new
 linear perspective used for religious meaning.

Books and Articles on Aspects of Florentine Painting

Letter: Samuel Y. Edgerton, Jr., Art Bulletin 61, no. 4 (1979):661.

171 EKWALL, SARA. "Birgitta utdelande klosterregeln." Konsthistorisk Tidskrift 39, no. 3-4 (1970):169-70, 1 illus. In Swedish with English summary. Iconography of Saint Bridget distributing the rules, in relation to new document regarding Giovanni da Rovezzano's 1439 commission for an altar for Paradiso Monastery, Florence. Two wings in Getty Museum may be related.

172 FASOLO, VINCENZO. "Riflessi brunellescchiani nelle architetture dei pittori." In Atti del I⁰ Congresso nazionale di storia dell'architettura. Florence: Sansoni, 1938, pp. 197-207, 11 illus. Brunelleschian details in backgrounds of paintings, particularly of Angelico and Gozzoli.

173 FIOCCO, GIUSEPPE. "Les précurseurs de Andréa Mantegna." Renaissance de l'art français 9, no. 3 (1926):146-52, 9 illus. Impact of Florentine artists on Paduan school in early fifteenth century. Discusses Uccello, Castagno, and Dello Delli.

174 _____. "Il rinnovamento toscano dell'arte del musaico a Venezia." Dedalo 6, no. 1 (1925):109-18, 7 illus. Discusses contributions particularly of Uccello and Castagno to Venetian scene. Works primarily in San Marco.

175 FRY, ROGER. "A Florentine Pietà." Burlington Magazine 42, no. 241 (1923):161-62, 1 illus. Publishes painting, Ruck Collection, dated 1460. Assigns to Castagno School, rather than to Pollauiolo.

176 GARDNER VON TEUFFEL, CHRISTA. "Lorenzo Monaco, Filippo Lippi, and Filippo Brunelleschi: Die Erfindung der Renaissancepala." Zeitschrift für Kunstgeschichte 45, no. 1 (1982):1-30, 27 illus. Traces development of altars for Florentine chapels from late Gothic to early Renaissance. Studies relation to settings. Emphasizes Lippi's Annunciation, S. Lorenzo, and its relation to Brunelleschi's architecture. Also discusses works of Lorenzo Monaco, Gozzoli, and others.

177 GILBERT, CREIGHTON. "Florentine Painters and the Origins of Modern Science." In Arte in Europa: Scritti di storia dell'arte in onore di Edoardo Arslan. 2 vols. Milan: Artipo, 1966, pp. 333-40. Considers various issues about Renaissance thought that are being or have been debated: scientific thought; the

Books and Articles on Aspects of Florentine Painting

Renaissance as the rediscovery of the world and of man; the
element of physical truth in paintings by Giotto, Masaccio,
Uccello, and Leonardo; physical truth in painting as a
groundwork for modern science, as in Galileo.

178 HARTT, FREDERICK. "Art and Freedom in Quattrocento Florence."
 In Marsyas: Studies in the History of Art. Suppl. 1,
 Essays in Memory of Karl Lehmann. New York: Institute of
 Fine Arts, New York University, 1964, pp. 114-31, 12 illus.
 Essay examining historical and cultural reasons for sty-
 listic change in early fifteenth century. Includes discussion
 of Masaccio's Trinity and Tribute Money.

*179 HATFIELD, ROBERT ALLAN. "Three Kings and the Medici: A
 Study in Florentine Art and Culture During the Quattrocento."
 2 vols. Ph.D. dissertation, Harvard University, 1966.
 Source: entries 974-75.

180 HENNIKER-HEATON, RAYMOND. "An Early Florentine Madonna."
 Art in America 12, no. 5 (1924):211-15, 3 illus.
 Madonna and Child, Art Museum, Worcester, found similar
 to triptych in Jarves Collection attributed to Ambrogio di
 Baldese.

181 JAESCHKE, EMIL. In Die Antike in der bildenden Kunst des
 quattrocento. Vol. 1, "Die Antike in der Florentiner
 Malerei des quattrocento. Zur Kunstgeschichte des
 Auslandes, 3. Strassburg: Heitz, 1900, 62 pp.
 Brief survey of development of knowledge and use of
 antiquity. Includes chapters on the church, Cosimo de' Medici,
 and works by Lippi and Gozzoli.

182 LERNER-LEHMKUHL, HANNA. Zur Struktur und Geschichte des
 Florentinischen Kunstmarktes im 15. jahrhundert.
 Lebensraüme der Kunst, 3. Wattenscheid: Karl Busch Verlag,
 1936, 59 pp.
 Discusses contracts and costs for various commissions.
 Includes transcriptions of documents, charts with payments.

183 LOGAN, MARY. "Compagno di Pesellino e quelques peintures de
 l'école." Gazette des beaux arts 26, no. 529 (1901):18-34,
 7 illus.; no. 532 (1901):333-43, 4 illus.
 Study of group of works here attributed to a student
 of Pesellino. Defines style, attributes several Madonnas.
 Assigns other works to other members of the school.

184 LONGHI, ROBERTI. "Una Madonna fiorentina del decennio di
 crisi 1430-40." Paragone 16, no. 187 (1965):56-57, 1 b&w
 and 1 color illus.
 Published panel of Madonna and Child, in private collec-
 tion, that demonstrates opposing old and new trends in Florentine
 art of 1430s. Style close to Domenico Veneziano.

Books and Articles on Aspects of Florentine Painting

185 MARIANI, VALERIO. Problemi della pittura del quattrocento.
 Naples: Libreria scientifica editrice, [1961?], 147 pp.
 Essays on Masaccio, emphasizing his realism and on
 Uccello, emphasizing fantasy. Bibliography.

186 MEISS, MILLARD. "Jan van Eyck and the Italian Renaissance."
 In Venezia e l'Europa. Atti del XVIII Congresso
 internazionale di storia dell'arte, 1955. Venice: 1956,
 pp. 58-69, 26 illus. Reprinted in The Painter's Choice:
 Problems in the Interpretation of Renaissance Art (New York:
 Harper & Row, 1976), pp. 19-35.]
 Discusses affinities between Jan and Masaccio. Influence
 of Jan's works on Masaccio's successors including Lippi and
 Piero.

187 MICHELETTI, EMMA. "Pitture pervenute e non pervenute." In
 Primo rinascimento in Santa Croce. Florence: Edizioni
 città di vita, 1968, pp. 105-30, 24 illus.
 Reviews works done in church ca. 1440-70 recorded in
 early sources, particularly Vasari. Some lost, locations of
 others noted.

188 MODE, ROBERT L. "Masolino, Uccello, and the Orsini 'Uomini
 Famosi.'" Burlington Magazine 114, no. 831 (1972):368-78,
 15 illus.
 Attaches names of Masolino and Uccello to lost uomini
 famosi cycle from the Orsini Palace at Monte Giordano in Rome,
 now dated ca. 1430. Refers to recently published documents and
 copies after the cycle.

189 NEUMEYER, ALFRED. "The Lanckoronski Annunciation in the
 M.H. de Young Memorial Museum." Art Quarterly 28, nos. 1 &
 2 (1965):4-17, 8 illus. [Reprinted in Gesammelte Schriften
 (Munich: W. Fink, 1977).]
 Places painting, either a predella or furniture panel,
 stylistically between Fra Angelico and Domenico Veneziano,
 dated ca. 1445-50. Links to Davis Madonna in Metropolitan
 Museum, New York.

190 NICOLSON, BENEDICT. "Two Little-known Paintings at Hampton
 Court." Burlington Magazine 91, no. 554 (1949):137, 2
 illus.
 Includes panel of Savior Blessing, Florentine, ca. 1430-
 35, recently cleaned and put on exhibit.

191 OS, H.W. VAN. "Discoveries and Rediscoveries in Early
 Italian Painting." Arte cristiana 71, no. 695 (1983):69-80,
 16 illus.
 Publishes works in various private collections. Includes
 Starnina, Master of 1419, Zanobi Machiavelli, and Mariotto di
 Nardo.

Books and Articles on Aspects of Florentine Painting

192 OS, H.W. VAN, and PRAKKEN, MARIAN, eds. The Florentine
 Paintings in Holland, 1300-1500. Maarssen: Schwartz, 1974,
 120 pp., 84 illus.
 Catalogs sixty-four works in eleven collections. In-
 cludes checklist of additional works. Entries give precise
 description and condition. Indexes of owners, former owners,
 location, and artists.

193 PACCIANI, RICCARDO. "Ipotesi di omologie fra impianto
 fruitivo e stuttura spaziale di alcune opere del primo
 Rinascimento fiorentino: Il rilievo della base del S.
 Giorgio di Donatello, la Trinità di Masaccio,
 l'Annunciazione del convento di S. Marco del Beato
 Angelico." In La prospettiva rinascimentale: Codificazioni
 e trasgressioni. Edited by Marisa Dalai Emiliani. Florence.
 Centro Di, 1980, pp. 73-79, 15 illus.
 Analysis of structures and spatial depth of three works,
 with diagrams, plans, constructions. Reviews earlier literature.

194 PARRONCHI, ALESSANDRO. "Due note para-uccellesche." Arte
 antica e moderna, 30 (April-June 1965):169-80, 12 illus.
 Discusses panels of a predella, private collection,
 Florence, and Figdor Collection, Vienna. Identifies iconog-
 raphy as regarding Saint Catherine. Attributes to circle of
 Uccello. Also publishes works by a documented Soror Antonia,
 daughter of Uccello.

195 PITTALUGA, M[ARY]. "Note sulla bottega di Filippo Lippi."
 L'arte 44, no. 1 (1941):20-37, 16 illus.; no. 2 (1941):67-
 81, 11 illus.
 Reviews attribution and dating questions in works by
 various artists. Works by Pesellino, Francesco di Stefano,
 Giovanni di Francesco, and other anonymous hands. Particular
 attention to Trinity, National Gallery, London.

196 POGGI, GIOVANNI. "La compagnia del Bigallo. Affreschi."
 Rivista d'arte 2, no. 10-11 (1904):189-209, 5 illus.
 Surveys building and its decoration, including frescoes
 on inside and outside of structure. Some fifteenth-century
 activity.

197 POPE-HENNESSY, JOHN. "The Ford Italian Paintings." Bulletin
 of the Detroit Institute of Arts 57, no. 1 (1979):15-23, 8
 b&w and 1 color illus.
 Discusses paintings from bequest of Eleanor Clay Ford,
 including two panels of an Angel and a Virgin by Fra Angelico
 and a Madonna Enthroned by Benozzo Gozzoli.

198 _____. "The Interaction of Painting and Sculpture in
 Florence in the Fifteenth Century." Journal of the Royal
 Society of Arts 117, no. 5154 (1969):406-24, 13 illus.

Books and Articles on Aspects of Florentine Painting

Investigates various aspects of the relationship between the media, including examples of painters' influence on Donatello and Ghiberti, instances of competition, and examples of painters using sculptural models. Works by Fra Angelico, Masaccio, Uccello, Lippi and others.

199 PROCACCI, UGO. "Di Jacopo di Antonio e delle compagnie di pittori del Corso degli Adimari nel XV secolo." Rivista d'arte 35 (1960):3-70, 10 illus.
Reconstructs career of Jacopo di Antonio, and then investigates organizations of painters and workshops in the early Renaissance in Florence. Publishes new documentary material.

200 PUDELKO, GEORG. "The Minor Masters of the Chiostro Verde." Art Bulletin 17, no. 1 (1935):71-89, 16 illus.
Discusses frescoes in Sta. M. Novella cloister not executed by Uccello. Attributes work to Dello Delli, Master of the Bargello tondo, and "Pseudo Ambrogio Baldese." Discusses other attributions to these artists and appends a list of works by "Pseudo Ambrogio Baldese."

201 REINACH, SALOMON. "La vision de saint Augustin." Gazette des beaux arts 1 (May 1929):257-64, 4 illus.
Publishes panel in Museum, Cherbourg. Attributes to school of Fra Angelico, possibly Pesellino or assistant of Gozzoli. Discusses rarity of subject. English summary.

202 REYMOND, MARCEL. "L'architecture des peintres aux premières années de la renaissance." Revue de l'art ancien et moderne 16, no. 93 (1904):463-72, 6 illus.; 17, no. 94 (1905):41-52, 5 illus.; 17, no. 95 (1905):137-47, 6 illus.
Investigates use of architectural backgrounds to determine dates of works in first half of quattrocento in Florence. Compares to known examples of architecture.

203 SALMI, MARIO. "Aggiunte al tre e al quattrocento fiorentino." Rivista d'arte 16 (1934):168-86, 14 illus.; 17 (1935):411-21, 11 illus.
Publishes and discusses attributions of a variety of works, including some by Delli, Rossello di Jacopo Franchi, Domenico di Michelino, and the Master of the Castello Nativity.

204 _____. "Contributi fiorentini alla storia dell'arte II: Richerche intorno a un perduto ciclo pittorico del rinascimento." In Atti e memorie dell'Accademia toscana di scienze morali, la Colombaria 1 (1943-6), pp. 421-32, 8 illus.
Investigates descriptions and fragmentary remains of fresco cycle, S. Egidio, Florence. Discusses participation of Domenico Veneziano, Baldovinetti, Piero, and Castagno.
Review: Luisa Becherucci, Rivista d'arte 26 (1950):223-27, 10 illus.

Books and Articles on Aspects of Florentine Painting

205 _____. "Fuochi d'artificio o della pseudo critica."
Commentari 5, no. 1 (1954):65-78, 13 illus.
Discusses Longhi's ideas, particularly regarding the
Master of Pratovecchio (entry 1110), here identified with
Domenico Veneziano. Also comments regarding, among others,
Neri di Bicci.

206 _____. "Lorenzo Ghiberti e la pittura." In Scritti di
storia dell'arte in onore di Lionello Venturi. Vol. 1.
Rome: De Luca, 1956, pp. 223-37, 15 illus.
Discusses window, Duomo, Florence. Relates to Mariotto
di Nardo.

207 _____. "Note sulla galleria di Perugia." L'arte 24, no. 4
(1921):155-71, 20 illus.
Discusses among others, works by Mariotto di Nardo, in-
cluding a window in S. Domenico, Perugia, and works by Benozzo
Gozzoli.

208 _____. Paolo Uccello, Andrea del Castagno, Domenico
Veneziano. 2d ed. Milan: Hoepli, 1938, 203 pp., 224
illus. [French ed. Paris: Weber, 1937.]
Study of three artists, first published in 1936, with
attention to their stylistic affinities. Reviews each career,
then gives biographies and critical comments. Lists of works,
lost works, and attributed works. Notes on plates.
Review: Ruth Wedgwood Kennedy, Art Bulletin 21, no. 3
(1939):298.

209 SALVINI, ROBERTO. "In margine ad Agnolo Gaddi." Rivista
d'arte 16 (1934):205-28, 13 illus.
Gathers works by artists in orbit of Gaddi, including
paintings by Pietro di Miniato, Meo di Fruosino, and a Maestro
Vaticano.

210 SANTI, FRANCESCO. "Appunti su inediti in Umbria: Opere
fiorentine in Valcastoriana." In Scritti di storia
dell'arte in onore di Mario Salmi. Vol. 2. Rome: DeLuca,
1962, pp. 56-60, 4 illus.
Publishes predella panels, now Galleria Nazionale,
Perugia, attributed to Rossello di Jacopo Franchi. Also
anonymous triptych, Parrochiale, Preci, by a fifteenth-century
Florentine.

211 SINDONA, ENIO. "Gotico e rinascimento. Pisanello, Paolo
Uccello e il pittore dell'Adorazione." Fede e arte 8, no. 2
(1960):172-95, 22 illus.
Studies Adoration, Berlin. Rejects various attributions,
notes features recalling Tuscan, North Italian, and Flemish
art. Discusses Gentile, Uccello, Piero, and Domenico Veneziano.

Books and Articles on Aspects of Florentine Painting

212 SIRÉN, OSVALD. "Di alcuni pittori fiorentini che subirono
 l'influenza di Lorenzo Monaco." L'arte 7 (1904):337-55, 7
 illus.
 Study of artists at beginning of fifteenth century who
 follow trecento traditions. Sections, each with brief bibliog-
 raphy and list of works, on Lorenzo di Niccolo, Andrea di
 Giusto, Bicci di Lorenzo, Master of the Bambino Vispo, and a
 "Compagno di Bicci."

213 _____. "Early Italian Pictures, the University Museum,
 Göttingen." Burlington Magazine 26, no. 141 (1914):107-14,
 9 illus.
 Includes works by Lorenzo Monaco, Mariotto di Nardo,
 Parri Spinelli, and a student of Agnolo Gaddi. Lists works in
 other collections associated with each artist.

214 _____. "Notizie di opere di alcuni minori pittori
 fiorentini." L'arte 8 (1905):48.
 Adds several new finds to article of 1904 (entry 213).

215 _____. "Some Early Italian Paintings in the Museum Collec-
 tion." Bulletin of the Museum of Fine Arts (Boston) 14, no.
 82 (1916):11-15, 7 illus.
 Makes various attributions, including works by Ambrogio
 di Baldese, Lorenzo di Niccolo, Mariotto di Nardo, Lippi, and
 Giovanni Utili da Faenza.

216 _____. "Trecento Pictures in American Collections. III."
 Burlington Magazine 14, no. 71 (1909):325-26, 5 illus.
 Discusses works in Jarves Collection, New Haven, by Lorenzo
 Monaco, Mariotto di Nardo, Master of the Bambino Vispo, Andrea
 di Giusto, and Giovanni dal Ponte.

217 SPARROW, JOHN. "Latin Evidence in Renaissance Painting."
 Burlington Magazine 111, no. 799 (1969):612-16, 3 illus.
 Criticizes Gilbert's article on Archbishop Antoninus
 (entry 136), suggesting different readings of Latin text. Also
 disagrees with Gilbert's reading of inscription on Piero's
 diptych (entry 1803).

218 THOMAS, ANABEL JANE. "Workshop Procedures of Fifteenth
 Century Florentine Artists." Ph.D. dissertation, University
 of London, 1976, 318 pp.
 Studies art production and industry, based primarily on
 catasto declarations. Section on physical arrangements of
 workshops, business arrangements, hierarchies within shops, and
 relation to market.

219 TOESCA, PIETRO. "Umili pittori fiorentini del principio del
 quattrocento." L'arte 7 (1904):49-58, 9 illus.
 Group of works usually assigned to Jacopo Casentino given
 to an anonymous Florentine, ca. 1435, working in a conservative

style. Includes five parts of a predella and a triptych with Coronation, all in Uffizi, Florence. Makes additional attributions to same artist.

220 VENTURI, LIONELLO. "Nella collezione Nemès." L'arte 34, no. 3 (1931):250-66, 4 illus.
 Discusses, among others, Adoration of Magi, attributed to Fra Angelico, ca. 1430-40, and relevant problems of Angelico scholarship. Also publishes Madonna and Child with Two Angels, attributed to Lippi, along with a list of other examples of same theme.

221 WALKER, SCOTT R. "Florentine Painted Refectories 1350-1500." Ph.D. dissertation, Indiana University, 1979, 271 pp., 38 illus.
 Investigates type of setting, of which twenty-five examples are recorded or still extant. Considers sources, content of painted images, functions of rooms. Catalogs existing examples, with description, history, bibliography, documents. Includes works of Fra Angelico and Castagno, as well as anonymous fifteenth-century artists.

222 WULFF, O. "Unbeachtete Malereien des 15. Jahrhunderts in florentiner Kirchen und Galerien." Zeitschrift für bildende Kunst 18 (1907):99-106, 8 illus.
 Attributes fresco of bishop, Spini Chapel, Sta. Trinità, Florence, to Master of Carrand Triptych. Attributes Christ in the Tomb and Adoration, Accademia, Florence, to Pesellino.

223 ZUCKER, PAUL. Raumdarstellung und Bildarchitekturen im florentiner Quattrocento. Leipzig: Klinkhardt & Biermann, 1913, 170 pp., 41 illus.
 A chronological survey of architectural constructions and depth arrangements in painting and sculpture. Sections on individual artists. Appendix on Umbrian and Sienese art. Bibliography.

EXHIBITIONS

224 FLORENCE. CONVENTO DI SAN MARCO. Mostra del tesoro di Firenze sacra. Florence: 1933, 142 pp., 32 illus.
 Catalog listing objects in extensive, much reviewed exhibition covering all media. No entries or introduction. Indexes of locations, lenders, artists.
 Review: Richard Offner, Burlington Magazine 63, no. 367 (1933):166-78, 13 illus.

225 FLORENCE. FORTE DI BELVEDERE. Mostra di affreschi staccati. Catalog by Umberto Baldini and Luciano Berti. Introduction by Ugo Procacci. Florence: Forte di Belvedere, 1957, 77 pp., 41 illus.

Exhibitions

Important exhibition of frescoes removed for restoration.
Sinopie. Works by Parri Spinelli, Bicci, Franchi, Uccello,
Lippi (?), Master of the Orange Cloister, and Piero.
Review: Robert Oertel, Kunstchronik 11, no. 11
(1958):317-23, 5 illus.

226 FLORENCE. PALAZZO STROZZI. Mostra di quattro maestri del
primo rinascimento. Catalog by Mario Salmi et al. 2d ed.
Florence: Palazzo Strozzi, 1954, 291 pp., 100 illus.
Major exhibition of Florentine artists, including chap-
ters on Masaccio by Umberto Baldini, Paolo Uccello by Emma
Micheletti, Domenico Veneziano by Luciano Berti, and Andrea del
Castagno by Luciano Berti. Each section includes biography of
artist and lengthy scholarly entries for each work. At end,
chronological bibliographies for each artist. Index of works
cited.
Review: Marita Horster, Kunstchronik 7, no. 7
(1954):177-80, 2 illus.

227 FLORENCE. SOPRINTENDENZA ALLE GALLERIE PER LE PROVINCIE DI
FIRENZE, AREZZO E PISTOIA. Mostra di opere d'arte
restaurate. Florence: Tip. Giuntina S.A. arti grafiche,
1946, 48 pp., 8 illus.
Exhibition of objects moved to Florence during war that
were being restored. Thirty-two objects, including works by
Master of Griggs Crucifixion, Fra Angelico, Bicci, Masolino,
Starnina, and Masaccio.

228 LONDON. BURLINGTON FINE ARTS CLUB. Catalogue of an Exhibi-
tion of Florentine Painting Before 1500. London: Printed
for the Burlington Fine Arts Club, 1920, 44 pp., 38 illus.
Introduction on the art of Florence. Catalog of thirty-
eight paintings, as well as drawings, furniture, and objects.
Review: Roger Fry, Burlington Magazine 35, no. 196
(1919):3-12, 4 b&w and 1 color illus.

See also entries 356, 361.

Siena

Documents (See also General Material: Source Material: Documents, and Tuscany: Source Material: Documents)

229 BORGHESI, S[CIPIONE], and BANCHI, L[UCIANO]. Nuovi documenti per la storia dell'arte senese. Siena: Enrico Torrini, editore, 1898, 712 pp. Reprint. Soest: DAVACO, 1970.
 Three hundred fifty documents from Sienese archives, dating from 1297 to 1679. Arranged chronologically, each with brief description and some annotations. List of documents, index of artists' names, and index of places and things.

230 FEHM, SHERWOOD A., Jr. "Notes on the Statues of the Sienese Painters Guild." Art Bulletin 54, no. 2 (1972):198-200.
 Establishes that guild's list of Sienese painters, usually dated 1389, actually contains a part added in ca. 1414-17. Includes document.

231 LIBERATI, A[LFREDO]. "Nuovi documenti artistici dello Spedale di Santa Maria della Scala di Siena." Bulletino senese di storia patria 33-34, no. 2 (1926-27):147-79.
 Publishes documents from 1344-1598.

232 _____. "Nuovi documenti sul Pellegrinaio dello Spedale di Santa Maria della Scala in Siena." La Diana 4, no. 3 (1929):239-43.
 New documents dating from 1441-80, concerning Priamo della Quercia, Vecchietta, and Domenico di Bartolo.

233 LISINI, ALESSANDRO. "Elenco dei pittori senesi vissuti nel secolo XV." La Diana 3, no. 1 (1928):64-74, 8 illus.
 Alphabetical list of Sienese painters for whom documentary references are known. Some dates noted, sources given.

Source Material

Notes on little-known works, chosen to illustrate fifteenth-century Sienese school.

234　MILANESI, GAETANO. <u>Documenti per la storia dell'arte</u>
<u>senese</u>. Vol. 2, <u>Secoli XV e XVI</u>. Siena: Presso Onorato
Porri, 1854, 482 pp. Reprint. Holland: DAVACO, 1969.
　　Basic compilation of documents arranged chronologically.
List at end of volume indicates artists discussed in each one.

<u>Sources up to 1700</u> (see also General Material: Source Material:
Sources up to 1700 and Tuscany: Source Material: Sources up to 1700)

235　UGURGIERI-AZZOLINI, ISIDORO. "Sanesi pittori, scultori,
architetti, ed altri artefici famosi." In <u>Pompe sanese o'</u>
<u>vero relazione delli huomini, e donne illustri di Siena e</u>
<u>suo stato</u>. Vol. 2. Pistoia: Stamperia di Pier Antonio
Fortunati, 1649, pp. 328-93.
　　Chapter in history of famous Sienese citizens, organized
by occupation. Includes brief paragraphs on Domenico di Bartolo,
Giovanni di Paolo, Vecchietta, Sano di Petro, and a few others.

<u>SURVEYS OF SIENESE PAINTING</u> (See also General Material:
Surveys of Italian Painting, and Tuscany: Surveys of Tuscan Painting)

236　BRANDI, CESARE. "Introduzione alla pittura senese del primo
quattrocento." <u>Rassegna d'Italia</u> 1, no. 9 (1946):26-37.
　　Essay concerning conflicting character of early Renais-
sance art in Siena, which is seen as vacillating between old
and new, and sometimes as intentionally retardataire. Dis-
cusses Sassetta, Giovanni di Paolo, and especially Domenico di
Bartolo.

237　_____. <u>Quattrocentisti senesi</u>. Valori plastici, 5. Milan:
Hoepli, 1949, 295 pp., 248 illus.
　　Basic survey of school, with many illustrations. In-
cludes a section of notes on the plates. Introduction defines
special character of Sienese art.

238　BROGI, F. <u>Inventario generale degli oggetti d'arte della</u>
<u>provincia di Siena</u>. Siena: Editore Carlo Nava, 1897,
658 pp.
　　Elaborate guide to area, organized alphabetically by city
(or town) and then by buildings. Works described in exact
locations. Gives subject, size, condition, artist (if known),
date. Indexes of towns, locations, and artists.

239　CARLI, ENZO. "Quattrocento 'Gotico.'" In <u>La pittura</u>
<u>senese</u>. Milan: Electa editrice, 1955, pp. 178-237, 24 b&w
and 30 color illus.

Surveys school, including Sassetta, Master of the
Osservanza, Giovanni di Paolo, Pietro di Giovanni Ambrogio,
Domenico di Bartolo, Sano di Pietro, and Vecchietta. Sees
group as still essentially Gothic although infused with new
ideas.

240 DELLA VALLE, GUGLIELMO. Lettere sanesi sopra le belle arti.
 2 vols. Rome: Giovanni Zempel, 1782-88, 762 pp., 2 illus.
 Series of essays on art in Siena. Includes very brief
 sections on Vecchietta, Domenico di Bartolo Sano di Pietro, and
 some miniaturists, based on documented information.

241 DESTRÉE, JULES. Sur quelques peintres de Sienne. Brussels:
 Dietrich, 1903, 127 pp., 20 illus.
 Early survey of major painters in area, with chapters on
 Sassetta, Sano di Pietro, and Vecchietta. Each lists artist's
 works and bibliography.

242 EDGELL, GEORGE HAROLD. "The Early Renaissance in Siena."
 In A History of Sienese Painting. New York: Dial Press,
 1932, pp. 184-223, 75 illus.
 Basic survey of period and school on a general level.
 Amply illustrated. Notes and bibliography.

243 JACOBSEN, EMIL. Das Quattrocento in Siena: Studien in der
 Gemäldegalerie der Akademie. Zur Kunstgeschichte des
 Auslandes, 59. Strassburg: Heitz, 1908, 96 pp., 120 illus.
 Survey of lives and careers of major painters, with
 special attention to works in Siena.

244 POPE-HENNESSY, JOHN. Sienese Quattrocento Painting.
 Oxford: Phaidon; New York: Oxford University Press, 1947,
 33 pp., 113 illus.
 General survey of period and area. Introductory essay,
 detailed notes on plates. Concentrates on work of twelve major
 artists. Index of collections. Bibliography in notes.

245 ROMAGNOLI, ETTORE. Biografia cronologica de' bellartisti
 senesi dal secolo XII a tutto il XVIII. Vol. 4, 1400-1450.
 Vol. 5, 1450-1500. Manuscript, 1835, 970 pp. and 958 pp.
 Reprint. Florence: Ediz. S.P.E.S., 1976.
 Lengthy handwritten opus, describing careers of artists
 in all media, mentioning works and documents. Each volume has
 chronological list, alphabetical index, and historical
 introduction.

246 SANDBERG-VAVALÀ, EVELYN. Sienese Studies: The Development
 of the School of Painting of Siena. Florence: Olschki,
 1953, 428 pp., 195 illus.
 Traces evolution of school by examples in gallery of
 Siena. Includes chapters on Sassetta, Domenico di Bartolo,

Surveys of Sienese Painting

Vecchietta, Pietro di Giovanni Ambrogio, Sano di Pietro, and
Giovanni di Paolo. Indexes of names and places.

BOOKS AND ARTICLES ON ASPECTS OF SIENESE PAINTING

247 BOSKOVITS, MIKLÒS. "Su Niccolò di Buonaccorso, Benedetto di
Bindo e la pittura senese del primo quattrocento." Paragone
31, no. 359-61 (1980):3-22, 41 illus.
Reconstructs careers of several minor masters. Makes
attributions and datings and reviews previous scholarship.
Attributes frescoes in sacristy of Duomo, Siena, to Benedetto.

248 BROWN, AUGUSTUS CAESAR. "The Eight Surviving Pellegrinaio
Frescoes of the Ospedale della Scala and their Social and
Visual Scources." Ph.D. dissertation, University of
Pittsburgh, 1976, 146 pp., 117 illus.
Reviews works by Vecchietta, Domenico di Bartolo, and
Priamo della Quercia, 1440-44, reflecting Florentine style.
Emphasizes function as visual record of hospital and of
caritas.

249 DE NICOLA, GIACOMO. "Arte inedita in Siena e nel suo antico
territorio." Vita d'arte 10, no. 56 (1912):41-58, 12 illus.
Includes triptych by Sassetta, Museum, Pienza, and panel
by Giovanni di Paolo, Museo dell'Opera, Siena.

250 EDGELL, GEORGE H[AROLD]. "Six Unpublished Sienese Paintings
in Boston." Art in America 28, no. 3 (1940):93-98, 9 illus.
Publishes, among other items, fragment of Coronation
attributed to Giovanni di Paolo, ca. 1445, and S. Bernardino by
Sano di Pietro, ca. 1450.

251 ELLON, F. "Tavolette dipinte della Bicherna di Siena che si
conservano nel Museo di Berlino." Bullettino senese di
storia patria 2 (1895):101-11.
Description of five small works, some of early fifteenth
century.

252 GALLAVOTTI, DANIELA. "Gli affreschi quattrocenteschi della
Sala del Pellegrinaio nello Spedale di Santa Maria della
Scala in Siena." Storia dell'arte 13 (January-March
1972):5-42, 10 illus.
Examination of sala as unique extant example of hospital
decoration of period. Development of styles of Vecchietta and
Domenico di Bartolo. Appendix with documents, critical notes,
bibliography. English summary.

253 GENGARO, MARIA LUISA. "Sogno e realtà nella primitiva arte
senese." La Diana 7, no. 3 (1932):151-59, 13 illus.
Discusses visionary quality of landscapes in Sienese art
of 1300-1500. Compares to Far Eastern examples.

Books and Articles on Aspects of Sienese Painting

254 HUTTON, EDWARD. The Sienese School in the National Gallery.
London: Medici Society, 1925, 85 pp., 36 illus.
 Illustrates works in collection, with some comments for
each plate. Includes Sassetta, Heads, Priamo della Quercia's
Madonna with Angels, and Giovanni di Paolo's(?) Sts. Fabian and
Sebastian. Brief list of Sienese works in England.

255 LACLOTTE, MICHEL. "Sassetta, le Maître de l'Observance et
Sano di Pietro. Un problème critique." Information de
l'histoire d'art 5, no. 2 (1960):47-53, 5 illus.
 Reviews modern "discovery" of Sassetta and various opin-
ions on the problem of Sano di Pietro and the Osservanza Master.

256 LISINI, ALESSANDRO. Le tavolette dipinti di biccherna e di
gabella del R. Archivio di Stato in Siena. Florence:
Olschki, 1904, 115 pp., 103 illus.
 Includes introduction regarding history of type of decor-
ated covers, followed by corpus of plates, each with descrip-
tion. Items date from 1258 to 1689. Index of names of
artists, patrons, and subject matter. Catalog of additional
examples not in Siena.

257 LUSINI, V. "Siena: Di alcuni affreschi che ritornano in
luce." Rassegna d'arte senese 2, no. 3 (1906):93-97; 3, no.
3-4 (1907):100-103.
 Recounts restoration of frescoes in sacristy of Duomo,
Siena. Works primarily by Niccolo di Naldi and Gualtieri di
Giovanni, ca. 1410. Quotes from documents, discusses histor-
ical background.

258 MORANDI, UBALDO. Le biccherne senesi: Le tavolette della
gabella e di altri magistrature dell'antico stato senese
conservate presso l'Archivio di Stato di Siena. Siena:
Monte dei Paschi, 1964, 236 pp., 124 color illus.
 Surveys development of type of painted record book cov-
ers, including ones documented by well-known painters. Useful
illustrations.

259 PERKINS, F. MASON. "Alcuni dipinti inediti senesi."
Rassegna d'arte senese 15, no. 3-4 (1922):61-69, 4 illus.
 Includes Madonna, Acton Collection, Florence, by Pietro
di Giovanni d'Ambrosio and a miracle of a Saint, Vatican,
attributed to Vecchietta.

260 _____. "Alcuni dipinti senesi sconosciuti o inediti."
Rassegna d'arte 13, no. 8 (1913):121-26, 14 illus.; 13, no.
12 (1913):195-200, 15 illus.; 14, no. 5 (1914):97-104, 16
illus.; 14, no. 7 (1914):163-68, 9 illus.
 Numerous works, including ones by Sassetta, Giovanni di
Paolo, and Sano di Pietro.

Books and Articles on Aspects of Sienese Painting

261 _____ . "Ancora dei dipinti sconosciuti della scuola
senese." Rassegna d'arte senese 3, no. 3-4 (1907):73-84, 4
illus.
 Lists unpublished works by various artists, including
Domenico di Bartolo, Giovanni di Paolo, Pietro di Domenico,
Sano di Pietro, and Vecchietta.

262 _____ . "Note su alcune pitture senesi." Balzana 1, no. 4
(1927):143-48, 4 illus.
 Includes Annunciation, Helen C. Frick Collection, New
York.

263 _____ . "Nuovi appunti sulla Galleria Belle Arti di Siena."
Balzana 2, no. 5 (1928):143-61, 8 illus.; no. 6 (1928):183-
203, 9 illus.
 Comments on works by various artists in collection
including Sano di Pietro, Giovanni di Paolo, Sassetta, and
others.

264 _____ . Pitture senesi. Siena: Editrice d'arte "La Diana,"
202 pp., 213 illus.
 Catalog of little-known paintings, mostly in province of
Siena, some recently published, with complete illustrations.
Alphabetically arranged by location. Lengthy, annotated dis-
cussion of each work. Indexes of places and names.

265 _____ . "Pitture senesi poco sconosciute." La Diana 5
(1930):187-206, 244-61; 6 (1931):10-36, 90-109, 187-203,
244-261; 7 (1932):44-55, 79-90, 179-94, 236-46; 8 (1933):51-
67, 213 illus.
 Series of articles calling attention to many works.
Arranged by location. Includes among many others: Pietro
di Giovanni, Giovanni di Paolo, Sano di Pietro, Domenico di
Bartolo, and Vecchietta.

266 _____ . "Some Sienese Paintings in American Collection."
Art in America 9, no. 1 (1920):6-21, 8 illus.; no. 2
(1921):45-61, 10 illus.
 Discusses, among others, Saints, Davis Collection,
Newport, attributed to Martino di Bartolommeo; scene from life
of Saint Anthony by Sassetta, Lehman Collection, New York; Way
to Cavalry, Johnson Collection, Philadelphia; and Descent into
Limbo, Fogg Museum, Cambridge, by a Sassetta follower. In-
cludes some works by Giovanni di Paolo: Presentation,
Blumenthal Collection, New York, Expulsion, Lehman Collection,
New York: and Bishop, Ickelheimer Collection, New York.

267 _____ . "Spigolature di arte senese." Rassegna d'arte
senese 6, no. 4 (1910):71-73, 3 illus.
 Includes Madonna by Domenico di Bartolo, 1437, Johnson
Collection, Philadelphia, and miniature of Christ and Apostles,
in the library of the Duomo, Siena, by Vecchietta.

POPE-HENNESSY, JOHN. "The Development of Realistic Painting in Siena." See entry 966.

268 SOUTHARD, EDNA CARTER. "The Frescoes in Siena's Palazzo Pubblico 1285-1539: Studies in Imagery and Relation to Other Communal Palaces in Tuscany." 2 vols. Ph.D. dissertation, Indiana University, Bloomington, 1978, 617 pp., 228 illus. New York: Garland, 1979.

Study of frescoes in palazzo and their relationships to each other. Discusses how understood by contemporary viewers and considers various functions. Catalogs works. Includes appendix of cycles in other Tuscan communal palaces. Includes works by Vecchietta, Sano di Pietro, Cenni. Bibliography.

EXHIBITIONS

269 LONDON. BURLINGTON FINE ARTS CLUB. Exhibition of Pictures of the School of Siena and Examples of the Minor Arts of that City. Introduction by Langton Douglas. London, 1904, 103 pp., 47 illus.

Large volume with full page plates. Introductory chapters on painting and on minor arts. Catalog entries for seventy-eight paintings and sixty-eight objects of ca. 1300-1600.

270 SIENA. ARCHIVIO DI STATO. Le tavolette di biccherna e di altri uffici dello stato di Siena. Catalog by Enzo Carli. Florence: Electa editrice, 1950, 127 pp., 64 b&w and 8 color illus.

Exhibition of 124 newly restored covers dating from thirteenth to early seventeenth centuries. Lists lost works. Bibliography. Many by important artists, including Sano di Pietro, Giovanni di Paolo, and Vecchietta.

Review: John Pope-Hennessy, Burlington Magazine 92, no. 572 (1950):320.

271 SIENA. PALAZZO PUBBLICO. Il Palazzo Pubblico di Siena e la mostra d'antica arte senese. Edited by Corrado Ricci. Bergamo: Istituto italiano d'arti grafiche, 1904, 183 pp., 215 illus.

Volume published at time of exhibition, as guide to building and exhibition. Includes chapter on palace with views of rooms, architecture, and frescoes. Chapter on exhibition, as narrative guide, divided into sections by rooms. Very amply illustrated. See entries 272 and 273.

Review: F. Mason Perkins, Burlington Magazine 5, no. 18 (1904):581-84, 5 illus.

272 _____. Mostra dell'antica arte senese. Catalogo generale. Introduction by Corrado Ricci. Siena: Tip. edit. Sordomuti di L. Lazzeri, 1904, 374 pp., 12 illus.

Exhibitions

Major loan exhibition of works in all media. Catalog follows the layout of forty rooms in the Palazzo Pubblico with brief description and comment on each work, by various authors. Index of artists. See entries 271 and 273.

Review: Mary Logan, Gazette des beaux arts 32, no. 567 (1904):200-213, 7 illus.

273 SIENA. PINACOTECA. I caplavori dell'arte senese. Catalog by Enzo Carli. Florence: Electa editrice, 1947, 110 pp., 234 illus.

Catalog of exhibition, Pinacoteca, Siena, 1944. Fully illustrated with descriptive entry on each work and review of artist's life. See entries 271 and 272.

Lazio

Documents (see also General Material: Source Material: Documents)

274 CORBO, ANNA MARIA. Artisti e artigiani in Roma al tempo di
 Martino V e di Eugenio IV. Raccolta di fonti per la storia
 dell'arte diretta da Mario Salmi, 2d ser. 1. Rome: De
 Luca, 1969, 257 pp.
 Compilation of documents relating to art in Rome from
 1420 to 1445. Many previously unpublished. Organized by loca-
 tion and medium. Index of artists' names, brief bibliography.
 Review: D. Bodart, Revue belge 49, no. 3 (1971):1091-92.

275 _____. "Chiese e artisti viterbesi nella prima metà del
 secolo XV." Commentari 28, no. 1-3 (1977):162-171.
 A variety of documents from Archivio di Stato, Viterbo.

276 MÜNTZ, EUGÈNE. "Les arts à la cour des papes: Nouvelles
 recherches sur les pontificats de Martin V, d'Eugène IV, de
 Nicolas V, de Calixte III, de Pie II, et de Paul II."
 Mélanges d'archéologie et d'histoire 4, no. 3-4
 (1884):274-303.
 Publication of documents additional to those in book of
 1878 (entry 277). Most, but not all, from Archivio Segreto,
 Vatican. Organized primarily by medium. Includes references
 to Martin V's visit to Florence in 1418, and to activity of
 Gentile da Fabriano in the 1420s.

277 _____. Les arts à la cour des papes pendant le XV et le XVI
 siécle. Vol. 1, Martin V - Pie II, 1417-1464.
 Bibliothèque des écoles françaises d'Athènes et de Rome, 4.
 Paris: Ernest Thorin, 1878, 364 pp. Reprint. Zurich,
 Hildesheim, and New York: Georg Olms, 1983.
 Major source of documentary material regarding art done
 for the papal courts of Martin V, Eugene IV, Nicholas V,
 Calixtus II, and Pius II. Arranged by pope. Each section with

Source Material

a preliminary historical introduction. Then divided mostly by
location, with background commentary for each group of docu-
ments. Sections on Nicholas V and Pius II include a few pages
regarding principal artists under each reign.

SURVEYS OF PAINTING IN LAZIO (see also General Material: Surveys of Italian Painting)

278 BERTINI CALOSSO, ACHILLE. "Le origini della pittura del
quattrocento attorno a Roma." Bollettino d'arte 14, no. 5-8
(1920):97-114; no. 9-12 (1920):185-232, 59 illus.
Recounts blossoming of artistic atmosphere in Rome with
advent of Martin V. Discusses works by Gentile and Masolino
and the state of art in various parts of Italy ca. 1425-50, all
feeding into Rome. Examines cycle in Sta. Caterina, Roccantica,
by Pietro Coleberti, and other works by Coleberti and others.

279 GOLZIO, VINCENZO. "La pittura a Roma e nel Lazio." In
L'arte in Roma nel secolo XV. Istituto di studi romani,
storia di Roma, 28. Bologna: Cappelli, 1968, pp. 197-304,
91 illus.
Volume constitutes first substantial study of region in
quattrocento and includes sections on International Gothic and
on Florentines and Umbrians in Rome. Critical and chronological
bibliography and indexes.

BOOKS AND ARTICLES ON ASPECTS OF PAINTING IN LAZIO

280 FALDI, ITALO. "Antonio da Viterbo, Francesco d'Antonio,
Gabriele di Francesco e la cultura del gotico
internazionale" and "L'affermazione della nuova visione
rinascimentale: Lorenzo da Viterbo e il suo sequito
locale." In Pittori viterbesi di cinque secoli. Rome:
Ugo Bozzo, 1970, pp. 16-37, 101 b&w and 18 color illus.
Lavishly illustrated survey, with comments on plates,
index, and bibliography.

281 GALASSI, GIUSEPPE. "Appunti sulla scuola pittorica romana
del quattrocento." L'arte 16 (1913):107-11, 3 illus.
Attributes frescoes in Sta. Maria Maggiore, Rome, and in
vault of Cappella di San Michele e di San Pietro ad vincula, to
a follower of Piero della Francesca, close to Lorenzo da Viterbo.
Also publishes work by Antonio de Calvis, Museum, Lisieux.

282 HERMANIN, FEDERICO. "Le pitture della cappella
dell'Annuziata a Cori presso Rome." L'arte 9 (1906):45-52,
3 illus.
Describes frescoes in small building. Sees as painted in
three periods, mostly early fifteenth century. Notes influence
of Masolino on latest and strongest master.

Books and Articles on Aspects of Painting in Lazio

283 LEONARDI, VALENTINO. "Affreschi dimenticati del tempo di
 Martino V." In <u>Atti</u> <u>del</u> <u>Congresso</u> <u>internazionale</u> <u>di</u> <u>scienze</u>
 <u>storiche</u>, 7, 1903. Rome: 1905, pp. 287-308, 7 illus.
 Studies cycle in Oratorio dell'Annunziata, Riofreddo,
 dated 1422, by an anonymous master from area, somewhat aware of
 new Tuscan ideas. Notes relation to Masolino.

Marches and Umbria

Documents (see also General Material: Source Material: Documents)

284 ALEANDRI, VITTORIO. "Documenti per la storia dell'arte
 nelle Marche (secolo XV)." Rassegna bibliografica dell'arte
 italiana 8, no. 8-10 (1905):149-57.
 Includes documents regarding Paolo da Visso (1453) and
 Giacomo di Cola da Camerino (1455).

285 FIOCCO, GIUSEPPE. "I pittori marchigiani a Padova nella
 prima metà del quattrocento." Atti del reale Istituto
 veneto di scienze, lettere e arti 91, no. 2 (1931-32):
 1359-70.
 Publishes documents indicating presence in Padua of
 Gerolamo da Camerino, Boccati, and especially Giovanni
 Francesco da Rimini in 1440s and 1450s.

286 GIANANDREA, A. "Ancora del pittore Oliviccio di Ciccarello
 e di altri suoi contemporanei in Ancona." Nuova rivista
 misena 6, no. 3 (1893):35-38.
 Three new documents of 1390. Lists other artists of
 1300-1500 with information known about them from documentary
 research. Includes brief mentions of Pietro di Domenico, Paolo
 d'Ancona, and Bartolommeo di Tommaso.

287 GNOLI, UMBERTO. "Documenti inediti sui pittori perugini."
 Bollettino d'arte 9, no. 5 (1915):119-28.
 Numerous unpublished documents from various archives not
 used by earlier scholars, concerning artists from fifteenth and
 early sixteenth centuries. Arranged alphabetically by artist.
 Includes Caporali, Bonfigli, and Francesco d'Antonio.

288 MANZONI, LUIGI. "Appunti e documenti per l'arte del pinger
 su vetro in Perugia nel sec. XV." Repertorium für
 Kunstwissenschaft 26 (1903):120-32.

Source Material

Records activity at S. Domenico, Perugia. Also publishes documents concerning Bonfigli.

289 M[AZZATINTI], G. "Appunti per l'arte umbra nel secolo XV." Rassegna bibliografica dell'arte italiana 3, no. 3–5 (1900):68–71.
Includes report on documents regarding painters, including Policreto di Cola (1425–37), Francesco d'Antonio (1425–44), Bartolommeo Caporali (1472), and other minor artists.

290 ROSSI, ADAMO. "I pittori di Foligno." Giornale di erudizione artistica 1, no. 9 (1872):249–307.
Publication and analysis of various documents, mostly on later artists but also referring to several minor figures of early fifteenth century.

291 SASSI, R[OMUALDO]. "Documenti di pittori fabrianesi." Rassegna marchigiana 3, no. 2 (1924–1925):45–56, 2 illus.
Discussion of various documents, mostly concerning minor artists.

SURVEYS OF PAINTING IN THE MARCHES AND UMBRIA
(see also General Material: Surveys of Italian Painting)

292 BOMBE, WALTER. Geschichte der peruginer Malerei bis zu Perugino und Pinturicchio. Berlin: Bruno Cassirer, 1912, 427 pp., 90 illus.
Important early chronological survey of school, including long sections on Bonfigli and Caporali. Documents, index.

293 BROUSSOLE, JULES CÉSAR. "La peinture ombrienne avant le Pérugin" and "La peinture ombrienne vers la milieu du XVe siecle." In La jeunesse du Pérugin et les origines de l'école ombrienne. Paris: H. Oudin, 1901, pp. 1–233, 45 illus.
Chapters in chronological survey with emphasis on general character of Umbrian art. Bibliography, index of names.

294 CARDONA, MARIO. Camerino, un secolo e sei pittori. Quaderni dell'appennino camerte, 15. Camerino: 1965, 87 pp., 8 illus.
Brief monograph on fifteenth-century painting in the city. General chapter on setting, then sections on individual artists. Lists of works, bibliography, and index.

295 CAVALCASELLE, G.B., and MORELLI, GIOVANNI. "Catalogo delle opere d'arte nelle Marche e nell'Umbria." Le gallerie nazionali italiane 2 (1896):191–349.
Records of project of compiling list of works in region, begun in 1861. Text follows authors' travels through area like

Surveys of Painting in the Marches and Umbria

a guide, with catalog entries and evaluations for works seen.
Provides fundamental directory.

296 COLASANTI, ARDUINO. Italian Painting of the Quattrocento in
 the Marches. Florence: Pantheon, 1932, 166 pp., 84 illus.
 Survey of period with sections on Gentile and his fol-
 lowers, the Salimbeni, and other topics. Lengthy bibliography,
 indexes.

297 DANIA, LUIGI. La pittura a Fermo e nel suo circondario.
 Introduction by Alvaro Valentini. Fermo: Cassa di
 risparmio, 1967, 481 pp., 150 b&w and 105 color illus.
 Works in Fermo and area, fourteenth through seventeenth
 centuries. Organized as a critical catalog, alphabetically by
 artist. Includes some works by Salimbeni and school, and by
 Giacomo di Niccolo da Recanati. Extensive bibliography,
 indexes.

298 DENNISTOUN, JAMES. "The Umbrian School of Painting, Its
 Scholars and Influences." In Memoirs of the Dukes of
 Urbino. Notes by Edward Hutton. Rev. ed. Vol. 2. New
 York and London: John Lane, 1909, pp. 184-215.
 Sections in the standard history of the houses of
 Montefeltro and della Rovere, first published in 1851. Brief
 discussion of a large number of artists.

299 DESTRÉE, JULES. Sur quelques peintres des Marches et de
 l'Ombrie. Brussels: Dietrich, 1900, 102 pp., 7 illus.
 Surveys region in brief descriptive and historical chap-
 ters, including sections on the Salimbeni, Boccati, and Bonfigli.
 Includes lists of works.

300 GNOLI, UMBERTO. Pittori e miniatori nell'Umbria. Spoleto:
 Claudio Argentieri, 1923, 411 pp., many unnumbered illus.
 Reprint. Foligno: Ediclio, 1980.
 A directory of artists from medieval times through 1600.
 Bibliographies for each entry. Topographical index.

301 GRASSI, LUIGI. Pittura umbra del quattrocento. Rome:
 Ateneo, 1952, 178 pp.
 Lengthy introduction emphasizing the importance of
 Florentine and Sienese art. Sections on the Folignese school,
 on relations to other regions and individual artists.

302 JACOBSEN, EMIL. Umbrische Malerei des vierzehnten,
 funfzehnten und sechzehnten jahrhunderts: Studien in der
 gemäldegalerie zu Perugia. Zur Kunstgeschichte des
 Auslandes, 107. Strassburg: Heitz, 1914, 160 pp., 73 illus.
 One of standard surveys of Umbrian school. Also includes
 some Sienese artists. Bibliography.

Surveys of Painting in the Marches and Umbria

303 MARIOTTI, A. "Sopra diverse memorie pittoriche perugine del
 secolo XV," and "Di alcune opere spettanti alle arti del
 disegno fatte in Perugia nel XV secolo." In Lettere
 pittoriche perugine. Perugia: Della stampe Badueliane,
 1788. Reprint. Bologna: Arnaldo Forni, 1975, pp. 64-119.
 Discusses major painters, notes impact of Sienese art and
 of works in other media or by non-Perugians. Index.

304 RICCI, AMICO. "Di Gentile da Fabriano"; "Dei discepoli di
 Gentile"; and "Delle arti e degli artisti nella Marca nel
 secolo XV." In Memorie storiche delle arti e degli artisti
 della Marca di Ancona. Vol. 1. Macerata: Mancino, 1834,
 pp. 145-204. Reprint. Bologna: Forni, 1970.
 Early survey of period. Includes notes, documents, in-
 dexes, and some important sources.

305 ROTHES, WALTER. Anfänge und entwickelungsgänge der alt-
 umbrischen Malerschulen, insbesondere ihre Beziehungen zur
 frühsienesischen Kunst. Zur Kunstgeschichte des Auslandes,
 61. Strassburg: 1908, 85 pp., 46 illus.
 Brief essay organized geographically, with special empha-
 sis on relation to other schools. Bibliography, index.

306 SERRA, LUIGI. L'arte nelle Marche: Il periodo del
 rinascimento. Rome: Arti grafiche Evaristo Armani, 1934,
 547 pp., 698 illus.
 Important, in-depth study of region, organized into chap-
 ters on geographical centers, with section on Umbrian input.
 Indexes of locations, artists.

307 _____. Inventario degli oggetti d'arte d'Italia. Vol. 8,
 Provincie di Ancona e Ascoli Piceno. Rome: Libreria dello
 stato, 1936, 364 pp., hundreds of illus.
 Reference tool to works in all media. Entries arranged
 by location. Indexes of artists, anonymous works, illustra-
 tions, places.

308 _____. "La scuola pittorica sanseverinate." Rassegna
 marchigiana 11, no. 4 (1933):141-72, 18 illus.
 Overview of school, with attention to previous scholar-
 ship. Concentrates on the Salimbeni brothers. Discusses at-
 tributions and style.

309 VITALINI SACCONI, G[IUSEPPE]. Pittura marchigiana: La
 scuola camerinese. Macerata: Cassa di risparmio della
 provincia, 1968, 265 pp., 159 b&w and 30 color illus.
 Introductory chapters on Marches ca. 1300-1500, followed
 by chapters on individual artists from Camerino, including
 Olivuccio, Arcangelo di Cola, Boccati, and Girolamo di Giovanni.
 Extensive notes with bibliography, brief general bibliography.
 Large illustrations. Index.

Books and Articles on Aspects of Painting in the Marches and Umbria

310 ZAMPETTI, PIETRO. Paintings from the Marches: Gentile to
 Raphael. Translated by R.G. Carpanini. London: Phaidon,
 1971, 277 pp., 187 b&w and 40 color illus. [Italian ed.
 Milan: Electa editrice, 1969.]
 Basic modern overview of fifteenth century in region,
 organized by geographic centers. Includes major and minor
 artists. Extensive bibliography, index.
 Review: Luisa Vertova, Burlington Magazine 115, no. 846
 (1973):608-10, 3 illus.

 BOOKS AND ARTICLES ON ASPECTS OF PAINTING
 IN THE MARCHES AND UMBRIA

311 BIANCHI, LIDIA. "Gli affreschi dell'Oratorio della SS.
 Annunziata in Riofreddo." Arti 5, no. 3 (1943):143-49, 6
 illus.
 Cycle dated 1422, probably by Marchigian artist. Rejects
 attributions to Arcangelo di Cola da Camerino and Pietro di
 Domenico da Montepulciano.

312 BOSKOVITZ, MIKLOS. "Osservazioni sulla pittura tardogotica
 nella Marche." In Rapporti artistici fra le Marche e
 l'Umbria. Convegno interregionale di studio, 1974.
 Perugia: Arti grafiche Città di Castello, 1977, pp. 29-47,
 33 illus.
 Essay making a variety of observations on little studied
 art, ca. 1400, in region. Considers important contribution of
 Salimbeni, their sources and influence. Discusses Carlo da
 Camerino, Giovanni di Corraduccio, Olivuccio di Ciccarello.

313 _____. Pittura umbra e marchigiana fra medioevo e
 rinascimento. Florence: Edam, 1973, 45 pp., 89 illus.
 A survey of works in the National Gallery, Perugia,
 mostly from the fourteenth century, but including Lorenzo
 Salimbeni and Lello da Velletri.

314 CALZINI, E. "L'arte marchigiana (a proposito di un articolo
 del prof. J. Natali, così intitolato)." Rassegna
 bibliografica dell'arte italiana 8, no. 11-12 (1905):177-80.
 Disputes definition of the school as really Umbro-
 Marchigian. Asserts autonomous character of Marchigian art.

315 _____. "A proposito del pittore degli affreschi di S.
 Vittoria in Matenano." L'arte 9 (1906):228-29.
 Dates Matenano frescoes later than early fifteenth cen-
 tury. Letter from Arduino Colasanti, L'arte 9 (1906):302, with
 reply L'arte 10 (1907):59.

316 _____. "Della scuola pittorica urbinate (dal XIV al XVI
 secolo)." Rassegna bibliografica dell'arte italiana 11, no.
 11-12 (1908):189-96.

Books and Articles on Aspects of Painting in the Marches and Umbria

Asserts that Urbino not a branch of Umbrian style. Notes various artists active there, proving independence of Marchigian style.

317 _____. "Di un affresco del secolo XV recentemente scoperto in Urbino." Rassegna bibliografica dell'arte italiana 9, no. 6-8 (1906):106-09.
Crucifixion, Sta. Maria della Bella. Dates mid-century and notes influence of Piero. Rejects attribution to Fra Carnevale.

318 _____. "Vecchie pitture murali del XIV e XV secolo: Contributo alla storia dell'arte nelle Marche." Rassegna bibliografica dell'arte italiana 9, no. 1-2 (1906):21-29; no. 3-5 (1906):63-69.
Short sections on a variety of little-known and fragmentary cycles, in Ascoli Piceno.

319 COLASANTI, ARDUINO. "Arte retrospettiva: La chiese farfense di S. Vittoria in Matenano e i suoi affreschi." Emporium 23 (1906):20-31, 10 illus.
Description of history of church, then presentation of frescoes, by an anonymous artist. Discusses relationship to Gentile, rejects attribution to him. Dates ca. 1400.

320 _____. "Contributo alla storia della pittura nelle Marche." Bollettino d'arte 9, no. 12 (1915):355-74, 12 illus.
Publishes frescoes attributed to Lorenzo Salimbeni in Pesaro and Mercatello and group attributed to Nelli, ca. 1417 in Fossombrone, Cappella di S. Aldebrando.

321 _____. "Un sequace di Gentile da Fabriano a Fermo." Bollettino d'arte 2, no. 7 (1908):244-55, 10 illus.
Eight small panels of life of Saint Lucy, in "Canonica" of Sta. Lucia, Fermo, attributed to Marchigian master, mid-fifteenth century. Same artist responsible for large Crucifix, Chiesa dell'Angelo Custode, Fermo.

322 CROCETTI, GIUSEPPE. "Gli affreschi di S. Maria della Petrella." Notizie da Palazzo Albani 8, no. 1 (1979):15-45, 18 illus.
Studies decoration of small church in Ripatransone. Describes frescoes of 1403, signed by Antonio di Nicolò; altarpiece of 1426 by Ugolino di Vanne da Milano; later fifteenth-century frescoes of facade wall; and graffiti inscriptions of fifteenth and sixteenth centuries.

323 DONNINI, GIAMPIERO. "Per Cristoforo da S. Severino e Angelo da Camerino." Commentari 25, no. 3-4 (1974):155-63, 8 illus.

Books and Articles on Aspects of Painting in the Marches and Umbria

Discusses works on which two artists collaborated,
including frescoes, parish church, Patrignone. Relates to
Marchigian school.

324 _____. "Schede di pittura marchigiana." Antichità viva 16,
no. 5 (1977):3-10, 13 illus.
Publishes several works, including Madonna Enthroned,
fresco, Sta. Maria, Esanatolia, by unknown painter, and genea-
logical tree, Oratorio dei Beati Becchetti, Fabriano, ca. 1410-
20. English summary.

325 _____. "Schede di pittura umbra del '400." Commentari 28,
no. 1-3 (1977):139-49, 5 illus.
Includes discussion of a Madonna fresco in church of the
Rocchicciola, Rocca S. Angelo.

326 FALOCI-PULIGNANI, MICHELE. "Le arti e le lettere alla corte
dei Trinci." Archivio storico per le Marche e l'Umbria 4,
no. 13-14 (1888):113-260.
Studies culture at court of Trinci family, centered in
Foligno. Describes various decorations of palace, including
works by Nelli, Fra Angelico, and Bartolommeo di Tommaso da
Foligno.

327 GIOVAGNOLI, ENRICO. "Arte umbra primitiva." Cronache
d'arte 1, no. 6 (1924):291-301, 10 illus.
Reviews recently discovered early Umbrian works: fres-
coes by Nelli at S. Domenico in Gubbio; also others at Città di
Castello by Nelli school.

328 _____. Le origini della pittura umbra: Gli affreschi
recentemente scoperti nell'alta umbra. Città di Castello:
"Il Solco" casa editrice, 1922, 71 pp., 17 illus.
History of medieval painting in Umbria (early eleventh
and thirteenth centuries) as background to fifteenth century.
Emphasizes art of Nelli. Also discusses frescoes in S. Domenico,
Gubbio (by a follower of Nelli), and the diffusion of Nelli's
art. Analyzes the characteristics of the Umbrian school and
its relation to the Renaissance.

329 GNOLI, UMBERTO. "Pietro da Montepulciano e Giacomo da
Recanati." Bollettino d'arte 15, no. 12 (1922):574-580, 8
illus.
Madonna of Humility, Metropolitan Museum, New York,
signed by Pietro and dated 1420, establishes artist as from
Montepulciano and not Recanati. Also reviews career of his
follower, Giacomo da Recanati, active 1443-60s.

330 _____. "Una tavola sconosciuta di Cristoforo da S. Severino
e Angelo da Camerino." Rassegna bibliografica dell'arte
italiana 12, no. 10-11 (1909):151-58, 1 illus.

Books and Articles on Aspects of Painting in the Marches and Umbria

Publishes <u>Madonna</u> <u>Enthroned</u>, private collection, Perugia, signed by two artists and dated 1448. Work provides one of few known facts regarding these two artists of school of San Severino.

331 GRIGIONI, CARLO. "I dipinti della chiesa di S. Francesco o di S. Maria Magna in Ripatransone." <u>Rassegna</u> <u>d'arte</u> 7, no. 1 (1907):7-10, 2 illus.
 Publishes scenes by an unidentified artist, with dates from 1460s. Suggests Giacomo da Campli as artist.

332 LONGHI, ROBERTO. "Un 'familiare del Boccati.'" <u>Paragone</u> 13, no. 153 (1962):60-64, 5 illus. [Reprinted in <u>Fatti</u> <u>di</u> <u>Masolino</u> e <u>di</u> <u>Masaccio</u> e <u>altri</u> <u>studi</u> <u>sul</u> <u>quattrocento</u> (Florence: Sansoni, 1975), pp. 139-42.]
 Makes various attributions, including four to an associate of Boccati and two to Domenico Veneziano.

333 MARCHINI, GIUSEPPE. "Ancora primizie sul Ghiberti." In <u>Lorenzo</u> <u>Ghiberti</u> <u>nel</u> <u>suo</u> <u>tempo</u>. Vol. 1. Atti del Convegno internazionale di studi, 1978. Florence: Olschki, 1980, pp. 89-97, 9 illus.
 Notes Florentine elements in several works in the Marches from ca. 1400. Suggests attribution to Ghiberti during his early visit there.

334 PUNGILEONI, LUIGI. <u>Elogio</u> <u>storico</u> <u>di</u> <u>Giovanni</u> <u>Santi</u> / <u>Pittore</u> e <u>poeta</u> / <u>Padre</u> <u>del</u> <u>gran</u> <u>Raffaello</u> <u>di</u> <u>Urbino</u>. Urbino: Vincenzo Guerrini, 1822, 140 pp.
 Study of late fifteenth-century artist and writer. Treatise discusses earlier artistic ambience of Urbino. Mentions works by many artists including Gentile, Salimbeni, Nelli, Fra Carnevale, Uccello, and Piero. Edition appends documents from a variety of sources from late fourteenth century on and discusses genealogical tree of Santi family from 1300. See also entry 12.

335 ROSSI, FRANCESCO. "Appunti sulla pittura gotica tra Ancona e Macerata." <u>Bollettino</u> <u>d'arte</u> 53, no. 4 (1968):197-206, 24 illus.
 Discusses continuing Gothic elements in art of Marches and Rimini. Influence of Gentile and Venetian art.

336 _____. "Lo 'stile feltresco.' Arte tra Gubbio e Urbino nella prima metà delle '400." In <u>Rapporti</u> <u>artistici</u> <u>fra</u> <u>le</u> <u>Marche</u> e <u>l'Umbria</u>. Convegno interregionale di studio, 1974. Perugia: Arti grafiche Città di Castello, 1977, pp. 55-68.
 Works in area ruled by Montefeltro, early fifteenth century, seen in regional context. Mentions works by Salimbeni, Nelli, and others.

Books and Articles on Aspects of Painting in the Marches and Umbria

337 ROTONDI, PASQUALE. Il palazzo ducale di Urbino. 2 vols.
Urbino: Istituto statale d'arte per il libro, 1950-51, 511
pp., 601 illus. [English ed., abridged. London: Tiranti,
1969.]
Book concerned primarily with architecture, with brief
sections concerning Piero's contribution to ambience (pp. 66-
77) and the fresco cycle attributed to Boccati (pp. 155-67, 14
illus.).
Review: G. Rosi, Bollettino d'arte 37, (1952):92-93.

338 _____. Studi e ricerche intorno a Lorenzo e Jacopo
Salimbeni da S. Severino, Pietro da Montepulciano e Giacomo
da Recanati. Argomenti di arte marchigiana, I. Fabriano:
Arti grafiche "Gentile" XV, 1936, 161 pp., 73 illus.
A series of essays concerning chronology of Salimbeni
brothers and the differentiation of their styles, and works in
the oratory of Sta. Monica, Fermo. Detailed bibliography.

339 SALMI, MARIO. "Un ciclo di affreschi umbri nella galleria
nazionale di Budapest." Bollettino della Deputazione di
storia patria per l'Umbria 51 (1954):73-82, 14 illus.
Publishes cycle of virtues with inscription, from Palazzo
Isidori in Piazza Morlacchi, Perugia. Notes similarities to
style of Bartolommeo di Tommaso da Foligno.

340 _____. "Dipinti del quattrocento a Città di Castello."
Bollettino della R. Deputazione di storia patria per
l'Umbria 24 (1918):157-79, 7 illus.
Publishes works in various locations in city, from first
half of fifteenth century. Includes, among numerous minor
masters, Death of the Virgin by Nelli in Sta. M. delle Grazie.

341 SANTI, FRANCESCO. Gonfaloni umbri del rinascimento.
Perugia: Editrice volumnia, 1976, 105 pp., 31 color illus.
Series of color plates of decorated banners, each with
annotation. Includes works by Bonfigli, Caporali, and others.
Review: Enzo Carli, Antichità viva 15, no. 6 (1976):
66-69.

342 _____. La nicchia di S. Bernardino a Perugia. Milan:
Electa editrice, 1963, 82 pp., 2 b&w and 29 color illus.
Brief introduction to large series of color plates of
cycle of 1470s from Oratorio di S. Bernardino, now in Galleria
Nazionale, Perugia. Includes discussion of banner by Bonfigli,
1465, and miniature by Bartolommeo Caporali. Bibliography.

343 SERRA, LUIGI. "La pittura del rinascimento nelle Marche:
Relazioni con l'arte umbra." Rassegna marchigiana 9, no. 5-
6 (1930-31):211-28, 279-93, 15 illus.
Attempts to compare and contrast schools by examining art
of Ottaviano Nelli, Matteo da Gualdo, and a group of lesser
masters in Foligno.

Books and Articles on Aspects of Painting in the Marches and Umbria

344 _____. "La pittura del rinascimento nelle Marche:
Relazioni con la scuola veneta: La prima metà del
quattrocento." Rassegna marchigiana 10 (1932):67-86,
11 illus.
Attempts to clarify relationship between two areas.
Deals with Venetian works in situ in Marches.

345 VAN MARLE, RAIMOND. "Quattro dipinti marchigiani del
principio del quattrocento." Rassegna marchigiana 4, no. 6
(1925-26):225-32, 4 illus.
Publishes Saint by Gentile da Fabriano, Spiridon Collec-
tion, Rome; Madonna, by Arcangelo di Cola, National Gallery,
Edinburgh; Coronation of the Virgin by Lorenzo Salimbeni; and a
fresco in grisaille of Crucifixion, Asilo di S. Benedetto,
Perugia, by anonymous master from Sanseverino.

346 VENTURI, ADOLFO. "Pitture inedite del Bonfigli e del
Caporali." L'arte 30 (1927):86-88, 2 illus.
Publishes two Madonnas, one by Bonfigli in Lazzaroni
Collection, Rome, and one by Caporali in Fabrizi Collection,
Rome.

347 VENTURI, LIONELLO. "A traverso le Marche." L'arte 18
(1915):1-28, 172-208, 63 illus.
Publishes numerous works from region from eleventh
through sixteenth centuries. Includes works by Gentile and his
school, Arcangelo, Pietro and Giacomo da Recanati, and Girolamo
da Giovanni.

348 VITALINI SACCONI, GIUSEPPE. "Due schede di pittura
marchigiana." Commentari 23, no. 1-2 (1972):164-66, 2
illus.
Publishes Madonna della Misericordia by Girolamo di
Giovanni, Chiesa di Villa, Cessapalombo, and anonymous Virgin
Enthroned, Ospedale del Buon Gesu, Fabriano.

349 ZAMPETTI, PIETRO. "La pittura del quattrocento nelle Marche
e i suoi vari rapporti con quella veneta." In Umanesimo
europeo e umanesimo veneziano. Edited by Vittore Branca.
Florence: Sansoni, 1963, pp. 417-33.
Discusses flowering of International Gothic in Marches,
seen in art of Gentile and also Salimbeni brothers. Emphasizes
Marchigian origins of Gentile.

350 ZERI, FEDERICO. "Tre argomenti umbri." Bollettino d'arte
48, no. 1-2 (1963):29-45, 26 illus.
Includes sections on Bartolommeo di Tommaso with addi-
tions to his oeuvre and on Maestro di Eggi, an anonymous mid-
century Umbrian.

EXHIBITIONS

351 MACERATA. S. PAOLO. Pittura nel Maceratese dal duecento al
 tardo gotico. Introduction by Pietro Torriti. Catalog
 entries by Alberto Rossi, Giuseppe Vitalini Sacconi, Luigi
 Dania, and others. Macerata: 1971, 246 pp., 88 illus.
 Exhibition catalog covering fifty-six works by artists
 from region.
 Review: Antonio Castellani and Giacomo Bettoli, Arte
 cristiana 59, no. 10 (1971):283-88, 13 illus.

352 PERUGIA. GALLERIA NAZIONALE. Four Centuries of Painting in
 Umbria. An Exhibition Commemorating the Fifth Centenary of
 the Birth of Pietro Perugino. Translated by Perry B. Cott.
 Introduction by Achille Bertini-Calosso. Perugia: 1945, 46
 pp., 51 illus.
 Catalog of exhibition of fifty-one works, very brief
 annotations.

353 PERUGIA. PALAZZO DEL POPOLO. L'arte umbra alla mostra di
 Perugia. By Umberto Gnoli. Raccolte d'arte, 6. Bergamo:
 Istituto italiano d'arti grafiche, 1908, 258 pp., 251 illus.
 Volume published at time of major exhibition, covering
 works in all media. Includes works by Gentile, Girolamo di
 Giovanni, Bonfigli, Nelli, Gozzoli, Caporali. See entry 354.

354 PERUGIA. PALAZZO DEL POPOLO. Catalogo della mostra
 d'antica arte umbra. Edited by Giulio Urbini. Perugia:
 Tip. di Vincenzo Bartelli, 1907, 226 pp.
 Catalog following arrangement of rooms with rather brief
 descriptions. See entry 353.

Special Topics

CONSERVATION AND TECHNIQUE (including exhibitions)

355 AREZZO. S. FRANCESCO. "Dipinti, scultore, e arti minore."
 In Arte nell'Aretino: Recuperi e restauri dal 1968 al 1974.
 By Anna Maria Maetzke. Florence: Editrice Edam, 1975, pp.
 15-144, 178 b&w and 8 color illus.
 Exhibition in S. Francesco, Arezzo, of recently restored
 works. Includes some unpublished paintings by artists from
 various regions. Each entry discusses work, restoration, bib-
 liography.
 Review: Luciano Bellosi, Prospettiva 3 (October 1975):
 55-60, 17 illus.

356 BALDINI, UMBERTO. "Restauri di dipinti fiorentini in
 occasione della mostra di quattro maestri del rinascimento."
 Bollettino d'arte 39, no. 3 (1954):221-40, 31 illus.
 Detailed account of restoration on Masaccio and Masolino's
 Madonna and St. Anne, Uccello's Battle of San Romano and Mira-
 cle of the Host. Numerous illustrations of work in progress.

357 BODKIN, THOMAS. Dismembered Masterpieces: A Plea for their
 Reconstruction by International Action. London: Collins,
 1945, 50 pp., 76 illus.
 Presentation aimed for general audience, enumerating
 scattered parts of various important works. Includes
 Pesellino's Trinity, Domenico Veneziano's St. Lucy altarpiece,
 Fra Angelico's S. Marco altarpiece, and Sassetta's San Sepolcro
 altarpiece.

358 CONTI, ALESSANDRO. "Quadri alluvionati, 1333, 1557, 1966."
 Paragone 19, no. 215 (1968):3-22, 22 illus.; no. 223
 (1968):3-27, 22 illus.
 Discusses damage and condition of a variety of works,
 including Gentile, Masaccio, Angelico, Giovanni di Francesco,
 and Baldovinetti. Detailed photos.

Conservation and Technique

359 DELBOURGO, SUZY. "Application of the Electron Microprobe to
 the Study of Some Italian Paintings of the Fourteenth to the
 Sixteenth Century." In Conservation and Restoration of
 Pictorial Art. Edited by Norman Brommelle and Perry Smith.
 London and Boston: Butterworths, 1976, pp. 27-35, 10 illus.
 Use of electron microscope to analyze layers and elements
 of paintings. Works from Campana Collection, including Andrea
 di Bartolo, Giovanni di Paolo, and Francesco d'Antonio.

360 ÉMILE-MÂLE, GILBERTE; MOGNETTI, ELIZABETH; and BERGEON,
 SÉGOLÈNE. "La restauration des primitifs italiens du Musée
 du Petit Palais d'Avignon." Revue du Louvre et des musées
 de France 27, no. 4 (1977):259-70, 27 illus.
 Describes several recent restorations. Includes, among
 others, Starnina's Angel of Annunciation, Giovanni di Paolo's
 St. Augustine, and St. Lawrence triptych by a follower of
 Lorenzo Monaco.

361 FLORENCE. FORTEZZA DA BASSO. Firenze restaura, il
 laboratorio nel suo quarantennio. By Umberto Baldini and
 Paolo dal Poggetto. Florence: Fortezza da Basso, 1972, 154
 pp., 215 illus.
 Exhibition of 363 works restored over forty-year period.
 Includes X-rays, photographs, history of restoration tech-
 niques. Includes works by Starnina, Uccello, Neri di Bicci,
 Fra Angelico, Lippi, and others.

362 GAY, MARIE CHRISTINE. "Application of the Staining Method
 to Cross-sections in the Study of the Media of Various
 Italian Paintings of the Fourteenth and Fifteenth Centuries."
 In Conservation and Restoration of Pictorial Art. Edited
 by Norman Brommelle and Perry Smith. London and Boston:
 Butterworths, 1976, pp. 78-83, 6 illus.
 Analysis of media of works in Campana Collection. Use of
 oil and/or egg in paintings by Neri di Bicci, Andrea di Bartolo,
 and others.

363 JOHNSON, MERYL, and PACKARD, ELIZABETH. "Methods Used for
 the Identification of Binding Media in Italian Paintings of
 the Fifteenth and Sixteenth Centuries." Studies in Conser-
 vation 16, no. 4 (1971):145-64, 9 illus.
 Results of a study of paintings in the Walters Art Gal-
 lery, Baltimore, to determine whether glue, egg, or oil was
 used. Majority of fifteenth-century works found to be entirely
 of egg tempera. Diagrams, details, and bibliography.

364 PRINZ, WOLFRAM. "Dal vero o dal modello? Aggiunte e
 testimonianze sull'uso dei manichini nella pittura del
 Quattrocento." In Scritti di storia dell'arte in onore di
 Ugo Procacci. Milan: Electa, 1977, pp. 200-208, 14 illus.
 Inquiry into early use of mannequins as models. Evidence
 in Uccello and Piero, among others. Possibility that used by

Masolino and Masaccio. Includes texts of references to prac-
tice found in writings from fifteenth and sixteenth centuries.

365 PROCACCI, UGO. "Recent Restoration in Florence."
 Burlington Magazine 89, no. 536 (1947):309-10, 3 illus.;
 no. 537 (1947):330-34, 12 illus.
 Accounts of restoration to Masaccio and Masolino's St.
 Anne altarpiece, Uffizi, and triptychs by Fra Angelico and
 Sassetta, S. Domenico, Cortona.

366 _____. La tecnica degli antichi affreschi e il loro
 distacco e restauro. Florence: Comitato della II mostra di
 affreschi staccati, 1958, 31 pp., 31 illus.
 Reprinting, with amplifications, of essay that prefaced
 fresco exhibition (entry 225). Describes various features of
 working process; methods of detaching and restoring works 1300-
 1500.

See also entries 115-116, 225, 227, 368, 383, 386.

DRAWINGS (including exhibitions and catalogs of collections)

367 AMES-LEWIS, FRANCIS. Drawing in Early Renaissance Italy.
 New Haven: Yale University Press, 1981, 207 pp., 182 b&w
 and 8 color illus.
 Surveys period. Chapters on materials, techniques,
 sketch books, figure and compositional drawings. Bibliography,
 glossary, and index.
 Review: Hellmut Wohl, Art Bulletin 66, no. 2 (1984):
 335-37.

368 BALDINI, UMBERTO. "Dalla sinopia al cartone." In Studies
 in Late Medieval and Renaissance Painting in Honor of
 Millard Meiss. Edited by Irving Lavin and John Plummer. New
 York: New York University Press, 1977, pp. 43-47, 10 illus.
 Investigation of working procedures, particularly chang-
 ing use of sinopie from Bicci di Lorenzo to Castagno.

369 BERENSON, BERNARD. I disegni dei pittori fiorentini.
 Translated by Luisa Vertova Nicolson. 3d ed. 3 vols.
 Milan: Electa editrice, 1961, 1081 pp., 1000 b&w and 23
 color illus.
 Revised version of entry 370, incorporating new material
 into text. Adds comparative illustrations. Updates annota-
 tions and bibliography.
 Review: Philip Pouncey, Master Drawings 2, no. 3
 (1964):278-93.

370 _____. The Drawings of the Florentine Painters. 2d ed. 3
 vols. Chicago: University of Chicago Press, 1938, 781 pp.,
 1009 illus.

Drawings

Monumental corpus of approximately 3000 drawings of Renaissance period, originally published in 1903. Text volume discusses groups of related artists, and, in the second edition, adds appendices with additional material. Catalog arranged alphabetically by artist and then by location, with very brief annotations for each item. See also entry 369.

371 COLVIN, SIDNEY. A Florentine Picture Chronicle. London: Bernard Quaritch, 1898, 151 pp., 217 illus. Review: New York: Benjamin Blom, 1970.
 Reproductions, with commentary, of folio sketch book in British Museum, ca. 1430, dealing with sacred and profane history. Tentatively attributed to Maso Finiguerra.

372 DEGENHART, BERNHARD. Italienische Zeichnungen des frühen 15 Jahrhunderts. Basel: Amerbach, 1949, 52 pp., 40 illus.
 Includes introductory essay on transitional character and functions of drawing at beginning of century. Catalogs 34 works, with comments and bibliography.

373 DEGENHART, BERNHARD, and SCHMITT, ANNEGRIT. Corpus der italienischen Zeichnungen, 1300-1450. 4 vols. Berlin: Mann, 1968, 763 pp., 1645 illus.
 Catalogs 635 drawings from southern and central Italy ca. 1300-1450. Text includes numerous comparative illustrations, lengthy scholarly discussions. Appendices on Vasari's Libro, Gentile's sketchbook, and other issues. Lengthy bibliography.
 Review: Roberto Salvini, Commentari 23, no. 4 (1972):335-50, 9 illus.

374 FLORENCE. GALLERIA DEGLI UFFIZI. Catalogo riassuntivo della raccolta di disegni antichi e moderni posseduta dalla R. Galleria degli Uffizi di Firenze. By Pasquale Nerino Ferri. Rome: I principali librai, 1890, 502 pp.
 The basic general catalog of collection. Arranged by geographic school and then alphabetically. Very little commentary. Indexes of artists and of works to which drawings relate.

375 _____. I disegni antichi degli Uffizi: I tempi del Ghiberti. By Fiora Bellini. Introduction by Luciano Bellosi. Contribution by Giulia Brunetti. Florence: Olschki, 1978, 133 pp., 142 illus.
 Exhibition of 102 drawings from the Uffizi, on six-hundredth birthday of Ghiberti. Works date from late fourteenth and fifteenth century. Bibliography, index.

376 GRASSI, LUIGI. I disegni italiani del trecento e quattrocento: Scuole fiorentina, senese, marchigiana, umbra. I disegno italiano, Collana diretta da Luigi Grassi. Venice: Sodalizio del libro, [1961], 275 pp., 117 illus.

Introductory essays on each region in each century. Catalog of selected representative drawings, arranged by artist, with biographical essays. Bibliography, index of artists.

377 HAYNES, SYBILLE. "A Fifteenth-century Drawing and its Classical Prototypes." Burlington Magazine 121, no. 919 (1979):653-54, 5 illus.
 Traces derivation of Tuscan drawing, ca. 1430, British Museum, with nude women with headdress of reeds, to a type originating with ancient Greek sculpture of Saltanes Lacaenae by Kallimachos.

378 LONDON. BRITISH MUSEUM. Italian Drawings in the Department of Prints and Drawings in the British Museum: The Fourteenth and Fifteenth Centuries. By A[rthur] E. Popham and Philip Pouncey. 2 vols. London: British Museum, 1950, 262 pp., 333 illus.
 Includes several central Italian works among many.
Entries include literature, provenance, and notes.

379 LONDON. ROYAL ACADEMY, BURLINGTON HOUSE. Italian Drawings Exhibited at the Royal Academy, Burlington House, London. By Arthur E. Popham. London: Oxford University Press and Executive Committee of the Exhibition, 1931, 102 pp., 326 illus.
 Catalogs 326 drawings from major loan exhibition. Arranges chronologically. Indexes.
 Review: Kenneth Clark, Burlington Magazine 56, no. 325 (1930):175-87, 7 illus.

380 MELLER, PETER. "Two Drawings of the Quattrocento in the Uffizi: A Study in Stylistic Change." Master Drawings 12, no. 3 (1974):261-79, 30 illus.
 Head of a Warrior, usually attributed to Baldovinetti, here considered North Italian, perhaps by Antonio Maineri. Head of a Man, sometimes attributed to Castagno, analyzed as in fact derived from Mantegna, probably as a Verrocchio shop exercise. Also discusses portraits by Verrocchio and/or Perugino.

381 MUNICH. STAATLICHE GRAPHISCHE SAMMLUNG. Italienische Zeichnungen der Frührenaissance. By Annegrit Schmitt. Munich: Staatliche graphische sammlung, 1966, 77 pp., 63 b&w and 1 color illus.
 Exhibition of thirty works from before 1460 from museums in Milan, Berlin, and Munich. Includes several by Gentile, Arcangelo di Cola, Domenico di Bartolo, and anonymous hands.

382 OERTEL, ROBERT. "Perspective and Imagination." In Studies in Western Art. Acts of the Twentieth International Congress of the History of Art. Vol. 2, The Renaissance and

Drawings

<u>Mannerism</u>. Princeton: Princeton University Press, 1963, pp. 146-59, 9 illus.
Traces transition from designs made directly on surface to be painted to more complicated creative process in fifteenth century. Attributes development to Renaissance desire for exactness of representations, particularly in perspective. Works by Castagno, Masaccio, and Masolino.

383 ____. "Wandmalerei und Zeichnung in Italien: Die Anfänge der Entwurfzeichnung und ihre monumentalen Vorstufen." <u>Mitteilungen</u> <u>des</u> <u>kunsthistorischen</u> <u>Institutes</u> <u>in</u> <u>Florenz</u> 5, no. 4-5 (1940):217-314, 35 illus.
Fundamental study of various kinds of preparatory drawings for large works. Includes model books, large-scale wall drawings, squared sheets, cartoons. Includes studies by Lorenzo Monaco, Uccello, and Masaccio.

384 PARKER, K.T. "Tuscan (about 1400)." <u>Old</u> <u>Master</u> <u>Drawings</u> 9, no. 34 (1934):23-25, 3 illus.
Publishes <u>Study</u> <u>of</u> <u>a</u> <u>Man's</u> <u>Head</u>, Ashmolean Museum, Oxford. Rejects attribution to Uccello.

385 POPHAM, A[RTHUR] E. "A Book of Drawings of the School of Benozzo Gozzoli." <u>Old</u> <u>Master</u> <u>Drawings</u> 4, no. 16 (1930):53-58, 3 illus.
Publication of album, Koenig Collection, Haarlem. Lists contents by folio, notes three separated sheets originally from same series. Attributes to Gozzoli school, after 1474.

386 PROCACCI, UGO. <u>Sinopie</u> <u>e</u> <u>affreschi</u>. Milan: Electa editrice, 1961, 271 pp., 78 b&w and 176 color illus.
Surveys sinopie, ca. 1300-1450, with large numbers of illustrations. Introductory essay on wall drawing. Lengthy catalog by region. Appendix of comparative illustrations.
Review: Michelangelo Muraro, <u>Art</u> <u>Bulletin</u> 45, no. 2 (1963):154-57.

387 RAGGHIANTI-COLLOBI, LICIA. <u>Il</u> <u>libro</u> <u>de'</u> <u>disegni</u> <u>del</u> <u>Vasari</u>. 2 vols. Florence: Vallecchi, 1974, 548 pp., 549 illus.
Catalogs 526 surviving drawings from Vasari's collection, arranged by artists, following Vasri's attributions, with commentaries noting recent attributions and bibliography. Discusses lost works, history of collection. Appendix on original mounts. Index.
Review: Gigetta dalli Regoli, <u>Critica</u> <u>d'arte</u> 41, no. 146 (1976):39-43, 7 illus.

388 SALMI, MARIO. "Un libro di disegni fiorentino del sec. XV." <u>Rivista</u> <u>d'arte</u> 12 (1930):87-95, 4 illus.
Comments on various sheets in a book of drawings, Haarlem, Koenigs Collection (formerly Milan, Biblioteca

Trivulzio), Gozzoli School. May be collection made by Gozzoli
of his students' work.

389 SCHELLER, R.W. "Uomini famosi." Bulletin van het
 Rijksmuseum 10, no. 2-3 (1962):56-67, 5 illus.
 Publishes recently acquired drawing with nine famous
 people. Sees as based on Masolino's lost Orsini cycle, similar
 to codex in Crespi Collection, Milan. Rejects idea that comes
 from Uccello's lost cycle in Padua.

390 VAN REGTEREN ALTENA, J.Q. "Een bladzijde uit een Italiaanse
 codex van omstreeks 1445." Bulletin van het Rijksmuseum 7,
 nos. 3-4 (1959):82-83, 1 illus.
 Newly acquired drawing with nine famous men. Some simi-
 larities to Piero's art.

ICONOGRAPHIC STUDIES

391 AMES-LEWIS, FRANCIS. "Early Medicean Devices." Journal of
 the Warburg and Courtauld Institutes 42 (1979):122-43, 13
 illus.
 Analyzes devices used by Medici, with implications for
 patronage and attitudes to art. Includes works by Lippi and
 Domenico Veneziano. Appendix with early mentions of various
 devices.

392 ARASSE, DANIEL. "Iconographie et évolution spirituelle: La
 tablette de saint Bernardin de Sienne." Revue d'histoire de
 la spiritualité 50, no. 3-4 (1974):433-56, 6 illus.
 Reviews various aspects of saint's iconography, particu-
 larly in Sienese art of 1450-1500. Emphasizes plaque that
 saint holds.

393 BORSOOK, EVE. "Cults and Imagery at Sant'Ambrogio in
 Florence." Mitteilungen des kunsthistorischen Institutes
 in Florenz 25, no. 2 (1981):147-202, 21 illus.
 Study of cults of Corpus Christi and Immaculate Concep-
 tion as practiced at S. Ambrogio. Interprets various works of
 art in reference to religious practices including Masolino and
 Masaccio's St. Anne altarpiece, Lippi's Coronation, Baldovinetti
 and Il Graffione's altarpiece of Virgin Adoring Child. Appen-
 dixes on St. Anne altarpiece, manuscripts for church, texts of
 documents. Much new documentary material. Mention of young
 Fra Diamante.

394 BRIGSTOCKE, HUGH. "Panels Showing the Death of St.
 Ephraim." Burlington Magazine 118, no. 881 (1976):
 585-89, 4 illus.
 Discusses panels dependent on fourteenth-century Death of
 St. Ephraim, including one in Uffizi, circle of Fra Angelico.
 Examines variations in iconography of theme.

Special Topics

Iconographic Studies

395 CALLMAN, ELLEN. "The Growing Threat to Marital Bliss as
 Seen in Fifteenth-Century Florentine Paintings." Studies in
 Iconography 5 (1979):73–92, 18 illus.
 Documents change in point of view in decorated cassoni
 and deschi in mid-fifteenth century from emphasis on love and
 fidelity to a more negative view of women. Describes changing
 social circumstances that may have caused shift.

396 COOK, CHARLES. "The Origin of the Dominican Habit (A Pic-
 ture in the National Gallery – School of Fra Angelico)."
 Burlington Magazine 35, no. 199 (1919):175–76.
 Letter suggesting source for imagery of painting in leg-
 end in Acta Sanctorum.

397 ECHOLS, MARY TUCK. "The Coronation of the Virgin in Fif-
 teenth Century Italian Art." Ph.D. dissertation, University
 of Virginia, 1976, 317 pp., 21 illus.
 Traces theme, which underwent important reinterpretations
 in quattrocento. Considers historical events, theological
 writings. Discusses sources, identifies five modes of repre-
 senting scene. Includes work of Fra Angelico, Lippi, and
 Gentile da Fabriano. Lists of works, lost works, earlier and
 later examples. Bibliography.

398 KAFTAL, GEORGE. Iconography of the Saints in Tuscan Paint-
 ing. Florence: Sansoni, 1952, 50 pp., plus 1274 columns,
 1186 b&w and 8 color illus.
 Detailed reference work, limited to panel and fresco
 painting in Tuscan schools 1200–1600. Catalogs Saints and
 Blessed in alphabetical order. For each lists biographical
 facts, types of images, scenes and cycles, published represen-
 tations, literary sources, hagiographical bibliography. Many
 illustrations, explanatory introduction. Section on unidenti-
 fied saints. Index of attributes, distinctive signs and
 scenes. Indexes of painters, locations, and subjects.
 Review: Millard Meiss, Art Bulletin 36, no. 2
 (1954):148–49.

399 KENNEDY, RUTH WEDGWOOD. The Renaissance Painter's Garden.
 New York, London, Toronto, and Washington, D.C. (Smithsonian
 Institute): Oxford University Press, 1948, 30 pp., intro-
 duction, comments on unnumbered plates, 91 b&w and 1 color
 illus.
 Large collection of plates, mostly details, of paintings
 ca. 1300–1600. Introductory essays concern functions and mean-
 ings of gardens and flowers in culture and art of period. Each
 plate has commentary that identifies plants.

400 KURTH, WILLY. "Der Darstellung des nackten Menschen in dem
 Quattrocento von Florenz." Ph.D. dissertation, University
 of Berlin, 1912, 120 pp.

Discusses theme in paintings and sculpture. Considers cultural background, trecento precedents, antique concepts. Chapters on realism (Natur) and new stylistic elements. Includes Masaccio, Masolino, Uccello, Piero.

401 LAVIN, MARILYN ARONBERG. "Giovanni Battista: A Study in Renaissance Religious Symbolism." Art Bulletin 37, no. 2 (1955):85-101, 27 illus.
 Traces images of the young Saint John from mid-thirteenth century to ca. 1500. Discusses changing choices of scenes and increasingly close association with Infant Christ. Includes, among others, works by Salimbeni brothers, Baldovinetti, and Filippo Lippi. Appendix with Lucrezia de Medici's life of the Saint.

402 _____. "Giovannino Battista: A Supplement." Art Bulletin 43, no. 4 (1961):319-26, 10 illus.
 Additional representations of legends of Saint John's life, including works by Domenico Veneziano, and Filippo Lippi. See entry 401.

403 _____. "Studies in Urbinate Painting 1458-1474, Piero della Francesca, Paolo Uccello, and Joos van Ghent." New York: New York University, 1973, 86 pp., 78 illus.
 Reissues three earlier articles (entries 1829, 1831, 2116) with introduction, conclusion, additional bibliography, and corrections. All three studies represent religious themes to which contemporary experiences are paralleled.

404 LEVI D'ANCONA, MIRELLA. The Garden of the Renaissance: Botanical Symbolism in Italian Painting. Florence: Olschki, 1977, 603 pp., 212 illus.
 Lexicon of plants found in Italian Renaissance paintings. Entries include symbolic meanings and works in which plant appears. Extensive bibliography. Index of artists, iconography, paintings by places and symbols.
 Review: Helen S. Ettlinger, Burlington Magazine 122, no. 924 (1980):197-98.

405 MALKE, LUTZ S. "Contributo alle figurazioni dei trionfi e del canzoniere del Petrarca." Commentari 28, no. 4 (1977):236-61, 40 illus.
 Iconographic study of scenes of triumph. Includes cassoni by Domenico di Michelino, Apollonio di Giovanni, and Pesellino.

406 MEISS, MILLARD. "Scholarship and Penitence in the Early Renaissance: The Image of St. Jerome." Pantheon 32, no. 2 (1974):134-40, 16 illus. [Reprinted in the Painter's Choice (New York: Harper & Row, 1976), pp. 189-202.]
 Traces the representation of Saint Jerome in penitence, which begins in Florence ca. 1400.

Iconographic Studies

407 MELLER, PETER. "Ritratti 'bucolici' di artisti del
quattrocento." Emporium 132, no. 787 (1960):3-10, 12 illus.
Discusses use of images of oxen as important quattrocento
motif. Works by Gozzoli, Lippi, Castagno, and others.

408 MODE, ROBERT LOUIS. "The Monte Giordano Famous Men Cycle of
Cardinal Giordano Orsini and the 'Uomini famosi' Tradition
in Fifteenth-Century Italian Art." Ph.D. dissertation,
University of Michigan, 1970, 355 pp.
Concerns lost fresco cycle with 300 images, largest pro-
gram of type done in fifteenth century. Done for Cardinal
Orsini, completed 1432 and known via copies and descriptions.
Offers no secure attribution, although style seen as associated
with Tuscan tradition.

409 _____. "San Bernardino in Glory." Art Bulletin 55, no. 1
(1973):58-76, 21 illus.
Traces glorification and canonization of S. Bernardino
(1450), and development of his iconography in various centers.
Discusses, among others, works by Parri Spinelli and Sano di
Pietro.

410 OS, H. W. VAN. Marias Demut und Verherrlichung in der
sienesischen Malerei 1300-1450. s'-Gravenhage: Ministerie
van Cultuur, Recreatie en Maatschappelijk Werk, 1969, 239
pp., 134 illus.
Iconographic study of works of Giovanni di Paolo, Pietro
di Giovanni d'Ambrogio, Andrea di Bartolo. Considers origins
and transformations of themes of Annunciation, Virgin of Humil-
ity, and Assumption. Indexes, bibliography.
Review: Sherwood A. Fehm, Jr., Burlington Magazine 116,
no. 851 (1974):116-17.

411 _____. "St. Francis of Assisi as a Second Christ in Early
Italian Painting." Simiolus 7, no. 3 (1974):115-32, 19
illus.
Discusses origin and development of theme of Franciscus
alter Christus. Works by Sassetta and Gozzoli.

412 _____. "Schnee in Siena." Nederlands kunsthistorisch
Jaarboek 19 (1968):1-50, 37 illus.
Study of the legend of the Madonna of the Snow and the
foundation of Sta. Maria Maggiore in Rome, as represented both
in and outside of Rome. Liturgical tradition in manuscripts
and altarpieces. Works of Masolino, Sassetta, and later
fifteenth-century Sienese artists.

413 PILLION, LOUISE. "La légende de Saint Jérôme d'après
quelques peintres italiennes du XVe siècle au musée du
Louvre." Gazette des beaux arts 39, no. 610 (1908):303-18,
8 illus.

Studies content of scenes of Saint's life in works in
Louvre, including predella to Madonna and Saints attributed
incorrectly to Gozzoli, fragments by Sano di Pietro, and frag-
ments attributed to Pesellino.

414 PRAMPOLINI, GIACOMO. L'Annunciazione nei pittori primitivi
 italiani. Milan: Hoepli, 1939, 119 pp., 261 b&w and 2
 color illus.
 Survey of theme in thirteenth through fifteenth centu-
 ries. Includes general introduction on iconographic type and
 its geographic diffusion. Organizes chapters by period and
 region. Index.

415 SCAGLIA, GUSTINA. "An Allegorical Portrait of Emperior
 Sigismund by Mariano Taccola of Siena." Journal of the
 Warburg and Courtauld Institutes 31 (1968):428-34, 4 illus.
 Frontispiece of Mariano's De ingeneis, written and illus-
 trated 1430-32, represents Emperor Sigismund stepping on the
 tail of heraldic lion. Interprets as symbol of Sigismund's aid
 to Siena against Florence. Also identifies eldest king as
 portrait of Sigismund in several Adorations including ones by
 Gentile and Sassetta.

416 SIMON, KATHRIN. "The Dais and the Arcade: Architecture and
 Pictorial Narrative in Quattrocento Painting." Apollo 81,
 no. 38 (1965):270-78, 9 illus.
 Examples of particular architectural arrangement, used
 specifically to give eminence to figure seated on dais and to
 suggest an avenue of approach to him following the arches.
 Examples in Fra Angelico and others.

417 SPENCER, JOHN R. "Spatial Imagery of the Annunciation in
 Fifteenth Century Florence." Art Bulletin 37, no. 4
 (1955):273-80, 13 illus.
 Organizes representations by iconographic types, which
 are seen as responses to new aesthetic of period and to
 Masaccio's lost Annunciation from S. Nicolo sopr'Arno.

418 STERLING, CHARLES. "Fighting Animals in the Adoration of
 the Magi." Bulletin of the Cleveland Museum of Art 61, no.
 10 (1974):350-59, 14 illus.
 Traces motif in Italian works ca. 1300-1500, including
 those of Giovanni di Paolo and Gentile da Fabriano. Suggests
 interpretation as symbol of hostility overcome by Christ.

419 VAN MARLE, RAIMOND. Iconographie de l'art profane au moyen
 age et à la renaissance et la décoration des demeures. Vol.
 1, La vie quotidienne. Vol. 2, Allégories et symboles. Le
 Hague: Martinus Nijhoff, 1931-32, 1045 pp., 1057 illus.
 Reprint. New York: Hacker, 1971.
 Enormous compilation of works of nonreligious subject
 matter, in many media. Arranged by topic including chapters on

Iconographic Studies

such subjects as life of the nobility, rural life, war, nature, and various pastimes. Second volume concerns allegorical images such as Virtues and Vices, Sciences and Arts, Death and Love. Bibliography.
Review of Vol. 1: J.G.N., Burlington Magazine 59, no. 341 (1931):97-98.

420 VERTOVA, LUISA. "Cupid and Psyche in Renaissance Painting before Raphael." Journal of the Warburg and Courtauld Institutes 42 (1979):104-21, 18 illus.
Traces theme, which has its earliest appearance on a pair of cassone panels of 1444.

421 WATSON, PAUL F. "Boccaccio's Ninfale Fiesolano in Early Florentine Cassone Painting." Journal of the Warburg and Courtauld Institutes 34 (1971):331-33, 5 illus.
Discusses iconography of two cassone panels, ca. 1430, Bowdoin College Museum, and Academy of Arts, Honolulu. Relates to Master of Griggs Crucifixion.

422 _____. The Garden of Love in Tuscan Art of the Early Renaissance. Philadelphia: Art Alliance Press, 1979, 188 pp., 97 illus. [British ed. London: Associated University Presses, 1979.]
Analyzes theme in secular art of fourteenth and fifteenth-century Italy. Discusses sources, variations, different media. Includes cassoni, manuscripts, drawings, and some interior wall decoration.
Review: Carter Ratcliff, Art in America 68, no. 1 (1980):21-25.

423 _____. "Virtù and Voluptas in Cassone Painting." Ph.D. dissertation, Yale University, 1970, 662 pp., 97 plates.
Analyzes iconography of cassoni in quattrocento. Primarily concerned with mid-century shift away from allegories and narratives of love. Discusses reconciliation of contrasting themes of virtù and voluptas. Considers societal factors including changing reputation of Boccaccio. Appends list of paintings and some documents.

424 WITTHOFT, BRUCIA. "Marriage Rituals and Marriage Chests in Quattrocento Florence." Artibus et historiae 5 (1982):43-51, 8 illus.
Discusses customs relating to chests, which were purchased by groom, filled by bride, and carried in marital procession. Subjects reflect rituals. Notes change in second quarter of century from amorous themes to martial ones, reflecting social and educational changes. Describes processions, including expressions of hostility.

425 WOLFE, ALICE. "The Thebaid Fragments of the Yale Art Gallery and the Zurich Kunsthaus." In Essays in Honor of Hans

Tietze 1880-1954. Directed by Ernst Gombrich, Julius S.
Held, Otto Kurz. N.p.: Gazette des beaux arts, 1958, pp.
393-406, 12 illus.
 Study of nine fragments, probably from a group of furni-
ture panels or interior architectural decoration. Compares to
other works with same subject, discusses iconographic problems.

See also entries 62, 92, 171.

LIGHT AND COLOR

426 ACKERMAN, JAMES S. "On Early Renaissance Color Theory and
 Practice." Studies in Italian Art and Architecture Fif-
 teenth Through Eighteenth Centuries. Edited by Henry A.
 Millon. Memoirs of the American Academy in Rome, 35; Stud-
 ies in Italian Art History, 1. Rome: American Academy in
 Rome, 1980, pp. 11-44, 7 illus.
 Surveys fifteenth and early sixteenth-century techniques.
 Includes discussion of Alberti's approach to modeling of single
 objects, for relief, but not to reproduce optical or atmos-
 pheric experience. Appendix on ancient and medieval tradition.

427 BARASCH, MOSHE. "Cennini and Alberti." In Light and Color
 in the Italian Renaissance Theory of Art. New York: New
 York University Press, 1978, pp. 1-43.
 History of theoretical concepts. Bibliography, index.

*428 COWARDIN, S. "Some Aspects of Color in Fifteenth Century
 Florentine Painting." Ph.D. dissertation, Harvard Univer-
 sity, 1963, 241 pp., 83 b&w and color illus.
 Source: entry 975.

429 GAVEL, JONAS. Colour: A Study of Its Position in the Art
 Theory of the Quattro and Cinquecento. Stockholm Studies in
 the History of Art, 32. Stockholm: Almqvist & Wiksell,
 1979, 178 pp., 1 color illus.
 Deals with use of color in Renaissance art from a theo-
 retical approach, considering its different uses and meanings.
 Charts, bibliography.

430 GOMBRICH, E[RNST] H. "Light, Form, and Texture in Fifteenth
 Century Painting North and South of the Alps." Journal of
 the Royal Society of Arts 112, no. 5099 (1964):826-49, 16
 illus. [Reprinted in The Heritage of Apelles: Studies in
 the Art of the Renaissance (Ithaca: Cornell University
 Press, 1976), pp. 19-35, 34 b&w and 1 color illus.]
 Discusses light and color as form creating elements.
 Includes ideas of Alberti, works of Masaccio and Fra Angelico.
 Considers influence of Northern technique, particularly work of
 Jan van Eyck.

Light and Color

431 GOULD, CECIL. "On the Direction of Light in Italian Renais-
 sance Frescoes and Altarpieces." Gazette des beaux arts 97,
 no. 1344 (1981):21-25.
 Analyzes solution formulated by Masaccio and Masolino in
 Brancacci Chapel, with light painted as though coming from
 direction of actual windows. Discusses subsequent attempts to
 continue practice.

432 KAUFMANN, THOMAS DA COSTA. "The Perspective of Shadows:
 The History of the Theory of Shadow Projection." Journal of
 the Warburg and Courtauld Institutes 38 (1975):258-87, 6
 illus.
 Importance of "proper depiction of shadows" in Renais-
 sance. Surveys theory, concentrates on Lomazzo's treatment of
 problem. Includes section on "Alberti and His Predecessors on
 Cast Shadows."

MINIATURES (including documents,
exhibitions, and catalogs of collections)

433 AESCHLIMANN, ERHARD, and D'ANCONA, PAOLO. Dictionaire des
 miniaturistes du moyen âge et de la renaissance dans les
 différentes contrées de l'Europe. 2d ed. Milan: Hoepli,
 1949, 239 pp., 148 b&w and 7 color illus. Reprint:
 Nendeln, Liechtenstein: Kraus, 1969.
 Basic reference source for miniaturists, arranged by
 their names. Entries, sometimes signed, give information on
 lives, known works, and bibliography. Index divides artists
 into periods, countries, and local schools.

434 BACCI, PELEO. "I miniatori fiorentini Cosmo di Giovanni,
 Prete Guasparri di Matteo, Fra Jacopo di Filippo e i maestri
 dei 'graduali' della Cattedrale di Pistoja (1456-1475)." In
 Documenti toscani per la storia dell'arte. Vol. 2.
 Florence: Ferrante Gonnelli, 1912, pp. 63-112.
 Publishes documents relating to manuscripts in Pistoia.
 Concerns particularly a set of five works commissioned in 1457.

435 BECK, JAMES H. "Historical 'Taccola' and Emperor Sigismund
 in Siena." Art Bulletin 50, no. 4 (1968):309-20, 27 illus.
 Biographical background and artistic activity of Sienese
 engineer Taccola (1381-1453/8). Discussion of manuscript,
 Biblioteca Nazionale, Florence, with drawings, dedicated to
 Emperor Sigismund. Appendix with documents.

436 BERENSON, BERNARD. "Due illustratori italiani dello
 Speculum humanae salvationis." Bollettino d'arte 19, no. 7
 (1926):289-320; no. 8 (1926):353-84, 64 illus.
 Discusses a manuscript in the Bibliothèque del'Arsenal,
 Paris, ca. 1400, by an artist working around Foligno, Chieti,
 and Spoleto. Primarily concerned with iconography.

437 BOMBE, WALTER. "Dokumente und Regesten zur Geschichte der
 Peruginer Miniaturmalerei." Repertorium für
 Kunstwissenschaft 33 (1910):6-21, 107-19.
 Publishes documents of 1322-1529. Includes contracts and
 matriculation registers.

438 BOSKOVITZ, MIKLÓS. "Su Don Silvestro, Don Simone e la
 'scuola degli angeli.'" Paragone 23, no. 265 (1972):35-61,
 28 illus.
 Reconstructs activity of miniaturists working for the
 monastery of Maria degli Angeli in Florence between about 1370
 and 1420.

439 BRIEGER, PETER; MEISS, MILLARD; and SINGLETON, CHARLES S.
 Illuminated Manuscripts of the Divine Comedy. 2 vols.
 Bollingen Series, 81. Princeton: Princeton University
 Press, 1969, 420 pp., 1230 b&w and 41 color illus.
 Catalog of illustrated codices of poem, preceded by es-
 says by authors. Analysis of cantos. Catalog by location.
 Bibliography, iconographical index, and general index. In-
 cludes, in Millard Meiss, "The Smiling Pages in Illuminated
 Manuscripts of the Divine Comedy," pp. 70-80, 269-75, a discus-
 sion of Yates Thompson manuscript, British Museum, London, with
 illustrations of Inferno and Purgatorio attributed to Priamo
 della Quercia, ca. 1442-50. Also analyzes Paradiso miniatures
 by Giovanni di Paolo.
 Review: A. Daneu Lattanzi, Bollettino d'arte 53, no. 2-3
 (1968):167-68.

440 D'ANCONA, PAOLO. "Contributo alla storia della miniatura
 nel sec. XV: Documenti dell'archivio della Basilica di San
 Lorenzo in Firenze." In Scritti di storia dell'arte in
 onore di Mario Salmi. Vol. 2. Rome: DeLuca, 1962, pp.
 329-37.
 Publication of twenty-four documents of 1399-1500, refer-
 ring to miniaturiss and cartolai.

441 _____. La miniatura fiorentina. 2 vols. Florence:
 Olschki, 1914, 1059 pp., 109 b&w and 1 color illus.
 General introduction followed by large plates, each with
 descriptive catalog entry. Arranged chronologically. Includes
 works of Lorenzo Monaco, Strozzi, Torelli, and others. Indexes
 of locations, texts, topics, and artists.

442 DE MARINIS, T., and ROSSI, FILIPPO. "Notice sur les
 miniatures du 'Virgilius' de la Bibliothéque Riccardi de
 Florence (Ms. 492)." Bulletin de la société française de
 reproductions de manuscrits a peintures 13 (1929):17-31, 13
 illus.
 Publishes manuscript containing complete works of Virgil
 with eighty-eight miniatures. Reviews earlier attributions to
 circles of Gozzoli, Pesellino, and Dido Master. Attributes to

Miniatures

a secondary artist, related to cassoni shops. Dates ca. 1444-
52 and later.

443 DI COCCO, GIOVANNI. "I corali miniati di Monteoliveto
 Maggiore conservati nella Cattedrale di Chiusi." Bollettino
 d'arte 4, no. 11-12 (1910):458-80, 10 illus.
 Catalogs collection of twenty-two corali, 1450-70, with
 decorations by Lorenzo di Bindo Rosselli and Sano di Pietro,
 among others.

444 DONATI, LAMBERTO. Bibliografia della miniatura. 2 vols.
 Biblioteca di bibliografia italiana, no. 69. Florence:
 Olschki, 1972, 1220 pp.
 Reference tool, organized into a variety of sections.
 Geographical locations, names of artists, subjects, collec-
 tions, and exhibitions, etc.

445 FLORENCE. BIBLIOTECA RICCARDIANA. Miniature riccardiane.
 By Maria Luisa Scuricini Greco. Florence: Sansoni
 antiquariato, 1958, 316 pp., 37 illus.
 Catalog of 325 manuscripts with miniatures in collection
 of Biblioteca Riccardiana. Introduction on history and scope
 of collection, followed by entries on each work, with descrip-
 tions of individual illuminations. Bibliography, indexes by
 century and school.

446 FLORENCE. MUSEO DI S. MARCO. I codici miniati del Museo di
 S. Marco a Firenze. By Renzo Chiarelli. Florence:
 Bonechi, 1968, 71 pp., 43 color illus.
 Catalogs codices in collection, mostly of fifteenth cen-
 tury. Notes on plates, brief bibliography. Works by Fra
 Angelico, Strozzi, Torelli, Bartolommeo di Fruosino, and
 others.

447 LEVI D'ANCONA, MIRELLA. Miniatura e miniatori a Firenze dal
 XIV al XVI secolo: Documenti per la storia della miniatura.
 Florence: Olschki, 1962, 480 pp., 40 illus.
 Documents, with commentary, concerning 150 miniaturists.
 Arranged alphabetically by artists. Annotated plates. Indexes
 of locations, patrons, subjects. Chronological table. Anno-
 tated bibliography.
 Review: Dario A. Covi, Art Bulletin 46, no. 3
 (1964):409-11.

448 MILANESI, GAETANO. Storia della miniatura italiana con
 documenti inediti. Florence: Grazzini, 1850, 194 pp.
 Excerpt from Milanesi's edition of Vasari's Lives, pub-
 lished as a separate volume. Deals mostly with about forty
 choirbooks from cathedrals of Florence and Siena. Descriptions
 of artists, books, documents (1440-1529).

449 OXFORD. BODLEIAN LIBRARY. Illuminated Manuscripts in the
 Bodleian Library, Oxford. By Otto Pächt and J.J.G.
 Alexander. Vol. 2, Italian School. Oxford: Clarendon
 Press, 1970, 173 pp., many b&w and 1 color illus.
 Catalog of collection, including numerous items from
 early quattrocento, many anonymous. Arranged by area.

450 PAOLI, MARCO. "Disegni senesi del quattrocento in un codice
 inedito dei 'Vaticinia de summis pontificibus.'" In Arte e
 cultura artistica a Lucca. Pisa: Quaderni dell' Istituto
 di storia dell'arte dell'università, no. 3, 1979, pp. 35-51,
 14 illus.
 Discusses style and content of images of prophets and
 popes in manuscript in Biblioteca Statale, Lucca. Dates 1455-
 65, attributes to a Sienese hand.

451 POPE-HENNESSY, JOHN, ed. A Sienese Codex of the Divine
 Comedy. Oxfod and London: Phaidon, 1947, 35 pp., 98 illus.
 Discusses Yates-Thompson manuscript of Dante's poem,
 British Museum. Terms "most important Sienese secular manu-
 script" of fifteenth century. Dates 1438-44, attributes
 Inferno and Purgatorio to Vecchietta, confirms attribution of
 Paradiso to Giovanni di Paolo.

452 ROME. PALAZZO DI VENEZIA. Mostra storica nazionale della
 miniatura. Catalog by Giovanni Muzzioli. Florence:
 Sansoni, 1954, 561 pp., 105 b&w and 5 color illus.
 Major exhibition of 748 manuscripts, fifth through six-
 teenth centuries. Organized chronologically and regionally.
 Includes sections on Tuscany, Umbria, and Rome. Also includes
 some paintings related to the miniatures. Extensive bibliogra-
 phy and indexes.
 Review: Alessandro Marabottini, Emporium 119, no. 714
 (1954):243-61, 13 illus.

453 [ROSSI, ADAMO.] "L'arte de' miniatori in Perugia."
 Giornale di erudizione artistica 2, no. 11-12 (1873):305-17,
 350.
 Documents listing matriculants in the guild from late
 fourteenth century on. Discusses importance of group.

454 SERAFINI, ALBERTO. "Ricerche sulla miniatura umbra (secoli
 XIV-XVI)." L'arte 15 (1912):41-66, 98-121, 233-62, 417-39,
 64 illus.
 Survey of Umbrian miniatures. Includes sections on
 Sienese influence, on Umbrians before Perugino, on Peruginesque
 school, and on Ferrarese influence. Considers questions of
 patronage, particularly in Urbino, of local styles, and of
 various influences from in and outside Italy. Lists names of
 known active figures and their works.

Museums and Collections

MUSEUMS AND COLLECTIONS

455 ALTENBURG. STAATLICHE LINDENAU MUSEUM. Frühe italienische
 Malerei in Altenburg. Beschreibender Katalog der Gemälde
 der 13. bis 16. Jahrhunderts im Staatlichen Lindenau-Museum.
 By Robert Oertel. Berlin: Henschelverlag, 1961, 320 pp.,
 206 b&w and 25 color illus.
 Scholarly catalog with introductory essay, history of
 collection and catalog entries by geographic school. Entries
 include biography of artist, bibliography, measurements, condi-
 tion, medium, and comments.
 Review: Federico Zeri, Bollettino d'arte 49, no. 1
 (1964):45-53, 21 illus.

456 _____. Italienische Malerei der Vor- und Frührenaissance im
 Staatlichen Lindenau-Museum Altenburg. By Hanns-Conon Von
 der Gabelentz. Altenburg: Staatliches Lindenau-Museum,
 1955, 108 pp., 42 illus.
 Brief review of collection.

457 ASSISI. PERKINS COLLECTION. Collezione Federico Mason
 Perkins. By Giuseppe Palumbo. Assisi: Sacro convento di
 S. Francesco, 1973, 90 pp., 73 b&w and 57 color illus.
 Catalog of works from Perkins Collection in Sacro Convento,
 Assisi, with commentary, bibliography. Also publishes Perkins's
 own catalog of his entire collection with illustrations. In-
 troduction on Perkins, bibliography of his writings.

 AVIGNON. See entry 360.

458 BALTIMORE. WALTERS ART GALLERY. "The Fifteenth Century."
 In Italian Paintings in the Walters Art Gallery. By
 Federico Zeri. With condition notes by Elisabeth C.G.
 Packard. Edited by Ursula E. McCracken. Vol. 1.
 Baltimore: Walters Art Gallery, 1976, pp. 71-232, 115
 b&w and 1 color illus.
 Catalogs collection, by regional schools. Lengthy entry
 on each work with discussion, provenance, condition, refer-
 ences. Vol. 2 includes concordances and indexes.
 Review: David Alan Brown, Art Bulletin 60, no. 2
 (1978):367-69.

459 BERN. KUNSTMUSEUM. Italienische Malerei: 13. bis 16.
 Jahrhundert. By Hugo Wagner. Bern: Graf-Lehmann, 1974,
 147 pp., 76 b&w and 3 color illus.
 Catalogs twenty-nine works, mostly Tuscan, in collection.
 Extensive bibliography. Index.

 BOSTON. See entries 215, 250.

460 BUDAPEST. MUSEUM OF FINE ARTS and ESZTERGOM CHRISTIAN
 MUSEUM. Tuscan Paintings of the Early Renaissance:
 Budapest Museum of Fine Arts; Esztergom Christian Museum.

By Miklós Boskovits. Translated by Eva Racz. New York: Taplinger Publishing Co., 1968, 25 pp., plus text accompanying 48 color illus.

Catalogs works in major Hungarian collections. General introduction followed by catalog format discussions of works illustrated. Bibliography.

461 CAMBRIDGE. FITZWILLIAM MUSEUM. Catalogue of Paintings. Vol. 2, Italian Schools, by J.W. Goodison and G.H. Robertson. Cambridge: Syndics of the Fitzwilliam Museum, 1967, 214 pp., 64 illus.

Catalogs collection alphabetically by artist. Plates arranged by geographic school. Entries include biographical sketch, discussion of painting. Indexes. See entry 107.

CRACOW. See entry 55.

DETROIT. See entry 197.

DRESDEN. See entry 483.

462 FLORENCE. GALLERIA DEGLI UFFIZI. Gli Uffizi: Catalogo generale. Edited by Luciano Berti and Caterina Caneva. Florence: Centro Di, 1979, 1207 pp., 4115 b&w and 85 color illus.

Major comprehensive publication that catalogs alphabetically, in chart format, every painting in collection. Entries include small photograph, statistics, bibliography, and annotation. Contributions by numerous scholars. Index.

FLORENCE. See also entries 145, 147, 153, 374, 445, 446.

463 FLORENCE. VILLA I TATTI. The Berenson Collection. Edited by Franco Russoli. Translated and edited by Francis and Sidney Alexander. Preface by Nicky Mariano. Milan: Arti grafiche ricordi, 1964, 32 pp. plus text accompanying 5 b&w and 102 color illus.

Catalogs works. Each entry has comments, bibliography, condition, and, in many cases, a relevant quote from Berenson.

GÖTTINGEN. See entry 213.

HOLLAND. See entry 192.

464 KRESS COLLECTION. Paintings from the Samuel H. Kress Collection. Vol. 1, Italian Schools XIII-XV Century, by Fern Rusk Shapley. London: Phaidon, 1966, 435 pp., 430 b&w and 20 color illus.

Catalogs collection, now dispersed to various locations, with each regional school arranged by artist. Biographies and lists of works. Gives location, provenance, bibliography for each painting. Indexes of attributions, subjects, owners, places, and artists.

Museums and Collections

Review: Federico Zeri, Burlington Magazine 109, no. 773 (1967):473-77, 11 illus.

465 LONDON. NATIONAL GALLERY. The Earlier Italian Schools. By Martin Davies. 2d ed. National Gallery Catalogues. London: National Gallery, 1961, 623 pp.
 Alphabetical catalog of works up to ca. 1500. Biographical notices, information on condition, notes on subject attribution, and provenance. Lists reproductions and references. Includes several appendices including one with a new transcription of contract for Sassetta's Sansepolchro altarpiece. List of changes in attributions from earlier catalogs; indexes of subjects, collections, catalog numbers. Plates in separate volume.

 LONDON. See also entries 254, 378.

466 MARCHES. Le gallerie comunali delle Marche. By Luigi Serra. Rome: Soc. ed. d'arte illustrata, [1926], 239 pp., 82 illus.
 Fundamental guide to twenty-three public galleries in region. Organized by city, then institution, with brief paragraph on history of each collection and description of individual works. Indexes of places and artists.

467 MILAN. BRERA. Catalogo della R. Pinacoteca di Brera. By Francesco Malaguzzi-Valeri. Preface by Corrado Ricci. Bergamo: Istituto italiano d'arti grafiche, 1908, 427 pp., 77 illus.
 Catalogs collection, with fairly lengthy discussion of each work.

 MUNICH. See entry 483.

468 NEW HAVEN. JARVES COLLECTION, YALE UNIVERSITY. A Descriptive Catalogue of the Pictures in the Jarves Collection Belonging to Yale University. By Osvald Sirén. New Haven: Yale University Press, 1916, 316 pp., 90 illus. [British ed. London: Humphrey Milford, Oxford University Press.]
 Catalog of 119 works, including a substantial portion from the 1400s. Many are illustrated. Lengthy discussions include biography of artist and bibliography.

469 NEW HAVEN. YALE UNIVERSITY ART GALLERY. Early Italian Paintings in the Yale University Art Gallery. By Charles Seymour, Jr. New Haven and London: Yale University Press, 1970, 339 pp., 186 illus.
 Entries include description, condition, provenance, exhibitions, bibliography, and sometimes a discussion. Volume includes concordance, iconographical guide, and indexes.
 Review: Everett Fahy, Art Bulletin 56, no. 2 (1974):283-85

470 _____. Italian Primitives at Yale University: Comments and Revisions. By Richard Offner. New Haven: Yale University Press, 1927, 63 pp., 91 illus.

Surveys works and comments on them as they illustrate developments in the history of paintings. Indexes.
Review: Mario Salmi, Rivista d'arte 11 (1929):267-73, 3 illus.

NEW HAVEN. See also entry 216.

471 NEW YORK. METROPOLITAN MUSEUM. Italian Paintings: A Catalogue of the Collection of the Metropolitan Museum of Art: Florentine School. By Federico Zeri with Elizabeth E. Gardner. New York: Metropolitan Museum, 1971, 242 pp., 135 illus.
Arranged chronologically by artist. Each entry includes provenance, exhibitions, extensive annotated bibliography, and detailed discussion. Includes brief bibliographies of major artists. Indexes.

472 _____. Italian Paintings; Sienese and Central Italian Schools. By Federico Zeri with Elizabeth E. Gardner. New York: Metropolitan Museum, 1980, 119 pp., 112 illus.
Catalogs works by artist or shop. Each entry includes biography of artist, discussion of work, condition, provenance, and annotated bibliography. Index of former owners. General index.

473 NEW YORK. RABINOWITZ COLLECTION. The Rabinowitz Collection. By Lionello Venturi. New York: Twin Editions, 1945, 81 pp., 47 b&w and 12 color illus.
Catalog of thirty-eight paintings, each with a large illustration and a descriptive page. Includes Sassetta, Lippi, Giovanni dal Ponte, Castagno, and Master of Castello Nativity

474 OBERLIN. ALLEN MEMORIAL ART MUSEUM, KRESS COLLECTION. "Catalogue, Samuel H. Kress Study Collection." By Wolfgang Stechow. Allen Memorial Art Museum Bulletin 19, no. 1 (1961):9-51, 36 illus.
Includes discussion of Neri di Bicci's Five Saints and Giovanni Boccati's Sts. John the Baptist and Sebastian.

475 OXFORD. ASHMOLEAN. A Catalogue of the Earlier Italian Paintings in the Ashmolean Museum. By Christopher Lloyd. Oxford: Clarendon Press, 1977, 249 pp., 166 illus.
Catalogs works by artists born between 1260 and 1560. Brief biographies, bibliographies. Concordance with earlier catalogs, various indexes. Brief section on icons. Each entry includes condition, literature, discussion, and references.
Review: Francis Russell, Burlington Magazine 119, no. 894 (1977):654.

OXFORD. See also entry 449.

Museums and Collections

476 PARIS. LOUVRE. Description raisonnée des peintures du
Louvre. Vol. 1, Écoles étrangères: Italie et Espagne, by
Seymour de Ricci. Paris: Imprimerie de l'art, 1913, 219 pp.
 Basic catalog of collection, listing works alphabetically
by artist with comments, provenance, bibliography, and repro-
duction. General introductory bibliography including extensive
list of earlier catalogs. Index.

477 _____. La peinture au musée du Louvre: Écoles italiennes:
XIII, XIV, XV siècles. By Louis Hautecoeur. Paris:
Guiffrey, n.d., 121 pp., 103 b&w and 1 color illus.
 Includes description and discussion of numerous works
from early fifteenth century as well as other periods. Entries
review scholarly opinions, include some bibliography.

478 PERUGIA. GALLERIA NAZIONALE DELL'UMBRIA. Dipinti, sculture
e oggetti d'arte di età romanica e gotica. By Francesco
Santi. Rome: Istituto poligrafico dello stato, 1969, 215
pp., 187 illus.
 Includes sections on early fifteenth-century schools of
Siena, Florence, Umbria, and the Marches.

479 _____. La Galleria nazionale dell'Umbria in Perugia. By
Giovanni Cecchini. Rome: Libreria dello stato, 1932, 255
pp., 68 illus.
 Enumerates objects in galleries, with brief comment.
Indexes of artists and of subjects. Bibliography.

PERUGIA. See also entries 207, 302, 313.

480 PHILADELPHIA. JOHN G. JOHNSON COLLECTION. Catalogue of a
Collection of Paintings and Some Art Objects. Vol. 1,
Italian Paintings, by Bernhard Berenson. Philadelphia:
John G. Johnson, 1913, 219 pp., 303 illus.
 Earliest catalog of collection, including works ca. 1300-
1800. Organized by geographic school. Indexes of painters and
places. Each entry includes brief biography and descriptive
analysis, with some references to earlier opinions and writings.

481 _____. Catalogue of Italian Paintings. Edited by Barbara
Sweeney. Philadelphia: George Buchanan, 1966, 262 pp.,
approx. 300 b&w and 1 color illus.
 Alphabetical catalog of collection that contains many
fifteenth-century works. Entries include provenance and de-
tailed bibliography.

482 PISA. MUSEO NATIONALE. Museo di Pisa. Edited by Enzo
Carli. Pisa: Cassa di risparmio, 1974, 141 pp., 161 b&w
and 26 color illus.
 Catalog with elaborate color and many black and white
illustrations. Catalog entries and extensive bibliography for
each work. Arranged by chronological and geographical divisions.

483 ROME. BORGHESE and DORIA PAMFILI GALLERIES. Italian Paint-
 ers: Critical Studies of their Works. By Giovanni Morelli.
 Translated by Constance Jocelyn Ffoulkes. Vol. 1, The
 Borghese and Doria Pamfili Galleries in Rome. London: John
 Murray, 1892, 367 pp., 49 illus.
 MUNICH and DRESDEN. GALLERIES. Vol. 2, The Galleries of
 Munich and Dresden. London: John Murray, 1893, 334 pp., 48
 illus.
 Republication and expansion of controversial articles
 published in 1870s. Volume 1 includes a section on "Principles
 and Method" written as a conversation, insisting on importance
 of knowing an artist's style and "treatment of form." Each
 collection then examined school by school.

484 SIENA. DUOMO. Il Duomo di Siena: Parte seconda. By
 Vittorio Lusini. Siena: Soc. an. grafiches S. Bernardino,
 1939, 369 pp., 109 illus.
 Covers the material in the cathedral from the Renais-
 sance, as well as the contents of the Piccolomini library.
 Indexes of names and places.

485 SIENA. PINACOTECA. La Pinacoteca Nazionale di Siena: I
 dipinti dal XII al XV secolo. By Piero Torriti. Geneva:
 Sagep, 1977, 437 pp., many unnumbered illus., many in color.
 Catalogs hundreds of works in collection, chronologi-
 cally, citing earlier literature. Indexes, bibliography, and
 history of the collection.
 Review: John Pope-Hennessy, Apollo 109, no. 206
 (1979):325-26.

486 _____. La regia Pinacoteca di Siena. By Cesare Brandi.
 Rome: La Libreria dello stato, 1933, 383 pp., 85 illus.
 Early handbook of collection. Lists works alphabetically
 by artist, each with commentary and bibliography. Brief intro-
 duction on history of collection.

 SIENA. See also entry 263.

 VATICAN. See entries 53, 59, 106.

 VIENNA. See entry 86.

487 WASHINGTON. NATIONAL GALLERY. Washington, D.C., National
 Gallery of Art. Catalogue of the Italian Paintings. By
 Fern Rusk Shapley. 2 vols. Washington: 1979, 602 pp., 378
 illus.
 Comprehensive catalog of holdings in collection, includ-
 ing updated entries on Kress Collection, and adding entries on
 works from other donors and sources. Numerous indexes.
 Review: Ellis Waterhouse, Burlington Magazine 122, no.
 930 (1980):637-38.

See also entries 49, 192.

PERSPECTIVE

488 ANGELI, RENATO, and ZINI, RENATO. "La prospettiva:
Invenzione o scoperta?" In La prospettiva rinascimentale:
Codificazioni e trasgressioni. Edited by Marisa Dalai
Emiliani. Florence: Centro Di, 1980, pp. 125-36, 4 illus.
 Defines perspective as both an invention of a system and
a discovery of optical phenomena. Analyzes (among others)
Masaccio's Trinity and Uccello's Hawkwood.

489 BATTISTI, EUGENIO. "Note sulla prospettiva rinascimentale."
Arte lombarda 16 (1971):87-97, 13 illus.
 Presents the variety of the possible uses of perspective,
with examples especially in fifteenth-century Italian works,
including Masaccio, Uccello.

490 BOGGILD-JOHANNSEN, BIRGITTE, AND MARCUSSEN, MARIANNE. "A
Critical Survey of the Theoretical and Practical Origins of
Renaissance Linear Perspective." Translated by David
Hohnen. Acta ad archaeologiam et artium historiam
pertinentia 1 (1981):191-227, 7 illus.
 Investigation of early development of linear perspective.
Sees sources in combination of a variety of disciplines: op-
tics, measuring and statistics, and geography and astronomy.

491 BOSKOVITS, M[IKLÒS]. "'Quello Ch'e Dipintori Oggi Dicono
Prospettiva.' Contributions to Fifteenth Century Italian
Art Theory." Acta historiae artium 8, no. 3-4 (1962):241-
60; 9, no. 1-2 (1963):39-62.
 Examines sources and background for development of per-
spective. Stresses influence of immediately preceding artistic
developments (not just optical theory). Ideas of Brunelleschi,
Piero, and Alberti.

492 CHASTEL, ANDRÉ. "Les apories de la perspective au
quattrocento." In La prospettiva rinascimentale:
Codificazioni e trasgressioni. Edited by Marisa Dalai
Emiliani. Florence: Centro Di, 1980, pp. 45-62, 18 illus.
 Evolution of attitudes to and uses of perspective from
its discovery to Vasari. Examines uses with both naturalistic
and architectural backgrounds.

493 DALAI EMILIANI, MARISA. "La questione della prospettiva
1960-68." L'arte 2 (1968):96-105.
 Surveys major recent literature, including works by
Panofsky, White, Gioseffi, Francastel, and others.

494 DEGL'INNOCENTI, GIOVANNI, and BANDINI, PIER LUIGI. "Per una
più corretta metodologia della restituzione prospettica:
Proposte e verifiche." In La prospettiva rinascimentale:
Codificazioni e trasgressioni. Edited by Marisa Dalai
Emiliani. Florence: Centro Di, 1980, pp. 547-63, 15 illus.

Presents methods of reconstructing depicted space. Analysis of Lippi's Pitti tondo. Diagrams and reconstructions.

495 DEL BRAVO, CARLO. "La dolcezza della immaginazione."
Annali della Scuola normale superiore di Pisa 7, no. 2
(1977):759-99, 54 illus.
 Possibilities for variety within the regularity of mathematical perspective. Discusses works by Brunelleschi, Masaccio, Gentile, and Castagno.

496 DEL CANTON, GIUSEPPINA. "Ipotesi e proposte per una lettura
semiologica della prospettiva rinascimentale." Arte
lombarda 16 (1971):108-13.
 Argues for a semiological interpretation of quattrocento perspective as a systematic language.

497 EDGERTON, SAMUEL Y., Jr. "The Art of Renaissance Picture-
making and the Great Western Age of Discovery." In Essays
Presented to Myron P. Gilmore. Edited by S. Bertelli and
G. Ramakus. Vol. 2. Florence: La nuova Italia editrice,
1978, pp. 133-53, 5 illus.
 Investigates possible reasons leading to Western scientific revolution, using advent of linear perspective as an indicator. Sees catalyst for development of linear perspective in replacement of medieval maps with more rational Ptolemaic longitude-latitude system. Examples in Brunelleschi, Alberti, and Columbus.

498 _____. The Renaissance Rediscovery of Linear Perspective.
New York: Basic Books, 1975, 223 pp., 55 illus.
 Discusses Brunelleschi's discovery of and Alberti's communication of perspective, in their philosophical and cultural contexts. Reconstructs Brunelleschi's perspective experiment. Glossary, index, and many diagrams.
 Review: Kim H. Veltman, Art Bulletin 59, no. 2
(1977):281-82.

499 GIOSEFFI, DECIO. "Complementi di prospettiva." Critica
d'arte 4, no. 24 (1957):468-88, 15 illus.; 5, no. 25-26
(1958):102-49, 22 b&w and 4 color illus.
 Discusses idea in White's Birth and Rebirth of Pictorial
Space (entry 518), schemes of ancients, Brunelleschi's second panel, and especially the devices used by Uccello.

500 _____. Perspectiva artificialis: Per la storia della
prospettiva: Spigolature e appunti. Trieste: Università
degli studi di Trieste, Istituto di storia dell'arte antica
e moderna, no. 7, 1957, 145 pp., 57 illus.
 Reviews optical basis of perspective and its development in painting. Reviews theories, particularly Panofsky's. Emphasizes uniqueness of perspective, not symbolic or expressive

Perspective

content. Sees vision of image in perspective as same as vision
of actual objects.
Review: M.H. Pirenne, Art Bulletin 41, no. 2 (1959):
213-17.

501 _____. "Perspective." Encyclopedia of World Art. Vol. 11.
London: McGraw Hill, 1966, col. 183-221, 57 b&w and 2 color
illus.
Reviews historical development, including experiments and
theories of Brunelleschi and Alberti. Detailed bibliography.

502 _____. "Prospettiva e semiologia." In La prospettiva
rinascimentale: Codificazioni e trasgressioni. Edited by
Marisa Dalai Emiliani. Florence: Centro Di, 1980, pp. 13-
26, 12 illus.
Rejects semiological interpretation of perspective as
being independent of naturalism. Investigates codifications of
perspective, especially those of Brunelleschi.

503 HORSTMANN, RAINER. "Die Vorstufen der perspektivischen
Deckenmalerei." In Die Entstehung der perspektivischen
Deckenmalerei. Munich: UNI-Druck, 1968, pp. 5-36, 12
illus.
Rather brief survey of illusionistic ceilings in fif-
teenth and sixteenth-century Italy. Includes, in a chapter on
forerrunners, works seen as if from below by Masaccio, Uccello,
Castagno, and Domenico di Bartolo.

504 IVINS, WILLIAM M., Jr. On the Rationalization of Sight:
with an Examination of Three Renaissance Texts on Perspec-
tive. Metropolitan Museum Papers, no. 8. New York: 1938,
53 pp., 37 illus. Reprint. New York: Da Capo, 1975.
Detailed examination of perspective schemes of Alberti,
Pelerin, and Durer.

505 KLEIN, ROBERT. "Études sur la perspective à la renaissance,
1956-1963." Bibliothèque d'humanisme et de la renaissance 25
(1963):577-87.
Reviews recent literature on issues of Brunelleschi's
invention, of bifocal vision and distance point method, and of
curvilinear perspective.

506 _____. "Pomponius Gauricus on Perspective." Art Bulletin
43, no. 3 (1961):211-30, 25 illus.
In context of a discussion of ideas expressed in Gauricus's
De sculptura of 1504, provides useful explanation of fifteenth
century perspective practices, particularly those of Brunelleschi,
Alberti, and Uccello. See entry 513.

507 KRAUTHEIMER, RICHARD, and KRAUTHEIMER-HESS, TRUDE. "Linear
Perspective." In Lorenzo Ghiberti. 2d ed. Princeton:
Princeton University Press, 1970, pp. 229-53, 4 illus.

Reconstructs Brunelleschi's discovery and its use by
painters and Alberti as well as by Ghiberti.

508 MYERS, MARSHALL NEAL. "Observations on the Origin of Ren-
 aissance Perspective: Brunelleschi, Masaccio, Petrus
 Christus." Ph.D. dissertation, Columbia University, 1978-
 79, 227 pp., 59 illus.
 Investigates the origins and development of perspective
 in painting. Links to branches of philosophy and theology,
 which revered numerical relationships. Numerical exegesis and
 reconstruction of Masaccio's Trinity. Discusses Brunelleschi's
 ideas, including a possible method of discovering perspective.

509 NICCO-FASOLA, GIUSTA. "Svolgimento del pensiero prospettico
 nei trattati da Euclide a Piero della Francesca." Arti 5,
 no. 2 (1942-43):59-71.
 Reviews Renaissance theory, as well as ideas of Ghiberti,
 Alberti, and finally Piero, whose originality is seen in his
 making perspective the sole subject of a treatise.

510 OLSCHKI, LEONARDO. "Die technischen und mathematischen
 Schriften der Renaissance." In Geschichte der neusprachlichen
 wissenschaftlichen Literatur. Vol. 1, Die Literatur der
 Technik und der angewandten Wissenschaften. Heidelberg:
 Carl Winter's Universitatsbuchhandlung, 1919, pp. 45-150.
 Reprint. Vaduz: Kraus Reprint, 1965.
 Discusses ideas of Alberti, Piero, Ghiberti, and others
 from a scientific, mathematical point of view.

511 PANOFSKY, ERWIN. "Die Erfindung der verschiedenen
 Distanzkonstrucktionen in der malerischen Perspektive."
 Repertorium für Kunstwissenschaft 45 (1925):84-86.
 Reply to Wieleitner (entry 519), citing ideas developed
 in Piero's treatise regarding distance point. Includes rejoin-
 der by Wieleitner.

512 _____. La prospettiva come "forma simbolica" e altri
 scritti. Edited by Guido D. Neri, with a contribution by
 Marisa Dalai. Translated by Enrico Filippini. Milan:
 Feltrinelli, 1976, 220 pp., 72 illus.
 Contains a translation of famous article of 1924-25
 ["Perspektive als symbolische Form," Vorträge der Bibliothek
 Warburg 4 (1924-25):258-330], which attempts to trace changes
 in perspective systems in relation to changing world views,
 contrasting particularly the ancient view of aggregate space to
 Renaissance systematic space. Also includes translation of
 several other articles by Panofsky on various aspects of art
 theory, style, and development; as wll as an essay by Guido D.
 Neri on Panofsky's theory and figurative space, and one by
 Marisa Dalai on perspective.
 Review: G. Previtali, Paragone 12, no. 141 (1961):52-58.

Perspective

513 PARRONCHI, ALESSANDRO. "Il 'punctum dolens' della
 'costruzione legittima.'" Paragone 13, no. 145 (1962):58-
 72, 3 illus. [Reprinted in Studi su la dolce prospettiva
 (Milan: Martello, 1964), pp. 296-312.]
 Discusses question of distance point with references to
 trecento artists, Brunelleschi, and Alberti, primarily in re-
 sponse to ideas of Robert Klein (entry 505).

514 RONCHI, VASCO. "La prospettiva della rinascita e le sue
 origini." In Donatello e il suo tempo. Atti dell' VIII
 Convegno internazionale di studi sul rinascimento, 1966.
 Florence: Istituto nazionale di studi sul rinascimento,
 1968, pp. 131-54.
 Traces pre-Renaissance evolution of perspective, leading
 to a concept of perspective as part of realism of Renaissance.

515 SINDONA, ENIO. "Prospettiva e crisi nell'umanesimo." In La
 prospettiva rinascimentale: Codificazioni e trasgressioni.
 Edited by Marisa Dalai Emiliani. Florence: Centro Di,
 1980, pp. 95-124, 11 illus.
 Evolution of use of perspective, particularly as modified
 for expressive ends by Lippi and Uccello. Diagrams.

516 VAGNETTI, LUIGI, ed. "Quattrocento." In De naturali et
 artificiali perspectiva. Studi e documenti di architettura,
 9-10: Prospettiva. Florence: Edizione della cattedra di
 composizione architettonica I A di Firenze et della L.E.F.,
 1979, pp. 195-280, 6 illus.
 Useful reference tool, with brief introductory essay on
 theory and practice, including Brunelleschi, Alberti, and Piero.
 Followed by comprehensive annotated bibliography of writings
 arranged by subject matter: general works, sources, and indi-
 vidual artists.

517 VELTMAN, KIM. "Panofsky's Perspective: A Half Century
 Later." In La prospettiva rinascimentale: Codificazioni e
 trasgressioni. Edited by Marisa Dalai Emiliani. Florence:
 Centro Di, 1980, pp. 565-84, 10 illus.
 Reviews ideas of and reactions to Panofsky's essay
 on perspective as symbolic form (entry 512). Extensive
 bibliography.

518 WHITE, JOHN. The Birth and Rebirth of Pictorial Space. 2d
 ed. New York: Harper & Row, 1967, 289 pp., 155 illus.
 Studies changes and development of space 1200-1500. In-
 cludes chapters on the development of the theory of artificial
 perspective, on major artists, and on illusionism and perspec-
 tive. Index. Bibliography with references. See entry 499.
 Review: John Spencer, Art Bulletin 42, no. 3 (1960):225-28.

519 WIELEITNER, H. "Zur Erfindung der verschiedenen Distanz-
 konstruktionen in der malerischen Perspective." Repertorium
 für Kunstwissenschaft 42 (1920):249-62, 4 illus.

Mathematician's historical overview of perspective as
practiced in Renaissance. Describes, then discusses various
practitioners and critics. Does not find clear indications of
use of distance point in Italy until early sixteenth century.
See Panofsky's reply, entry 511.

520 WITTKOWER, R. "Brunelleschi, and 'Proportion in Perspec-
tive.'" Journal of the Warburg and Courtauld Institutes 16
(1953):275-91, 14 illus. [Reprinted in Ideas and Image:
Studies in the Italian Renaissance (London: Thames &
Hudson, 1978), pp. 125-36.]
Sees Renaissance perspective as including science of
proportions between different images. Considers Alberti's
visual pyramid, Piero's investigation of ratios of diminution,
and Leonardo. Applies ideas to Brunelleschi's architecture.
Diagrams.

See also entries 48, 193; sections on Alberti, Brunelleschi, and Piero.

PORTRAITS

521 ALAZARD, JEAN. "The Florentine Portrait before Leonardo."
In The Florentine Portrait. Translated by Barbara Whelpton.
London and Brussels: Nicholson & Watson, 1948, pp. 23-39,
13 illus.
Discusses works in various media and contexts, including
those by Castagno, Uccello, Piero, and Baldovinetti. Topics
include famous men, artists, profiles, and influence of medals.
Review: Louis Hourticq, Revue de l'art 1 (1926):248-53,
2 illus.

522 HATFIELD, RAB. "Five Early Renaissance Portraits." Art
Bulletin 47, no. 3 (1965):315-34, 23 illus.
Study of group of very similar profile portraits, which
represent a widely used type, seen as signifying a social
ideal. Suggests attributions to Domenico Veneziano, Domenico
di Bartolo, and Piero. Rejects authorship by Masaccio or
Uccello.

523 LIPMAN, JEAN. "The Florentine Profile Portrait in the
Quattrocento." Art Bulletin 18, no. 1 (1936):54-102, 42
illus.
Fundamental study of fifty examples in second half of
fifteenth century. Discusses historical context, genesis of
mode, and various aspects of style and format. Appendix with
catalog of most important examples.

524 MAMBOUR, JOSÉE. "L'évolution esthétique des profils
florentins du quattrocento." Revue belge d'archéologie et
d'histoire de l'art 38 (1969):43-60, 8 illus.

Portraits

Within survey of entire century (mostly later part), notes individualism of works of 1420-50, Gothicism in ones of 1450-70.

525 POPE-HENNESSY, JOHN. The Portrait in the Renaissance. Mellon Lectures in the Fine Arts, no. 12. Bollingen Series, 35. New York: Bollingen Foundation, 1966, 380 pp., 330 illus. [Distributed by Pantheon Books.]
Series of essays developed from lectures. Topics include fifteenth-century efforts to record viable likenesses; the impact of humanist thinking; and portraits of donors and participants.
Review: Creighton Gilbert, Burlington Magazine 110, no. 782 (1968):278-85.

526 PUDELKO, GEORG. "Florentiner Porträts der Frührenaissance." Pantheon 15 (March 1935):92-98, 6 illus.
Survey of fifteenth-century works. Sees origins of portrait in images of donors of fourteenth-century altarpieces. Discusses relation to Netherlandish School. English summary.

527 SCHAEFFER, EMIL. Das florentiner Bildnis. Munich: F. Bruckman, 1904, 237 pp., 102 illus.
Survey of types of portraits in Florentine art of ca. 1300-1600. Includes chapters on portraits in frescoes and in altarpieces, on profile portraits, and on rulers. Index of artists' names.

528 SLEPTZOFF, L.M. Men or Supermen? The Italian Portrait in the Fifteenth Century. Jerusalem: Magnes Press, Hebrew University, 1978, 159 pp., 49 illus.
Examines portraits of famous men, organized by categories of condottieri, citizens, philosophers, and artists. Concentrates on Florence, ca. 1430-1500. Sees evolution from general types to true realistic portraiture.
Review: Cecil H. Clough, Apollo 111, no. 215 (1980): 72-73.

SECULAR ART

529 BORENIUS, TANCRED. "Unpublished Cassone Panels: Parts V and VI." Burlington Magazine 41, no. 234 (1922):104-9, 3 illus.; no. 237 (1922):256-59, 1 illus.
Publishes two cassoni fronts with triumphs, Burns Collection. Attributes to Andrea di Giusto, first half of fifteenth century. Also discusses Florentine panel with scenes from life of Alexander, British Museum, ca. 1450.

530 COMSTOCK, HELEN. "Italian Birth and Marriage Salvers." International Studio 85, no. 352 (1926):50-59, 11 illus.

Publishes examples, particularly in American collections.
Includes works attributed to Masaccio and Boccati.

531 DAWSON, PENELOPE. "A Perplexing Panel in the Jacquemart-
 André Collection in Paris." Art Bulletin 30, no. 1
 (1948):67, 4 illus.
 Identifies subject of fifteenth-century panel as Pasiphae
 and the bull, rather than the rape of Europa.

532 DE NICOLA, GIACOMO. "Notes on the Museo Nazionale of
 Florence: VI and VII." Burlington Magazine 32, no. 182
 (1918):169-70, 4 illus.; 183 (1918):218-26, 4 illus.
 Criticizes Schubring, Cassoni (entry 549), for weaknesses
 in heraldic research and in identifying subjects. Cassone of
 ca. 1400 identified as illustration of story of Saladin, from
 Boccaccio's Decameron rather than story of Mattabruna. Part 7
 discusses another cassone, ca. 1416-7, illustrating feast of
 Saint John.

533 FRY, R[OGER] E. "Note on the Anghiari and Pisa Cassoni
 Panels." Burlington Magazine 22, no. 118 (1913):239.
 Comments on high quality of two panels in Lane Collec-
 tion, possibly attributable to Uccello.

534 GRUNDERSHEIMER, HERMANN. "Ein Cassone aus dem Kreise des
 Giovanni di Paolo." Pantheon 1 (March 1928):132-34, 4
 illus.
 Discusses work at Bottenweiser, Berlin. Subject identi-
 fied as story of Esther and Ahasuerus. Attributed to Sienese
 School, mid-fifteenth century.

535 HUELSEN, CH. "Di alcune nuove vedute prospettiche di Roma."
 Bullettino della Commissione archaeologica comunale di Roma
 39 (1911):3-22, 4 illus.
 Publishes works with views of Rome, including numerous
 cassone panels. Lists additional works, with details of Rome.
 Identifies specific buildings.

536 LACLOTTE, MICHEL. "'Une chasse' du quattrocento florentin."
 Revue de l'art 40-41 (1978):65-70, 14 b&w and 2 color illus.
 Decorative panel, Musée des Augustins, Toulouse, repre-
 senting a hunt with view of Florence in background. Dates ca.
 1450-70. Style close to Pesellino.

537 LEHMANN, HEINZ. "Une vue de la place Ognissanti à
 Florence." Gazette des beaux arts 15, no. 876 (1936):244-
 47, 4 illus.
 Scene on cassone panel, Schlossmuseum, Berlin, identified
 as Piazza Ognissanti, Florence, ca. 1450-75.

538 LOSS, ARCHIE K. "The 'Black Figure' in the Baltimore Copy
 of Piero della Francesca's Lost Ferrara Frescoes." L'arte 1
 (1968):98-106, 6 illus.

Secular Art

Identifies mounted black figure in <u>Battle Scene</u>, Walters
Gallery, Baltimore, as Saracen type from Legend of Roland, also
found in French manuscripts, particularly the <u>Grandes
chroniques de France</u>.

539 MATHER, FRANK JEWETT, Jr. "Three Florentine Furniture
 Panels: The Medici Desco, the Stibbert Trajan and the Horse
 Race of the Holden Collection." <u>Art in America</u> 8, no. 4
 (1920):148-59, 6 illus.
 Birth salver in New York Historical Society attributed to
Baldovinetti. Cassone in Stibbert Museum, Florence, seen as
designed by Castagno, ca. 1460. Cassone in Holden Collection,
Cleveland Museum of Art, attributed to school of Uccello.

540 _____. "Two Sienese Cassone Panels." <u>Art in America</u> 2, no.
 6 (1914):397-403, 2 illus.
 Cassone with <u>Story of Coriolanus</u>, in Otto Kahn Collec-
tion, New York, attributed to school of Vecchietta. Dates ca.
1460.

541 MISCIATTELLI, PIERO. "Cassoni senesi." <u>La Diana</u> 4, no. 2
 (1929):117-26, 34 illus.
 Surveys a variety of works. Mentions Vecchietta, Giovanni
di Paolo, Sassetta, and Sano di Pietro, along with numerous
later works.

542 MÜNTZ, E[UGENE]. "Les plateaux d'accouchées et la peinture
 sur meubles du XIVe and XVIe siècle." In <u>Monuments et
 memoires. L'académie des inscriptions et belles letters</u>.
 Vol. 1. Paris: Fondation Eugène Piot, 1894, pp. 203-32, 10
 illus.
 Overview of known birth salvers and cassoni, including
lists arranged by subject.

543 OFFNER, RICHARD. "Italian Pictures at the New York Histor-
 ical Society and Elsewhere. III." <u>Art in America</u> 8, no. 1
 (1919):7-14, 4 illus.
 Discusses two birth salvers from first half of fifteenth
century, which can be attributed only to anonymous masters.

544 PEARCE, STELLA MARY. "Costumi tedeschi e borgognoni in
 Italia nel 1452." <u>Commentari</u> 8, no. 4 (1957):244-47, 6
 illus.
 Analyzes costumes worn by figures in two cassoni,
Worcester Art Museum.

545 POPE-HENNESSY, JOHN, and CHRISTIANSEN, KEITH. "Secular
 Painting in Fifteenth-century Tuscany. Birth-trays, Cassone
 Panels, and Portraits." <u>Bulletin of the Metropolitan Museum
 of Art</u> 38, no. 1 (1980):1-64, 13 b&w and 45 color illus.
 Survey of nonreligious works in the museum's collection
and on long-term loan. Many details illustrated. Discussion
of style, dates, iconography, and literary sources.

546 RANKIN, WILLIAM, AND MATHER, FRANK JEWETT. "Cassone Fronts
 in American Collections." Burlington Magazine 9, no. 40
 (1906):288, 1 illus.; 10, no. 43 (1906):67-68, 1 illus.; 11,
 no. 50 (1907):131-32, 2 illus.; 11, no. 53 (1907):339-41, 2
 illus.
 Series of articles intending to publish all cassone
 panels and salvers in the United States. Lists in first in-
 stallment, and then describes in first and subsequent articles.
 Includes Pesellino's Six Triumphs of Petrarch, Gardner Collec-
 tion, Boston, dated a little before 1450, as well as other
 Florentine works.

547 SCHUBRING, PAUL. "Cassoni Panels in English Private Collec-
 tions." Burlington Magazine 22, no. 117 (1912):158-65, 2
 illus.; no. 118 (1913):196-202, 14 illus.; no. 120
 (1913):326-31, 5 illus.
 Discusses various panels, mostly mid-fifteenth century.

548 _____. "Cassoni Pictures in America." Art in America 11,
 no. 5 (1923):231-43, 8 illus.; no. 6 (1923):314-22, 4 illus.
 Includes two works by Dido Master, Jarves Collection, New
 Haven.

549 _____. Cassoni: Truhen und truhenbilder der italienischen
 Frührenaissance, ein Beitrag zur Profanmalerei im
 Quattrocento. 2d ed. 2 vols. Leipzig: Hiersemann, 1923,
 514 pp., 226 illus.
 Basic corpus of painted chests. For each, traces his-
 tory, sources, discusses subject. Illustrates and catalogs 959
 works. Numerous indices and appendices including a discussion
 of the shop book of Marco del Buono and Apollonio di Giovanni.

550 _____. "New Cassone Panels." Apollo 3, no. 17 (1926):250-
 57, 12 illus.; 5, no. 27 (1927):104-9, 14 illus.; no. 28
 (1927):154-59, 10 illus.
 Publishes cassoni in private collections discovered since
 publication of author's corpus (entry 549).

551 _____. "Neue cassoni." Belvedere 8, no. 6 (1929):176-79,
 10 illus.; 9, no. 7-8 (1930):1-3, 8 illus.
 Variety of works recently discovered, in private
 collections.

552 _____. "New Cassoni Paintings." Art in America 18, no. 5
 (1930):228-35, 4 illus.
 Publishes, among others, cassone in Nèmes Collection,
 Munich, illustrating story of Amphitryon, father of Hercules
 (Sienese, ca. 1460), and a birth salver in Munster illustrating
 the triumph of Chastity, associated with same school.

553 _____. "Two New 'Deschi' in the Metropolitan Museum."
 Apollo 6, no. 33 (1927):105-7, 2 illus.

Secular Art

> Publishes two wedding platters, ca. 1420, recently
> acquired by museum.

554 SPYCHALSKA-BOCZKOWSKA, ANNA. "Diana with Meleagros and
Actaeon. Some Remarks on a XV-Century Italian Cassone."
Bulletin du Musée national de Varsovie 9, no. 2 (1968):29-
36, 6 illus.
> Attributes panel from early fifteenth century to circle
of Mariotto di Nardo. Identifies figures of Meleagros and
Atalanta and interprets in terms of marriage symbolism.

555 TONGIORGI TOMASI, LUCIA. "Osservazioni su una tavola poco
nota raffigurante La presa di Pisa." Antichità pisane 2,
no. 2 (1975):11-18, 4 illus.
> Analyzes scene of capture of Pisa on cassone, National
Gallery of Ireland, Dublin, pendant to cassone with battle of
Anghiari. Unusual and original subject matter, based on actual
event of 1406, presented like a documentary. Accepts attribu-
tion to Uccello school.

556 WEISBACH, WERNER. "Eine Darstelling der letzten deutschen
Kaiserkrönung in Rom." Zeitschrift für bildende Kunst 24
(1913):255-66, 9 illus.
> Studies a cassone, Worcester Museum of Art, by a Sienese
master, showing the coronation of Frederick III.

See also entries 395, 419-24.

Artists

ALBERTI (1404-72)

Editions of Alberti's Treatise on Painting

557 ALBERTI, LEON BATTISTA. Della pittura. Edited by Luigi
 Mallé. Florence: Sansoni, 1950, 167 pp.
 Major critical edition of Italian text of Alberti's hu-
 manist treatise. Several essays in an introductory section
 discuss earlier theory, Alberti, and Florence, parallels to
 ancient poetry, the codifying of perspective, and the theoret-
 ical attitudes of Alberti. Appendixes on philological ques-
 tions and critical history. Bibliography, index.

558 _____. "Leon Battista Alberti's kleinere kunsttheoretische
 Schriften." Edited by Hubert Janitschek. In Quellenschriften
 für Kunstgeschichte. Edited by Rudolf Eitelberger. Vol.
 11. Vienna: Wilhelm Braumüller, 1877, 270 pp. Reprint.
 Osnabruck: Zeller, 1970.
 Italian texts of Alberti's treatises with German transla-
 tion. Extensive notes and appendixes on letter to Giovanni
 Francesco Marchini, on Massacio, and on codices. Index.

559 _____. On Painting. Translated with an introduction and
 notes by John R. Spencer. Rev. ed. New Haven and London:
 Yale University Press, 1966, 141 pp., 7 illus.
 Annotated translation made from Latin and Italian manu-
 scripts. Critical introduction with discussion of major con-
 cepts of treatise and its impact. List of manuscript sources,
 index.
 Review: Samuel Y. Edgerton, Jr., Art Bulletin 51, no. 4
 (1969):397-99.

560 _____. On Painting and Sculpture: The Latin Texts of De
 Pictura and De Statua. Edited by Cecil Grayson. London:
 Phaidon, 1972, 167 pp., 8 illus.

Alberti

Juxtaposes Latin text with English translation. Includes
comments on dating, textual, and art historical issues. Bib-
liography, including list of versions of texts. Appendix on
Alberti's work on painting and sculpture.
Review: John R. Spencer, Art Bulletin 55, no. 4
(1973):627-28.

561 ____. Opere volgari. Edited by Cecil Grayson. Vol. 3.
Bari: Gius. Laterza e figli, 1973, 439 pp.
Includes treatises De pictura and Elementi di pittura.
Latin and Italian texts are juxtaposed, page by page. Critical
notes at end of volume.

Books and Dissertations

562 BEHN, IRENE. Leone Battista Alberti als Kunstphilosoph.
Zur Kunstgeschichte des Auslandes, 85. Strassburg: Heitz,
1911, 141 pp.
Discussion of Alberti's philosophical attitudes. Chap-
ters on concept of beauty (Begriff des Schönen), on the artist,
and on the various media.

563 BORSI, FRANCO. "The Della Pittura and the De Statua." In
Leon Battista Alberti. Translated by Rudolf G. Carpanini.
Oxford: Phaidon, 1977, pp. 292-304, 28 illus. [Italian ed.
Milan: Electa editrice, 1975.]
Surveys Alberti's ideas, influence and relation to
Florentine culture. Bibliography, index, and anthology of
sources.
Review: Deborah Howard, Burlington Magazine 120, no. 902
(1978):321-22.

564 EDGERTON, SAMUEL Y., Jr. "Alberti's Optics." Ph.D. disser-
tation, University of Pennsylvania, 1965, 268 pp., 51 illus.
Studies Alberti's sources for treatise on painting; par-
ticularly those in medieval optics, on Alberti's perspective,
and on Alberti's color. Index and bibliography.

565 FLEMMING, WILLI. Die Begründung der modernen Ästhetik und
Kunstwissenschaft durch Leon Battista Alberti. Berlin and
Leipzig: B.G. Teubner, 1916, 126 pp.
Early study of fundamental tenets of Alberti's theory.
Sections on his aesthetic, his sources, and his significance.

566 GADOL, JOAN. "Leon Battista Alberti: The Renaissance of
Geometric Space in Art and Science." Ph.D. dissertation,
Columbia University, 1963, 419 pp., 31 illus.
Attempts to present a unified approach to Alberti's
achievements based on idea that mathematics and a mathematical
treatment of problems link his work in art, science, and human-
ism. Deals with writings related to art. Analyzes perspective

construction, theoretical background, and concepts of space in writing and architecture.

567 ____. Leon Battista Alberti: Universal Man of the Early Renaissance. Chicago and London: University of Chicago Press, 1969, 281 pp., 65 illus.
Attempts to deal with intellectual character of Alberti and his relationship to many facets of Renaissance culture. Presents his outlook as a unified one, based on a belief in a cosmic rational order, represented particularly by perspective.
Review: Cecil Grayson, Renaissance Quarterly 24, no. 1 (1971):51-53.

*568 GALANTIC, IVAN. "The Sources of Leon Battista Alberti's Theory of Painting." Ph.D. dissertation, Harvard University, 1969.
Source: entry 567.

569 MANCINI, GIROLAMO. Vita di Leon Battista Alberti. 2d ed. Florence: Carnessecchi, 1911, 531 pp.
Early biography of artist, originally published 1882. Includes chapter on his ideas on painting.

570 MICHEL, PAUL HENRI. Un ideal humain au XVe siècle: La pensée de L. B. Alberti. Paris: Société d'editions 'les belles' lettres, 1930, 649 pp.
Publication of dissertation for University of Paris on Alberti's attitudes concerning society, art, philosophy, and morality. Traces intermingled medieval and modern ideas. Index.

571 MÜHLMANN, HEINER. Ästhetische Theorie der Renaissance: Leon Battista Alberti. Bonn: Rudolf Habelt, 1981, 183 pp.
Publication of dissertation written for the University of Munich in 1968. Discusses early aesthetic theory, based primarily on Alberti's ideas on painting and architecture. Relates to rhetorical theory, history of philosophy.

572 SANTINELLO, GIOVANNI. Leon Battista Alberti: Una visione estetica del mondo e della vita. Facoltà di magistero dell'Università di Padova, 5. Florence: Sansoni, 1962, 311 pp.
A study of Alberti's thought and philosophy, as seen in his own writings. Traces development, discusses ideas on beauty and art. Appendix on relation to Niccolo Cusano. Bibliography. Index.

573 STOKES, ADRIAN. Art and Science: A Study of Alberti, Piero della Francesca and Giorgione. London: Faber & Faber, 1949, 75 pp., 24 illus.

Alberti

Essay on aesthetic of period through work of three
artists. Sees aspects of mathematics and poetry. Index,
bibliographical appendix.
 Review: A.T. Hopwood, Museums Journal 49, no. 11
(1950):282-83.

574 TOBIN, RICHARD. "Leon Battista Alberti: Ancient Sources
 and Structure in the Treatises on Art." Ph.D. dissertation,
 Bryn Mawr, 1979, 249 pp.
 Studies relation of Alberti's writing to existing ancient
 texts. Sees Alberti's goal as raising artists to cultural
 parity with intellects of antiquity. Finds sources especially
 in Aristotle's Rhetorica and Cicero's Orator.

Articles

575 ACKERMAN, JAMES S. "Alberti's Light." In Studies in Late
 Medieval and Renaissance Painting in Honor of Millard Meiss.
 Edited by Irving Lavin and John Plummer. New York: New
 York University Press, 1977, pp. 1-27, 3 illus.
 Discusses Alberti's theories of optics, particularly the
 visual pyramid, as related to light, shadow, and color. Sees
 ideas as derived from medieval sources, providing link between
 art and natural science.

576 ARRIGHI, GINO. "Leon Battista Alberti e le scienze esatte."
 In Convegno internazionale indetto nel V centenario di Leon
 Battista Alberti. Problemi attuali di scienza e di cultura,
 quaderno n. 209, yr. 371. Rome: Accademia nazionale dei
 lincei, 1974, pp. 155-212.
 Examines passages in Alberti's writing dealing with math-
 ematics, physics, and engineering. Includes extracts from
 Della pitura and Elementi di pittura.

*577 _____. "Il 'modo optimo' dell'Alberti per la costruzione
 prospettica." Phisis 14, no. 3 (1972):295-98.
 Source: entry 516.

578 BARELLI, EMMA. "'Sister Acts' in Alberti's 'Della
 Pittura.'" British Journal of Aesthetics 19, no. 3
 (1979):251-62.
 Investigates analogies between painting and literature as
 described by Alberti.

579 BAXANDALL, MICHAEL. "Alberti and Cristoforo Landino: The
 Practical Criticism of Painting." Convegno internazionale
 indetto nel V centenario di Leon Battista Alberti. Problemi
 attuali di scienza e di cultura, quaderno n. 209, yr. 371.
 Rome: Accademia nazionale dei lincei, 1974, pp. 143-54, 4
 illus.

Sees Landino's remarks on artists in commentary to Dante as reflecting Alberti's opinions.

580 BIRKMEYER, K. "Leon Battista Alberti and Jan van Eyck on the Origin of Painting." Italian Quarterly 2, no. 2 (1958):35-54, 6 illus.
Parallels experiences of Alberti and Jan to illustrate Renaissance nature of latter. Finds idea of confrontation of image, of painting as mirror of nature, in both.

581 BLUNT, Sir ANTHONY. "Alberti." In Artistic Theory in Italy 1450-1600. Oxford, London, and New York: Clarendon Press, 1940, pp. 1-22, 2 illus.
Provides fundamental introduction to Alberti's theories for the general reader. Also includes brief bibliography and index.

582 BOLTEN, JAAP. "Ut Grammatica Pictura. A Method of Learning." In Ars auro prior: Studia Ioanni Bialostocki sexagenario dedicata. Warsaw: Panstwowe Wydawnictwo Naukowe, 1981, pp. 71-74, 2 illus.
Relation between theories of drawing and writing in Alberti and later thinkers. Alberti's ancient sources.

583 CAMERON, ERIC. "The Depictional Semiotic of Alberti's On Painting." Art Journal 35, no. 1 (1975):25-28.
Interprets Alberti's ideas in terms of semiotic theory, to give them more relevance to contemporary artists.

584 CLARK, KENNETH. "Leon Battista Alberti on Painting." Proceedings of the British Academy 30 (1944):283-302, 8 illus.
Background on Alberti and introduction to his philosophy and major concepts of his treatise. Indicates its direct influence on Uccello and Piero.

585 CORSANO, A. "Motivi della civiltà umanistica e rinascimentale. I. Il trattato Della pittura di Leon Battista Alberti." Atti della accademia pontaniana 1 (1947-48):181-85.
Passages in Della pittura that reveal Alberti's humanist and modern attitudes towards art and the role of the artist.

586 DAMISCH, HUBERT. "Le dit du peintre. En marge du Livre I du Della pittura de Leon Battista Alberti." In La prospettiva rinascimentale: Codificazioni e trasgressioni. Edited by Marisa Dalai Emiliani. Firenze: Centro Di, 1980, pp. 409-15.
Examines Alberti's theoretical point of view in relation to ancient materialism, and also as a practitioner of painting.

Alberti

587 EDGERTON, SAMUEL Y., Jr. "Alberti's Colour Theory: A Medi-
 eval Bottle Without Renaissance Wine." Journal of the
 Warburg and Courtauld Institutes 32 (1969):109-34.
 Demonstrates that Alberti's color theory is deeply rooted
 in medieval and Aristotelian ideas. Outlines various compo-
 nents of theory and concludes that not entirely successful.

588 _____. "Alberti's Perspective: A New Discovery and a New
 Interpretation." Art Bulletin 48, no. 3-4 (1966):367-78, 19
 illus.
 Reexamines Alberti's perspective, particularly regarding
 placement of distance point. Discusses ideas of Grayson and
 Panofsky (entries 593 and 602). Interprets as artistic rather
 than scientific device, based on older workshop practices,
 particularly the bifocal scheme. Many diagrams.

589 GAMBUTI, ALESSANDRO. "Nuove ricerche sugli Elementa
 picturae." Studi e documenti di architettura 1
 (December 1972):133-72, 53 illus.
 Puts into graphic form, by means of numerous diagrams,
 the exercises outlined by Alberti in treatise on elements of
 painting. Juxtaposes relevant Latin and Italian texts. Com-
 ments on significance of Alberti's theoretical approach.

590 GILBERT, CREIGHTON E. "Antique Frameworks for Renaissance
 Art Theory: Alberti and Pino." Marsyas 3 (1943-45):87-106.
 Interprets Alberti's On Painting as paralleling organiza-
 tion of ancient isagogic treatises, as exemplified by Horace's
 Art of Poetry. Contrasts with different point of view in
 Pino's Dialogue on Painting (1548). Appendix of Pino's Renais-
 sance sources.

591 GOMBRICH, E[RNST] H. "A Classical Topos in the Introduction
 to Alberti's Della pittura." Journal of the Warburg and
 Courtauld Institutes 20 (1957):173.
 Sees sources for Alberti's praise of Brunelleschi in
 Della pittura in writings of the younger Pliny and even earlier
 in a Greek epigram on Homer.

592 GRAYSON, C[ECIL]. "A Portrait of Leon Battista Alberti."
 Burlington Magazine 96, no. 615 (1954):177-79, 1 illus.
 Publishes drawing, in manuscript of Tranquillità
 dell'animo, Biblioteca Nazionale, Rome, with full-length con-
 temporary portrait of Alberti. Suggests that perhaps a self-
 portrait.

593 _____. "L.B. Alberti's 'costruzione legittima.'" Italian
 Studies 19 (1964):14-27, 4 illus.
 Attempts to clarify perspectival construction described
 by Alberti by examining Latin, rather than Italian versions of
 the text. Deals particularly with placing and importance of

distance point. Discusses editing and correcting of text by
Ferrarese friar Battista Panetti.

594 _____. "Studi su Leon Battista Alberti II: Appunti sul
testo Della pittura." Rinascimento 4, no. 1 (1953):54-62.
Observations on Italian text of On Painting, as published
by Mallé (entry 557). Comparisons to Latin version, and
arguments in favor of latter's priority.

595 _____. "The Text of Alberti's De Pictura." Italian Studies
23 (1968):71-92, 1 diag.
Reviews and compares Latin and Italian versions of the
text of treatise on painting. Juxtaposes sections to point out
discrepancies, notes problematic nature of Latin version.

596 KATZ, M. BARRY. "Humanistic Concepts of Painting and
Alberti." In Evolution général et developpements regionaux
en histoire de l'art. Actes du XXII Congrès international
d'histoire de l'art, 1969. Vol. 2. Budapest: Akdémiai
Kiadó, 1972, pp. 529-34.
Interprets Alberti's Della pittura as an effort to paral-
lel painting with historiography, thus making it a part of the
humanistic disciplines.

597 KRAUTHEIMER, RICHARD and KRAUTHEIMER-HESS, TRUDE. "Ghiberti
and Alberti." In Lorenzo Ghiberti. 2d ed. Princeton:
Princeton University Press, 1970, pp. 315-34.
Discusses Alberti's ideas, especially in Della pittura,
as reflected in Ghiberti's work.

598 MAIORINO, GIANCARLO. "Linear Perspective and Symbolic Form:
Humanistic Theory and Practice in the Work of L.B. Alberti."
Journal of Aesthetics and Art Criticism 34, no. 4
(1976):479-86.
Relationship of Alberti's system of linear perspective
and of his concept of virtù in Della famiglia, both seen as
representing exemplary patterns.

599 MALLÉ, LUIGI. "Appunti albertiani in margine al Della
pittura." In Studi in onore di Giusta Nicco Fasola. Arte
lombarda 10 (1965):211-230.
Includes sections considering reflections of Della
pittura in various works in Florence, on the ideas of the
treatise extending into Alberti's De re aedificatoria, on its
relation to Alberti's moral treatises, and on its ideas as
reflected in Alberti's own architecture.

600 MALTESE, CORRADO. "Colore, luce e movimento nello spazio
albertiano." Commentari 28, no. 3-4 (1976):238-47, 5 illus.
Reexamines Alberti's theories of perspective, composi-
tion, and color and light as the foundation for a dynamic
method of representation rather than a static one.

Alberti

601 _____. "La traité De la peinture de Léon-Baptiste Alberti: Version latine et version vulgaire." Revue des études italiennes 8, no. 1 (1961):80-91.
Problems mostly concerning the dating of existing manuscripts of the treatise, which derive from both Latin and Italian originals.

602 PANOFSKY, E[RWIN]. "Das perspektivische Verfahren Leone Battista Albertis." Kunstchronik 26, no. 41-42 (1915):504-16, 7 illus.
German translation of Alberti's description of perspective presented parallel to Italian text. Discusses and presents reconstruction of method of "costruzione legittima" that is now widely accepted. Emphasizes importance of Alberti's ideas for Renaissance artists. Rejects idea that Alberti using distance point construction.

603 PARRONCHI, ALESSANDRO. "La 'costruzione legittima' è uguale alle 'costruzione con punti di distanza.'" Rinascimento 4 (1964):35-40.
Reads Latin texts of Alberti's De pittura as indicating identity of two phrases. Postulates that Alberti's "little space" was part of a single construction process, rather than a separate operation.

604 _____. "Due note: I: Postilla alla 'costruzione legittima.'" Rinascimento 8 (1968):351-56, 6 illus.
Response to Dalai (entry 493) regarding precise nature of Alberti's perspective system. Illustrates sixteenth-century drawing, Casa Buonarroti, Florence, as proof of interpretation of method.

_____. "Leon Battista Alberti as Painter." See entry 1623.

605 _____. "L'operazione del 'levare dalla pianta' nel trattatello albertiano De pittura." Rinascimento 16 (1976):207-12, 4 illus.
Different processes used in projecting profile views and ground plans, as referred to in Alberti's text. Comments on Grayson's edition of treatise (entry 560) and on Brunelleschi's role in the invention of perspective.

606 _____. "Prospettiva e pittura in Leon Battista Alberti." In Convegno internazionale indetto nel V centenario di Leon Battista Alberti. Problemi attuali di scienza e di cultura, quaderno n. 209, yr. 371. Rome: Accademia nazionale dei lincei, 1974, pp. 213-29, 28 illus.
Postulates alternative method of perspective, called by author "intersected construction," using central vertical axis. Presents various examples.

607 _____. "Sul significato degli Elementi di pittura di L.B.
Alberti." Cronache di archeologia e di storia dell'arte 6
(1967):107-15.
Shows closeness of Elementi di pittura to treatise on
painting. Aligns practical operations outlined in former with
"costruzione legittima" defined in latter.

*608 PICCHIO-SIMONELLI, M. "On Alberti's Treatises on Art and
Their Chronological Relationships." Italian Studies Annual
(Toronto) 1 (1971):75-102.
Source: entry 516.

609 PITTALUGA, M[ARY]. "Massacio e L.B. Alberti." Rassegna
italiana (1929):779-90.
Sees direct references to Massacio in Alberti's writing.

610 PROCACCINI, ALFONSO. "Alberti and the 'Framing' of Perspec-
tive." Journal of Aesthetics and Art Criticism 40, no. 1
(1981):29-39.
Sees perspective as representative of ideology of fif-
teenth century and as the factor leading to the theory of the
autonomy of a work of art.

611 SPENCER, JOHN R. "Ut Rhetorica Pictura: A Study in
Quattrocento Theory of Painting." Journal of the Warburg
and Courtauld Institutes 20 (1957):26-44.
Considers relationships between theory of painting in the
fifteenth century, particularly in Alberti, and theory of Roman
oratory as advanced by Cicero. Parallels ideas, forms.

612 STAIGMÜLLER, H. "Kannte Leone Battista Alberti den
Distanzpunkt?" Repertorium für Kunstwissenschaft 14
(1891):301-4, 3 illus.
Believes Alberti not using distance-point construction.
Rejects ideas of Janitschek (entry 558).

613 VENTURI, LIONELLO. "La critique d'art en Italie à l'époque
de la renaissance. I. Léon-Battista Alberti." Gazette des
beaux arts 5, no. 728 (1922):321-31, 4 illus.
Introduction to Alberti's ideas in treatise on painting.

614 VESCO, GIACOMO. "Leon Battista Alberti e la critica d'arte
in sul principio del rinascimento." L'arte 22 (1919):57-71,
95-104, 136-48.
Discusses Alberti's ideas in a wide ranging context that
includes earlier theorists and later critics of Alberti.

615 WAKAYAMA, EIKO M.L. "Teoria prospettica albertiana e
pittura del quattrocento." In Il Sant'Andrea di Mantova e
Leon Battista Alberti. Atti del convengo, Mantua, 1972.
Mantua: Edizione della Biblioteca Communale di Mantova,
1974, pp. 175-88, 9 illus.

Alberti

Reconstructs Alberti's perspective from a practical point of view, emphasizing importance of position of observers. Diagrams.

616 WATKINS, RENÉE. "Note on the Parisian Ms. of L.B. Alberti's Vernacular <u>Della</u> <u>pittura</u>." <u>Rinascimento</u> 6, no. 2 (1955):369-72.
 Sees early sixteenth century manuscript as probably independent of Florentine manuscript published by Mallé, because includes unique passages.

617 WESTFALL, CARROLL W. "Painting and the Liberal Arts: Alberti's View." <u>Journal</u> <u>of</u> <u>the</u> <u>History</u> <u>of</u> <u>Ideas</u> 30, no. 4 (1969):487-506.
 Attempts to interpret Alberti's theory in context of humanist thought of ca. 1400-35. Discusses ideas other than practice of perspective and sees painting presented as a liberal art, related to virtue as were other liberal arts.

618 WOLFF, GEORG. "Zu Leon Battista Albertis Perspektivlehre." <u>Zeitschrift</u> <u>für</u> <u>Kunstgeschichte</u> 5 (1936):47-54, 12 illus.
 Sees Alberti's perspective system as found in his writing as fundamental to later systems of Dürer and Leonardo. Diagrams.

619 ZOUBOV, V.P. "Léon-Battista Alberti et Léonard de Vinci." <u>Raccolta</u> <u>vinciana</u> 18 (1960):1-14.
 Finds analogies in Leonardo's writing with <u>De</u> <u>pictura</u> and asserts that Leonardo had read it.

<u>GIULIANO</u> <u>AMEDEI</u> (act. 1446-after 1470)

620 SALMI, MARIO. "Piero della Francesca e Giuliano Amedei." <u>Rivista</u> <u>d'arte</u> 24 (1942):26-44, 12 illus.
 Attributes parts of Piero's San Sepolcro altarpiece (mostly in predella) to Amedei.

<u>ANDREA</u> <u>DI</u> <u>GIUSTO</u> (act. 1427-55)

621 HADELN, DETLEV VON. "Andrea di Giusto und das dritte Predellenstück vom pisanischen Altarwerk des Massacio." <u>Monatshefte</u> <u>für</u> <u>Kunstwissenschaft</u> 1, no. 9 (1908):785-89, 3 illus.
 Attributes panel with scenes of Saints Julian and Nicholas, Staatliches Museum, Berlin, to Andrea di Giusto.

FRA ANGELICO (ca. 1400-1455)

Books and Dissertations

622 ARGAN, GIULIO CARLO. Fra Angelico. Translated by James
 Emmons. Taste of Our Time, 10. Skira: Lausanne, 1955, 127
 pp., 49 color illus.
 Survey of life, critical tradition, and aesthetic of
 artist, with emphasis on spiritual aspects and relation to
 Thomist views. Discussion of works organized into altarpieces,
 frescoes, and lost pieces. Selected bibliography, index of
 names with biographical notices.
 Review: Ives Bonnefoy, Critique d'art (1956):133-41.

623 BALDINI, UMBERTO. Beato Angelico. Bergamo: Istituto
 italiano d'arti grafiche, 1964, 107 pp., 20 b&w and 36 color
 illus.
 Overview of career, written in a fairly general style.

624 BALDINI, UMBERTO, and MORANTE ELSA. L'opera completa
 dell'Angelico. Classici dell'arte, 38. Milan: Rizzoli,
 1970, 119 pp., approx. 300 b&w and 44 color illus.
 Full-scale monograph, with brief introduction to artist,
 followed by excerpts of critical writings, essential bibliogra-
 phy, chronology of documents and detailed catalog of works,
 completely illustrated. Sections on attributed works and works
 known from sources. Index.

625 BANTI, ANNE. Fra Angelico. Milan: Sidera, 1953, 17 pp., 9
 b&w and 34 color illus.
 Folio-sized book of very large color plates of fairly
 good quality. Very brief introductory text.

626 BARGELLINI, PIERO. La pittura ascetica del beato Angelico.
 Rome: Del Turco, 1949, 273 pp., 90 b&w and 4 color illus.
 Monograph with emphasis on spiritual aspects of Fra
 Angelico's art and on historical context.

627 BAZIN, GERMAIN. Fra Angelico. Translated by Marc Logé.
 Paris: Hyperion Press, 1949, 185 pp., 149 b&w and 16 color
 illus.
 Brief introductory essay discussing as Christian human-
 ist, monk, artist, iconographer, and master of a workshop.
 Notes on individual plates.
 Review: Creighton Gilbert, Journal of Aesthetics and Art
 Criticism 9, no. 1 (1950):63.

628 BEISSEL, STEPHAN. Fra Angelico: Seine Leben und seine
 Werke. 2d ed. Freiburg im Breisgau: Herder'sche
 Verlagshandlung, 1905, 140 pp., 94 illus.
 Early monograph, originally published in 1895, with
 chapters on major periods of artist's life, on influences, on

Fra Angelico

paintings of the Last Judgment as related to Dante, and on
images of Mary. Bibliography.

629 BERING, KUNIBERT. "Fra Angelico: Ein Maler der florentiner
Frührenaissance." Ph.D. dissertation, Ruhr-Universität,
Bochum, 1978, 143 pp.
Provides survey of works and bibliography.

630 BERTI, LUCIANO. Fra Angelico. Translated by Pearl Sanders.
London and New York: Thames & Hudson, 1968, 40 pp., 5 b&w
and 85 color illus. [Italian ed. Florence: Sadea editore,
1967.]
Brief text covering life, works, critical opinions, and
notes on the plates.

631 BERTI, LUCIANO; BELLARDONI, BIANCA; AND BATTISTI, EUGENIO.
Angelico a San Marco. Naples: Armando Curcio, 1965, 165
pp. plus text accompanying 133 color plates, 5 b&w illus.
Lavish book dealing with all aspects of Angelico's rela-
tion to S. Marco, including sections on frescoes and panel
paintings, the institution, the Dominican order, and Angelico's
relation to the society of his time. Appendixes on bibliogra-
phy, chronology, biographies of Giovanni Dominici and Saint
Antonine, and on other frescoes in convent.

632 BROUSSOLE, J.-C. La critique mystique et Fra Angelico.
Paris: H. Oudin, 1902, 175 pp.
Essay concerning the widespread interpretation of Fra
Angelico as a Saint portraying visions, rather than an artist.
Proposes to show his greatness as an artist. Considers his
development, his technique, and his naturalism.
Review: Jules Helbig, Revue de l'art chrétien 14, no. 3
(1903):197-200.

633 CARDILE, PAUL JULIUS. "Fra Angelico and his Workshop at San
Domenico (1420-35): The Development of his Style and the
Formation of his Workshop." Ph.D. dissertation, Yale Uni-
versity, 1976, 574 pp.
Studies decorative program for artist's community in
Fiesole. Considers both Angelico as organizer of shop and the
role of assistants, especially Zanobi Strozzi, Battista di
Biagio Sanguigni, and Giovanni di Gonsalvo da Portogallo.
Transcribes documents.

634 CIRAOLO, CLARA, and ARBIB, BIANCA MARIA. Il beato Angelico:
La sua vita e le sue opere. Bergamo: Istituto italiano
d'arti grafiche, 1925, 65 pp., 117 illus.
Includes biography and chronological survey of works.
Catalogs works by location. Provides brief bibliography,
index, and ample illustrations.
Review: B. Serra, L'arte 28 (1925):226-27.

635 CIUTI, PIO. Il beato Angelico. Florence: Vallecchi, 1940,
 374 pp., 25 illus.
 Monograph emphasizing artist as Saint, beginning with
 chapter on his soul, and then reviewing his life and work.

636 COCHIN, HENRY. La bienheureux Fra Angelico de Fiesole. 6th
 ed. Paris: Librairie Victor Lecoffre, 1919, 293 pp.
 Monograph, first published in 1906, emphasizing religious
 character of Fra Angelico's art. Bibliography.

637 COLE, DIANE ELYSE. "Fra Angelico: His Role in Quattrocento
 Painting and Problems of Chronology." Ph.D. dissertation,
 University of Virginia, 1977, 657 pp., 73 illus.
 Reevaluates artist's activity before 1440. Discusses
 documentary and historical evidence, surveys bibliography,
 reassesses chronology, and proposes corpus of early works.
 Sees artist as progressive. Catalogue raisonnée up to 1440.
 Appendix on lost early works and appendix of documents, some
 new.

638 DOUGLAS, R. LANGTON. Fra Angelico. 2d ed. London: George
 Bell & Sons, 1902, 223 pp., 74 illus.
 Fundamental early study of Fra Angelico, first published
 1900, emphasizing his modern Renaissance character, particu-
 larly his interest in nature and classical art. Appendices
 concerning artistic influence, the S. Marco choirbooks, and
 architectural forms in Annunciation, Cortona. Documents,
 bibliography, and indexes.

639 FROSALI, SERGIO. L'Angelico. Florence: Libreria editrice,
 1965, 148 pp., 122 b&w and 16 color illus.
 Discussion of artist's background and development. Itin-
 erary of works, organized by location. Brief bibliography.

640 GRECO, ANTONELLA. La cappellà di Niccolo V del beato
 Angelico. Rome: Istituto poligrafico e zecco dello stato,
 Libreria dello stato, 1980, 91 pp., 31 b&w and 10 color
 illus.
 Study of project, including critical history and review
 of Angelico's life. Provides large amount of supportive mate-
 rial, including sources and documents, profiles of important
 historical figures, chronological table (1402-55), and bibliog-
 raphy and indexes.

641 HAUSENSTEIN, WILHELM. Fra Angelico. Translated by Agnes
 Blake. New York: E.P. Dutton & Co.; London: Methuen,
 1928, 126 pp., 65 illus. [German ed. Munich: K. Wolff,
 1923.]
 Overview with historical background and survey of works.

642 HERTZ, ANSELM. Fra Angelico. Freiburg: Herder, 1981, 189
 pp., 65 b&w and 65 color illus.

Fra Angelico

Lavishly illustrated monograph. Two chapters on context of Angelico's art, followed by survey of major works. Chronological chart. Brief bibliography.

643 MARCHESE, VINCENZO. S. Marco, convento dei padri predicatori di Firenze. Florence: Presso la società artistica, 1853, 167 pp., 44 illus.
Large volume with engraved illustrations. Includes survey of Fra Angelico's life and list of his works, in history of convent and its contents.

644 MURATOFF, PAUL Fra Angelico. Translated by E. Law-Gisiko. London and New York: Frederick Warne & Co., 1930, 93 pp., 296 illus.
Originally written in Russian. Introduction attempting to define artist's place in evolution of Italian art. Many illustrations with some comparative material.

645 ORLANDI, STEFANO. Beato Angelico. Florence: Olschki, 1964, 250 pp., 64 b&w and 1 color illus.
Complete modern monograph with long bibliography, chapters covering artist's career, his followers, and his drawings. Documents, lists of works described and not described, and index.
Review: Creighton Gilbert, Art Bulletin 47, no. 2 (1965):273-74. See also entry 682.

646 PAPINI, ROBERTO. Fra Giovanni Angelico. Bologna: Casa editrice Apollo, 1925, 61 pp., 60 illus.
Monograph dealing with biography of artist, essence of his art, and works in chronological order. Sees as representative of transition between Gothic and Renaissance.

647 PICHON, ALFRED. Fra Angelico. Paris: Librairie Plon, 1912, 208 pp., 24 illus.
Monograph discussing career and work. Chapters organized by geographic location of each period in career. Chronological table, catalog of works by location, bibliography, and index.

648 POPE-HENNESSY, JOHN. Angelico. Florence: Scala, 1974, 79 pp., 88 color illus.
Lavish color illustrations in a glossy book. Reviews career. Selected bibliography.

649 _____. Fra Angelico. 2d ed. Ithaca, N.Y.: Cornell University Press, 1974, 248 pp., 260 b&w and 15 color illus.
Expands and revises monograph first published in 1952. Introductory discussion of career and artistic development. Catalog of works with scholarly analysis. Catalogs of attributed works, of drawings, and of lost works. Geographical index.

Review: Miklós Boskovitz, Paragone 27, no. 313
(1976):30-54, 23 illus. See also entry 687.

650 PROCACCI, UGO. Beato Angelico al museo di San Marco a
 Firenze. Milan: Silvana, 1972, 95 pp., 12 b&w and 28 color
 illus.
 Brief Italian text surveying career, interpreting artist
 as mystic. Summaries in French, English, and German. Very
 large color plates of panels and frescoes in S. Marco.

651 ROME. VATICAN. Mostra delle opere di Fra Angelico nel
 quinto centenario della morte, 1455-1955. Contributions by
 Luciano Berti, Deoclecio Redig de Campos, Umberto Baldini,
 and Anna Maria Francini Ciaranfi. Introduction by Mario
 Salmi. 3d ed. Rome: Palazzo apostolico vaticano, 1955,
 289 pp., 111 illus.
 Catalog of major international loan exhibition including
 sixty works by Fra Angelico and thirty-seven others by Andrea
 di Giusto, Zanobi Strozzi, Domenico di Michelino, and Battista
 Sanguigni. Important scholarly entries, sections on fresco
 cycles in Rome, Florence, and Orvieto. Chronological
 bibliography.
 Review: Licia Collobi Ragghianti, Critica d'arte 2, no.
 10 (1955):389-94, 12 illus. Reply by Mario Salmi, Commentari
 7, no. 1 (1956):3-8, 207; 8, no. 1 (1957):14-16.

652 ROTHES, WALTER. Die Darstellungen des Fra Giovanni Angelico
 aus dem Leben Christi und Mariae: Ein Beitrag zur
 Ikonographie der Kunst des Meisters. Zur Kunstgeschichte
 des Auslandes, 12. Strassburg: Heitz, 1902, 47 pp., 24
 illus.
 Study of Angelico's imagery in relation to earlier repre-
 sentations, mostly from the trecento, of lives of Christ and
 Virgin.

653 SALMI, MARIO. Il beato Angelico. Spoleto: Edizioni valori
 plastici, 1958, 127 pp., 123 b&w and 4 color illus.
 Monograph with introduction surveying artist's career,
 brief chronology, bibliography, survey of sources, and critical
 opinions. Lists of works, lost works, and attributed works.
 Full comments on the plates, which include details.

654 SCHNEIDER, ÉDOUARD. Fra Angelico da Fiesole. Les maîtres
 du moyen age et de la renaissance, 1. Paris: Albin Michel,
 1933, 175 pp., 103 illus.
 Surveys career and works. Appendices on drawings, chron-
 ology, and lists of accepted works and doubtful ones. Bibliog-
 raphy, index.

655 SCHOTTMÜLLER, FRIDA. Fra Angelico da Fiesole. Des Meisters
 Gemälde. Klassiker der Kunst, 18. Stuttgart and Leipzig:
 Deutsche Verlagsanstalt, 1924, 298 pp., 359 illus.

Fra Angelico

Brief essay introducing large assemblage of photographs, including many details. Chronological list of works. Geographical and subject indexes.

656 SERAFINI, ANGELO. L'epopea cristiana nei dipinti di beato Angelico, con appendice di documenti tratti dall'archivio dell'opera di Orvieto. Orvieto: Tip. M. Marsili, 1911, 129 pp., 5 illus.
Monograph emphasizing Angelico's work in Orvieto, but discussing his earlier career as well. Section on historical context, survey of works. Long section of sixty-three documents pertaining to projects in Orvieto 1446-49.

657 SORTAIS, GASTON. Le maître et l'élève: Fra Angelico and Benozzo Gozzoli. Lille and Paris: Société Saint-Augustin, Desclée, De Brouwer & Co., 1905, 275 pp., 47 b&w and 5 color illus.
A double monograph with separate bibliography, catalog of principal works, and discussion for each artist. Sees two as representing same spirit. Includes chapters that consider spiritualism and naturalism, and the Florentine environment.

*658 STERLING, [M.] Die Entwicklung der Komposition in den Werken des Fra Giovanni Angelico da Fiesole. Zurich: Aschmann & Scheller, 1920, 68 pp.
Source: entry 38, and Répertoire d'art et archéologie (1922). Dissertation written for University of Freiburg.

659 STRUNK, INNOCENZ M. Fra Angelico aus dem Dominikanerorden. 3d ed. Munich: Gladbach, 1916, 176 pp., 132 b&w and 1 color illus.
Monograph with works organized partly by commissioning bodies: Dominicans, non-Dominicans, and nonmonastic groups. Final section collects representations of artist in later art. Bibliography, indexes, and plan of S. Marco.

660 TAURISANO, INNOCENTO. Beato Angelico. Rome: Palombi, 1955, 218 pp., 80 b&w and 2 color illus.
Monograph concerned primarily with historical circumstances, particularly activities of various religious groups (primarily Dominican) with which artist associated. Relatively brief descriptions of works, often in terms of exemplification of Dominican ideas. Frequent references to material in archives of various institutions. Includes essay on historical opinions of artist, bibliography, index, and list of works.

661 TUMIATI, DOMENICO. Frate Angelico. Florence: Roberto Paggi, 1897, 256 pp.
Overview of career, chronologically organized. Attention to earlier scholars. Notes various influences on artist.

662 URBANI, GIOVANNI. Beato Angelico. Verona: Arnaldo
Mondadori, 1957, 214 pp., 162 illus.
Monograph with rather brief and general text accompanying
numerous photographs. Makes reference to recent scholarship.
Attempts to define artist in relation to varying trends of the
early quattrocento.

663 WURM, ALOIS. Meister- und Schülerarbeit in Fra Angelicos
Werk. Zur Kunstgeschichte des Auslandes, 13.
Strassburg: Heitz, 1907, 54 pp., 4 illus.
Attempt to separate hand of Angelico from that of his
students. Divides career into three periods and analyzes indi-
vidual works.

Articles and Booklets

664 AHL, DIANE COLE. "Fra Angelico: A New Chronology for the
1430s." Zeitschrift für Kunstgeschichte 44, no. 2
(1981):133-58, 19 illus.
Revision of chronology, based on documents published by
W. Cohn and S. Orlandi in the 1950s (entries 645, 684-5).
Dates a number of important works, some of which have been
dated later, to this period. Discusses relation to Ghiberti
and emphasizes Fra Angelico's predominance in the decade.

665 _____. "Fra Angelico: A New Chronology for the 1420s."
Zeitschrift für Kunstgeschichte 43, no. 4 (1980):360-81, 22
illus.
Reconstructs artist's early activity, discussing large-
scale panel paintings. Emphasizes influence of Massacio and
Gentile da Fabriano and notes Fra Angelico's receptivity to
progressive ideas.

666 ALEXANDER, MARY. "The Sculptural Sources of Fra Angelico's
Linaiuoli Tabernacle." Zeitschrift für Kunstgeschichte 40,
no. 2 (1977):154-163, 12 illus.
Postulates specific sculptural sources for shutter fig-
ures of Linaiuoli tabernacle, S. Marco Museum, Florence, par-
ticularly in figures done for the Duomo facade by Piero di
Giovanni Tedesco in the fourteenth century.

667 ARGAN, GIULIO CARLO. "La tradizione critica intorno
all'Angelico." In Saggi e lezioni sull'arte sacra. Rome:
Istituto beato Angelico di studi per l'arte sacra, 1944,
pp. 65-79.
Reviews attitudes to painter's art from Vasari to early
twentieth century, noting vacillations in emphasis between
mysticism and naturalism.

Fra Angelico

668 BALDINI, UMBERTO. "Contributi all'Angelico: La predella
 della pala di San Marco e l'armadio per gli argenti della
 SS. Annunziata." Commentari 7, no. 2 (1956):78-85, 6 illus.
 Technical observations on predella panels of S. Marco
 altarpiece, confirming that seven go together and postulating
 original order. Also suggests regrouping of scenes of Life of
 Virgin, S. Marco Museum, Florence, into two sportelli rather
 than four.

669 _____. "Contributi all'Angelico: Il trittico di San
 Domenico di Fiesole e qualche altra aggiunta." In Scritti
 di storia dell'arte in onore di Ugo Procacci. Milan:
 Electa, 1977, pp. 236-46, 15 illus.
 Study of recently restored triptych (1428-30). Defines
 Lorenzo di Credi's later contributions. Publishes Lorenzo
 Monaco's Saints on frame. Also publishes Crucifixion, S.
 Niccolo del Ceppo, Florence, and three other panels that may
 have formed a triptych. Diagrams, X-rays, and details.

670 BERTI, LUCIANO. "Un foglio miniato dell'Angelico."
 Bollettino d'arte 47, no. 2-3 (1962):207-15, 12 b&w and
 1 color illus.
 Miniature page with Crucifixion, Convento di S. Trinità,
 Florence, ca. 1438.

671 _____. "Miniature dell'Angelico (e altro). Acropoli 2, no.
 4 (1961-62):277-308, 10 b&w and 11 color illus.; 3, no. 1
 (1963):1-38, 9 b&w and 15 color illus.
 Study of Missal 558 in the S. Marco Museum, Florence,
 generally attributed to Fra Angelico. Attributes illuminations
 to two hands: master and an assistant, probably Zanobi Strozzi,
 ca. 1430.

672 BERTINI-CALOSSO, ACHILLE. Il beato Angelico e la pittura
 umbra. Nozze Buffa di Perrero-Visconti. Spoleto: 1940, 24
 pp., 3 illus.
 Pamphlet with general essay suggesting examples of in-
 fluence of Fra Angelico on Umbrian works. Mentions Bonfigli,
 several anonymous works of 1450s, Angelico's altarpiece for S.
 Domenico in Perugia, and works by other Florentines who might
 have communicated his ideas.

673 BIAGETTI, BIAGIO. "Una nuova ipotesi intorno alla cappella
 di Niccolo V nel Palazzo Vaticano." Atti della pontificia
 accademia romana di archeologia 4 (1933):205-14.
 Reviews information regarding payments made for Angelico's
 work in Vatican. Dissociates payment of 1451 from Chapel of
 Nicholas V.

674 BODKIN, THOMAS. "A Fra Angelico Predella." Burlington
 Magazine 58, no. 337 (1931):183-94, 9 illus.

Reconstruction of predella of S. Marco altarpiece. Lists six panels with stories of Cosmas and Damian, establishes an order, and affirms attribution of all six.

675 BONSANTI, GIORGIO. "Preliminari per l'Angelico restaurato." Arte cristiana 71, no. 694 (1983):25-34, 18 illus.
 Reports on cleaning of first-floor frescoes of S. Marco. Distinguishes Angelico's hand from assistants in a variety of locations.

676 BORENIUS, TANCRED. "A Fra Angelico for Harvard." Burlington Magazine 39, no. 224 (1921):209-10, 3 illus.
 Crucifixion, dated ca. 1449-53, Fogg Art Museum, Cambridge. Includes Dominican monk identified as Juan de Torquemada.

677 BOSKOVITZ, MIKLÒS. Un'adorazione dei Magi e gli inizi dell'Angelico. Monographien der Abegg-Stiftung Bern, 11. Bern: Abegg-Stiftung, 1976, 63 pp., 51 b&w and 2 color illus.
 Study of painting in Fondazione Abegg, Riggisberg. Dates just after 1423. Proposes earlier dates for other works of Angelico, in attempt to define his unknown early style. Adds some new attributions.

678 _____. "La fase tarda del beato Angelico: Una proposta di interpretazione." Arte cristiana 71, no. 694 (1983):11-24, 16 illus.
 Discusses artist's style after mid-1430s. Notes influence of Flemish painting and of Saint Antonine, who was probably important for design of S. Marco fresco cycle. Publishes two tabernacle shutters, private collection, an octagonal panel with head of Christ, private collection, and a Crucifixion, location unknown.

679 BRUNETTI, GIULIA. "Una vacchetta segnata A." In Scritti di storia dell'arte in onore di Ugo Procacci. Milan: Electa, 1977, pp. 228-35, 2 illus.
 Publishes parish register of 1430-47 for chapel in SS. Annunziata, Florence (now in Biblioteca Marucelliana, Florence). Includes inventory of 1439 with possible reference to Fra Angelico Christ, Sta. Maria del Soccorso, Livorno.

680 CASALINI, EUGENIO. "L'Angelico e la cateratta per l'armadio degli argenti alla SS. Annunziata di Firenze." Commentari 14, no. 2-3 (1963):104-24, 4 illus. [Reprinted in La SS. Annunziata di Firenze (Florence: Convento della SS. Annunziata, 1971), 1:27-47.]
 Reconstructs arrangement of panels for silver chest, as single shutter that dropped down from above. Separates out Fra Angelico's contribution. Dates after 1450.

Fra Angelico

681 CENCI, PIO. "Il beato Angelico e le cappelle private dei
 Papi nel Palazzo apostolico." In Saggi e lezioni sull'arte
 sacra. Rome: Istituto beato Angelico di studi per l'arte
 sacra, 1944, pp. 53-64.
 Traces history of two small rooms decorated by Fra
 Angelico, one of them destroyed.

682 CENTI, TIMOTEO M. "Sulla nuova cronologia dell'Angelico."
 Bollettino dell'Istituto storico artistico orvietano 19-20
 (1963-64):91-100.
 Criticizes new chronology for Fra Angelico presented in
 Orlandi's monograph (entry 645). Demonstrates alternative
 readings of various documents.

683 CHIARINI, MARCO. "Nota sull'Angelico." Arte antica e
 moderna 11 (July-September 1960):278-81, 2 illus.
 Various elements in early style of Angelico. Takes par-
 ticular note of Gentile's influence on Madonna in Van Beuningen
 Collection, Vierhouten (now Rotterdam, Boymans-Van Beuningen
 Museum).

684 COHN, WERNER. "Il beato Angelico e Battista di Biagio
 Sanguini: Nuovi documenti." Rivista d'arte 30 (1955):
 207-16.
 Publishes new document, indicating Fra Angelico's entry
 into Compagnia di S. Niccolo di Bari in 1417 under a lay name,
 therefore not yet invested as a Dominican. Also publishes
 information about miniaturist Battista di Biagio Sanguini.

*685 _____. "Nuovi documenti per il beato Angelico." Memorie
 domenicane 73 (1956):218-20.
 Documents. Reprinted in Orlandi (entry 645).

686 COLE, DIANE E[LYSE]. "Fra Angelico—A New Document."
 Mitteilungen des kunsthistorischen Institutes in Florenz 21,
 no. 1 (1977):95-100.
 Publishes document locating artist in Cortona in 1438 and
 including full patronymic. Allows dating of portal fresco, S.
 Domenico, in 1438, and of triptych no later than 1438.

687 COLLOBI-RAGGHIANTI, LICIA. "Studi angelichiani." Critica
 d'arte 2, no. 7 (1955):22-47, 36 illus.
 Critique of Pope-Hennessy's monograph (entry 649) par-
 ticularly in regard to early period of Angelico, before 1428.
 Comments on other attributions. Also discusses various attri-
 butions to Zanobi Strozzi.

688 DELLAMORA, RICHARD J. "The Revaluation of 'Christian Art':
 Ruskin's Appreciation of Fra Angelico 1845-60." University
 of Toronto Quarterly 43, no. 2 (1974):143-50.

Discusses Ruskin's changing presentation of Fra Angelico, from early praise of artist for religious devotion to later rejection for lack of social concern.

689 FAUCON, MAURICE. "L'oeuvre de Fra Angelico a Rome." L'arte 35 (1883):141-47, 167-75, 7 illus.
 Study of Angelico's work principally for Pope Nicholas V. Influence of Roman environment on his work. Stylistic analysis.

690 GENGARO, MARIA LUISA. Il beato Angelico a S. Marco. Bergamo: Istituto italiano d'arti grafiche, 1944, 10 pp., 41 illus.
 Very brief introduction describing style and general character of Fra Angelico. Large, clear black-and-white plates of S. Marco frescoes.

691 GIBOULOT, GENEVIÈVE. "Le rationalisme pictural de Fra Angelico." Revue d'esthétique 9, no. 2 (1956):166-81, 11 illus.
 Analysis of Angelico's compositions and the varying types of movement in them. Compares to music. Emphasizes artist's rational concept of universe. Diagrams.

692 GILBERT, CREIGHTON. "Fra Angelico's Fresco Cycles in Rome: Their Number and Dates." Zeitschrift für Kunstgeschichte 38, no. 3-4 (1975):245-65, 2 illus.
 New analysis of documents relating to Fra Angelico in Rome. Concludes that four fresco cycles were executed in Vatican and St. Peter's from 1446 to 1449.

693 GLASER, CURT. "The Louvre Coronation and the Early Phase of Fra Angelico's Art." Gazette des beaux arts 22, no. 910 (1942):149-64, 9 illus.
 Examines early works in relation to art of the period, to refute the current undervaluation of artist's position. Emphasizes new features of Louvre Coronation, defines particular character of artist's realism.

694 GÓMEZ-MORENO, CARMEN. "A Reconstructed Panel by Fra Angelico, and Some New Evidence for the Chronology of his Work." Art Bulletin 39, no. 3 (1957):183-93, 12 illus.
 Associates two fragments: Madonna, Rijksmuseum, Amsterdam, and panel of an Angel, Wadsworth Atheneum, Hartford. Traces development in use of light in artist's works and chronological evolution of decorative motifs in haloes. Dates reconstructed panel ca. 1438-40.

695 HULFTEGGER, ADELINE. Le Couronnement de la Vierge: Fra Angelico. Paris: Vendôme, 1947, 22 pp., 23 b&w and 8 color illus.

Fra Angelico

Well-illustrated pamphlet examining Coronation, Louvre,
ca. 1430. Discusses earlier representations of theme and works
by Angelico's contemporaries.

696 KRAUTHEIMER, RICHARD. "Fra Angelico and--perhaps--Alberti."
 In Studies in Late Medieval and Renaissance Painting in
 Honor of Millard Meiss. Edited by Irving Lavin and John
 Plummer. New York: New York University Press, 1977, pp.
 290-96, 6 illus.
 Sees, in three of Fra Angelico's scenes in Chapel of
 Nicholas V, Vatican, reflections of ideas from the rebulding
 project for St. Peter's. Most fully developed in Ordination of
 St. Stephen. Suggests Alberti'a participation in St. Peter's
 project of late 1440s.

697 LADIS, ANDREW T. "Fra Angelico: Newly Discovered Documents
 from the 1420s." Mitteilungen des kunsthistorischen
 Institutes in Florenz 25, no. 3 (1981):378-79.
 Publishes document of 1425 with commission for altar to
 be done by an unnamed artist, probably Fra Angelico.

698 LLOYD, CRISTOPHER. Fra Angelico. Phaidon Colour Plate
 Series. Oxford and New York: Phaidon Press, E.P. Dutton,
 1979, 16 pp., 48 color illus.
 Brief introductory essay, selected bibliography, and
 outline biography, to supplement large color illustrations
 of high quality.

699 LONGHI, ROBERTO. "Un dipinto dell'Angelico a Livorno."
 Pinacotheca 1, no. 3 (1928):153-59, 5 illus.
 Christ Crowned with Thorns, Sta. Maria del Soccorso,
 Livorno. Lengthy argument regarding attribution. Considers
 other images of same subject.

700 MAIONE, ITALO. "Fra Giovanni Dominici e beato Angelico."
 L'arte 17 (1914):281-89, 361-68, 11 illus.
 Analysis of Angelico's works as reflection of Dominican
 ideals. Examines S. Marco frescoes, with comparisons to Giotto.

701 MANTZ, PAUL. "Fra Angelico da Fiesole." Gazette des beaux
 arts 1, no. 3 (1859):193-206, 3 illus.
 Introduction to artist, character of his work, and prog-
 ress of his career. Emphasizes religious feeling.

702 MATHER, FRANK JEWETT, Jr. "Two Unpublished Fra Angelicos."
 Art in America 22, no. 3 (1934):92-95, 1 illus.
 Madonna and St. John, recently acquired by Princeton
 University Art Museum, attributed to Fra Angelico, ca. 1425.

703 MESSINI, ANGELO. "In traccia del beato Angelico a Foligno."
 Rivista d'arte 24 (1942):70-73.

Considers possibility of Fra Angelico's presence in
Foligno ca. 1410-14, with group of Dominican monks from
Fiesole.

704 MIDDELDORF, U[LRICH]. "L'Angelico e la scultura."
 Rinascimento 6, no. 2 (1955):179-194, 19 illus. [Reprinted
 in Raccolta di scritti [Collected Writings], vol. 2.
 (Florence: Studio per edizioni scelte, 1980), pp. 183-99.]
 Discusses many examples of influence of Ghiberti on Fra
 Angelico. Considers figure style, architectural background,
 and other details.

705 MÜNTZ, EUG[ÈNE]. "Un document inédit sur Fra Angelico."
 Chronique des arts, no. 18 (1876):163-4. [Reprinted in
 La nazione, 16 May 1876.]
 Extracts from registers of 1447-58 regarding Fra
 Angelico's activities in Rome.

*706 NICCO-FASOLA, G[IUSTA]. "Architettura nell'opera del beato
 Angelico." In Saggi e lezioni. Rome: Istituto beato
 Angelico di studi per l'arte sacra, 9 (1938).
 Source: entry 640.

707 ORLANDI, STEFANO. "Il beato Angelico." Rivista d'arte 29
 (1954):161-97. [Also printed in Memorie domenicane 72
 (January-March 1955):3-37.]
 Numerous new documents. Reviews and corrects earlier
 published documents. Establishes artist's date of birth ca.
 1400 and determines other dates in his biography. Sets up
 chronology of his works.

708 PACCHIONI, GUGLIELMO. "Gli ultimi anni del beato Angelico."
 L'arte 12 (1909):1-14, 7 illus.
 Study of frescoes in Chapel of Nicholas V, Vatican, and
 in Duomo, Orvieto. Historical and iconographical overview.

709 PADOA RIZZO, ANNA. "Nota breve su Colantonio, Van der Wyden
 e l'Angelico." Antichità viva 20, no. 5 (1981):15-17, 4
 illus.
 Fra Angelico's Deposition, S. Marco Museum, Florence,
 seen as source for Roger's Passion tapestries, and in turn for
 Colantonio's Deposition, S. Domenico Maggiore, Naples, ca.
 1455-60. English summary.

710 PAPINI, ROBERTO. "Riguardo al soggiorno dell'Angelico in
 Roma." L'arte 13 (1910):138.
 Notes a document indicating Angelico was finishing work
 in Rome in June 1449. Hypothesizes that he left with Gozzoli.

711 PARRONCHI, ALESSANDRO. "Due pale dell'Angelico per due
 conventi." Commentari 12, no. 1 (1961):31-37, 4 illus.

Fra Angelico

[Reprinted in Studi su la dolce prospettiva (Milan: Martelli, 1964), pp. 429-36.]
Reassignment of two altarpieces that author believes to have been confused by critics. One from S. Francesco al Bosco and the other from Convento di Annalena, now both in S. Marco Museum, Florence.

712 PERKINS, F. MASON. La Deposizione, beato Angelico. Florence: Electa editrice, 1948, 47 pp., 46 illus.
Brief introduction to plates, dating ca. 1435-40. Photographs of every possible detail of altarpiece.

713 PICAVET, CAMILLE GEORGES. "Note sur un tableau de Fra Angelico: La Roue symbolique." Mélanges d'archéologie et d'histoire 25, no. 3-4 (1905):329-38, 1 illus.
Iconographic study of Wheel, Galleria Antica e Moderna (now S. Marco Museum). Arrangement based on Ezekiel and Saint Gregory, with Fra Angelico's own modifications.

714 PICHON, ALFRED. "Une Annonciation nouvelle de Fra Angelico." Revue de l'art ancien et moderne 31, no. 178 (1912):35-50, 7 illus.
Attribution of work in convent of Montecarlo, ignored or disputed by earlier scholars. Compares to other Annunciations by artist.

715 PITORY, ROBERT. "Fra Angelico da Fiesole und Til Riemenschneider: Eine Studie zur Kunstlerpsychologie des ausgehenden Mittelaltars." Walhalla 8 (1912):173-213, 5 illus.
Fra Angelico as an example of the contemplative spirit, in contrast to active Til Riemenschneider.

716 P[OGGI], G[IOVANNI]. "L'Annunziazione del beato Angelico a S. Francesco di Montecarlo." Rivista d'arte 6, no. 2 (1909):130-32, 1 illus.
Rarely published work. Affirms attribution to Fra Angelico.

717 REDIG DE CAMPOS, DEOCLECIO. "Di una presunta immagine del beato Bonaventura da Padova dipinta dall'Angelico in Vaticano." In Miscellaneo Pio Paschini. Vol. 2. Rome: N.p., 1949, pp. 157-64, 4 illus.
Discusses figure of Saint beside door in Chapel of Nicholas V. Originally painted as Saint Jerome, changed into Saint Bonaventure in sixteenth century.

718 SALMI, MARIO. "Problemi dell'Angelico." Commentari 1, no. 2 (1950):75-81, 13 illus.; no. 3 (1950):146-56, 32 illus.
Concentrates on three unsettled issues: formation of artist, chronology, and collaboration of disciples. Discusses

a variety of specifics. Includes early miniatures, works of Starnina, Gozzoli, and others.

719 SEIDEL, CURT. "Fra Angelico." Arte e storia 31, no. 12 (1912):361-62.
 Essay on emotional qualities of Angelico's art and its unique features.

720 URBANI, GIOVANNI. "Angelico, Frate." In Encyclopedia of World Art. Vol. 1. London: McGraw Hill, 1959, col. 437-46, 10 b&w and 7 color illus.
 Outlines life, emphasizes chronology of works, with some attention to aspects of style. Distinguishes hands of assistants. Bibliography.

721 VALOIS, NOEL. "Fra Angelico et le Cardinal Jean de Torquemada." Société nationale des antiquaires de France, centenaire 1804-1904: Recueil de memoires (1904):461-70, 1 illus.
 Identifies portrait of donor in Crucifixion (formerly Timbal Collection, now Fogg Museum, Cambridge) as Cardinal Juan de Torquemada, a Spanish Dominican. Dates painting ca. 1447.

722 VAUGHAN, HERBERT M. "Fra Angelico (1387-1455)." In Studies in the Italian Renaissance. New York: E.P. Dutton; London: Methuen, 1930, pp. 241-60.
 Interprets artist as a "spiritual reactionary" parallel to Savonarola. Differentiates from contemporaries.

723 VENTURI, ADOLFO. "Beato Angelico e Benozzo Gozzoli." L'arte 4 (1901):1-29, 22 illus.
 Characterizes art of two masters and postulates areas where Gozzoli's hand is evident in Fra Angelico's works, particularly in Orvieto and Rome.

724 _____. "Un disegno del beato Angelico." L'arte 34, no. 3 (1931):244-49, 1 illus.
 Discusses and rejects five drawings commonly attributed to Angelico. Only assigns study for Deposition, Fabra Collection, Barcelona.

725 WINGENROTH, MAX. "Beiträge zur Angelico-Forschung." Repertorium für Kunstwissenschaft 21 (1898):335-45, 427-38.
 Discusses Fra Angelico's position in early quattrocento, with reference particularly to writings of Tumiati (entry 661). Attributes various manuscripts to artist.

726 WURM, ALOIS. "Eine Alternative in Sachen Fra Angelico." Zeitschrift für christliche Kunst 23 (1910):7-14, 4 illus.
 Questions attributions of Madonna and Saints, Palazzo Pitti, Florence (now S. Marco Museum), and Madonna and Saints, S. Domenico, Fiesole.

Fra Angelico

727 _____. "Fra Angelicos Linajuolitafel und die Krönung in den
Uffizien." Zeitschrift für christliche Kunst 24 (1911):149-
54, 3 illus.
 Identifies areas of shopwork in these two works.

728 WYZEWA, T[HEODOR] DE. "Fra Angelico au Louvre et la légende
dorée." Revue de l'art ancien et moderne 16, no. 92
(1904):329-40, 6 illus.
 Sees detailed fidelity to descriptions in Golden Legend
in various predella panels by artist.

ANGELO DEL MACCAGNINO (act. 1447-56)

729 BEENKEN, HERMANN. "Angelo del Maccagnino und das Studio von
Belfiore." Jahrbuch der preussischen Kunstsammlungen 61
(1940):147-62, 13 illus.
 Attributes group of works to an Angelo del Maccagnino and
asserts that they are Sienese, not Ferrarese, and relate to
works known from descriptions in Belfiore, near Ferrara, done
before 1449. Compares to Domenico di Bartolo.

730 GOMBOSI, GEORG. "A Ferrarese Pupil of Piero della Francesca."
Burlington Magazine 62, no. 359 (1933):66-78, 7 illus.
 Makes attributions to Angelo di Pietro da Siena, also
known as Angelo Parrasio or Maccagnino, a Sienese working in
Ferrara 1447-56.
 Letter: Kenneth Clark, Burlington Magazine 62, no. 360
(1933):142-43, 4 illus.

ANTONIO DA FIRENZE (act. mid-fifteenth century)

731 FIOCCO, GIUSEPPE. "Chi fu Antonio da Firenze." Arte veneta
11 (1957):35-38, 5 illus.
 Attempts to reconstruct artist's career. Attributes St.
Anthony Hermit mosaic, S. Marco, Venice, 1458.

732 SCERBACIOVA, MARIA. "Un dipinto di Antonio da Firenze
all'Ermitage." Arte veneta 11 (1957):29-34, 6 illus.
 Attributes Madonna and Saints with Crucifixion on back,
ca. 1480. Notes influence of Castagno and Venetian art.

733 ZERI, FEDERICO. "Antonio da Firenze: Un'aggiunta e un
ridimensionamento." Paragone 11, no. 123 (1960):50-57, 1
illus.
 Discusses problem of reconstructing career of Antonio da
Firenze. Believes not active in Venice. Comments on Fiocco's
ideas (entry 731). Attributes standard in Berenson Collection.

APOLLONIO DI GIOVANNI (1415 or 1417-65)

Book and Dissertation

734 CALLMANN, ELLEN. "Apollonio di Giovanni." Ph.D. disserta-
tion, New York University, 1970, 307 pp., 137 illus.
 Discusses work and workshop of Florentine cassone
painter. Attempts to establish method for attributing panels
to the shop. Includes catalogue raisonnée, appendixes of doc-
uments and rejected works, and bibliography.

735 _____. Apollonio di Giovanni. Oxford: Clarendon
Press, 1974, 111 pp., 274 b&w and 1 color illus.
 Examines nearly 200 cassone panels and manuscripts. Cat-
alogue raisonnée, appendixes of documents, lists of rejected
works, bibliography, and index. Illustrations include many
details.
 Review: Luisa Vertova, Burlington Magazine 118, no. 880
(1976):523-24.

Articles

736 ANDERSON, BARBARA BERNHARD. "A Cassone Puzzle Recon-
structed." Museum Studies, [Art Institute of Chicago] 5
(1970):22-30, 7 illus.
 Proposes that a cassone, Art Institute of Chicago,
once decorated same chest as two cassoni in Ashmolean Museum,
Oxford, and National Gallery, Edinburgh. Together group repre-
sents founding of Rome. Maintains attribution to Apollonio de
Giovanni, ca. 1465.

737 CALLMANN, ELLEN. "An Apollonio di Giovanni for an Historic
Marriage." Burlington Magazine 119, no. 888 (1977):174-81,
8 illus.
 Proposes that panel in Indiana University Art Museum,
Bloomington, with two putti on dolphins, decorated the inside
of a cassone lid. Connects to 1461 commission for marriage
between Pazzi and Borromei families.

738 GOMBRICH, E[RNST] H. "Apollonio di Giovanni: A Florentine
Cassone Workshop Seen through the Eyes of a Humanist Poet."
Journal of the Warburg and Courtauld Institutes 18
(1955):16-34, 34 illus. [Reprinted in Norm and Form:
Studies in the Art of the Renaissance. (London: Phaidon,
1966), pp. 11-28, 140-43.]
 Identifies artist with Virgil Master and examines the
sources of his style. Subjects chosen discussed in context of
Florentine humanism. Appends extracts from poet Ugolino Verino.

Apollonio di Giovanni

739 STECHOW, WOLFGANG. "Marco del Buono and Apollonio di
 Giovanni: Cassone Painters." Bulletin of the Allen
 Memorial Art Museum, Oberlin 1, no. 1 (1944):1-23, 9 illus.
 Associates a number of cassone panels with shop of two
 artists, including recently acquired panel depicting a battle
 between Athenians and Persians.

740 WATSON, PAUL F. "Apollonio di Giovanni and Ancient Athens."
 Bulletin of the Allen Memorial Art Museum, Oberlin 37, no. 1
 (1979-80):3-25, 17 illus.
 Analyzes iconography of cassone panel illustrating
 Xerxes' Invasion of Greece and its relation to contemporary
 Florence humanist ideas.

 ARCANGELO DI COLA (act. 1416-29)

741 BERENSON, BERNARD. "Missing Pictures by Arcangelo di Cola."
 International Studio 93, no. 386 (1929):21-25, 8 illus.
 Publishes several paintings, locations unknown, in hope
 of discovering their whereabouts. Reprinted: entry 88,
 pp. 13-19, 8 illus.

742 COLASANTI, ARDUINO. "Nuovi dipinti di Arcangelo di Cola da
 Camerino." Bollettino d'arte 15, no. 12 (1922):539-45, 6
 illus.
 Attributes Madonnas in private collection, Berlin, and
 Stroganoff Collection, St. Petersburg. Reviews career and
 style of artist.

743 CONSTABLE, W.G. "An Umbrian Puzzle." Pantheon 3 (January
 1929):26-28, 3 illus.
 Attributes Madonna, Woodward Collection, London, to
 Arcangelo di Cola da Camerino rather than Pietro di Domenico da
 Montepulciano. Suggests that it copies a lost Gentile da
 Fabriano.

744 DE NICOLA, GIACOMO. "Di alcuni dipinti del Casentino."
 L'arte 17 (1914):257-64, 6 illus.
 Examines several unpublished works, with emphasis on
 attribution of Madonna in Prepositura, Bibbiena, to Arcangelo
 di Cola.

745 L[ONGHI], R[OBERTO]. "Arcangelo di Cola: Un pannello con
 la Sepoltura di Cristo." Paragone 1, no. 3 (1950):49-50, 2
 illus. [Reprinted in Fatti di Masolino e di Massacio e
 altri studi sul quattrocento (Florence: Sansoni, 1975),
 pp. 85-86.]
 Attribution of work, location unknown, ca. 1424-26.

746 PROCACCI, UGO. "Una nuova opera di Arcangiolo di Cola da
 Camerino." Rivista d'arte 11 (1929):359-61, 1 illus.
 Attributes Madonna and Angels, Openheim Collection,
 Vienna. Rejects earlier attribution to Fra Angelico.

747 ____. "Il soggiorno fiorentino di Arcangiolo di Cola."
 Rivista d'arte 11 (1929):119-27.
 Documents of 1420-22 concerning activity in Florence.

748 SANTONI, M. "Un trittico bruciato di Arcangelo di Cola da
 Camerino." Nuova rivista misena 3, no. 12 (1890):187-88.
 Describes recently destroyed triptych from Monastero
 dell'Isola, Cessapalombo. Signed and dated 1425.

749 VENTURI, A[DOLFO]. "Di Arcangelo di Cola da Camerino."
 L'arte 13 (1910):377-81, 4 illus.
 Attributes three works to Arcangelo. Reasserts attribu-
 tion of frescoes, Oratory, Riofreddo.

750 ZERI, FEDERICO. "Arcangelo di Cola da Cameriino: Due
 tempere." Paragone 1, no. 7 (1950):33-38, 2 illus.
 Attributes triptych, Città del Messico, and Madonna of
 Humility, Museum, Ancona. Attempts to clarify style and devel-
 opment of artist.

751 ____. "Opere maggiori di Arcangelo di Cola." Antichità
 viva 8, no. 6 (1969):5-15, 14 illus.
 Attributes two panels of Saints, National Gallery,
 Prague, and five panels with Miracles of Saint Zenobius,
 Galleria Estense, Modena. Also reconstructs a group of works
 by an anonymous Florentine of early fifteenth century, close to
 Arcangelo and Masolino. Suggests possible identification with
 Giuliano d'Arrigo, called Pesello.

 ALESSO BALDOVINETTI (1425-99)

Books

752 KENNEDY, RUTH WEDGWOOD. Alesso Baldovinetti: A Critical
 and Historical Study. New Haven: Yale University Press,
 1938, 259 pp., 171 illus.
 Thorough study of multiple aspects of Baldovinetti's art.
 Establishes a chronology. Bibliographic material in footnotes.
 Ample illustrations, including details. Chronological table,
 transcription of Riccordi, and index.
 Review: E. Wilder, Art Bulletin 21, no. 1 (1939):95-96.

753 LONDI, EMILIO. Alesso Baldovinetti: Pittore fiorentino.
 Florence: Alfani & Venturi, 1907, 102 pp., 23 illus.

Alesso Baldovinetti

> Early monograph on artist, dealing with his career in
> three periods: 1425-50, 1450-70, and 1470-99. Appendix with
> Libri di ricordi. Bibliography.

754 POGGI, GIOVANNI, ed. I ricordi di Aleso Baldovinetti.
Florence: Libreria editrice fiorentina, 1909, 53 pp., 2
illus.
Gathers documents of 1449-99 relating to Baldovinetti,
including entries from his own ledgers (books A & B), and items
from other sources. Chronology of his life.

Articles

755 BAGNESI-BELLINCINI, PIERO. "Pitture d'Alessio Baldovinetti
nella Cappella de' Gianfigliazzi in Santa Trinità."
Miscellanea d'arte 1, no. 3 (1903):50-52.
Publishes documents of 1470-1472.

756 BERENSON, B[ERNHARD]. "Alessio Baldovinetti et la nouvelle
Madone du Louvre." Gazette des beaux arts 20, no. 493
(1898):39-54, 8 illus. [Reprinted as "Alessio Baldovinetti
and the new 'Madonna' of the Louvre," in The Study and
Criticism of Italian Art, 2d ser. (London: G. Bell & Sons,
1920), pp. 23-38.]
Rejects attribution of Duchatel Madonna, Louvre, to
Piero. Gives to Baldovinetti. Reviews known and generally
accepted works by latter. Compares to Domenico Veneziano, who
may have been his master.

757 BOECK, WILHELM. "Ein Profilbildnis von Alesso Baldovinetti."
Pantheon 10 (September 1932):288-90, 1 illus.
Publishes and attributes portrait, private collection,
Berlin. English summary.

758 CASALINI, EUGENIO. "Culto ed arte all'Annunziata nel'400:
Il Crocifisso dei Bianchi; il Crocifisso del Baldovinetti;
due statue di terracotta del sec. XV." In La SS. Annunziata
di Firenze: Studi e documenti sulla chiesa e il convento.
Vol. 2. Florence: Chiesa della SS. Annunziata, 1978, pp.
11-60, 30 illus.
Publishes little-studied objects in the Villani Chapel,
including a painted Crucifixion that attributes to Baldovinetti.

759 CAVALLUCCI, C.J. "Il tempio di San Giovanni in Firenze."
Arte e storia 7, no. 6 (1888):41-43.
Includes mention of Baldovinetti's lost mosaic above door
of S. Giovanni, 1452-55, and his restoration of other works.
Includes documents of 1480s and 1490s.

760 CUST, LIONEL. "A Portrait by Alessio Baldovinetti(?) at
Hampton Court Palace." Apollo 7, no. 37 (1928):26-27, 1
color illus.

Alesso Baldovinetti

Publishes work, reviews critical opinions, and associates a group of portraits with Baldovinetti.

761 FABRICZY, C[ORNELIUS] V[ON]. "Aus dem Gedenkbuch Francesco Baldovinettis." Repertorium für Kunstwissenschaft 28 (1905):539-44.
 Transcription of passages written about Baldovinetti and his family, by relative who lived 1477-1545.

_____. "Urkundliches zu den Fresken Baldovinettis und Castagno's in S. Maria de' Servi a Florenz." See entry 890.

762 FRY, ROGER. "On a Profile Portrait by Baldovinetti." Burlington Magazine 18, no. 96 (1911):311-13, 1 illus.
 Attributes profile of a woman, National Gallery, London, to Baldovinetti, rather than Piero. Notes style, color, and technique.

763 GIGLIOLI, ODOARDO H. "La cappella del Cardinale di Portogallo nella chiesa di San Miniato al Monte e le pitture di Alesso Baldovinetti." Rivista d'arte 4, no. 5-6 (1906):89-99, 3 illus.
 Documents of 1466-73 establishing that paintings in chapel certainly by Baldovinetti.

764 _____. "Una pittura sconosciuta di Alesso Baldovinetti nella Chiesa di San Marco a Firenze." Rassegna d'arte 7, no. 2 (1907):26-28, 2 illus.
 Publishes Crucifixion, similar to one for Sta. Trinità.

_____. "Le pitture di Andrea del Castagno e di Alessio Baldovinetti per la chiesa di Sant'Egidio." See entry 901.

765 GRILLI, GOFFREDO. "Le pitture attribuiti ad Alessio Baldovinetti in San Miniato al Monte a Firenze." Rivista d'Italia 6, no. 1 (1903):156-65, 3 illus.
 Supports attribution of works in Chapel of Cardinal of Portugal to Baldovinetti, rather than to Piero Pollaiuolo.

766 HARTT, FREDERICK; CORTI, GINO; and KENNEDY, CLARENCE. The Chapel of the Cardinal of Portugal 1434-1459, at San Miniato in Florence. Philadelphia: University of Pennsylvania Press, 1964, 192 pp., 152 b&w and 4 color illus.
 Study of various aspects of the chapel's construction and decoration primarily based on documentary material. Deals with architecture, tomb by Rossellino shop and painting, primarily by Baldovinetti. Documents, bibliography, and index.
 Review: Martin Warnke, Zeitschrift für Kunstgeschichte 30, no. 2-3 (1967):257-63.

767 HORNE, HERBERT P. "A Newly Discovered Altarpiece by Alesso Baldovinetti." Burlington Magazine 8, no. 31 (1905):51-59, 3 illus.

Alesso Baldovinetti

Publishes painting commissioned 1469-70 for Sant'
Ambrogio, Florence, and discovered in sacristy storeroom. Cen-
tral image of Madonna and Child added later. Appends documents.

768 _____. "A Newly Discovered Libro di recordi of Alesso
Baldovinetti." Burlington Magazine 2, no. 4 (1903):22-32, 3
illus.; no. 5 (1903):167-74, 1 illus.; no. 6 (1903):377-90.
Publishes book in archives of Sta. Maria Nuova, Florence,
including several pages of artist's accounts from 1470 on.
Discusses primarily works connected with Sta. Trinità. Appends
documents.

769 KENNEDY, RUTH W. "Baldovinetti, Alesso." In Encyclopedia
of World Art. Vol. 2. London: McGraw Hill, 1960, col.
205.
Brief review of major facts of artist's career and impor-
tant works. Brief bibliography.

770 _____. "An Early Annunciation by Alesso Baldovinetti." Art
in America 28, no. 4 (1940):139-49, 3 illus.
Publishes panel at Wildenstein, New York, ca. 1449-54.
Shows relationship to circle of the engraver Finiguerra.

771 LONDI, E[MILIO]. "La data di nascita di Alesso Baldovinetti."
Rivista d'arte 4, no. 10-12 (1906):191-92.
Two documents that concur that artist born in 1425,
rather than 1427, as stated by Milanesi (entry 17).

772 MESNIL, JACQUES. "La cappella del Miracolo in S. Ambrogio e
una tavola di Alesso Baldovinetti." Rivista d'arte 3, no. 4
(1905):86-89.
Documents of 1469-85 regarding chapel and progress of
Baldovinetti's panel and other decorations for it.

773 PITTALUGA, MARY. "Note sul Baldovinetti." Emporium 82, no.
487 (1935):70-79, 11 illus.
Essay on artist, with particular attention to frescoes of
Chapel of Cardinal of Portugal, S. Miniato, Florence. Discus-
ses relation to Piero della Francesca.

774 ROWLANDS, ELIOT W. "Baldovinetti's Portrait of a Lady in
Yellow." Burlington Magazine 122, no. 930 (1980):624-27, 2
illus.
Identifies subject of portrait in National Gallery,
London, as Francesca degli Stati. Dates ca. 1450.

775 SIRÉN, OSWALD. "A Picture by Alesso Baldovinetti in the
Jarves Collection in New Haven." Art in America 2, no. 3
(1914):236-40, 1 illus.
Attributes scene of Infancy of a Saint. Dates ca. 1450.

776 VENTURI, ADOLFO. "Predella di Alessio Baldovinetti in Casa
 Buonarotti a Firenze." L'arte 30 (1927):34-38, 3 illus.
 Attribution of three scenes of life of Saint Nicholas.
 Rejects attribution to Francesco Pesello.

777 _____. "Ritratti del Baldovinetti a Hampton Court, del
 Perugino a Firenze, del Francia a Hannover, di Tiziano a
 Copenhagen." L'arte 25 (1922):10-14, 4 illus.
 Includes attribution of a profile portrait of a man.

778 WEISBACH, WERNER. "Eine Neuerwerbung des Louvre."
 Kunstchronik 9, no. 20 (1898):324-25.
 Announces acquisition by Louvre of Madonna, from Duchatel
 Collection, attributed to Baldovinetti rather than Piero.

 BARTOLOMEO DI FRUOSINO (1366-1444)

779 LEVI D'ANCONA, MIRELLA. "Bartolomeo di Fruosino." Art
 Bulletin 43, no. 2 (1961):81-97, 18 illus.
 Makes various attributions, especially of manuscripts.
 Publishes new documents. Notes influence of Lorenzo Monaco.

780 WATSON, PAUL F. "A desco da parto by Bartolomeo di
 Fruosino." Art Bulletin 56, no. 1 (1974):4-9, 10 illus.
 Attribution of birth salver, dated 1428, in New York
 Historical Society.

BARTOLOMEO DI TOMMASO DA FOLIGNO (ca. 1408/11-ca. 1455)

781 ADORNO, PIERO. "Gli affreschi della cappella Paradisi nella
 chiesa di San Francesco a Terni." Antichità viva 17, no. 6
 (1978):3-18, 26 illus.
 Analysis of frescoes in chapel. Accepts and amplifies
 attribution to Bartolomeo di Tommaso da Foligno, mid-fifteenth
 century. Defines expressive style of artist in relation to
 contemporary trends. English summary.

782 FALOCI-PULIGNANI, M. "Bartolomeo di Tommaso pittore umbro
 del XV secolo." Rassegna d'arte umbra 3, no. 3 (1921):65-
 80, 2 illus.
 Introduction to the artist, with sections on critical
 writings and documents, on frescoes in S. Salvatore, Foligno,
 and on work for Pope Nicholas V. Chronological summary.

783 _____. "Maestro Bartolomeo: Dipintore umbro del secolo
 XV." Arte e storia 6, no. 1 (1887):3-4.
 Gathers known information regarding Bartolomeo di Tommaso
 da Foligno, to construct his career. Enumerates his works.

Bartolomeo di Tommaso da Foligno

784 GRASSINI, PIERO. "Un ciclo di affreschi danteschi nel San
 Francesco di Terni." Bollettino della Deputazione di storia
 patria per l'Umbria 62 (1965):184-90.
 Reviews frescoes of 1453, by Bartolomeo di Tommaso. Dis-
 cusses relation to local interest in Dante.

785 SENSI, MARIO. "Documenti per Bartolomeo di Tommaso da
 Foligno." Paragone 28, no. 325 (1977):103-56.
 Documents of 1405-59 from a variety of sources. Includes
 a lengthy discussion of artist's activity. See entry 786.

786 TOSCANO, BRUNO. "A proposito di Bartolomeo di Tommaso."
 Paragone 28, no. 325 (1977):80-85.
 Discusses documents, especially those published by Sensi
 in same issue of journal (entry 785). Elucidates various
 points of artist's life and works.

787 _____. "Bartolomeo di Tommaso e Nicola da Siena."
 Commentari 15, no. 1-2 (1964):37-51, 13 illus.
 Sees Bartolomeo as representative of expressive quality
 in Umbrian art. Attributes little-known frescoes from S.
 Francesco a Cascia. Discusses artist's chronology.

788 ZANOLI, ANNA. "Un altare di Bartolomeo di Tommaso a Cesena."
 Paragone 20, no. 231 (1969):63-76, 7 illus.
 Documents of 1439 concerning commission for altar for S.
 Francesco, Cesena. Identifies two predella panels, Walters
 Gallery, Baltimore, and Cini Collection, Venice.

789 ZERI, FEDERICO. "Bartolomeo di Tommaso da Foligno."
 Bollettino d'arte 46, no. 1-2 (1961):41-64, 24 illus.
 Investigates career of artist, known from 1425-55. Adds
 new works. Defines phases of his career.

 BATTISTA DI GERIO (act. 1 half of fifteenth century)

790 MORIONDO, M. "Battista da Pisa." Bollettino d'arte 37, no.
 1 (1952):57, 2 illus.
 Publication of triptych in Pieve di SS. Giovanni Battista
 e Stefano, Camaiore. Signed and dated 1444.

791 ZERI, FEDERICO. "Battista di Gerio: Un piccolo passo in
 avanti." In Diari di lavoro, 2. Turin: Giulio Einaudi,
 1976, pp. 36-38, 2 illus.
 Attributes panel of Sts. Julian and Luke, location un-
 known, through a photograph. Associates with panel of three
 Saints, Atri Collection, Paris. Relates to Master of SS.
 Quirico e Giulitta.

792 ____. "Una scheda per Battista di Gerio." In Quaderni di
emblema, 2. Bergamo: Emblema editrice, 1973, pp. 13-16, 6
illus.
 On basis of altarpiece in SS. Giovanni Battista e
Stefano, Camaiore, makes several attributions. Includes
Madonna, in Johnson Collection, Philadelphia, usually
attributed to Master of Bambino Vispo.

JACOPO BEDI (act. 1432-75)

793 SALMI, MARIO. "Jacopo Bedi." Art in America 11, no. 3
(1923):150-57, 5 illus.
 Reviews career of Umbrian artist, follower of Nelli, who
worked in Gubbio. Discusses frescoes in chapel of the cemetery
of S. Secondo, 1458.

BENEDETTO DI BINDO (act. ca. 1409-17)

794 BACCI, PÈLEO. "Le storie della invenzione e esaltazione
della S. Croce, dipinte da Benedetto di Bindo e compagni per
'l'Arliquiera' del Duomo di Siena (1412)." In Fonti e
commenti per la storia dell'arte senese. Siena: Accademia
degli intronati, 1944, pp. 193-229, 17 illus.
 Discusses reliquary with scenes of history of True Cross.
Constructs history of object and its decoration, according to
documents.

795 VOLPE, CARLO. "Deux panneaux de Benedetto di Bindo." Revue
des arts 8, no. 4 (1958):172-76, 4 illus.
 Attributes Journey of the Magi, Museum, Dijon, and Adora-
tion of Magi, private collection. Latter (earlier of the two)
dated ca. 1410-20.

BICCI DI LORENZO (1373-1452)

Dissertation

796 WALSH, BARBARA BUHLER. "The Fresco Paintings of Bicci
di Lorenzo." Ph.D. dissertation, Indiana University, 1979,
278 pp.
 Interprets artist as representative of important conser-
vative trend. Establishes chronology of frescoes, considers
attributions. Traces trends in Florentine painting through his
eclecticism. Discusses sinopia drawings.

Bicci di Lorenzo

Articles

797 AHL, DIANE COLE, and LYNES, BARBARA BUHLER. "The Santa
 Maria a Castagnola Altarpiece." Source: Notes on the His-
 tory of Art 2, no. 3 (1983):1-4, 3 illus.
 Discusses altarpiece with central Assumption of the Vir-
 gin, and standing Saints in side panels, near Lastra a Signa.
 Attributes Saints to Bicci di Lorenzo and suggests attribution
 of central panel Lorenzo di Bicci.

798 BERENSON, MARY LOGAN. "Opere inedite di Bicci di Lorenzo."
 Rassegna d'arte 15 (1915):209-14, 11 illus.
 Numerous unpublished works, listed by location.

799 CONSTABLE, W.G. "A Florentine Annunciation." Bulletin of
 the Museum of Fine Arts, Boston 43, no. 254 (1945):72-76, 3
 illus.
 Publishes new acquisition, attributed to Bicci di
 Lorenzo, ca. 1435.

800 LYNES, BARBARA BUHLER. "Bicci di Lorenzo's 'Lost' Compagni
 Polyptych." Gazette des beaux arts 102, no. 1379
 (1983):208-14, 6 illus.
 Identifies altarpiece in Westminster Abbey, London, as
 originally in Compagni Chapel, Sta. Trinità, Florence, 1430s.

801 POGGI, GIOVANNI. "Gentile da Fabriano e Bicci di Lorenzo."
 Rivista d'arte 5, no. 5-6 (1907):85-88, 3 illus.
 Discusses imitations made by Bicci of works by Gentile.
 Attributes Madonna, Gallery, Fabriano, to Bicci rather than
 Gentile.

802 PROCACCI, UGO. "Una lettera di Baldinucci, e antiche
 immagini della beata Umiliana de' Cerchi." Antichità viva
 15, no. 3 (1976):3-10, 8 illus.
 Discusses early images of Blessed Umiliana, particularly
 one in panel of Coronation of Virgin from S. Firenze, Florence,
 presently in storerooms of the Soprintendenza alle Gallerie,
 which includes likeness not attributed to Bicci, and commis-
 sioned in 1436 by Bernardo da Gangalandi. Work mentioned in
 letter by Baldinucci, 1674. Article also publishes new docu-
 ments identifying frescoes in S. Martino a Gangalandi as by
 Bicci, ca. 1433. English summary.

803 SERVOLINI, LUIGI. "Un inedito di Bicci di Lorenzo." Arte
 figurativa antica a moderna 8 (March-April 1954):30-31, 3
 illus.
 St. Lucy, formerly Bellini Collection, Florence, attrib-
 uted to artist's late period.

804 TOLNAY, CHARLES DE. "The Music of the Universe. Notes on a
Painting by Bicci di Lorenzo." Journal of the Walters Art
Gallery 6 (1943):83-104, 23 illus.
Interprets Annunciation as illustrating doctrine of musi-
cal harmony of the universe. Traces doctrine from antiquity to
Leonardo.

805 WALSH, BARBARA BUHLER. "Two Early Bicci di Lorenzo
Annunciation." Antichità viva 20, no. 4 (1981):7-13,
10 illus.
Publishes two early frescoes in S. Simone and S. Marco,
Florence. Discusses artist's importance as representative of
late fourteenth-century trends.

806 ZERI, FEDERICO. "Una precisazione su Bicci di Lorenzo."
Paragone 9, no. 105 (1958):67-71, 5 illus.
Reconstructs polyptych from S. Niccolo in Cafaggio,
Florence, from segments scattered in a wide variety of col-
lections. Central Madonna, now in Pinacoteca, Parma, dated
1433.

GIOVANNI BOCCATI (ca. 1410-80)

Books

807 FELICIANGELI, B. Sulla vita di Giovanni Boccati da Camerino:
Pittore del secolo decimoquinto. San Severino-Marche;
Tipografia Francesco Taddeo, 1906, 48 pp., 1 illus.
Essay attempting to reconstruct career. Discusses docu-
mentary evidence, cultural ambience. General outline of chro-
nology of his art, relation to other artists. Chronological
chart, appendix of documents.

808 ZAMPETTI, PIETRO. Giovanni Boccati. [Milan]: Electa
editrice, 1971, 219 pp., 138 b&w and 19 color illus.
Full monograph on artist, surveying career in its geo-
graphic context. Catalog of works with bibliography. Chrono-
logical table of documentary and historical information.
Bibliography, index. Excellent illustrations, many details.
Review: Luisa Vertova, Burlington Magazine 115, no. 846
(1973):608-10, 3 illus.

Articles

809 BACCI, MINA. "Il punto su Giovanni Boccati."
Paragone 20, no. 231 (1969):15-33, 13 b&w and 1 color
illus.; no. 233 (1969):3-21, 24 illus.
Reconstructs Boccati's career. Discusses previous schol-
arship, gathers attributions, and adds new ones. Notes include

Giovanni Boccati

chronological bibliography, and descriptions and provenances of lesser-known works.

810 BORENIUS, TANCRED. "Some Reconstructions." Apollo 2, no. 10 (1925):200–203, 6 illus.
 Includes hypothesis that two panels with scenes of Saint Nicholas, in private collections, belonged originally to predella of a lost work by Boccati.

811 COLASANTI, ARDUINO. "Un polittico di Giovanni Boccati a Belforte del Chienti." L'arte 7 (1904):477–81, 2 illus.
 Publishes recently cleaned work with many panels. Signed and dated 1468.

812 CONSTABLE, W.G. "A Reconstruction Continued." Apollo 7, no. 40 (1928):155, 1 illus.
 Associates Madonna and Saints, 1473, Museum of Fine Arts, Budapest, with the predella panels attributed to Boccati by Borenius (entry 810). Reidentifies predella subjects as stories of Saint Sabinus.

813 DILLON, GIANVITTORIO. "Per Giovanni Boccati." Paragone 30, no. 357 (1979):75–80, 2 illus.
 Publishes predella panel of scenes of life of Saint Sabinus, private collection, Venice. Associates with altarpiece from Orvieto, now Szépmuvészeti Galeria, Budapest. Relates to Domenico Veneziano and Fra Angelico.

814 FELICIANGELI, B. "Un'altra tavola di Giovanni Boccati." Rassegna bibliografica dell'arte italiana 10, no. 7–9 (1907):97–102.
 Attributes Coronation of Virgin in Castel Santa Maria, dated 1463. Lists known facts of artist's life.

815 _____. "Ancora una tavola di Giovanni Boccati da Camerino." Atti e memorie della R. Deputazione di storia patria per le province delle Marche 9 (1913):1–7, 1 illus.
 Attributes Madonna and Saints in Nemi. Dates ca. 1466–73. Lists other known works by artist.

816 _____. "Opere ignorate da Giovanni Boccati." Rassegna bibliografica dell'arte italiana 9, no. 1–2 (1906):1–14, 3 illus.
 Lists works by Boccati, mostly little known, with brief discussion of each.

817 PERKINS, F. MASON. "Un gonfalone di Giovanni Boccati da Camerino." Rassegna d'arte 12, no. 11 (1912):170–71, 2 illus.
 Publishes banner representing Madonna della Misericordia, Platt Collection, Englewood, N.J.

818 REINACH, S[ALOMON]. "Un tableau de Boccatis." Bulletin des
 musées de France 1, no. 4 (1929):80-83, 2 illus.
 Attributes Madonna, Museum, Cherbourg, to early period of
 Boccati.

819 SIRÉN, OSVALD. "An Italian Salver of the Fifteenth Cen-
 tury." Burlington Magazine 30, no. 170 (1917):183-89, 2
 illus.
 Publishes salver, Museum of Fine Arts, Boston, decorated
 with meeting of Solomon and Sheba, and with putto with cornuco-
 pias. Attributes to Boccati, after 1450.

820 VENTURI, ADOLFO. "Studi sull'arte umbra del '400." L'arte
 12 (1909):188-202, 13 illus.
 Brief survey of region, concentrating on second half of
 century but including Boccati, seen as influenced by Domenico
 di Bartolo.

 BARTOLOMMEO DI ANDREA BOCCHI (1403-before 1476)

821 PROCACCI, UGO. "Di Bartolommeo d'Andrea Bocchi pistoiese."
 Rivista d'arte 14 (1932):395-99, 1 illus.
 Documentary material concerning artist and his work in S.
 Michele, Serravalle. Identifies a painting, private collec-
 tion, Warsaw, with a lost work known in nineteenth century.

822 _____. "Il pittore pistoiese Bartolommeo di Andrea Bocchi."
 In Egemonia fiorentina ed autonomie locali nella Toscana
 nordoccidentale del primo rinascimento. Convegno
 internazionale, 1975. Pistoia: Centro italiano di studi di
 storia e d'arte, 1978, pp. 235-54, 14 illus.
 Reconstructs artist's biography on basis of documents.
 Examines works, including painting of 1439, S. Michele,
 Serravalle. Commenbs by Lucia Gai, with reply.

 BENEDETTO BONFIGLI (1420-ca. 1496)

Dissertation

823 BOMBE, WALTER. "Benedetto Bonfigli: Eine kunsthistorische
 Studie." Ph.D. dissertation, University of Berlin, 1904,
 39 pp.
 Study that consists of brief monograph on artist. De-
 fines painting in Perugia before Bonfigli, gives biography.
 Discusses panels, banners, and frescoes of Cappella dei Priori,
 Palazzo Pubblico, Perugia. Lists rejected works. Relates to
 Perugino and Fiorenzo di Lorenzo. Section on school works and
 followers.

Benedetto Bonfigli

Articles

824 _____. "Die Tafelbilder, Gonfaloni, und Fresken des
Benedetto Bonfigli." Repertorium für Kunstwissenschaft 32
(1909):97-114, 231-46.
Study of the artist, with biographical notices and review
of stylistic development. Sections on panels, gonfaloni, and
frescoes in Palazzo Pubblico, Perugia. Documents.

825 _____. "Gonfaloni umbri (studi iconografi)." Augusta
Perusia 2, no. 1-2 (1907):2-7, 6 illus.
Study of banners made during times of plague. Includes
one of 1472, by Bonfigli.

826 BONUCCI, AMICCIO. "Una festa dell'arte nella chiesa di S.
Fiorenzo." Arte e storia 11, no. 22 (1892):170-71.
Describes banner of 1476 attributed to Perugino and
Bonfigli, in Perugia. Includes transcription of verses on it.

827 BRECK, JOSEPH. "Noch ein Beispiel für einen drachen-und
phoenix--teppich." Cicerone 4, no. 4 (1912):133-35, 1 illus.
Motif in Bonfigli's scene from life of the Baptist,
Jarves Collection, New Haven, compared to carpet in Kaiser
Friedrich Museum, Berlin.

828 HUTTON, EDWARD. "The Father of Perugian Painting."
Burlington Magazine 7, no. 26 (1905):133-38, 2 illus.
Traces career of Bonfigli. Notes relatively small in-
fluence of Florentine art. Describes conservative character of
his paintings.

829 MANZONI, LUIGI. "Ricerche sulla storia della pittura in
Perugia nel secolo XV, del Maestro di Pietro Vannucci detto
il Perugino e dei suoi contemporanei." Bollettino della R.
Deputazione di storia patria per l'Umbria 6, no. 2
(1900):289-316.
Includes review of Bonfigli's career. Publishes docu-
ments of 1454-96.

830 _____. "Spogli dell'Archivio notarile distrettuale di
Perugia." Bollettino della R. Deputazione di storia patria
per l'Umbria 3, no. 2 (1897):373-82.
Publishes documents, including some referring to Bonfigli
from 1445-1502.

831 SCALVANTI, O. "I gonfaloni del Bonfigli." Rassegna d'arte
1, no. 10 (1901):154-56.
Discussion of banners attributed to Bonfigli and Perugino.
Attributes banner of Saint Augustine, parish church, Corciano,
to Bonfigli.

Filippo Brunelleschi

832 _____. "Il serto di rose negli angeli di Bonfigli."
Rassegna d'arte 2, no. 7 (1902):103-7, 3 illus.
Considers the use of rose garlands in Bonfigli's works.
Discusses the possible influence of Beata Colomba da Rieta on
his work.

833 ZERI, FEDERICO. "An Annunciation by Benedetto Bonfigli."
Translated by Anthony M. Sutton. Apollo 108, no. 202
(1978):394-95, 3 illus.
Publishes painting in Thyssen Collection, Lugano, ca.
1440-45, influenced by Domenico Veneziano. Connects three
pinnacles by Caporali, in Loeser Collection, Florence, with
triptych of 1467 in Perugia, Galleria Nazionale, by Bonfigli
and Caporali.

FILIPPO BRUNELLESCHI (1377-1446)

Books

834 BOZZONI, CORRADO, and CARBONARA, GIOVANNI. Filippo
Brunelleschi: Saggio di bibliografia. 2 vols. Rome:
Istituto di fondamenti dell'architettura dell'università,
1977-78, 562 pp.
Chronological, annotated bibliography of approximately
200 items on all aspects of Brunelleschi, including life,
works, cultural ambience, and contribution to perspective.
Second volume continues entries, appends summaries of recent
congresses, and contains useful indexes, by author and subject
matter.

835 MANETTI, ANTONIO DI TUCCIO. The Life of Brunelleschi.
Edited, with introduction and notes by Howard Saalman.
Translated by Catherine Enggass. University Park, Penn. and
London: Pennsylvania State University Press, 1970, 183 pp.,
8 illus.
English edition of fifteenth-century biography, which
emphasizes artist's relation to antiquity and also describes
invention of perspective. Volume collates several manuscripts,
juxtaposes Italian text and English translation. Introduction
reviews various problems such as editions, authorship, date,
and reliability. Notes point out distortions of fact.
Review: James S. Ackerman, Art Bulletin 54, no. 2
(1972):208.

836 RAGGHIANTI, CARLO LUDOVICO. Filippo Brunelleschi: Un uomo
un universo. Florence: Banca toscana, 1977, 572 pp., 702
b&w and 12 color illus.
Includes chapters on perspective, on Masaccio's Trinity,
and on landscape and topography.

Filippo Brunelleschi

Articles

837 ARGAN, GIULIO CARLO. "The Architecture of Brunelleschi and
the Origins of Perspective Theory in the Fifteenth Century."
Journal of the Warburg and Courtauld Institutes 9 (1946):96-
121, 17 illus.
Discusses use of perspective as inseparable from study of
antiquity. Ideas carried out in Brunelleschi's research on
perspective and in his architecture.

838 ARNHEIM, RUDOLPH. "Brunelleschi's Peepshow." Zeitschrift
für Kunstgeschichte 41, no. 1 (1978):57-60.
Challenges assumption that Brunelleschi's two paintings,
described by Manetti, were first demonstrations of central
point perspective. Sees subjects as not useful for such an
exercise, and no evidence of geometrical constructions in
Brunelleschi's procedure.

839 BATTISTI, EUGENIO. "Experiments with Pespective." In
Filippo Brunelleschi: The Complete Work. Translated by
Robert Erich Wolf. New York: Rizzoli, 1981, pp. 102-13, 18
illus.
Description and reconstruction of experiments as de-
scribed by Manetti. Relates to Massacio's Trinity, Sta. Maria
Novella, Florence. Numerous diagrams. Illustrations of modern
students recreating experiment.

840 BELTRAME, RENZO. "Gli esperimenti prospettici del
Brunelleschi." Atti della accademia nazionale dei lincei.
Classe di scienze morali, storiche e filologiche.
Rendiconti 28, no. 3-4, yr. 370 (1973):417-68, 12 diagrams.
Examines Manetti's description of Brunelleschi's perspec-
tive experiments, suggesting that the artist used an astrolabe
or a quadrant. Diagrams method. Compares to Alberti.

841 COLLIER, JAMES M. "Brunelleschi's Perspective Demonstration
Recreated." Southeastern College Art Conference Review 10,
no. 1 (1981):4-7, 6 illus.
Account of author's recreation of perspective experiment,
leading to conclusion that Renaissance method of representation
was valid.

842 DEGL'INNOCENTI, GIOVANNI. "Il dimensionamento della
tavoletta del primo esperimento prospettico brunelleschiano."
In Filippo Brunelleschi: La sua opera e il suo tempo.
Convegno internazionale di studi, 1977. Vol. 2. Florence:
Centro Di, 1980, pp. 561-70, 9 illus.
Considers shape and size of panels described by Manetti
for Brunelleschi's experiment.

843 EDGERTON, SAMUEL Y. Jr. "Brunelleschi's First Perspective
Picture." Arte lombarda 18, no. 38-39 (1973):172-95, 26
illus.

Filippo Brunelleschi

Reconstruction of Brunelleschi's experiment. Considers concept of vanishing point, size of panels, viewing distance, viewing angle, and distance point. Discusses the second demonstration. Diagrams.

844 FEDERICI VESCOVINI, GRAZIELLA. "La prospettiva del Brunelleschi, Alhazen e Biagio Pelacani a Firenze." In Filippo Brunelleschi: La sua opera e il suo tempo. Convegno internazionale di studi, 1977. Vol. 1. Florence: Centro Di, 1980, pp. 333-48.
 Asserts influence of Alhazen and mathematician Biagio Pelacani of Parma on Brunelleschi.

845 GIOSEFFI, DECIO. "Filippo Brunelleschi e la svolta 'copernicana': La formalizzazione 'geometrica' della prospettiva. Gli inizi della scienza moderna." In Filippo Brunelleschi: La sua opera e il suo tempo. Convegno internazionale di studi, 1977. Vol. 1. Florence: Centro Di, 1980, pp. 81-91.
 Sees discovery of perspective as parallel to Copernican revolution of period.

846 KEMP, MARTIN. "Science, Non-science and Nonsense: The Interpretation of Brunelleschi's Perspective." Art History 1, no. 2 (1978):134-61, 12 illus.
 Examines evidence and differing interpretations of Brunelleschi's invention, indicating that no certain conclusions can be reached. Makes some suggestions regarding theoretical implications. Diagrams, appendix of medieval measuring techniques, and bibliography.

847 LANG, SUZANNE. "Brunelleschi's Panels." In La prospettiva rinascimentale: Codificazioni ed trasgressioni. Edited by Marisa Dalai Emiliani. Florence: Centro Di, 1980, pp. 63-72, 4 illus.
 Investigates Brunelleschi's motivation for perspective designs, which may have been prototypes for Vitruvian stage designs.

848 LEMOINE, JEAN-GABRIEL. "Brunelleschi et Ptolémée: Les origines géographiques de la 'Boîte d'optique.'" Gazette des beaux arts 51, no. 1072-73 (1958):281-96, 11 illus.
 Considers the invention of the Optical Box, originally an apparatus used for study of Ptolemy's ideas. Attributes to Brunelleschi, ca. 1425. Diagrams. English summary.

849 PARRONCHI, ALESSANDRO. "Le due tavole prospettiche del Brunelleschi." Paragone 9, no. 107 (1958):3-32, 6 illus.; 10, no. 109 (1959):3-31, 8 illus. [Reprinted in Studi su la dolce prospettiva (Milan: Martello, 1964), pp. 226-95.]

Filippo Brunelleschi

Investigation of Brunelleschi's experiments. Recon-
structs and proposes sources in contemporary shop practices and
medieval optics, as well as ancient treatises.

850 ROSSI, PAOLO ALBERTO. "Soluzione brunelleschiane:
Prospettiva, invenzione ed uso." Critica d'arte 46, no.
175-77 (1981):48-74, 36 illus.
Analyzes experiment. Argues for system of grid with
sixteen sections in a circle. Sees its use by Brunelleschi and
in Uccello's clock face, Duomo, Florence.

851 SANPAOLESI, PIERO; PORTOGHESI, PAOLO; and GARIN, EUGENIO.
"Brunelleschi, Filippo." In Encyclopedia of World Art.
Vol. 2. London: McGraw Hill, 1960, col. 651-70, 29 illus.
Reviews career, discusses contemporary mathematics and
science, and analyzes literature. Lengthy bibliography.

852 _____. "L'invenzione della prospettiva." In Brunelleschi.
Milan: Edizioni per il club del libro, 1962, pp. 41-53, 2
illus.
In monograph on architecture, describes experiment as
recorded by Manetti. Credits Brunelleschi with invention of
perspective and with design of architecture of Masaccio's
Trinity.

853 VAGNETTI, LUIGI. "La posizione di Filippo Brunelleschi
nell'invenzione della prospettiva lineare: Precisazioni ed
aggiornamenti." In Filippo Brunelleschi: La sua opera e il
suo tempo. Convegno internazionale di studi, 1977. Vol. 1.
Florence: Centro Di, 1980, pp. 279-306, 12 illus.
Reconstructs Brunelleschi's method, based on Vasari's
comments. Outlines a lengthy and complicated, but logical
procedure, later simplified by Alberti.

854 VERGA, CORRADO. "La prima prospettiva del Brunelleschi."
Critica d'arte 42, no. 154-56 (1977):71-83, 2 illus.; 43,
no. 157-59 (1978):119-32, 1 illus.
Study of process and implications of Brunelleschi's expe-
riment as described by Manetti. Diagrams.

BARTOLOMEO CAPORALI (ca. 1420-1508)

855 GARDNER, ELIZABETH E. "I disegni di G.B. Cavalcaselle e la
pala di Bartolomeo Caporali a Castiglione del Lago." In
Quaderni di emblema, 2. Bergamo: Emblema editrice, 1973,
pp. 47-49, 7 illus.
Publishes drawings made by Cavalcaselle after Caporali's
altarpiece, now scattered. Helps to identify its parts.

856 GNOLI, UMBERTO. "Bartolomeo Caporali a Roma." Rivista
d'arte 16 (1934):97.

Document of 1467 establishing Caporali's presence in Rome.

857 ____. "Una miniatura di Bartolomeo Caporali." Rassegna d'arte umbra 3, no. 2 (1921):33-37, 2 illus.
Attribution of page illustrating the Assumption of the Virgin, Academy, Vienna.

858 ____. "Una tavola di B. Caporali." Bollettino d'arte 10, no. 9-10 (1916):276-78, 4 illus.
Two fragments, Galleria Comunale, Udine, linked to panel of 1487, for Sta. Maria Maddalena di Castiglione del Lago.

859 LOTHROP, STANLEY. "Bartolomeo Caporali." Memoirs of the American Academy in Rome [School of Classical Studies] 1 (1915-16):87-102, 41 illus.
Overview of career and authenticated works, as well as some attributions.

860 PERROTT, EMILIA. "Un messale umbro del quattrocento." Bibliofilia 36 (1934):173-84, 16 illus.
Publishes manuscript in Biblioteca Olschki, Florence, dated 1469, with illuminations mostly by Caporali brothers.

861 RICCI, CORRADO. "Una tavola di Bartolomeo Caporali." Rivista d'arte 2, no. 2 (1904):38-40, 1 illus.
Publishes Madonna with Angels, newly acquired by R.R. Gallerie, Florence. Notes other works by Caporali and the characteristics of his art.

862 SALMI, MARIO. "Bartolomeo Caporali a Firenze." Rivista d'arte 15 (1933):253-72, 13 illus.
Asserts visit by Caporali to Florence and sees evidence in his works. Attributes fresco, monastery of S. Giorgio alla Costa, Florence, dated 1487.

863 ____. "Eine Madonna von Bartolomeo Caporali im Museum zu Budapest." Cicerone 16, no. 14 (1924):667, 1 illus.
Attributes painting to Caporali, rather than Fiorenzo di Lorenzo.

864 ZERI, FEDERICO. "Appunti nell' Ermitage e nel museo Pusckin." Bollettino d'arte 46, no. 3 (1961):219-36, 28 illus.
Includes discussion of two predella panels of Saints, Hermitage, here attributed to Caporali. Differentiates from art of Bonfigli.

Carlo da Camerino

CARLO DA CAMERINO
(active late fourteenth-early fifteenth centuries)

865 GABHART, ANN. "A Late Medieval Altarpiece." Walters Art
 Gallery Bulletin 23, no. 6 (1971):n.p., 4 illus.
 Publishes recently cleaned triptych by Carlo da Camerino,
 ca. 1410.

866 HECHT, ILSE. "Madonna of Humility." Bulletin of the Art
 Institute of Chicago 70, no. 6 (1976):10-13, 4 illus.
 Iconographic study of works by Carlo and Nardo di Cione.

867 VITALINI SACCONI, GIUSEPPE. "Carlo da Camerino in
 Sant'Agostino a Recanati." Antichità viva 15, no. 6
 (1976):12-17, 9 illus.
 Publishes fragments recently discovered in vault of
 chancel. Dates early fifteenth century, notes influence on
 Arcangelo di Cola and Bartolommeo di Tommaso da Foligno.
 English summary.

868 ZERI, FEDERICO. "Me Pinxit: Carlo da Camerino."
 Proporzioni 2 (1948):162-64, 2 illus.
 Attributes Annunciation, Gallery, Urbino.

FRA CARNEVALE. See MASTER OF THE BARBERINI PANELS

CARLO DI GIOVANNI

*869 GALLAVOTTI CAVALLERO, D. "Un nome nuovo per la pitture
 senese: Carlo di Giovanni." In Annuario, Instituto di
 storia dell' arte, Università degli studi. Rome, 1974-76,
 pp. 65-80, 9 illus.
 Source: Répertoire d'art et d'archéologie (1979).

ANDREA DEL CASTAGNO (1419-1457)

Books and Dissertations

870 BERTI, LUCIANO. Andrea del Castagno. Florence: Sadea,
 1966, 39 pp., 80 color illus.
 Brief introduction to rather small color plates. Out-
 lines life and career, highlights selected bibliography, and
 annotates plates.

871 DEUSCH, WERNER RICHARD. "Andrea del Castagno." Ph.D.
 dissertation, University of Konigsberg, 1928, 65 pp.
 Provides brief investigation of artist's career. Chap-
 ters on early Florentine period, Venetian style, famous men

cycle, and late work. Annotated chronology, catalog of works, and rather complete bibliography.

872 FORTUNA, ALBERTO M. Andrea del Castagno. Pocket Library of Studies in art, 9. Florence: Olschki, 1957, 117 pp., 14 illus.
 Reviews periods of career, incorporates large amount of documentary material. Brief essay on nature of art. Section on lost works. Appendix on sixteenth-century sources. Bibliography. Illustrations include photographs of documents.

873 HORSTER, MARITA. Andrea del Castagno: Complete Edition with a Critical Catalogue. Oxford: Phaidon; Ithaca: Cornell University Press, 1980, 224 pp., 154 b&w and 8 color illus.
 Survey of information, discussion of style and chronology. Selected documents and sources, extensive bibliography, and catalogs of extant paintings, drawings, lost paintings, and wrong attributions. List of painters associated with Castagno. Indexes.
 Review: Hellmut Wohl, Art Bulletin 64, no. 1 (1982): 145-51

874 RICHTER, GEORGE MARTIN. Andrea del Castagno. Chicago: University of Chicago Press, 1943, 34 pp., 89 illus.
 Aimed at general audience, text follows career chronologically, with short discussion of each work and emphasis on individual character of Castagno's style.
 Review: Ruth Wedgwood Kennedy, Art Bulletin 26, no. 3 (1944):201-2.

875 RUSSOLI, FRANCO. Andrea del Castagno. Collezione Silvana, 17. Milan: Amilcare Pizzi, 1957, 34 pp., 12 b&w and 28 color illus.
 Brief essay on stylistic development, biographical note, bibliography, notes on plates, and some attributed works. List of lost works.
 Review: Terence Mullaly, Apollo 68, no. 404 (1958):137.

876 SALMI, MARIO. Andrea del Castagno. Novara: Istituto geografico De Agostini, 1961, 69 pp., 86 b&w and 12 color illus.
 Bibliography, chronology, annotated catalog of works, and sections on lost and attributed works.
 Review: Frederick Hartt, Renaissance News 17, no. 1 (1964):37-40.

 _____. Paolo Uccello, Andrea del Castagno, Domenico Veneziano. See entry 208.

*877 VEDOVATO, GIUSEPPE; BARGELLINI, PIERO; POGGI, DINO; and BISORI, GUIDO. Andrea del Castagno nel V centenario della

Andrea del Castagno

morte. Empoli and Florence: Poligrafico toscano, 1958, 43 pp.
Source: *Répertoire d'art et d'archéologie* (1958).

878 WALDSCHMIDT, WOLFRAM. "Andrea del Castagno." Ph.D. dissertation, University of Berlin, 1900, 54 pp.
Gives brief early survey of Castagno's career, attempting to reconstruct his biography more completely than earlier sources. Influence of other artists, particularly Donatello, Masaccio, and Uccello. Significance in early quattrocento. Influence on Mantegna and Ferrarese artists.

879 YUEN, TOBY E.S. "Illusionistic Mural Decoration of the Early Renaissance in Rome." Ph.D. dissertation, New York University, 1972, 189 pp., 140 illus.
Discusses Roman *all'antica* mural decorations of fifteenth and early sixteenth centuries beginning with Biblioteca Graeca, Vatican, begun 1454, here attributed to Castagno.

Articles

880 ANTAL, FRIEDRICH. "Studien zur Gotik im Quattrocento: Einige Italienische Bilder des Kaiser-Friedrich-Museums." *Jahrbuch der preussischen Kunstsammlungen* 46 (1925):3-32, 15 illus.
Beginning with Castagno's *Assumption of the Virgin*, Berlin, traces "Gothic" characteristics in artist's late style and in other artists of forties and fifties, including Donatello, Uccello, Pesellino, and Giovanni di Francesco as well as other later and North Italian artists.

881 BELLOSI, LUCIANO. "Intorno ad Andrea del Castagno." *Paragone* 18, no. 211 (1967):3-18, 4 illus.
Attribution of *Crucifix*, SS. Annunziata, Florence, ca. 1450-53. Rejects attribution to Francesco Botticini.

882 BERTI, LUCIANO. "Appunto su Andrea del Castagno a S. Zaccaria." *Acropoli* 3, no. 4 (1963):261-92, 22 b&w and 17 color illus.
First publication in color of Castagno's figures of 1442 in S. Zaccaria, Venice. Suggests three separate phases in the project that show development of Castagno's style.

883 BROCKHAUS, HEINRICH. "Andrea del Castagnos Fresko der Dreieinigkeit in der Kirche der Annunziata." In *Forschungen über florentiner Kunstwerke*. Leipzig: N.p., 1902, pp. 69-79, 5 illus. [Italian ed. "L'affresco della SS. Trinità nella chiesa dell'Annunziata di Andrea del Castagno," in *Ricerche sopra alcuni capolavori d'arte fiorentina* (Milan: Hoepli, 1902).]

Andrea del Castagno

Description of Trinity fresco, SS. Annunziata, Florence.
Appendix on chapel and on discovery of fresco.

884 BROCKWELL, MAURICE W. "The Brigittine Altarpiece by Andrea
 del Castagno Erroneously Known as the 'Poggibonsi Altar-
 piece.'" Connoisseur 128, no. 522 (1951):6-9, 56, 7 illus.
 Postulates that so-called "Poggibonsi altarpiece" not
painted for the abbey of S. Michele, Poggibonsi, but actually
painted by Castagno in 1444 for the Brigittine nuns at Bagno a
Ripoli. Main panel in Sangiorgi Collection, Rome.

885 C[AGNOLA], G[UIDO]. "Il Davide di Andrea del Castagno."
 Rassegna d'arte 13, no. 3 (1913):49, 1 illus.
 Publishes leather shield, Widener Collection,
Philadelphia.

886 CAROCCI, G[UIDO]. "Gli affreschi di Andrea del Castagno
 nella Villa Pandolfini presso Firenze." Bollettino d'arte,
 1, no. 8 (1907):1-3, 2 illus.
 Account of restoration that uncovered Castagno's decora-
tion, including a putto.

887 CAVIGGIOLI, A[URÉ]. "Andrea del Castagno." Alte und neue
 Kunst 8 (1951):12-14, 2 illus.
 Publishes a drawing of Crucifixion, British Museum, which
attributes to Castagno. Reviews artist's career briefly.

888 DEUSCH, WERNER R. "Zur Entwicklung Andrea del Castagnos."
 Pantheon 14 (December 1934):355-64, 11 illus.
 Attempts to establish chronology of works from 1440 to
1457, dividing into three periods. English summary.

889 EINEM, HERBERT VON. "Castagno ein Mörder?" In Der Mensch
 und die Künste: Festschrift für Heinrich Lützeler zum 60.
 Geburtstage. Düsseldorf: L. Schwann, 1962, pp. 433-42, 2
 illus.
 Associates legend that Castagno murdered Domenico
Veneziano with Castagno's fresco of Saint Julian, SS.
Annunziata, Florence.

890 F[ABRICZY], C[ORNELIUS] V[ON]. "Urkundliches zu den Fresken
 Baldovinetti's und Castagno's in S. Maria de' Servi zu
 Florenz." Repertorium für Kunstwissenschaft 25 (1902):
 392-931
 Documents of 1455-62 regarding activities of both
artists.

891 FIOCCO, G[IUSEPPE]. "Andrea del Castagno a Venezia."
 L'arte 24 (1921):85-89, 2 illus.
 Publishes discovery of frescoes of 1442 signed by
Castagno, in Chapel of S. Tarasio, in S. Zaccaria.

Andrea del Castagno

892 _____. "Andrea del Castagno at Venice." Burlington
Magazine 40, no. 226 (1922):11-17, 7 illus.
Presents discovery of signatures of Castagno and Francesco
da Faenza in frescoes of 1442, S. Zaccaria, Venice. Importance
of Florentines for Venetian art.

893 _____. "Andrea del Castagno nel Veneto." Belvedere, no. 6
(1925):157-60, 9 illus.
Impact of Tuscan art, especially that of Castagno, on
Venetian and Paduan art in quattrocento.

894 _____. "Voci di Andrea del Castagno in Russia." Atti della
accademia nazionale dei lincei. Classe di scienze morali,
storiche e filologiche. Rendiconti 12, yr. 354 (1957):378-
85, 8 illus.
Publishes panel with Crucifixion and Madonna and Saints,
Hermitage, Leningrad, signed by Antonio da Firenze, probably a
student of Castagno. Other attributions of works in Venice to
Antonio and to a Maestro Silvestro. Rejects attributions to
Castagno of Madonna and Saints, Contini-Bonacossi, Collection,
Florence. See entry 927.

895 FORTUNA, ALBERTO M. "Alcune note su Andrea del Castagno."
L'arte 57, no. 4 (1958):345-55.
Publishes documents, with discussion following, concern-
ing Castagno's family, a window in the Duomo, Florence, the
supposed murder of Domenico Veneziano, the Villa Carducci fres-
coes, and the Niccolo of Tolentino fresco in the Duomo, Florence.
Diagrams genealogical table.

896 _____. "Altre note su Andrea del Castagno." L'arte 60, no.
3 (1961):165-76, 2 illus.
On basis of documents, discusses project in Sant'
Apollonia, Florence, and its relation to the papacy of Eugenius
IV. Dates project more precisely from April 1447 to the end of
1448. Also discusses date of Castagno's death in August 1457.

897 GAMBA, CARLO. "Un'opera ignota di Andrea del Castagno: Il
San Teodoro di Venezia." Dedalo 4, no. 1 (1923):173-80, 8
illus.
Attributes to Castagno a mosaic of Saint Theodore, S.
Marco. Reviews other works in Venice.

898 _____. "Una tavola di Andrea del Castagno." Rivista d'arte
7, no. 1-2 (1910):25-28, 3 illus.
Identifies painting at Kaiser Friedrich Museum, Berlin,
as Castagno's Assumption from S. Miniato fra le Torri, Florence.
Associates with documents published by Giglioli (entry 899).

899 GIGLIOLI, ODOARDO H. "A proposito di una tavola di Andrea
del Castagno nella Chiesa di S. Miniato fra le Torri."
Rivista d'arte 3, no. 4 (1905):89-91.

Publishes documents regarding Assumption mentioned by
sources, for S. Miniato fra le Torri, Florence, present loca-
tion unknown. See entry 898.

900 _____. "L'arte di Andrea del Castagno." Emporium 21
(1905):114-41, 33 illus.
Fundamental monographic article discussing Castagno's
career, influences upon him, documentation, and previous lit-
erature. Sees his art as a combination of expressive emotion-
alism and classical humanism.
Review: Laudedeo Testi, Archivio storico italiano 37
(1906):325-80.

901 _____. "Le pitture di Andrea da Castagno e di Alessio
Baldovinetti per la chiesa di Sant'Egidio ed il pergamo di
Giuliano da Maiano. Rivista d'arte 3, no. 10 (1905):206-8.
Two documents regarding contributions of two artists to
choir. Mentions Domenico Veneziano.

902 GRONAU, GIORGIO. "Andrea del Castagno debitore." Rivista
d'arte 14 (1932):503-4.
Document of 1457 regarding Castagno's debts at his death.

903 HARTT, FREDERICK, and CORTI, GINO. "Andrea del Castagno,
Three Disputed Dates." Art Bulletin 48, no. 2 (1966):
228-34.
Reexamination of documents indicating (1) Castagno's date
of birth in 1419 or before; (2) Death of Virgin mosaic, S.
Marco, Venice, executed in 1443; and (3) passion cycle, Sta.
Apollonia, Florence, done in 1447. Appends texts of documents.

904 _____. "The Earliest Works of Andrea del Castagno." Art
Bulletin 41, no. 2 (1959):159-81; 41, no. 3 (1959):225-36,
54 illus.
Detailed discussion of Crucifixion from Sta. Maria degli
Angeli, Florence, of frescoes in S. Zaccaria, Venice, and of
mosaics in S. Marco, Venice. Appendix on history of attribu-
tions of latter. Attributes most of mosaics of Death of Virgin
and St. Theodore to Castagno.

905 _____. "A New Attribution for a Famous Drawing." Art
Quarterly 19, no. 2 (1956):162-73, 11 illus.
Drawing of head of unknown man, Uffizi, Florence, attrib-
uted to Castagno, instead of Uccello. Dates ca. 1456.

906 HORNE, HERBERT P. "Andrea del Castagno." Burlington
Magazine 7, no. 25 (1905):66-69; no. 27 (1905):222-33, 1
illus.
Rejects some of the documents Milanesi (entry 17) asso-
ciated with Castagno. Sets birth date at ca. 1410. Dates Sta.
Apollonia works as artist's earliest, ca. 1434. Notes influ-
ence of Donatello. Postulates that was taught painting by a
late "Giotteschi." Appendix with documents.

Andrea del Castagno

907 HORSTER, MARITA. "Castagnos florentiner Fresken 1450-1457."
 Wallraf-Richartz Jahrbuch 17 (1955):79-131, 38 illus.
 Study of artist's major fresco ensembles of fifties with
 discussion of comparative material and sinopie. Emphasizes
 innovative character and relation to monumental style of
 Masaccio and Donatello.

908 _____. "Castagnos Fresken in Venedig und seine Werke der
 vierziger Jahre in Florenz." Wallraf-Richartz Jahrbuch 15
 (1953):103-34, 32 illus.
 Studies major works of the 1440s with attention to the
 influence of earlier artists, particularly Donatello, Masaccio,
 and Lippi, and to Castagno's historical importance.

909 _____. "Das florentiner Jünglingsporträt in München, Alte
 Pinakothek, Inv. 658." Pantheon 18, no. 4 (1960):209-12, 5
 illus.
 Considers present attribution of portrait of young man to
 Castagno the most likely possibility, rejecting earlier attri-
 butions to Masaccio and Domenico Veneziano.

910 JACOBSEN, EMIL. "Fresken von Castagno und seiner Schule in
 Florenz." Repertorium für Kunstwissenschaft 29 (1906):
 101-3.
 Attributes St. Jerome, S. Miniato, to Castagno. Also
 attributes six frescoed medallions with half figures from Old
 Testament, in SS. Annunziata vestibule, to Castagno school.

911 JOOST-GAUGIER, CHRISTIANE L. "Castagno's Humanistic Program
 at Legnaia and its Possible Inventor." Zeitschrift für
 Kunstgeschichte 45, no. 3 (1982):274-82.
 Castagno's series of uomini famosi, ca. 1450-51, also
 includes donne illustri and may reflect new sensitivity to
 significance of women. Program perhaps designed by Alamanno
 Rinuccini, translator of Plutarch's De mulierium virtutibus.

912 MARANGONI, MATTEO. "Una sinopia di Andrea del Castagno."
 Critica d'arte 1, no. 1 (1954):19-20, 1 illus.
 Publishes recently uncovered sinopia for Pietà from re-
 fectory, Sta. Apollonia, Florence.

913 MERKEL, ETTORE. "Un problema di metodo: La Dormitio
 Virginis dei Mascoli." Arte veneta 27 (1973):65-80, 20
 illus.
 Approaches mosaic, S. Marco, Venice, from various angles,
 reviewing documents, technique, and style. Attempts to define
 contributions of Castagno, Giambono, and Jacopo Bellini and to
 determine changes made to Castagno's original design.

914 _____. "La scuola di Andrea del Castagno nel mosaici
marciani." Atti dell' Istituto veneto di scienze, lettere,
ed arte 131 (1972-73):377-419, 14 illus.
 Influence of Castagno on Venetian mosaicists of late
fifteenth and early sixteenth century. Numerous documents.
English summary.

915 OFFNER, RICHARD. "The Unique Portrait by Andrea del
Castagno." Art in America 7, no. 6 (1919):227-35, 1 illus.
 Stylistic analysis of realistic nature of Castagno's
Portrait of a Man, Morgan Collection (now National Gallery,
Washington).

916 POGÁNY-BALÁS, EDITH. "Remarques sur la source antique du
David d'Andrea del Castagno à propos de la gravure d'Antonio
Lafréri d'aprés les Dioscures de Monte-Cavallo." Bulletin du
musée hongrois des beaux arts, no. 52 (1979):25-34, 10
illus.
 Presents Dioscuri group, Rome, as source for Castagno's
David, National Gallery, Washington. Rejects idea of influence
of Pedagogue figure from Niobid group because was known only in
fragmentary versions before 1500.

917 POGGI, GIOVANNI. "Degli affreschi di Andrea da Castagno
nella Cappella di San Giuliano della SS. Annunziata."
Rivista d'arte 4, no. 1-2 (1906):24-30, 3 illus.
 Publishes documents and photographs of recently uncovered
fresco of Saint Julian and reviews historical information.

918 _____. "Della data di nascita di Andrea del Castagno."
Rivista d'arte 11 (1929):43-63.
 Publishes documents that indicate artist's birthdate as
1423, later than usually supposed. Considers lost paintings of
hanged men on Palazzo della Podestà, Florence, activity in
Venice and after. Dates Sta. Apollonia frescoes ca. 1445-50.

919 PUCCI, GIAMPIERO. "Un affresco di Andrea del Castagno."
Rivista d'arte 12 (1930):37-49, 6 illus.
 Attributes fresco of Madonna and Saints, Castello del
Trebbio (now Contini Bonacossi Collection, Florence) to Castagno,
ca. 1445-50, rather than to his school.

920 PUDELKO, GEORG. "Two Portraits Ascribed to Andrea del
Castagno." Burlington Magazine 68, no. 398 (1936):235-40,
6 illus.
 Attributes two male portraits, Kunsthaus, Zurich, with
Medici arms on backs. Dates in 1440s, identifies as Piero and
Giovanni de' Medici.

921 RICHTER, GEORGE MARTIN. "The Beginnings of Andrea del
Castagno." Art in America 29, no. 4 (1941):177-99, 25
illus.

Andrea del Castagno

On basis of new birthdate of 1423 for Castagno, discusses relation to Paolo Schiavo. Attributes, among other works, details of Saints Stephen and Lawrence cycles in Castiglione d'Olona, ca. 1435-40, and Madonna and Saints Michael and Bridget, triptych in private collection, New York City, ca. 1443-44 (now J. Paul Getty Museum, Los Angeles, as Master of Pratovecchio or Giovanni di Francesco). Lists Castagno's works chronologically.

922 ROUSSEAU, THEODORE, Jr. "The Saint Sebastian by Andrea del Castagno." Bulletin of the Metropolitan Museum of Art 7, no. 5 (1949):125-35, 11 b&w and 1 color illus.
 Analyzes work attributed to Castagno as a votive image for intercession against the plague; places in context of Castagno's career. Dates ca. 1445. Technical notes appended.

923 SALMI, MARIO. "Gli affreschi di Andrea del Castagno ritrovati." Bollettino d'arte 35, no. 4 (1950):295-308, 30 illus.
 Recently discovered frescoes at Villa Pandolfini, Legnaia. Describes process of restoration, reconstructs scheme. Dates slightly after 1450.

924 _____. "Ancora di Andrea del Castagno: Dopo il restauro degli affreschi di San Zaccaria a Venezia." Bollettino d'arte 43, no. 2 (1958):117-40, 47 illus.
 Recent cleaning reveals divisions and progress of work. Attempts to assign parts to Castagno, Francesco da Faenza and possibly Domenico Veneziano. Diagrams, details.

925 _____. "Andrea del Castagno." In Encyclopedia of World Art. Vol. 1. London: McGraw Hill, 1959, col. 424-31, 13 b&w and 4 color illus.
 Reviews life, then surveys works and characteristics of style. Discusses sources and criticism. Bibliography.

926 _____. "Un' ipotesi per Andrea del Castagno." Commentari 28, no. 4 (1977):289-90, 1 illus.
 Proposes that Death of St. Albero, Sta. Maria in Traspontina, Rome, by Il Pomerancio (1610s), copies Castagno's lost Dormition of Virgin in Sant'Egidio, Florence.

927 _____. "Precisazioni su Andrea del Castagno." Atti della Accademia nazionale dei lincei. Classe di scienze morali, storiche e filologiche. Rendiconti 13, yr. 355 (1958):90-96, 19 illus.
 Various comments responding to Fiocco's article (entry 894) regarding art of mosaicist Antonio da Firenze, dates of works by Castagno, and activities of Maestro Silvestro. Affirms attribution to Castagno of Madonna, Contini Bonacossi Collection, Florence.

928 _____. "Nuove rivelazioni su Andrea del Castagno."
Bollettino d'arte 39, no. 1 (1954):25-42, 40 illus.
Publishes recently uncovered sinopie for Passion scenes,
refectory of Sta. Apollonia, Florence. Dates ca. 1445 and
rejects idea of collaboration.

929 SCHAEFFER, EMIL. "Ueber Andrea del Castagno's 'Uomini
Famosi.'" Repertorium für Kunstwissenschaft 25 (1902):
170-77.
Relates Castagno's images to earlier and later portrayals
of same characters.

930 SINIBALDI, GIULIA. "Andrea del Castagno." L'arte 36, no. 5
(1933):335-53, 6 illus.
Considers Castagno in relation to other fifteenth-century
artists: Masaccio, Donatello, Pollauiolo, and Domenico
Veneziano. Discusses Crucifixion and Resurrection, Sta.
Apollonia, Florence. Notes expressive strength of style as
well as luministic qualities relating to Piero della Francesca.

931 THODE, HENRY. "Andrea Castagno in Venedig." In Festchrift
für Otto Benndorf. Vienna: Alfred Hölder, 1898, pp. 307-
17, 2 illus.
Castagno's activity in Venice. Attributes Death of
Virgin in Mascoli Chapel, S. Marco, and dates 1445-50. Dis-
cusses emotionalism of style. Notes influence of style on
Jacopo Bellini and Mantegna.
Review: [P.d'] Ancona, L'arte 2 (1899):105.

932 TORLATI, FERDINANDO. "Un opera sconosciuta di Andrea del
Castagno a Venezia." Arte cristiana 8, no. 2 (1920):57-58,
4 illus.
Publishes discovery of signatures on frescoes, S. Tarasio
Chapel, S. Zaccaria.

933 VENTURI, ADOLFO. "Andrea del Castagno, il Pinturicchio,
Gaudenzio Ferrari, tre quadri inediti." L'arte 39, no. 2
(1936):123-31, 3 illus.
Publishes a panel of St. John, private collection.

934 _____. "La Resurrezione di Andrea del Castagno." L'arte 29
(1926):101-2, 1 illus.
Painting at Duveen Brothers. Relates to variety of other
representations of scene and to other artists.

935 VENTURI, LIONELLO. "Reconstruction of a Painting by Andrea
del Castagno." Art Quarterly 7, no. 1 (1944):23-32, 12
illus.
Fragments of a painting, on London market, that orig-
inally illustrated theme of the Pietà with an Abbreviated Story
of the Passion. Photographic reconstruction. Attributon to
Castagno.

Andrea del Castagno

936　YUEN, TOBY. "The Bibliotheca Graeca: Castagno, Alberti and Ancient Sources." Burlington Magazine 112, no. 812 (1970):725-36, 19 illus.
　　　Lengthy study of room in Vatican, originally forming part of library of Sixtus IV, with all'antica decoration. Dates in 1450s, attributes design to Castagno and Alberti in collaboration.

CENNI DI FRANCESCO (act. ca. 1370-ca. 1415)

937　BOSKOVITS, MIKLÒS. "Ein Vorläufer der spätgotischen Malerei in Florenz: Cenni di Francesco di ser Cenni." Zeitschrift für Kunstgeschichte 31, no. 4 (1968):273-92, 17 illus.
　　　Attempts to outline Cenni's development. Reviews earlier literature and attributions, gathers works together.

938　COLE, BRUCE. "Three New Works by Cenni di Francesco." Burlington Magazine 111, no. 791 (1969):83, 5 illus.
　　　Attributes two Madonna and Child groups, whereabouts unknown; and Annunciation fresco, Sta. Maria Novella, Florence, ca. 1390.

939　D[AINELLI], G[IOTTO]. "Un paesaggio realista del Cenni." Vita d'arte 5, no. 28 (1910):149-54, 4 illus.
　　　Landscape in frescoed Legend of True Cross, S. Francesco, Volterra, closely resembles local site. Unusually realistic in Cenni's oeuvre.

940　WILKINS, DAVID. "Maso di Banco and Cenni di Francesco: A Case of Late Trecento Revival." Burlington Magazine 111, no. 791 (1969):83-84, 4 illus.
　　　Demonstrates that Cenni used Maso's Madonna from altarpiece in Sto. Spirito, Florence, 1340, as a prototype. Exemplifies late trecento interest in Maso.

PIETRO CHELLINI (act. 1405-56)

941　COHN, W[ERNER]. "Maestri sconosciuti del quattrocento fiorentino. III. Pietro Chellini." Bollettino d'arte 45, no. 1-2 (1960):180-85, 5 illus.
　　　Publishes documents from 1405 to 1456 regarding various projects, including paintings in S. Giovanni Evangelista, Montelupo.

PIETRO COLEBERTI (act. early fifteenth century)

942　BERTINI-CALOSSO, ACHILLE. "Un affresco di Pietro Coleberti a Gubbio." Rivista dell'Istituto nazionale d'archeologia e storia dell'arte 1 (1952):298-316, 6 illus.

Dello Delli/Nicola Fiorentino

Attribution of fragmentary work. Subject identified as transportation of holy house of Loreto. Dated ca. 1390-1410. Includes bibliography on work, which is usually dated in trecento.

CRISTOFORO DI GIOVANNI (doc. 1433-died 1457-66)

943 ALEANDRI, VITTORIO EMANUELE. "Dei pittori sanseverinati Cristoforo di Giovanni, Bartolomeo Friginisco e Ludovico Urbani nella metà del secolo XV." Arte e storia 13, no. 20 (1894):153-57.
Publishes several documents regarding painters who followed the Salimbeni. Catalogs works by Urbani and makes some attributions to all three. Extensive footnotes.

944 PACHIARONI, RAOUL. "Documenti inediti di pittori sanseverinati: Cristoforo di Giovanni." Commentari 28, no. 4 (1977):297-99.
Reviews documents of 1433-66 clarifying career of artist.

DELLO DELLI (ca. 1403-71); NICOLA FIORENTINO (1413-70/71)

945 CASALINI, EUGENIO. "Un 'calvario' a fresco per la pietà di Dello Delli." In La SS. Annunziata di Firenze: Studi e documenti sulla chiesa e il convento. Vol. 1. Florence: Convento della SS. Annunziata, 1978, pp. 9-24, 2 illus.
Discusses fifteenth-century Calvary fresco, related to lost sculpted Pietà by Delli, mentioned by Vasari. Reconstructs history of Cappella della Pietà. Suggests fresco painted by Bicci di Lorenzo, 1420-24, or perhaps Delli.

946 CONDORELLI, ADELE. "Precisazioni su Dello Delli e su Nicola Fiorentino." Commentari 19, no. 3 (1968):197-211, 5 illus.
Reconstructs biography of Delli from documents. Separates out biography of Nicola Fiorentino, identified as Delli's brother. Appends documents.

947 FIOCCO, GIUSEPPE. "Dello Delli scultore." Rivista d'arte 11 (1929):25-42, 4 illus.
Review of documents concerning Bicci di Lorenzo to separate works from Dello Delli." Attributes Coronation of Virgin lunette from Sta. Maria Nuova, Florence, to Delli.

948 _____. "Il mito di Dello Delli." In Arte in Europa: Scritti di storia dell'arte in onore di Edoardo Arslan. 2 vols. Milan: Artipo, 1966, pp. 341-49, 7 illus.
Reviews various constructions of Delli's life and career. Rejects attribution of altarpiece, Salamanca.

Dello Delli/Nicola Fiorentino

949 GAMBA, CARLO. "Nuova testimonianze di Dello Delli." Dedalo
 8, no. 1 (1927-28):219-26, 5 illus.
 Publishes photographs of Delli's painting in Old Cathe-
 dral, Salamanca. Notes relationships with various important
 artists of the time.

950 GOMEZ-MORENO, M[ANUEL]. "El retablo de la catedral vieja y
 Nicolao Florentino." Boletin de la sociedad castellana de
 excursiones 2 (1905-6):131-36, 4 illus.
 Study of multipaneled altarpiece in Salamanca, 1440s,
 felt to be by a Tuscan artist. Discusses possible attribution
 to Nicolao, who may be identified with Dello Delli.

951 GOMEZ-MORENO, MANUEL, and SANCHEZ CANTON, FRANCISCO JAVIER.
 "El retablo de la catedral vieja de Salamanca." Archivo
 español de arte y arqueologia 4 (1928):1-24, 76 illus.
 Attributes many paneled retable to a "Nicolae Florentino,"
 ca. 1445, who is tentatively identified with Dello Delli.

952 GRONAU, GIORGIO. "Il primo soggiorno di Dello Delli in
 Spagna." Rivista d'arte 14 (1932):385-86.
 Publishes documents dating artist's first trip to Spain
 in 1433.

953 SALMI, MARIO. "Un' opera giovanile di Dello Delli."
 Rivista d'arte 11 (1929):104-10, 3 illus.
 Cassone front, Lindenau Museum, Altenburg, of battle
 scene, attributed to Delli early in career. Notes influence of
 Lorenzo Monaco.

954 SCHMARZOW, AUGUST. "Nicolas Florentino in Salamanca."
 Monatshefte für Kunstwissenschaft 4, no. 4 (1911):143-61,
 1 illus.
 Discusses multipaneled retable, in Old Cathedral,
 Salamanca, documented in 1445. Describes each panel.

 FRA DIAMANTE (ca. 1430-after 1498)

955 MILANESI, GAETANO. "Les élèves de Fra Filippo Lippi."
 L'arte 4, no. 1 (1878):63-65.
 Reviews careers of Fra Diamante and Jacopo Sellaio with
 some new documentation.

956 PITTALUGA, MARY. "Fra Diamante collaboratore di Filippo
 Lippi." Rivista d'arte 23 (1941):19-71, 20 illus.
 Basic attempt to define oeuvre of artist. Relates to
 Lippi and to Pesellino. Makes various attributions. Attrib-
 utes one group of works to Master of the Louvre Nativity.

 ULMANN, HERMANN. Fra Filippo Lippi and Fra Diamante als
 Lehrer Sandro Botticellis. See entry 1265.

957 VENTURI, A[DOLFO]. "Don Diamante prigione nel 1498." Arte
 e storia 3, no. 13 (1884):101-2.
 Publishes document written to Duke Ercole I that refers
 to Fra Diamante as a prisoner.

DOMENICO DI BARTOLO (ca. 1400-47)

Dissertation

958 WAGNER, HANS JOACHIM. "Domenico di Bartolo Ghezzi." Ph.D.
 dissertation, University of Göttingen, 1898, 42 pp.
 Brief thoughts on artist. Chapter on Taddeo di Bartolo
 as background. Sees Domenico as first Renaissance painter in
 Siena. Relates to other artists of time, especially Nelli.

Articles

959 BRANDI, CESARE. "Ein desco da parto und seine Stellung
 innerhalb der toskanischen Malerei nach dem Tode Massaccios."
 Jahrbuch der preussischen Kunstsammlungen 55, no. 3
 (1934):154-80, 16 illus.
 Plate with Birth of Virgin, Kaiser-Friedrich Museum,
 Berlin, attributed to Domenico di Bartolo rather than Masaccio.
 Stylistic analysis dates work in 1430s.

960 _____. "Die Verkündigung in S. Pietro a Ovile."
 Mitteilungen des kunsthistorischen Institutes in Florenz 3,
 no. 6 (1931):322-48, 19 illus.
 Attributes altarpiece in Siena to Domenico di Bartolo,
 1444-49. Reconstructs and places in context of artist's career.

961 CARLI, ENZO. "Sulla Madonna del Manto e su altri affreschi
 nello Spedale di Santa Maria della Scala a Siena." In
 Studies in Late Medieval and Renaissance Painting in Honor
 of Millard Meiss. Edited by Irving Lavin and John Plummer.
 New York: New York University Press, 1977, pp. 73-82, 14
 illus.
 Discusses Madonna del Manto by Domenico di Bartolo, re-
 stored in 1969. Sinopia, other designs, and additional frag-
 ments revealed, as well as fresco and preparatory design of
 Feeding of the Sick by anonymous master. Identifies figures,
 discusses original locations.

962 GAROSI, ALCIDE. "L'affresco di Domenico di Bartolo:
 L'assistenza e la cura degli infermi: Contributo alla
 storia dell'insegnamento clinico." Rinascita 5, no. 28
 (1942):607-12, 1 illus.
 Interprets painting in Spedale di Santa Maria della
 Scala, Siena, as a historical document representing the teach-
 ing of medicine. Describes care being administered.

Domenico di Bartolo

963 GENGARO, MARIA LUISA. "A proposito di Domenico di Bartolo."
 L'arte 39, no. 2 (1936):104-22, 7 illus.
 Discusses humanistic qualities of art and notes influence
 of Donatello and of Florentine painters.

964 MARINI FRANCESCHI, EVELYN. "L'opera di due vecchi pittori
 senesi a Sansepolcro." Bulletino senese di storia patria 11
 (1904):151-59, 2 illus. [Also published in Arte antica
 senese (Siena: Commissione di storia patria, 1904).]
 Discusses altarpiece of Resurrection. S. Chiara,
 Sansepolcro attributed to Domenico di Bartolo.

965 PERKINS, F. MASON. "Un capo-lavoro dimenticato di Domenico
 di Bartolo." Rassegna d'arte senese 4, no. 1 (1908):22-25.
 Attribution of panel painting of Praying Madonna, S.
 Raimondo (Chiesa del Refugio), Siena.

966 POPE-HENNESSY, JOHN. "The Development of Realistic Painting
 in Siena." Burlington Magazine 84, no. 494 (1944):110-19, 6
 illus.; no. 495 (1944):139-44, 7 illus.
 Account of stylistic development of Domenico di Bartolo,
 emphasizing his growing familiarity with Florentine art and
 deemphasizing Masacciesque character. Includes documentary
 information. Follows with variety of attributions given to and
 taken from later fifteenth-century Sienese painters, including
 Vecchietta.

967 TOESCA, PIETRO. "Una scatola dipinta di Domenico di Bartolo."
 Rassegna d'arte senese 13, no. 4 (1920):107-8, 2 illus.
 Attribution of wooden box, Figdor Collection, Vienna,
 with scene of lovers. Dates ca. 1438.

 DOMENICO DI MICHELINO (1417-91)

Book

968 MARCHISIO, CESARE. Il monumento pittorico a Dante in Santa
 Maria del Fiore. Domenico di Michelino, Bartolomeo Scala.
 Rome: Fratelli Palombi editori, 1956, 210 pp., 14 illus.
 Detailed analysis of historical situation and cultural
 background for painting. Examination of all its details. Dis-
 cussion of contribution of Baldovinetti. Sections on critical
 fortunes of work, artist's career, and on inscription and its
 author, Bartolommeo Scala. Lengthy appendix on matters relat-
 ing to Dante, including representations in art. Documents,
 bibliography, and indexes.

Articles

969 ALTROCCHI, RUDOLPH. "Michelino's Dante." Speculum 6, no. 1
 (1931):15-59, 8 illus.

Detailed study of painting of <u>Florence,</u> <u>Dante</u> <u>and</u> <u>the</u>
<u>Divine</u> <u>Comedy</u>, Duomo, Florence, 1465. Discusses history of the
work and its location. Publishes documents. Examines each
section of picture and its inscription, possibly written by
Bartolommeo Scala.

970 BALDINI, UMBERTO. "Die Sonne von Florenz." In <u>Dante</u>
<u>Alighieri</u>. Wurzburg: Leo Leonhardt Verlag, 1966, pp. 163-
67, 2 illus.
 Description of painting of Dante in Duomo, Florence, by
Domenico di Michelino, done in 1465 and restored in 1964. Notes
documentary accuracy of view of Florence. Golden rays issuing
from volume of <u>Commedia</u> identify it as the "sun" of Florence.
English summary.

971 CIARANFI, ANNA MARIA. "Domenico di Michelino." <u>Dedalo</u> 6,
no. 2 (1926):522-38, 12 illus.
 Reconstruction of artist's career. Style seen as close
to Lippi. Makes numerous attributions, including some usually
given to Giusto di Andrea.

972 LOOS, ERICH. "Das Bild als Deutung Dantes von Domenico
di Michelino in Santa Maria del Fiore, Florenz." In
<u>Festschrift</u> <u>für</u> <u>Otto</u> <u>von</u> <u>Simson</u> <u>zum</u> <u>65.</u> <u>Geburtstag</u>. Edited
by Lucius Grisebach and Konrad Renger. Munich: Propylaen
Verlag, 1977, pp. 160-72, 1 illus.
 Discusses iconography of painting.

973 RAGGHIANTI-COLLOBI, LICIA. "Domenico di Michelino."
<u>Critica</u> <u>d'arte</u> 8, no. 5 (1950):363-78, 19 illus.
 Attempt to reconstruct artist's career, with particular
attention to early period. Discusses numerous attributions,
evaluating those of earlier critics. Notes influence of Fra
Angelico.

DOMENICO VENEZIANO (ca. 1410-61)

<u>Book</u> <u>and</u> Dissertation

SALMI, MARIO. <u>Paolo</u> <u>Uccello,</u> <u>Andrea</u> <u>del</u> <u>Castagno,</u> <u>Domenico</u>
<u>Veneziano</u>. See entry 208.

974 WOHL, HELLMUT. "Domenico Veneziano Studies." 3 vols.
Ph.D. dissertation, New York University, 1958, 455 pp., 106
illus.
 Examines Domenico Veneziano's career and art as a whole.
Appendixes of lost works, documents and sources, and apocryphal
works.

975 _____. The <u>Paintings</u> <u>of</u> <u>Domenico</u> <u>Veneziano</u> <u>ca.</u> <u>1410-61:</u> A
<u>Study</u> <u>in</u> <u>Florentine</u> <u>Art</u> <u>of</u> <u>the</u> <u>Early</u> <u>Renaissance</u>. New York

Domenico Veneziano

and London: New York University Press, 1980, 437 pp., 254
illus.
 Comprehensive monograph on artist. Includes chapters on
biography and chronology, on St. Lucy altarpiece, and on phases
of development. Catalogue raisonnée of accepted, rejected, and
lost works. Documents and sources, bibliography.
 Review: Anne Markham Schulz, Art Bulletin 63, no. 2
(1981):334-35.

Articles

976 AMES-LEWIS, FRANCIS. "Domenico Veneziano and the Medici."
 Jahrbuch der Berliner Museen 21 (1979):67-90, 10 illus.
 Investigates possibility that some of Domenico's works
 were Medici commissions. Proposes Medici involvement in com-
 missioning of Cappella Maggiore, S. Egidio. Attributes Adora-
 tion, Berlin, to Domenico and suggests a Medicean provenance
 for it.

977 BATTISTI, EUGENIO. "Le conoscenza prospettiche di Domenico
 Veneziano." Arte lombarda 16 (1971):104-6, 14 illus.
 Analyzes system of St. Lucy altarpiece, Uffizi, Florence.
 Diagrams.

978 BERTI, LUCIANO. "Domenico Veneziano." In Encyclopedia of
 World Art. Vol. 4. London: McGraw Hill, 1961, col. 421-
 27, 5 b&w and 4 color illus.
 Reviews documented information and development of career.
 Discusses theories of artist's development and role. Evaluates
 attributions. Bibliography.

979 BODE, W[ILHELM] [VON]. "Aus der Berliner Gemäldegalerie:
 Eine Predellatafel von Domenico Veneziano." Jahrbuch der
 preussischen Kunstsammlungen 4 (1883):89-93, 2 illus.
 Attributes predella panel of Martyrdom of St. Lucy.

980 _____. "Domenico Venezianos Profilbildnis eines jungen
 Mädchens in der Berliner Galerie." Jahrbuch der
 preussischen Kunstsammlungen 18 (1897):187-93, 2 b&w and 1
 color illus.
 Attributes portrait and dates in 1460s. Compares to
 Piero's Battista Sforza. (This work is now also frequently
 attributed to Pollaiuolo.)

981 BODE, W[ILHELM], and TSCHUDI, H. VON. "Anbetung der Könige
 von Vittore Pisano und die Madonna mit Heiligen aus dem
 Besitz des Cav. dal Pozzo." Jahrbuch der preussischen
 Kunstsammlungen 6 (1885):10-22, 5 illus.
 Attributes Adoration, now often attributed to Domenico
 Veneziano, to Pisanello.

*982 BOECK, WILHELM. "Das Anbetungstondo von Domenico Veneziano
 im Kaiser Friedrich Museum." Sitzungsberichte der
 kunstgeschichtliche Gesellschaft, Berlin (1931-32):12ff.
 Source: entry 975.

983 ____. "Domenico Veneziano." Pantheon 13 (March 1934):79-
 85, 7 illus.
 Surveys origins and character of oeuvre, including Vene-
 tian elements, and relation to Piero. English summary.

984 BOMBE, WALTER. "Der Palast des Braccio Baglioni in Perugia
 und Domenico Veneziano." Repertorium für Kunstwissenschaft
 32 (1909):295-301.
 Rejects Milanesi's identification of Domenico Veneziano's
 lost frescoes with a series of uomini illustri also done for
 the palace (entry 17). Includes fifteenth-century epitaphs
 for latter.

985 BRANDI, CESARE. "I cinque anni cruciali per la pittura
 fiorentina del '400." In Studi in onore di Matteo
 Marangoni. Florence: Vallecchi, 1957, pp. 167-75, 5 illus.
 Considers art of period 1427-32, particularly activity of
 Domenico Veneziano. Notes influence of Masolino, suggests
 possible collaboration of Domenico in S. Clemente cycle, Rome.

986 BUSUIOCEANU, A. "Una nuova Madonna di Domenico Veneziano."
 L'arte 40, no. 1 (1937):3-15, 4 illus.
 Publication and attribution of Madonna and Child, Collec-
 tion of King of Rumania, Bucharest (now Art Museum of the
 Romanian People's Republic) to early period of Domenico
 Veneziano.

987 CHIAPPELLI, ALESSANDRO. "Una nuova opera di Domenico
 Veneziano." L'arte 27 (1924):93-97, 1 illus. [Also
 published as "Anconetta inedita di Domenico Veneziano," in
 Arte del rinascimento (Rome: Casa editrice Alberto Stock
 1925), pp. 137-42.]
 Publishes Crucifixion with Two Saints, Formilli Collec-
 tion, Florence. Argues for validity of signature. Believes to
 be center of predella of St. Lucy altarpiece. See entry 991.

988 DEGENHART, BERNHARD. "Domenico Veneziano als Zeichner." In
 Festchrift Friedrich Winkler. Berlin: Verlag Gebr. Mann,
 1959, pp. 100-113, 19 illus.
 Attributes several drawings. Discusses relation to
 Jacopo Bellini and Pisanello. Includes a list of attributed
 works.

989 GIOSEFFI, DECIO. "Domenico Veneziano: L'Esordio masaccesco'
 e la tavola con i SS. Girolamo e Giovanni Battista della
 National Gallery di Londra." Emporium 135, no. 806
 (1962):51-72, 18 illus.

Domenico Veneziano

Problems of chronology and attributions. Postulates
Domenico's authorship, ca. 1432, of panel in National Gallery,
London, usually given to Masaccio.

990 HALL, MARCIA. "The Tramezzo in S. Croce, Florence and
 Domenico Veneziano's Fresco." Burlington Magazine 112, no.
 813 (1970):797-99, 2 illus.
 Reconstructs original location of fresco of St. John the
 Baptist and St. Francis, on a projecting wall segment asso-
 ciated with gates of tramezzo structure, which was removed in
 sixteenth century.

991 LONGHI, ROBERTO. "Un frammento della pala di Domenico
 Veneziano per Santa Lucia de' Magnoli." L'arte 28
 (1925):31-35, 2 illus.
 Rejects Chiapelli's attribution of Crucifixion, Formilli
 Collection, Florence (see entry 987). Attributes Stigmatiza-
 tion of St. Francis, Rome, Contini-Bonacossi Collection, (now
 Washington, National Gallery), 1440, and Adoration of Magi,
 Berlin, ca. 1430-35.

992 MURARO, MICHELANGELO. "Domenico Veneziano at San Tarasio."
 Art Bulletin 41, no. 2 (1959):151-58, 32 illus.
 Frescoes in Chapel of S. Tarasio, in S. Zaccaria, Venice,
 recently restored. Attributes upper half of St. John Evangelist
 to Domenico Veneziano. Discusses other artists also working in
 chapel.

993 PACCAGNINI, GIOVANNI. "Una proposta per Domenico Veneziano."
 Bollettino d'arte 37, no. 2 (1952):115-26, 10 illus.
 Publishes and attributes a Madonna in the Museo
 Nazionale, Pisa, ca. 1440. Notes influence of Gentile, Fra
 Angelico, and Lippi.

994 POPE-HENNESSY, JOHN. "The Early Style of Domenico Veneziano."
 Burlington Magazine 93, no. 580 (1951):216-23, 6 illus.
 Attributes predella and foreground of Fra Angelico's
 Coronation, Louvre, to Domenico Veneziano. Dates ca. 1435-36,
 rather than 1448-50. Considers relation to Piero.

995 PUDELKO, GEORG. "Studien über Domenico Veneziano."
 Mitteilungen des Kunsthistorischen Institutes in Florenz 4,
 no. 4 (1934):145-200, 22 illus.
 Fundamental early study of artist. Sections on major
 works. Essay on Domenico and Florentine color. Excursus on
 development of sacra conversazione theme. Bibliography, biog-
 raphy, and list of attributed works.

996 SANTI, FRANCESCO. "L'affresco baglionesco della Galleria
 Nazionale dell'Umbria." Commentari 21, no. 1-2 (1970):51-
 54, 2 illus.

Fresco of man in armor, Galleria Nazionale, Perugia, identified as remnant of uomini illustri cycle from Palazzo Baglioni. Attributes to Domenico Veneziano, ca. 1438.

997 SCHMARSOW, AUGUST. "Die Cappella dell'Assunta in Dom zu Prato." Repertorium für Kunstwissenschaft 16 (1893):159-97. Attributes frescoes to Domenico Veneziano in 1440s.

998 _____. "Domenico Veneziano." L'arte 15 (1912):9-20, 81-98, 15 illus.
 Makes several attributions: Madonna (now attributed to Master of Castello Nativity), Louvre; frescoes in Cappella dell'Assunta, Duomo, Prato; and fresco of Sts. Francis and John the Baptist, Sta. Croce, Florence.

999 SEMENZATO, CAMILLO. "Un'opera giovanile di Domenico Veneziano?" Rivista d'arte 29 (1954):133-41, 2 illus.
 Attribution of Pietà, Museo di Castelvecchio, Verona, to Domenico rather than to Jacopo Bellini. Discusses interaction between of northern and southern Italy.

1000 SHELL, CURTIS. "Domenico Veneziano: Two Clues." In Festchrift Ulrich Middeldorf. Edited by Antje Kosegarten and Peter Tigler. Berlin: De Gruyter, 1968, pp. 150-54, 9 illus.
 Argues in favor of attribution of desco da parto, Berlin. Analyzes Madonna, Accademia Carrara, Bergamo, as a copy of a lost work by Domenico, made by Pseudo Pier Francesco Fiorentino. Proposes a chronology for Domenico's Madonnas.

1001 SUIDA, WILHELM. "Ein Bildnis von Domenico Veneziano." Belvedere 8, no. 12 (1929):433-34, 1 illus.
 Questions many portraits attributed to Domenico. Publishes male figure, private collection, Florence, which attributes to him.

1002 VAN MARLE, RAIMOND. "Ein Domenico Veneziano in der Sammlung Rohoncz." Cicerone 22, no. 13-14 (1930):369-70, 1 illus.
 Attributes figure of monk (now Thyssen Gallery, Lugano). Identifies tentatively as Saint Francis.

1003 VENTURI, ADOLFO. "Tavoletta di Domenico Veneziano. L'arte 28, (1925):28-30, 2 illus.
 Affirms attribution of Annunciation, Fitzwilliam Museum, Cambridge.

1004 VENTURI, L[IONELLO]. "Un quadro del Museo di Verona." L'arte 7 (1904):300-301, 1 illus.
 Attributes Crucifixion, Museo Civico, Verona.

1005 VERGA, CORRADO. "Un pavimento di Piero?" Critica d'arte 42, no. 151-53 (1977):100-115, 7 illus.

Artists

Domenico Veneziano

Reconstructs pavement and architectural space of Domenico
Veneziano's St. Lucy altarpiece, Uffizi. Sees ideas of Piero
in pavement design. Diagrams.

1006 WELLIVER, WARMAN. "The Symbolic Architecture of Domenico
 Veneziano and Piero della Francesca." Art Quarterly 36, no.
 1-2 (1973):1-30, 14 illus.
 Analyzes architecture in Piero's Flagellation and
 Montefeltro altarpiece and Domenico Veneziano's Annunciation
 and St. Lucy altarpiece. Considers fifteenth-century units of
 measurement, their relation to human proportions, and possible
 symbolism in proportions.

1007 WOHL, HELLMUT. "Domenico Veneziano Studies: The
 Sant'Egidio and Parenti Documents." Burlington Magazine
 113, no. 824 (1971):635-41.
 Documents payments for two lost projects for Sant'Egidio
 choir frescoes, 1439-41, and for two cassoni for Marco Parenti,
 1447. Establishes periods of activity. Appendix on terms and
 monetary units.

FRANCESCO D'ANTONIO ARETINO (doc. 1435-56)

1007a CORBO, ANNA MARIA. "Notizie romane di Francesco di Antonio
 pittore aretino." Commentari 21, no. 3 (1970):243-44.
 Publishes document of 1455 recording presence of artist
 in Rome. Cites other documents of 1450s.

FRANCESCO D'ANTONIO FIORENTINO (1394-1433 or later)

1008 BERTI, LUCIANO. "Francesco d'Antonio di Bartolomeo."
 Bollettino d'arte 37, no. 2 (1952):175-78, 6 illus.
 Reproduces and discusses Madonna della Cintola, S. Vito,
 Loppiano, and polyptych, S. Niccolo, Florence, ca. 1428.

1009 GRONAU, GIORGIO. "Francesco d'Antonio pittore fiorentino."
 Rivista d'arte 14 (1932):382-85.
 Documents establishing birthdate as 1394. Mentions other
 documentary information.

1010 RICE, EUGENE. "St. Jerome's Vision of the Trinity: An
 Iconographic Note." Burlington Magazine 125, no. 960
 (1983):151-54, 2 illus.
 Discusses Francesco's predella in Musée du Petit Palais,
 Avignon, and Castagno's fresco, SS. Annunziata, Florence.

1011 SALMI, MARIO. "Francesco d'Antonio fiorentino." Rivista
 d'arte 11 (1929):1-24, 291, 11 illus.

Reconstruction of a group of works that are given to a Francesco d'Antonio. Belongs to retardataire trend, influenced primarily by Lorenzo Monaco.

1012 SHELL, CURTIS. "Francesco d'Antonio and Masaccio." Art Bulletin 47, no. 4 (1965):465-69, 14 illus.
 Attributes Healing of Lunatic Boy, Johnson Collection, Philadelphia, to Francesco d'Antonio, ca. 1429. Demonstrates "empirical" rather than "advanced" nature of perspective scheme and its dependence on Masolino, not Masaccio.

1013 ZERI, FEDERICO. "Note su quadri italiano all'estero II: Ricostruzione di un trittico di Francesco di Antonio di Bartolomeo." Bollettino d'arte 34, no. 1 (1949):22-26, 4 illus.
 Unites Madonna, National Gallery, Washington, with pairs of Saints in Museum, Pisa.

ROSSELLO DI JACOPO FRANCHI (ca. 1376-1456)

Dissertation

1014 PETERS, CAROL TALBERT. "Rossello di Jacopo Franchi: Portrait of a Florentine Painter, ca. 1376-1456." Ph.D. dissertation, Indiana University, 1981, 385 pp., 84 plates.
 Reconstructs chronology of artist, based primarily upon preserved catasti. Attention to cultural milieu and relation to current artistic trends in fifteenth-century Florence.

Articles

1015 BERENSON, BERNARD. "Due quadri inediti a Staggia." Rassegna d'arte 5, no. 1 (1905):9-11, 2 illus.
 Includes Madonna Enthroned signed by Rossello di Jacopo Franchi. Mentions other works by same artist.

1016 GAMBA, C[ARLO]. "Un altro quadro di Rosello di Jacopo Franchi." Rassegna d'arte 6, no. 9 (1906):144.
 Locates work signed and dated 1439 in Franchi Collection, Siena. Identifies artist with Siren's "Compagno di Bicci" (entry 212).

GENTILE DA FABRIANO (ca. 1370-1427)

Books and Dissertations

1017 CHRISTIANSEN, KEITH R. "Gentile da Fabriano." 2 vols. Ph.D. dissertation, Harvard University, 1977, 419 pp., 72 illus.

Gentile da Fabriano

Monographic dissertation with chapters on artist's life, work in the Marches, Venice, and Florence. Catalogue raisonnée of attributed works, with sections on lost works and erroneous attributions. Attempts to define Gentile's contribution.

1018 _____. Gentile da Fabriano. Ithaca, N.Y.: Cornell University Press, 1982, 202 pp., 166 b&w and 4 color illus.
Modern monograph on artist's work and career, emphasizing his innovative role in the early fifteenth century. Includes catalog of works, documents, appendix reconstructing Orvieto fresco, and bibliography.
Review: Julian Gardner, Burlington Magazine 125, no. 963 (1983):364-65.

1019 COLASANTI, ARDUINO. Gentile da Fabriano. Collezione di monografie illustrate, 6. Bergamo: Istituto italiano d'arti grafiche, 1909, 96 pp., 114 illus.
Early monograph. Reviews life and formative elements of art, including late fourteenth-century painting in Fabriano, early fifteenth-century school of the "appennino centrale." Discusses work and influence. Much comparative material and many details in illustrations.

1020 GOLLOB, HEDWIG. Gentile da Fabriano und Pisanellos Fresken am Hospitale von St. Giovanni in Laterano zu Rom. Zur Kunstgeschichte des Auslandes, 124. Strassburg: Heitz, 1927, 36 pp., 20 illus.
Seventeenth-century watercolors after Job and Tobias cycles from facade of hospital of San Giovanni Laterano. Attributes Job cycle to Gentile.
Review: Bruno Molajoli, Gentile da Fabriano, no. 3 (August-September 1928):88.

1021 GRASSI, LUIGI. Tutti la pittura di Gentile da Fabriano. Biblioteca d'arte Rizzoli, 13. Milan: Rizzoli, 1953, 78 pp., 104 b&w and 4 color illus.
Survey of career, chronological outline, list of works in the form of notes on the plates, and notes on lost paintings and attributed paintings. Geographical index. Excerpts from critical writings, brief bibliography.

*1022 HUTER, CARL. "The Veneto and the Art of Gentile da Fabriano." Ph.D. dissertation, University of London, 1966.
Source: entry 1018.

1023 MELNIKAS, ANTANAS. "Gentile da Fabriano: The Origins and Development of His Style." Ann Arbor: University of Michigan, 1961, 362 pp., 145 illus.
Monograph with survey of major phases of Gentile's art, catalog of works, and appendixes of poems admiring Magdalen from Valle Romita altarpiece and of section of Codice Malatestiano. Bibliography.

1024 MICHELETTI, EMMA. L'opera completa di Gentile da Fabriano.
 Classici dell' arte, 86. Milan: Rizzoli, 1976, 96 pp., 52
 b&w and 64 color illus.
 Introductory essay, survey of critical writings, bibliog-
 raphy, and documents. Catalogs of works and of attributed
 works.

1025 MOLAJOLI, BRUNO. Gentile da Fabriano. Fabriano: Edizione
 dello stabilmento tip. "Gentile," 1927, 125 pp., 26 illus.
 Monograph with fairly general overview. Brief
 bibliography.

1026 VASARI, GIORGIO. Le vite: Gentile da Fabriano e il
 Pisanello. Edited by Adolfo Venturi. Florence: Sansoni,
 1896, 145 pp., many unnumbered illus.
 Reprints both editions of Vasari's biographies. Text of
 later 1568 edition, printed in black surrounding text of 1550
 edition in red. Followed by series of fifty-two short sections
 on various documented activities.

Articles

1027 ARSLAN, EDOARDO. "Gentile da Fabriano." In Encyclopedia of
 World Art. Vol. 6. London: McGraw Hill, 1962, col. 108-
 12, 5 b&w and 2 color illus.
 Reviews development, emphasizing relation to Lombard
 style.

1028 BAXANDALL, MICHAEL. "Bartholomaeus Facius on Painting: A
 Fifteenth Century Manuscript of the De Viris Illustribus."
 Journal of the Warburg and Courtauld Institutes 27
 (1964):90-107, 8 illus.
 Publishes text of chapter De pictoribus from manuscript
 in Vatican Library. Juxtaposes with English translation. Ana-
 lyzes Facius's artistic standards, which transfer attitudes
 about poetry. Text includes life of Gentile.

1029 BEHLING, LOTTLISA. "Das italienische Pflanzenbild um 1400-
 zum Wesen des pflanzlichen Dekors auf dem Epiphaniasbild des
 Gentile da Fabriano in den Uffizien." Pantheon 24, no. 6
 (1966):347-59, 15 illus.
 Analysis of thirty-six plants on corner posts of frame of
 Adoration, Uffizi, Florence. Compares choices to ones found on
 Northern European paintings. Symbolism corresponds to subject
 of altarpiece, especially to Christ as light. English summary.

1030 BERENSON, B[ERNHARD]. "Gentile da Fabriano (scoperte e
 primizie artistiche)." Rassegna d'arte 4, no. 10
 (1904):158.
 Brief notice of portrait of young man, Leatham Collec-
 tion, Miserden Park, Cirencester, England.

Gentile da Fabriano

1031 BOMBE, WALTER. "L'opere di Gentile da Fabriano alla mostra
 d'arte antica umbra." Augusta Perusia 2, no. 7-8
 (1907):113-15, 1 illus.
 Discusses attributions to Gentile of several Madonnas in
 exhibition.

1032 BRANDI, CESARE. "A Gentile da Fabriano at Athens."
 Burlington Magazine 120, no. 903 (1978):385-86, 4 illus.
 Attribution of Madonna and Child, National Gallery,
 Athens. Dates ca. 1418.

1033 CANTALAMESSA, GIULIO. "Un dipinto sconosciuto di Gentile da
 Fabriano." Bollettino d'arte 9, no. 9 (1915):257-61, 3
 illus.
 Publishes Madonna and Child with Santa Rosa, Galleria,
 Urbino. Accepts attribution to Gentile. Suggests various
 possible non-Italian influences on style.

1034 _____. "Vecchi affreschi a S. Vittoria in Matenano
 attribuiti a Gentile." Nuova rivista misena 3, no. 1
 (1890):3-10.
 Describes cycle, mentioned by Vasari as in manner of
 Gentile. Attributes to him, dates in early years of fifteenth
 century.

1035 CHIAPPELLI, ALESSANDRO. "Per la predella del polittico
 Quaratesi di Gentile da Fabriano." Gentile da Fabriano 3
 (August-September 1928):60-61.
 Traces provenance of part of predella, location unknown
 (now National Gallery, Washington).

1036 CHIAPPINI DI SORIO, ILEANA. "Documenti bresciani per
 Gentile da Fabriano." Notizie da Palazzo Albani 2, no. 2
 (1973):17-26, 1 illus.
 Gathers documents, published and unpublished, concerning
 Gentile's sojourn in Brescia 1414-19 and his decoration of the
 Cappella del Broletta.

1037 CHRISTIANSEN, KEITH. "The Coronation of the Virgin by
 Gentile da Fabriano." J. Paul Getty Museum Journal 6-7
 (1978-1979):1-12, 10 illus.
 Newly acquired panel paired with Stigmatization of St.
 Francis, Milan, Carminati Collection. Dates ca. 1420. Reas-
 sesses Gentile's chronology and his relation to Florentine art.
 Appendix on provenance. Technical report by David Bull.

1038 CLERI, BONITA. "La Madonna del Pianto di Sant'Angelo in
 Vado: Un' ipotesi per Gentile da Fabriano." Notizie da
 Palazzo Albani 8, no. 1 (1979):7-14, 6 b&w and 1 color
 illus.
 Publishes recently restored work. Considers close to,
 perhaps even attributable to Gentile, very early in career.

1039 COLASANTI, ARDUINO. "Le prime opere di Gentile da Fabriano."
 Rassegna marchigiana 12, no. 5 (1934):180-86, 4 illus.
 Discusses early style in Valle Romita altarpiece, Milan,
 Brera, Stigmatization of St. Francis, formerly in Fornari Col-
 lection, Fabriano, and Madonna and Saints, Kaiser Friedrich
 Museum, Berlin.

1040 _____. "Un quadro ignorato di Gentile da Fabriano."
 Bollettino d'arte 5, no. 2 (1911):33-35, 76, 1 illus.
 Publishes Madonna, Musée des Arts Decoratifs, Paris.
 Dates ca. 1423-25.

1041 _____. "Un quadro inedito di Gentile da Fabriano."
 Bollettino d'arte 1, no. 11 (1907):19-22, 2 illus.
 Supports attribution of Stigmatization of St. Francis,
 Fornari Collection, Fabriano (now Carminati Collection, Milan),
 to Gentile. Attributes copy, in same collection, to Giovanni
 di Paolo.

1042 CRISPINI, GIUSEPPE. "Un dipinto del periodo giovanile di
 Gentile da Fabriano." In Studi maceratesi. Vol. 5, Civiltà
 del rinascimento nel Maceratesa. Atti del V Convegno del
 centro di studi storici maceratesi. Macerata: N.p., 1971,
 pp. 248-54, 1 illus.
 Attribution of fresco of Miracle of St. Anthony, S.
 Francesco, Sanginesio. Dates earlier than usual, ca. 1385-90.
 Comments on local elements of Gentile's early career.

1043 CUST, LIONEL, and HORNE, HERBERT. "Notes on the Pictures in
 the Royal Collection. Article VII: The Quaratesi Altar-
 piece by Gentile da Fabriano." Burlington Magazine 6, no.
 24 (1905):470-74, 2 illus. [Reprinted in Notes on Pictures
 in the Royal Collection (London: Chatto & Windus, 1911).]
 Madonna, Buckingham Palace, identified as central panel
 of altarpiece for S. Niccolo, Florence, in 1425. Associates
 with four Saints in Uffizi.

1044 D'ANCONA, PAOLO. "Intorno alla iscrizione oggi perduta
 della tomba di Gentile da Fabriano." L'arte 11 (1908):51-52.
 Publishes fragments of inscription probably referring to
 Gentile and a fifteenth-century epigram honoring him.

1045 DAVISSON, DARRELL D. "The Iconology of the S. Trinità
 Sacristy, 1418-1435: A Study of the Private and Public
 Functions of Religious Art in the Early Quattrocento." Art
 Bulletin 57, no. 3 (1975):315-34, 16 illus.; no. 4
 (1975):608.
 Reinterpretation of Gentile's altarpiece of the Adora-
 tion, Uffizi, Florence. Considers its original location, and
 its relation to the major and minor sacristies of Sta. Trinità,
 patronized by the Strozzi family. Reconstruction of Lorenzo
 Monaco's altar. Appendix of major documents.

Gentile da Fabriano

1046 ____. "New Documents on Gentile da Fabriano's Residence in
Florence, 1420-22." Burlington Magazine 122, no. 932
(1980):759-63.
 Three unpublished references for rent paid for house next
to former Strozzi Palace, near Sta. Maria Ughi.

1047 DEGENHART, BERNHARD, and SCHMITT, ANNEGRIT. "Gentile da
Fabriano in Rom und die Anfängen des Antikenstudiums."
Münchner Jahrbuch der bildenden Kunst 11 (1960):59-151, 106
illus.
 Study of a group of drawings used as models by Gentile,
Pisanello, Arcangelo, and others when in Rome. Many of them
copies from earlier works by other artists. Drawings by same
group of artists after ancient sculpture. Includes catalog of
ancient monuments copied by circle of artists. Index.

1048 GRASSI, LUIGI. "Considerazioni intorno al 'polittico
Quaratesi.'" Paragone 2, no. 15 (1951):23-30, 6 illus.
 Sees Florentine elements in polyptych of 1425 as in-
creased over those of Adoration of 1423. Dates other works on
basis of development. Discusses scenes on drapery.

1049 HUTER, CARL. "Gentile da Fabriano and the Madonna of Humil-
ity." Arte veneta 24 (1970):26-34, 12 illus.
 Attribution of two Virgins of Humility to Gentile. Dis-
cusses iconography of type, as adapted by Gentile. Sees sources
in Venetian tradition, which may indicate where Gentile's ar-
tistic beginnings were.

1050 LAVAGNINO, EMILIO. "Un affresco di Gentile da Fabriano a
Roma." Arti figurative 1, no. 1-2 (1945):40-48, 3 illus.
 Attribution of the recently uncovered Crucifix, Cappella
dei Conversi, S. Paolo fuori le Mura, Rome. Convent archives
include document that refers to Gentile.

1051 LONGHI, ROBERTO. "Me pinxit: Un San Michele Arcangelo di
Gentile da Fabriano." Pinacotheca 1, no. 2 (1928):71-87, 5
illus.
 Includes a study of Archangel Michael, Stoclet Collec-
tion, Brussels, here attributed to Gentile da Fabriano (now
Museum of Fine Arts, Boston).

1052 LUGANO, P. "Gentile da Fabriano e l'ordine di Monteoliveto."
Rivista storica benedettina 16 (December 1925):305-21, 1
illus.
 Discusses lost work by Gentile for Sta. Maria Nuova,
Rome, mentioned by Vasari. Documents regarding Gentile in
Rome, his family, and the order, founded in Fabriano.

1053 MANCINI, AUGUSTO. "Ancora sull'iscrizione sepolcrale di
Gentile da Fabriano." Rivista d'arte 23 (1941):258-63.

Considers possible reconstructions of inscriptions, recorded by various sources, in Sta. Francesca Romana, Rome.

1054 MARIOTTI, RUGGERO. "Nuovi documenti di Gentile da Fabriano sui freschi della cappella Malatestiana a Brescia." Nuova rivista misena 5, no. 1 (1892):3-4.
 Publishes text of documents of 1414 and 1418. No commentary.

1055 MAYER, AUGUST L. "Zum Problem Gentile da Fabriano." Pantheon 11 (February 1933):41-46, 7 illus.
 Investigates north Italian influence in formation of Gentile's art. Connections with International Gothic style. English summary.

1056 MICHELETTI, EMMA. "Qualche induzione sugli affreschi di Gentile da Fabriano a Venezia." Rivista d'arte 28 (1953):115-20, 2 illus.
 Finds reflections in anonymous image of Saint Romano, Pinacoteca, Ferrara, of Gentile's lost frescoes from Sala del Maggior Consiglio, Palazzo Ducale, Venice, done between 1409 and 1412/13.

1057 MOLAJOLI, BRUNO. "L'affresco di Gentile nella chiesa di S. Maria Nuova." Gentile da Fabriano 2 (June 1928):49.
 Work in Rome, recorded by Vasari, now completely lost.

1058 _____. "Bibliografia di Gentile da Fabriano." Bollettino del reale Istituto di archeologia e storia dell'arte 3, no. 4-5 (1929):102-7.
 Bibliography of writings relating to artist. Arranged by type of publication: sources; general works; dictionaries and catalogs; and scholarly works.

1059 _____. "Un dipinto inedito di Gentile da Fabriano." Rassegna marchigiana 5, no. 7 (1926-27):291-97, 2 illus.
 Publishes Coronation of the Virgin, Accademia, Venice. Precedes Virgin in Hengel Collection, Paris.

1060 _____. "Gentile da Fabriano." Gentile da Fabriano 1 (May 1928):3-6, 7 illus.
 Brief essay on life, works, and art, as introductory chapter in celebratory volume.

1061 _____. "Un ignorato affresco Gentilesco a Roma." Gentile da Fabriano 2 (June 1928):49.
 Publishes work in sacristy of Chiesa del Divino Amore, with image of Saints Cecilia and Valerian crowned by an angel, and two additional Saints.

1062 _____. "Un nuovo quadro di Gentile da Fabriano." Gentile da Fabriano 2 (June 1928):39-41, 1 illus.

Gentile da Fabriano

Confirms attribution of <u>Madonna</u> <u>and</u> <u>Saints</u>, formerly
Paolini Collection, Rome. Considers earliest work.

1063 ____. "La predella del polittico Quaratesi." <u>Gentile</u> <u>da</u>
<u>Fabriano</u> 2 (June 1928):41-45, 5 illus.
Supports attribution of St. Nicholas panels, Vatican, and
association of them with Quaratesi <u>Madonna</u>, National Gallery,
London.

1064 PANCZENKO, RUSSELL. "Gentile da Fabriano and Classical
Antiquity." <u>Artibus</u> <u>et</u> <u>historiae</u> 2 (1980):9-27, 22 illus.
Declares that Gentile should be grouped with artists who
were interested in antique. Many examples of influence given,
primarily from <u>Adoration</u>, Uffizi, Florence. Differentiates
Gentile's use of antiquity from Brunelleschian approach. Eng-
lish summary.

1065 P[ERKINS, F.] M[ASON]. "Un dipinto inedito di Gentile da
Fabriano." <u>L'arte</u> 18 (1915):232-33, 1 illus.
Publishes <u>Madonna</u> <u>and</u> <u>Child</u> <u>with</u> <u>Sta.</u> <u>Rosa</u>, recently
acquired by Direzione generale di antichità e belle arti (now
Galleria Nazionale della Marche, Urbino).

POGGI, GIOVANNI. "Gentile da Fabriano e Bicci di Lorenzo."
See entry 801.

1066 RAGGHIANTI, CARLO L[UDOVICO]. "Incontri fatidici." <u>Critica</u>
<u>d'arte</u> 41, no. 145 (1976):71-73.
Suggests meeting of Ghiberti and Gentile da Fabriano in
Florence ca. 1400.

1067 ____. "Postillina gentilesca." <u>Critica</u> <u>d'arte</u> 1, no. 6
(1954):585, 1 illus.
Attributes <u>Martyrdom</u> <u>of</u> <u>St.</u> <u>Stephen</u>, Gemäldegalerie,
Vienna, to Gentile.

1068 RICCI, CORRADO. "Gentile da Fabriano." <u>Gentile</u> <u>da</u> <u>Fabriano</u>
3 (August-September 1928):53-59, 3 illus. [Also published
in <u>Eroi,</u> <u>santi</u> <u>e</u> <u>artisti</u> (Milan: Hoepli, 1930), pp. 43-53,
3 illus.]
Bemoans losses in Gentile's oeuvre, records his reception
in various cities, and notes International Gothic element in
his art.

1069 ROSSI, FRANCESCO. "Ipotesi per Gentile da Fabriano a
Brescia." <u>Notizie</u> <u>da</u> <u>Palazzo</u> <u>Albani</u> 2, no. 1 (1973):11-22,
9 illus.
Discusses group of works that relate to Gentile's time in
Brescia, 1414-19. Assigns several works by artist to this
period and also cites various examples of works by Lombard
artists that show his influence.

1070 SASSI, R[OMUALDO]. "Altri appunti su la famiglia di Gentile
da Fabriano." Rassegna marchigiana 6 (1927-28):259-67.
Discussion of documents regarding members of Gentile's
family. Expands genealogical chart into sixteenth century.

1071 _____. "La famiglia di Gentile da Fabriano." Rassegna
marchigiana 2, no. 1 (1923-24):21-28, 3 illus.
Publishes information from documents of 1322-1472 con-
cerning artist's family and living circumstances. Includes a
genealogical chart.

1072 _____. "Gentile da Fabriano, il padre di Gentile, e
l'ordine di Monte Oliveto." Rassegna marchigiana 3, no. 7
(1924-25):247-51.
Discusses documents concerning dealings of Gentile, his
father, and his uncle with Monte Olivetan order, founded in
Fabriano in 1397.

1073 _____. "Gentile nella vita fabrianese del suo tempo."
Gentile da Fabriano 1 (May 1928):7-13; 2 (June 1928):33-38.
Discusses political and religious circumstances in
Fabriano, which affected Gentile's life directly and indi-
rectly. Traces family housing and draws family tree.

1074 _____. "Sonetti di poeti fabrianesi in onore di Gentile da
Fabriano." Rassegna marchigiana 2, no. 7 (1923-24):273-82,
2 illus.
Series of sixteenth-century poems praising Gentile's
works, particularly Mary Magdalen, Brera, Milan.

1075 SERRA, LUIGI. "Le origini artistiche di Gentile da Fabriano."
Rassegna marchigiana 11 (1933):59-65.
Reviews various theories regarding influences on the
formation of Gentile's art, with its non-Umbrian features.
Sees a variety of factors built upon a central Italian
foundation.

1076 STERLING, CHARLES. "Un tableau inédit de Gentile da
Fabriano." Paragone 9, no. 101 (1958):26-33, 4 illus.
Attribution of Madonna and Saints, private collection,
France (now Frick Collection, New York). Dates ca. 1423-25, or
ca. 1426, noting Sienese influences.

1077 STRINATI, REMIGIO. "La 'modernità' di Gentile." Gentile da
Fabriano 2 (June 1928):29-32.
Notes innovative classicizing quality in works, espe-
cially in predella panels. Parallels to modernism of nine-
teenth century.

1078 SUIDA, WILHELM. "Two Unpublished Paintings by Gentile da
Fabriano." Art Quarterly 3, no. 4 (1940):348-52, 3 illus.

Gentile da Fabriano

Discusses <u>Martyrdom</u> of <u>St</u>. <u>Peter</u>, Dumbarton Oaks Collection, Washington, as an early work, and <u>Miraculous</u> <u>Healing</u> <u>of</u> <u>the</u> <u>Sick</u> <u>at</u> <u>the</u> <u>Tomb</u> <u>of</u> <u>St</u>. <u>Nicholas</u> <u>of</u> <u>Bari</u>, from the Quaratesi altarpiece, ca. 1425, National Gallery, Washington.

1079 SUTER, KARL FRIEDRICH, and BEENKEN, HERMANN. "Ein unbekanntes Fresko des Gentile da Fabriano." <u>Zeitschrift</u> <u>für</u> <u>bildende</u> <u>Kunst</u> 60 (1926-27):84-88, 6 illus.
 Attribution of recently discovered fresco of young martyr, S. Niccolo sopr'Arno, Florence.

1080 TEZA, E[MILIO]. "Per una firma di Gentile." <u>Augusta</u> <u>Perusia</u> 2, no. 9-10 (1907):145.
 Reads inscription on halo of Gentile's Pisa <u>Madonna</u> as Gentile's signature, written right to left.

1081 VAN MARLE, RAIMOND. "A proposito di una Madonna sconosciuta di Gentile da Fabriano." <u>Gentile</u> <u>da</u> <u>Fabriano</u> 3 (August-September 1928):81-84, 1 illus.
 Attribution of work in private collection. Dates during time of Gentile's trip to Venice.

1082 VENTURI, ADOLFO. "Gentile da Fabriano and Vittore Pisano." <u>Jahrbuch</u> <u>der</u> <u>preussischen</u> <u>Kunstsammlungen</u> 16 (1895):65-87.
 Corrects a wide variety of misunderstandings regarding careers of two artists, many based on misreadings of documents.

1083 _____. "Un nuovo dipinto di Gentile da Fabriano." <u>L'arte</u> 9 (1906):222.
 Publishes work in Museo Civico, Fabriano. Places in early period of artist's career.

1084 _____. "Quadri di Gentile da Fabriano a Milano e a Pietroburgo." <u>L'arte</u> 1 (1898):495-97, 2 illus.
 Publishes and attributes two Madonnas of Humility, one recently acquired by the Museo Poldi Pezzoli, Milan, and the other in the Stroganoff Collection, St. Petersburg (now Hermitage, Leningrad).

1085 _____. "Un quadro di Gentile da Fabriano a Velletri." <u>Bollettino</u> <u>d'arte</u> 7, no. 3 (1913):73-75, 1 illus.
 Attribution of <u>Madonna</u>, Sala del Capitolo del Duomo. Quotes descriptions in earlier sources, transcribes two inscriptions.

1086 VOLPE, CARLO. "Due frammenti di Gentile da Fabriano." <u>Paragone</u> 9, no. 101 (1958):53-55, 2 illus.
 Publishes <u>Saints</u> <u>Peter</u> <u>and</u> <u>Paul</u>, Berenson Collection, Settignano (Villa I Tatti). Attributes to Gentile and associates with Valle Romita altarpiece, Brera, Milan.

1087 ZONGHI, A. "Gentile da Fabriano nel 1420." Le Marche 7,
 no. 2 (1907):137-38.
 Publishes documents locating Gentile in Fabriano in March
 and April 1420.

1088 [_____.] "L'anno della morte di Gentile da Fabriano."
 Nuova rivista misena 1, no. 1 (1888):9-10.
 Publishes document establishing Gentile's death before
 1428.

*1089 _____. "Gentile da Fabriano a Brescia." In Nozze Benigni-
 Corbelli. Fabriano, 1908, p. 51.
 Source: entry 1018.

 GEROLAMO DI GIOVANNI DA CAMERINO
 See GIROLAMO DI GIOVANNI DA CAMERINO

GIACOMO DI NICCOLO DA RECANATI (act. mid-fifteenth century)

1090 BISOGNI, FABIO. "Per Giacomo di Nicola da Recanati."
 Paragone 24, no. 277 (1973):44-62, 20 illus.
 Considers attributions and activity. Discusses eight
 scenes of a Saint, Musée des Arts Decoratifs, Paris. Identi-
 fies as Saint Elpidrio.

1091 VITALINI SACCONI, GIUSEPPE. "Una proposta per Giacomo di
 Nicola da Recanati." Paragone 24, no. 277 (1973):63-65, 5
 illus.
 Attributes frescoes, Sta. Maria, Rambona. Dates late in
 career.

 GIACOMO DEL PISANO (act. mid-fifteenth century)

1092 VAN MARLE, RAIMOND. "Giacomo del Pisano, aiuto di Giovanni
 di Paolo." Rassegna d'arte senese 12, no. 1-4 (1919):19-20,
 2 illus.
 Publishes Madonna and Saints triptych signed by Giacomo
 del Pisano, Stolk Museum, Haarlem.

1093 _____. "Il problema riguardante Giovanni di Paolo e Giacomo
 del Pisano." Bollettino d'arte 18, no. 12 (1925):529-42, 9
 illus.
 Analyzes works by two artists as examples of cooperation
 between master and student. Distinguishes their separate
 hands.

Giovanni d'Agnolo di Balduccio

GIOVANNI D'AGNOLO DI BALDUCCIO (ca. 1370-1452)

1094 DEL VITA, ALESSANDRO. "Documenti su pittori aretini dei
secoli XIV-XVI." Rivista d'arte 9, no. 2 (1916):142-59.
 Includes references of 1419-58 to Giovanni d'Agnolo di
Balduccio.

1095 _____. "Giovanni d'Agnolo di Balduccio: Pittore aretino
della prima metà del XV secolo." Bollettino d'arte 21, no.
9 (1927-28):446-64, 12 illus.
 Reconstructs oeuvre of artist, with particular attention
to works in S. Domenico, Arezzo. Rejects attribution of many
items to Parri Spinelli. Includes documents.

1096 DONATI, PIER PAOLO. "Su Giovanni d'Agnolo di Balduccio."
Antichità viva 3, no. 9-10 (1964):32-46, 20 illus.
 Reviews Del Vita's construction of artist's career (entry
1095) and adds new attributions. Considers artist in relation
to Spinello Aretino and later art in Arezzo.

GIOVANNI ANGELO DI ANTONIO DA CAMERINO
(act. mid-fifteenth century)

1097 FELICIANGELI, B. "Documenti relativi al pittore Giovanni
d'Antonio da Camerino." Arte e storia 29, no. 12
(1910):366-71.
 Publishes letters of 1451, concerning activities of
artist and of Boccati in late 1440s.

GIOVANNI ANTONIO DA PESARO (act. ca. 1461-1511)

1098 DONNINI, GIAMPIERO. "Un affresco e altre cose di Giovanni
Antonio da Pesaro." Antichità viva 18, no. 1 (1979):3-7, 7
illus.
 Attributes fresco, Sta. Chiara, Sassoferrato, and other
works in various regions of Italy. English summary.

1099 SERRA, LUIGI. "Arte marchigiana ignota." Rassegna
marchigiana 3, no. 1 (1924-25):2-12, 6 illus.
 Includes Madonna della Misericordia, Sta. Maria
dell'Arzilla presso Pesaro, signed by Giovanni Antonio da
Pesaro and dated 1462.

1100 ZERI, FEDERICO. "Me pinxit: Giovanni Antonio da Pesaro."
Proporzioni 2 (1948):164-66, 2 illus.
 Attribution of polyptych, Sta. Croce, Sassoferrato, to
Giovanni rather than to Antonio da Fabriano. Catalogs artist's
other works. Notes also discuss works by Pietro di Domenico
and Master of Staffolo.

Giovanni di Corraduccio

1101 . "Per Giovanni Antonio da Pesaro." Paragone 27, no.
317-19 (1976):59-62, 3 illus.
 Discusses St. Mark, Ashmolean, Oxford, signed and dated
1463, and two panels of Saints, Ruffo Collection.

GIOVANNI DE' CASTALDI (act. 1460)

1102 ROSS, D.J.A. "An Unrecorded Follower of Piero della
Francesca." Journal of the Warburg and Courtauld Institutes
17 (1954):174-81, 10 illus.
 Publishes illustrations in manuscript of an Epitome by
Justin of the Historia Philippica by Trogus Pompeius. Signed
by artist Giovanni de' Castaldi, dated 1460. Sees as influ-
enced by Piero, particularly Arezzo cycle.

GIOVANNI DI CORRADUCCIO (act. 1404-37)

Book

1103 SCARPELLINI, PIETRO. Giovanni di Corraduccio. Catalogo
della mostra fotografica promossa dall'Associazione dei
quartieri di Montefalco. Photographs by Carlo Fiorucci.
Foligno: Ediclio, 1976, 295 pp., 150 illus.
 Catalog of exhibition of photographs of artist's work.
Essays on critical history, on his career. Catalog of works
and related ones. Appendix on documents by Silvestor Nessi,
technical notes by Piero Nottiani. Bibliography. Indexes of
names and places.
 Review: Enrica Neri Lusanna, Paragone 29, no. 335
(1978):95-103.

Articles

1104 MOLAJOLI, BRUNO. "Nota su Giovanni di Corraduccio da
Foligno." Rassegna marchigiana 9 (1930-31):33-37, 2 illus.
 Suggests attribution of two fresco fragments, S. Venanzo,
Fabriano, possibly related to a document of 1415.

1105 ROSSI, ADAMO. "Una visita all'archivio notarile di
Fabriano." Giornale di erudizione artistica 2, no. 3
(1873):80-82.
 Includes a reference of 1415 concerning painting by
Giovanni di Corraduccio.

1106 ROSSI, ALBERTO. "Qualche considerazione sulla pittura-
umbro-marchigiana del trecento e del quattrocento." Notizie
da Palazzo Albani 3, no. 2-3 (1974):20-30, 13 figs.
 Includes attributions to Giovanni di Corraduccio.

Giovanni di Corraduccio

1106a ZERI, FEDERICO. "Un'aggiunta a Giovanni di Corraduccio."
 Diari di Lavoro, 2. Turin: Giulio Einaudi, 1976, pp. 20-
 26, 1 illus.
 Discusses triptych from Cernuschi Collection.

GIOVANNI DI FRANCESCO (ca. 1412-59)

Book

1107 FREDERICKSON, BURTON B. Giovanni di Francesco and the Mas-
 ter of Pratovecchio. Malibu, Calif.: J. Paul Getty Museum,
 1974, 39 pp., 41 illus.
 Attributes triptych, Getty Museum, to Giovanni di
 Francesco (da Rovezzano) on the basis of two documents from
 archives of Monastero del Paradiso, near Bagno a Ripoli. Dates
 early 1440s. Reconstructs artist's oeuvre and chronology,
 lists attributions not accepted. Identifies with Master of
 Pratovecchio.

Articles

1108 GIOVANNOZZI, VERA. "Note su Giovanni di Francesco."
 Rivista d'arte 16 (1934):337-65, 10 illus.
 Reconstructs artist's career, reviewing works. Rejects
 some earlier attributions.

1109 GIUSTINI, GIUSEPPE. "Un centenario dimenticato." L'arte
 59, no. 1-2 (1960):3-6, 2 illus.
 Overview of Giovanni di Francesco, with review of crit-
 ical opinions and special attention to fresco of Crucifixion,
 Sta. Maria Maggiore.

1110 LONGHI, ROBERTO. "Il 'Maestro di Pratovecchio.'" Paragone
 3, no. 35 (1952):10-37, 25 illus. [Reprinted in Fatti di
 Masolino e di Masaccio e altri studi sul quattrocento.
 (Florence: Sansoni, 1975), pp. 99-122.]
 Study of works to be attributed to anonymous artist of
 now scattered triptych from Pratovecchio. Active 1440-60.
 Emphasizes importance of Domenico Veneziano for a variety of
 artists in Florence and in Siena and Umbria.

1111 _____. "Ricerche su Giovanni di Francesco." Pinacotheca 1,
 no. 1 (1928):34-48, 8 illus.
 Artist as an example of Florentine second-rate artist
 picking up new ideas in 1440s and '50s. Suggests trained by
 Uccello. Examines various works, including old and new
 attributions.

1112 TOESCA, PIETRO. "Il 'pittore del trittico Carrand':
 Giovanni di Francesco." Rassegna d'arte 17, no. 1-2
 (1917):1-4, 3 illus.

Rejects Vasari's attribution of works by this hand to
Giuliano Pesello and proposes Giovanni di Francesco, who also
painted fresco, Loggia degli Innocenti, Florence. Gathers
other information about the artist, active from ca. 1446-59.

1113 WEISBACH, WERNER. "Der Meister des Carrandschen
 Triptychons." Jahrbuch der preussischen Kunstsammlungen
 22 (1901):35-55, 10 illus.
 Studies works associated with Master of Carrand triptych
and career of Giovanni Pesello and suggests identification of
two.

GIOVANNI DI MARCO. See GIOVANNI DAL PONTE

GIOVANNI DI PAOLO (ca. 1403-83)

Books

1114 BRANDI, CESARE. Giovanni di Paolo. Florence: Le Monnier,
 1947, 141 pp., 111 illus. [Reprinted from Le arti 3, no. 4
 (1941):230-50, 23 illus.; no. 5 (1941):316-41, 31 illus.]
 Analyzes art in context of own time. Surveys major
works, proposes reconstruction of Pizzicaiuoli altarpiece and
other works. Sees artist isolated by fantasy. Revises Pope-
Hennessy's chronology (entry 1115).
 Review: John Pope-Hennessy, Burlington Magazine 89, no.
530 (1947):138-39. Reply 89, no. 532 (1947):196.

1115 POPE-HENNESSY, JOHN. Giovanni di Paolo: 1403-83. London:
 Chatto & Windus; New York: Oxford University Press, 1938,
 208 pp., 55 illus.
 Scholarly study, arranging works chronologically and
describing stylistic development. Appendixes on book covers,
cassone panels, wrong attributions, and biography by Romagnoli
(entry 245). Index.
 Review: R. Langton Douglas, Burlington Magazine 72, no.
418 (1938):43-47, 3 illus. Reply 72, no. 419 (1938):95.

Articles

1116 ALEXANDER, MARY. "An Unknown Early Panel by Giovanni di
 Paolo." Pantheon 34, no. 4 (1976):271-74, 5 b&w and 1 color
 illus.
 Publishes predella panel of Crucifixion, Art Gallery,
Rockdale. Attributes to Giovanni, dates early in his career,
ca. 1423-26.

Giovanni di Paolo

1117 AMAUDRY, LÉONCE. "The Collection of Dr. Carvallo at Paris,
 Article III: Early Pictures of Various Schools."
 Burlington Magazine 6, no. 22 (1905):294-313, 11 illus.
 Includes St. John the Baptist in the Wilderness attrib-
 uted to Giovanni di Paolo. Also includes "A Note on Giovanni
 di Paolo," by Roger Fry, supporting the attribution, and com-
 paring miniature in Yates Thompson Divina commedia, which pub-
 lishes for first time. Attributes Purgatorio and Paradiso
 illustrations to Giovanni.

1118 BACCI, PÈLEO. "Una Madonna col Figlio di Giovanni di Paolo."
 Rivista d'arte 6, no. 1 (1909):39-43, 1 illus.
 Publishes work discovered in Pieve di Sta. Croce,
 Poggioferro.

1119 _____. "Ricordi della vita e dell'attività artistica del
 pittore senese Giovanni di Paolo di Grazia, detto Boccanera
 (1399 circa 1482)." Le arti 4, no. 1 (1941):11-39, 9 illus.
 Publishes forty-five documents of 1403-82 concerning
 artist.

1120 _____. "Un 'San Bernardino' sconosciuto di Giovanni di
 Paolo." Le arti 1, no. 6 (1939):549-59, 5 illus.
 Altarpieces painted for S. Domenico, Siena, for Malavolti,
 Branchini, and Guelfi families. Reviews documents, literature,
 and reconstructions. Publishes figure of S. Bernardino, part
 of Guelfi altarpiece.

1121 BARÁNSZKY-JÓB, LÁSZLÓ. "The Problems and Meaning of Giovanni
 di Paolo's Expulsion from Paradise." Marsyas 8 (1957-59):1-
 6, 9 illus.
 Iconographic study of panel in Lehman Collection, New
 York, which is seen to represent only the Expulsion, and not
 the creation of the world.

1122 BOMFORD, DAVID, and KIRBY, JO. "Giovanni di Paolo's SS.
 Fabian and Sebastian." National Gallery Technical Bulletin
 2 (1978):56-65, 11 illus.
 Report of cleaning of panel and description of its tech-
 nique. Supports attribution to Giovanni. Photos of details
 and techniques.

1123 BORENIUS, TANCRED. "SS. Fabian and Sebastian by Giovanni di
 Paolo." Burlington Magazine 28, no. 151 (1915):3, 1 illus.
 Publishes painting, Ross Collection.

1124 BRANDI, CESARE. "Gli affreschi di Monticiano." Dedalo 11,
 no. 11 (1931):709-34, 21 illus.
 Publishes frescoes at Convento di S. Agostino, Monticiano,
 which include a Last Supper by Giovanni di Paolo. Discusses
 artist's development.

1125 _____. "Recostruzione di un'opera giovanile di Giovanni di
Paolo." L'arte 37, no. 6 (1934):462-81, 9 illus.
 Assembles parts of Pecci altarpiece of 1426, possibly
from S. Domenico, Siena. Discusses various lost or fragmentary
works. Footnotes include documentation.

1126 BRECK, JOSEPH. "Some Paintings by Giovanni di Paolo." Art
in America 2, no. 3 (1914):177-86, 3 illus.; 2, no. 4
(1914):280-87, 3 illus.
 Publishes works in American collections, some illustrated
for first time.

1127 CARLI, ENZO. "Problemi e restauri di Giovanni di Paolo."
Pantheon 19, no. 4 (1961):163-77, 15 b&w and 1 color illus.
 Panels of life of Saint John in various collections
associated with fragments of a Crucifixion in SS. Giovannino e
Gennaro, Siena. Suggests that all part of large tabernacle
made ca. 1445-49. Also publishes recently restored Crucifixion
fresco in refectory of S. Leonardo al Lago, near Siena. Eng-
lish summary.

1128 DAMI, LUIGI. "Giovanni di Paolo miniatore e i paesisti
senesi." Dedalo 4, no. 2 (1923-24):269-303, 24 b&w and 1
color illus.
 Discusses antiphonal, Biblioteca Comunale, Siena, in
which attributes several miniatures to Giovanni di Paolo, ca.
1436. Notes influence of Ambrogio Lorenzetti in quattrocento.

1129 DE NICOLA, GIACOMO. "The Masterpiece of Giovanni di Paolo."
Burlington Magazine 33, no.185 (1918):45-54, 7 illus.
 Publishes six panels of life of Saint John, Ryerson
Collection, Chicago. Associates with other panels probably of
same series. Proposes a reconstruction of altar, dates ca.
1445-49.

1130 DUSSLER, LUITPOLD. "Some Unpublished Works by Giovanni di
Paolo." Burlington Magazine 50, no. 286 (1927):35-36, 4
illus.
 Publishes polyptych of 1454, panel with female Saints,
and scene of Saint Catherine of 1430s, all from Friedsam Col-
lection, New York. Also publishes Assumption of the Virgin,
Drey Collection, Munich, ca. 1440s.

1131 EDGELL, GEORGE HAROLD. "An Unpublished Painting in the
Cathedral of St. John the Divine, New York." Art Studies 3
(1925):35-37, 4 illus.
 Attributes polyptych to Giovanni di Paolo, ca. 1438.

1132 FRANCIS, HENRY SAYLES. "A New Giovanni di Paolo." Art
Quarterly 5, no. 4 (1942):313-22, 10 illus.

Giovanni di Paolo

Publishes Adoration of the Magi, recently acquired by the Cleveland Museum of Art. Associates with four other predella panels. Dates ca. 1445 and notes International Style features.

FRY, ROGER. "A Note on Giovanni di Paolo." See entry 1117.

1133　FRYNS, MARCEL. "Le retable dei Pizzicaiuoli." Annales de la Société royale d'archéologie de Bruxelles 50 (1956-61):96-103.
New identifications for several scenes from the life of Saint Catherine from Giovanni di Paolo's altar. Represent moments in her life different from traditional selection.

1134　GENGARO, MARIA LUISA. "Eclettismo e arte nel quattrocento senese." La Diana 7, no. 1 (1932):8-33, 15 illus.
Defines varied elements of art of Giovanni di Paolo. Reviews some works and critical opinions. Lists works by location with lengthy bibliography for each.

1135　KING, EDWARD. "Notes on the Paintings by Giovanni di Paolo in the Walters Collection." Art Bulletin 18, no. 2 (1936):215-39, 18 illus.
Considers six works first from technical angle and then stylistically. Confirms attribution of four predella panels to Giovanni. Assigns cassone with story of Hippo and altarpiece with Madonna and Saints to his school. Photos include X-rays, enlarged details.

1136　MC COMB, ARTHUR. "Un Giovanni di Paolo ad Utrecht." Rassegna d'arte senese 15, no. 3-4 (1922):45-46, 1 illus.
Publishes predella panel of Crucifixion, Museum, Utrecht.

1137　MEISS, MILLARD. "The Earliest Work of Giovanni di Paolo." Art in America 24, no. 4 (1936):137-43, 3 illus.
Attributes painted box, dated 1421, with scene of Venus and the three Graces, Louvre, Paris, to Giovanni di Paolo at age 18. Notes influence of Paolo di Giovanni Fei and of French illumination.

1138　_____. "A New Panel by Giovanni di Paolo from his Altarpiece of the Baptist." Burlington Magazine 116, no. 851 (1974):73-77, 7 illus.
Identifies panel of Baptism, Norton Simon Foundation, Los Angeles, as part of altarpiece. Proposes new reconstruction, dates ca. 1454, and suggests a source in Ghiberti's relief, Baptistry, Siena.

1139　_____. "Some Remarkable Early Shadows in a Rare Type of Threnos." In Festschrift Ulrich Middeldorf. Edited by Antje Kosegarten and Peter Tigler. Berlin: Walter de Gruyter, 1968, pp. 112-18, 10 illus.

Iconographic study, particularly of large shadow cast by
bearded man in Giovanni di Paolo's Entombment, 1426, Walters
Art Gallery, Baltimore. Relates to predella attributed to
Arcangelo di Cola, Bruscoli Collection, Florence. Notes
Byzantine, Sienese, and Florentine elements and influence of
Gentile.

1140 OS, H.W. VAN. "Giovanni di Paolo's Pizzicaiuolo Altar-
 piece." Art Bulletin 53, no. 3 (1971):289-302, 25 illus.
 Reconstructs altarpiece of 1447-49, which includes Puri-
fication of the Virgin, Pinacoteca, Siena, and now scattered
scenes from the life of Saint Catherine.
 Reply: Hayden B.J. Maginnis, Art Bulletin 57, no. 4
(1975):608-9, 2 illus.

1141 _____. "Reassembling a Giovanni di Paolo Triptych."
 Burlington Magazine 119, no. 888 (1977):191-92, 8 illus.
 Publishes three panels of a triptych now reunited at the
Kimball Art Museum, Fort Worth. Early photo shows the wings
flanking a copy of the central Madonna that includes a repro-
duction of a now lost section.

1142 PERKINS, F. M[ASON]. "Per un quadro di Giovanni di Paolo."
 Rassegna d'arte senese 5, no. 1-2 (1909):49-50.
 Madonna, dated 1447, Collegiata, Castiglione Fiorentino,
attributed to Giovanni di Paolo, not to Cecco d Giovanni.

1143 POPE-HENNESSY, JOHN. "Giovanni di Paolo." In Encyclopedia
 of World Art. Vol. 6. London: McGraw Hill, 1962, col.
 357.
 Brief review of major moments and works in career. Brief
bibliography.

1144 _____. "A Predella Panel by Giovanni di Paolo." Burlington
 Magazine 71, no. 414 (1937):108-9, 1 illus.
 Publishes little-known scene of Presentation of the
Virgin, private collection, ca. 1445-50. Finds iconographic
sources in Gentile da Fabriano and Ambrogio Lorenzetti.

1145 PREUSCHEN, GERHARD VON. "Eine Tafel des Giovanni di Paolo."
 In Festschrift Kurt Bauch. Munich: Deutscher Kunstverlag,
 1957, pp. 153-54, 1 color illus.
 Publishes panel of St. Christopher, in private
collection.

1146 ROMEA, VITALIANA. "Nuove opere di Giovanni di Paolo."
 Rassegna d'arte senese 18, no. 3-4 (1925):72-74, 4 illus.
 Attributions of several works, including Crucifixion,
Museo dell'Opera del Duomo, Siena, Assumption of Virgin,
Munich, and miniature of Death on Horseback, Biblioteca
Comunale, Siena.

Giovanni di Paolo

1147　ROSSI, PIETRO.　"L'ispirazione dantesca in una pittura di
　　　　Giovanni di Paolo."　Rassegna d'arte senese 14, no. 4
　　　　(1921):138-49, 5 illus.
　　　　　　Discusses influence of Divine Comedy on Last Judgment
　　　panel of 1445, Galleria di Belle Arti, Siena.　Cites specific
　　　motifs and lines in the poem.

1148　SALINGER, MARGARETTA.　"A New Panel in Giovanni di Paolo's
　　　　Saint Catherine Series."　Bulletin of the Metropolitan
　　　　Museum 1, no. 1 (1942):21-28, 7 illus.
　　　　　　Sees Miraculous Communion of St. Catherine as part of a
　　　series that also includes St. Catherine of Siena Receiving the
　　　Stigmata, Lyle Collection, New York, hitherto unpublished.
　　　Reviews life of Saint Catherine and known works from series.

1149　SCHUBRING, PAUL.　"Opere sconosciute di Giovanni di Paolo e
　　　　del Vecchietta."　Rassegna d'arte 12, no. 10 (1912):162-64,
　　　　5 illus.
　　　　　　Publishes two panels of Life of St. John, Muenster
　　　Museum, Cologne, and a pinnacle with Saint John, Schmietgen
　　　[sic] Museum, Cologne, ca. 1430, all by Giovanni di Paolo.
　　　Also a Resurrection by Vecchietta.

1150　TOESCA, PIETRO.　"Opere di Giovanni di Paolo nelle collezioni
　　　　romane."　L'arte 7 (1904):303-8, 6 illus.
　　　　　　Small works in Biblioteca Vaticana and Galleria Doria,
　　　Rome.

　　　　VAN MARLE, RAIMOND.　"Il problema riguardante Giovanni di
　　　　Paolo e Giacomo del Pisano."　See entry 1093.

1151　VENTURI, ADOLFO.　"Antifonario miniato di Giovanni di Paolo."
　　　　L'arte 26 (1923):192-96, 8 illus.
　　　　　　Publishes manuscript, in Biblioteca Civica, Siena, with
　　　photographs of details of illuminated initials.　Notes include
　　　list of additional images.

1152　　　　　.　"Una preziosa anconetta di Giovanni di Paolo."
　　　　L'arte 35, no. 1 (1931):43-44, 2 illus.
　　　　　　Publishes Assumption in private collection, Rome.　Com-
　　　pares to altarpiece in Asciano.

1153　WEIGELT, [CURT H.].　"Der Zug zum Kreuz des Giovanni di
　　　　Paolo."　Mitteilungen des kunsthistorischen Institutes in
　　　　Florenz 3 (July 1931):445-48, 4 illus.
　　　　　　Predella in Parma, rarely dealt with in literature.
　　　Dates ca. 1460.

GIOVANNI DAL PONTE (1385-ca. 1438)

1154　GAMBA, CARLO.　"Ancora di Giovanni dal Ponte."　Rivista
　　　　d'arte 4, no. 10-12 (1906):163-68, 4 illus.

Lists and describes seventeen works, which attributes to Giovanni and his school, amplifying his known oeuvre.

1155 _____. "Giovanni dal Ponte." Rassegna d'arte 4, no. 12 (1904):177-86, 10 illus.
Early attempt at reconstruction of artist's career and oeuvre. Includes documents.

1156 GUIDI, FABRIZIO. "Ancora su Giovanni di Marco." Paragone 21, no. 239 (1970):11-23, 22 illus.
Stylistic development of Giovanni dal Ponte in relation to trends of the first quarter of the fifteenth century.

1157 _____. "Per una nuova cronologia di Giovanni di Marco." Paragone 19, no. 223 (1968):27-46, 15 illus.
Considers various questions regarding activity of Giovanni dal Ponte and the dates of his works. Appends documents.

1158 HORNE, HERBERT. "Appendice di documenti su Giovanni dal Ponte." Rivista d'arte 4, no. 10-12 (1906):169-81.
Documents of 1427-42, mostly catasto declarations, which concern artist and Smeraldo di Giovanni.

1159 _____. "Giovanni dal Ponte." Burlington Magazine 9, no. 41 (1906):332-37.
Examination of Vasari's references to Giovanni dal Ponte, with particular attention to misstatements in Vasari's second edition. Mentions newly uncovered documents. Includes chronology of artist.

1160 PERKINS, F. MASON. "A Florentine Double Portrait at the Fogg Museum." Art in America 9, no. 4 (1921):137-48, 4 illus.
Identifies work as an early representation in panel painting of Dante and possibly Petrarch. Ascribes to Giovanni dal Ponte, ca. 1430-35. Reviews portraits of Dante.

1161 RAND, EDWARD KENNARD. "Dante and Petrarch in a Painting by Giovanni dal Ponte." Fogg Art Museum Notes 1, no. 3 (1923):25-33, 2 illus.
Identifies figures in panel as Sacred and Profane Poetry, represented by Dante and Petrarch.

1162 SALVINI, ROBERTO. "Lo sviluppo stilistico di Giovanni dal Ponte." Atti e memorie della R. Accademia petrarca 16 (1934):17-44, 7 illus.
Attempt to establish a chronology, based on three dated works and documented frescoes in Sta. Trinità, Florence. Groups other works around them, notes influence of Spinello Aretino, Lorenzo Monaco, and Masaccio.

Giovanni dal Ponte

1163 SANDBERG-VAVALÀ, EVELYN. "A <u>Madonna</u> <u>of</u> <u>Humility</u> by Giovanni dal Ponte." <u>Burlington</u> <u>Magazine</u> 88, no. 521 (1946):191-92, 3 illus.
 Attribution of panel, private collection, Florence. Dated late in artist's career, ca. 1430s.

1164 SCHUBRING, PAUL. "Die älteste Darstellung des <u>Trionfo</u> <u>della</u> <u>Fama</u> von Petrarca." <u>Pantheon</u> 4 (December 1929):561-62, 1 b&w and 1 color illus.
 Publishes cassone in Mog Collection, Munich, attributed to Giovanni dal Ponte, ca. 1420-30. Early illustration of Petrarch.

1165 SHELL, CURTIS. "Giovanni dal Ponte and the Problem of Other Lesser Contemporaries of Masaccio." Ph.D. dissertation, Harvard University, 1958, 326 pp., 86 illus.
 Considers art of 1420s and 1430s in terms of tradition and innovation in the evolution of style. Presents monographic treatment of Giovanni dal Ponte, to demonstrate Masaccio's influence and define style of time. Also surveys development of Francesco d'Antonio, Paolo di Stefano, Bicci di Lorenzo, and Andrea di Giusto.

1166 _____. "Two Triptychs by Giovanni dal Ponte." <u>Art</u> <u>Bulletin</u> 54, no. 1 (1972):41-46, 9 illus.
 Reconstructs six scattered panels into two triptychs, ca. 1427-30. Later one indicates a turning away from Masaccio to a style with more conservative elements.

GIOVANNI <u>DI</u> <u>PIETRO</u> <u>DA</u> <u>PISA</u> (act. 1401-21)

1167 MIGLIORINI, MAURIZIA. "Persistenze pisano-senesi nella pittura genovese del primo quattrocento: Un inedito di Giovanni di Pietro da Pisa." <u>Studi</u> <u>di</u> <u>storia</u> <u>delle</u> <u>arti</u> 2 (1978-79):97-103, 6 illus.
 Attributes altarpiece, SS. Annunziata in Portoria, Genoa, to Pisan artist. Considers interaction between Pisa and Genoa.

GIOVANNI <u>DI</u> <u>SAN</u> GIOVANNI <u>(LO</u> <u>SCHEGGIA)</u> (1406-after 1472)

1168 AHL, DIANE COLE. "Renaissance Birth Salvers and the Richmond <u>Judgment</u> <u>of</u> <u>Solomon</u>." <u>Studies</u> <u>in</u> <u>Iconography</u> 7-8 (1981-2):157-74, 13 illus.
 Discusses type. Attributes work, in Virginia Museum of Art, Richmond, to Lo Scheggia, and dates 1467.

1169 CAROCCI, GUIDO. "Gli affreschi della chiesa di S. Lorenzo in San Giovanni Valdarno." In <u>Masaccio:</u> <u>Ricordo</u> <u>delle</u> <u>onoranze</u>. Florence: Bernardo Seeber, 1904, pp. 53-59.

Girolamo di Giovanni da Camerino

Discusses lost decorations signed by Giovanni di San Giovanni, dated 1456-57. Identifies artist as Lo Scheggia, Masaccio's brother.

GIROLAMO DI GIOVANNI DA CAMERINO (act. 1449-73)

1170 BERENSON, B[ERNHARD]. "Gerolamo di Giovanni da Camerino." Rassegna d'arte 7, no. 9 (1907):129-35, 7 illus.
First major attempt to gather together works by artist, including signed and dated altarpiece in church of Madonna del Pozzo, Monte San Martino, 1473. Discusses various attributions.

1171 _____. "Un tableau de Giovanni da Camerino au musée de Tours." Musées de France (1912):18-20, 2 illus.
Attributes St. John the Baptist.

1172 DONNINI, GIAMPIERO. "Sui rapporti di Antonio da Fabriano e di Matteo da Gualdo con Gerolamo di Giovanni." Antichità viva 11, no. 1 (1972):3-10, 9 illus.
Girolamo presented as representing influence of school of Camerino on other artists and perhaps as teacher of Matteo da Gualdo. English summary.

1173 FELICIANGELI, B. "Un gonfalone sconosciuto di Gerolamo di Giovanni da Camerino." Atti e memorie della R. Deputazione di storia patria per le Marche 8 (1912):237-45, 1 illus.
Attributes banner, S. Martino, Tedico. Lists works noted by Berenson and Venturi (entries 39 and 1170) and suggests additional attributions.

1174 _____. "Sul tempo di alcune opere d'arte esistenti in Camerino. Part II. Quando, probabilmente, fu dipinti l'Annunciazione di Girolamo di Giovanni da Camerino." Atti e memorie della R. Deputazione di storia patria per le Marche 10 (1915):77-84.
Discusses work in Pinacoteca, Camerino, with history of Franciscan convent from which it came. Identifies patron as Giulio Cesare Varano. Dates 1484.

*1175 _____. Sulle opere di Girolamo di Giovanni da Camerino pittore del secolo XV. Camerino, 1910.
Source: entry 310.

1176 FRIZZONI, GUSTAVO. "Gerolamo di Giovanni da Camerino nel Museo Poldi-Pezzoli in Milano. Rassegna bibliografica dell'arte italiana 13, no. 5-7 (1910):45-48.
Publishes Madonna and Angels with side panels of Saints.

1177 PAOLUCCI, ANTONIO. "Per Girolamo di Giovanni da Camerino." Paragone 21, no. 239 (1970):23-41, 25 illus.

Girolamo di Giovanni da Camerino

> Traces career of artist in context of styles of Camerino. Active 1449-73.

1178 ROMANI, R. Affreschi del secolo XV a Bolognola. Fabriano: Tipografia economia, 1926, 18 pp., 8 illus.
> Attributes cycle in small chapel to Girolamo. Comments briefly on other Camerinese painters.

1179 SERRA, LUIGI. Girolamo di Giovanni da Camerino." Rassegna marchigiana 8 (1930):246-67, 6 illus.
> Study of artist with sections on unpublished works, known works, artistic origins, and an attempt to establish a chronology.

1180 ____. "Un nuovo dipinto di Girolamo di Giovanni." Rassegna marchigiana 1, no. 3 (1922-23):95-101, 6 illus.
> Publishes and attributes fresco of Madonna and Saints, S. Francesco, Camerino, dated 1462. Illustrates other works by artist.

BENOZZO GOZZOLI (1420-97)

Books

1181 BARGELLINI, PIERO. La fiaba pittorica di Benozzo Gozzoli. Florence: Arnaud editore, 1946, 227 pp., many b&w and 2 color illus.
> Surveys career with attention to historical circumstances, discusses reasons for popularity, and artistic significance.

1182 CONTALDI, ELENA. Benozzo Gozzoli: La vita, le opere. Preface by Adolfo Venturi. Milan: Hoepli, 1928, 270 pp., 120 b&w and 1 color illus.
> Biography with chronological chart. Survey of works. List of works, including section of lost works, and doubtful attributions. Bibliography.

1183 HOOGEWERFF, J.G. Benozzo Gozzoli. Paris: Alcan, 1930, 103 pp., 16 illus.
> Monograph following career. Section of documents with commentary. Brief catalogue raisonnée of works. Full bibliography, index.

1184 LAGAISSE, MARCELLE. Benozzo Gozzoli: Les traditions trecentistes et les tendences nouvelles chez un peintre florentin du quattrocento. Paris: Henri Laurens, 1934, 246 pp., 76 illus.
> Survey of career, then large section on characteristics of art and section on personality, influence and place in fifteenth century. Chronological list of works, bibliography.

1185 MENGIN, URBAIN. Benozzo Gozzoli. Paris: Plon, 1909, 168
 pp., 24 illus.
 Early monograph with chapters following Gozzoli to each
 location of his career. Chronological table, brief geograph-
 ical catalog of works. Bibliography, index. Defines artist as
 a painter of histories, concentrates on frescoes.

1186 PADOA RIZZO, ANNA. Benozzo Gozzoli: Pittore fiorentino.
 Florence: Edam, 1972, 178 pp., 230 b&w and 4 color illus.
 Examination of artist's career, with new material on
 earliest years. Survey of literature, catalog of works, each
 with full discussion and of lost works. Lengthy bibliography,
 index.

1187 WINGENROTH, MAX. Die Jugendwerke des Benozzo Gozzoli: Eine
 kunstgeschichtliche Studie. Heidelberg: Carl Winter's
 Universitätsbuchhandlung, 1897, 98 pp.
 Discusses works from early period, particularly in
 Montefalco and Viterbo. Chapters on apprenticeship and on
 influence on Umbrian school. Appendix on drawings.

Articles and Booklets

1188 BACCI, PÈLEO. "Gli affreschi inediti di Benozzo Gozzoli a
 Légoli." Bollettino d'arte 8, no. 12 (1914):387-98, 9
 illus.
 Little-known cycle in Legoli, Cappella Catanti, done in
 1479. Publishes documents, affirms attribution and importance.
 Discusses context in Gozzoli's late period.

1189 BARGELLINI, PIERO. The Medici Palace and the Frescoes of
 Benozzo Gozzoli. Translated by Gladys Hutton. Rome: Del
 Turco, 1954, 44 pp., 25 b&w and 4 color illus.
 Booklet describing architecture of palace, chapel, and
 its frescoes. Mostly illustrations. Brief biography of
 Gozzoli.

1190 BENVENUTI, GIOVANNI BATTISTA. Gli affreschi di Benozzo
 Gozzoli nella cappella del Palazzo Riccardi. Florence:
 Galletti & Cocci, 1901, 40 pp., 15 illus.
 Descriptions of frescoes, amplified by poems written by
 Lucrezia Tornabuoni de' Medici, wife of Piero, dealing with
 same subject matter.

1191 BERENSON, BERNARD. "Due o tre disegni di Benozzo." L'arte
 35, no. 2 (1932):91-103, 7 illus.
 Attributes drawing, Totila at the Siege of Perugia,
 Uffizi, Florence, ca. 1449, usually given to Bonfigli, and two
 studies for frescoes at Castelfiorentino, London, British Mu-
 seum, and Munich, Gabinetto delle stampe.

Benozzo Gozzoli

1192 BERTI-TOESCA, ELENA. Benozzo Gozzoli: Gli affreschi della
 Cappella Medici. Collezione Silvana, 18. Milan: Amilcare
 Pizzi editore, 1958, 16 pp., 8 b&w and 28 color illus.
 Brief text to large color plates with many details.
 Views of chapel interior from various angles. Brief
 bibliography.

1193 BIASIOTTI, GIOVANNI. "Affreschi di Benozzo Gozzoli in S.
 Maria Maggiore in Roma." Bollettino d'arte 7, no. 3
 (1913):76-86, 10 illus.
 Publishes remains of frescoes, 1447-49, by Gozzoli, cited
 by Vasari and considered lost. In vault of Cappella di S.
 Michele e di S. Pietro ad Vincula.

1194 BOSCHETTO, ANTONIO. Benozzo Gozzoli nella chiesa di San
 Francesco a Montefalco. Milan: Istituto editoriale
 italiano, 1961, 32 pp., 40 b&w and 20 color illus.
 Brief text accompanying large, clear photographs of
 Gozzoli's work in church, including the Cappella di S. Girolamo
 and the scenes of Saint Francis in the Cappella Maggiore.

1195 BRANDI, CESARE. "Postilla al restauro della pala del
 Bellini di Pesaro e del Gozzoli del 1456 della Pincoteca di
 Perugia." Bollettino dell'Istituto centrale del restauro 2
 (1950):57-62, 5 illus.
 Brief comment on glazing technique of Gozzoli's Madonna.

1196 BYAM SHAW, J. "School of Benozzo Gozzoli (1420-1497)." Old
 Master Drawings 6, no. 24 (1932):62, 1 illus.
 Publishes a drawing of Cow and Her Calf, Venice,
 Accademia.

1197 C., G.C. "Ein bisher unbekanntes Werk des Benozzo Gozzoli
 und des Giusto di Jacopo in Certaldo." Repertorium für
 Kunstwissenschaft 1 (1876):348-49.
 Publishes and describes frescoes of 1465 in tabernacle.

1198 CARNEVALI, NINO. "Un affresco di Benozzo Gozzoli."
 Rassegna d'arte 9, no. 2 (1909):24, 1 illus.
 Publishes photo of Madonna with Angels, on exterior of a
 wall on Via Tribuna di Campitelli, Rome, ca. late 1440s.

1199 CAROTTI, GIULIO. "Una tavoletta di Benozzo Gozzoli."
 L'arte 3 (1900):424.
 Announces work recently acquired by Brera, Milan, repre-
 senting miracle of San Domenico.

1200 _____. "Una tavoletta di Benozzo Gozzoli." Rassegna d'arte
 1, no. 5 (1901):72-74, 1 illus.
 Attribution of small predella panel of Miracle of S.
 Domenico, Milan, Brera. Associates with contract of 1461.

1201 CHIAPPELLI, ALBERTO. "Di due ultimi lavori, finora
 sconosciuti, di Benozzo Gozzoli e della morte di lui,
 secondo nuovi documenti pistoiese." Bollettino storico
 pistoiese 23 (1921):83-93, 2 illus.
 Publishes Crucifixion, Horne Collection, Florence, and
 information regarding lost Resurrection, done in 1497, last
 year of artist's life. Documents.

1202 _____. "In quale anno e in quale luogo morì Benozzo
 Gozzoli? E dove ebbe la sua sepoltura?" Archivio storico
 italiano 34 (1904):146-58.
 Document of 1497 in Biblioteca Forteguerri, Pistoia,
 states date of death as 4 October 1497, in Pistoia. Believes
 probably buried in Pistoia, although Vasari says tomb is in
 Campo Santo, Pisa.
 Review: [Cornelius de Fabriczy], Repertorium für
 Kunstwissenschaft 28 (1905):538.

1203 CUST, LIONEL, and HORNE, HERBERT. "Notes on Pictures in the
 Royal Collections. Article VIII: The Story of Simon Magus,
 Part of a Predella Painting by Benozzo Gozzoli." Burlington
 Magazine 7, no. 29 (1905):377-83, 2 illus.
 Panel at Hampton Court associated with an altar of 1461.
 Documents appended.

1204 CUST, R[OBERT] H[ORNE]. "Gli affreschi di Benozzo Gozzoli e
 della sua scuola a Castelfiorentino." Rassegna d'arte 5,
 no. 10 (1905):149-52, 5 illus.
 Describes two tabernacles: Chapel of the Madonna della
 Tosse, dated 1484 on facade, mostly not by Gozzoli's own hand,
 and Tabernacle of the Visitation, ca. 1450-55.

1205 D'ACHIARDI, PIETRO. "Una tavola di Benozzo." L'arte 16
 (1903):122-24, 1 illus.
 Publishes recently cleaned Madonna Enthroned with Saints,
 Palazzo del Cappellani, Duomo, Pisa, dated 1470.

1206 DAL POGGETTO, MARIA G. CIARDI DUPRÉ. "Sulla collaborazione
 di Benozzo Gozzoli alla Porta del Paradiso." Antichità viva
 6, no. 6 (1967):60-73, 17 b&w and 1 color illus.
 Attempts to identify Gozzoli's contribution to relief on
 baptistery doors in Florence and to elucidate his early career.
 Postulates his hand in details of Story of Saul and David,
 Solomon and Sheba, and Story of Joshua.

1207 ERICHSEN, NELLY. "Un nuovo affresco di Benozzo Gozzoli."
 Rassegna d'arte 8, no. 4 (1908):75-76, 1 illus.
 Discovery of frescoes in S. Francesco, Lucca: Presenta-
 tion and Marriage of Virgin, and fragments of others, ca.
 1469-85.

Benozzo Gozzoli

1208 FAUCON, MAURICE. "Benozzo Gozzoli a San Gimignano." L'arte
 (1881):125-34, 189-92, 201-5, 11 illus.
 Primarily description of frescoes in Sant'Agostino.

1209 FRERICHS, LIENEKE C.J. "Een verloren gegaan werk van
 Benozzo Gozzoli: Het fresco met de Dood van Mozes" [A lost
 fresco by Benozzo Gozzoli: The fresco with the death of
 Moses]. Bulletin van het Rijksmuseum 22, no. 2-3 (1974):65-
 80, 10 illus.
 In Dutch with English summary. Drawing in Princeton,
 ca. 1500, seen as probable copy of now deteriorated fresco by
 Gozzoli in Campo Santo, Pisa. Identifies scene as Balaam and
 King of Moab with scenes from Moses and Israelites' journey.

1210 FRONTISI, CLAUDE. "Recherches sur la composition des cycles
 peints en Toscane au XVE siècle: Benozzo Gozzoli."
 L'information d'histoire de l'art 17, no. 4 (1972):163-67,
 3 illus.
 Study of organization of Gozzoli's fresco cycles. Seen
 to follow narrative, rather than theoretical basis.

1211 GIUDICI, EMILIANI PAOLO. "Les fresques de San Gemignano."
 Gazette des beaux arts 1, no. 2 (1859):170-77, 2 illus.
 General description of works by Gozzoli.

1212 GOODISON, J.W. "Two Drawings by Benozzo Gozzoli."
 Burlington Magazine 59, no. 344 (1931):214-19, 4 illus.
 Attributes sheet with drawing on two sides, Fitzwilliam
 Museum, Cambridge, to Gozzoli. Compares to a similar sheet,
 Musée Conde, Chantilly. Related in style to Fra Angelico.

*1213 GRASSI, GIUSEPPE. "Intorno ad una anconetta attribuita a
 Benozzo Gozzoli." Rivista critica d'arte (May-June
 1919):41.
 Source: entry 1186.

1214 GROTE, ANDREAS. "A Hitherto Unpublished Letter on Benozzo
 Gozzoli's Frescoes in the Palazzo Medici-Riccardi." Journal
 of the Warburg and Courtauld Institutes 27 (1964):321-22.
 Publishes letter from Roberto Martelli to Piero di Cosimo
 de' Martelli that mentions cherubim in frescoes and a payment.

1215 KNAUER, ELFRIEDE REGINA. "Kaiser Sigismund. Eine
 ikonographische Nachlese." In Festschrift für Otto von
 Simson. Frankfurt am Main, Berlin, and Vienna: Propyläen
 Verlag, 1977, pp. 173-96, 8 illus.
 Includes a detail of Gozzoli's frescoes in Medici Chapel,
 Florence, among a review of newly identified portraits of
 Sigismund.

1216 LAGAISSE, MARCELLE. "Un'opera ignorata di Benozzo Gozzoli."
 L'arte 7, no. 4 (1936):237-42, 1 illus.

Publishes <u>Madonna</u> <u>and</u> <u>Child</u> <u>with</u> <u>Two</u> <u>Angels</u>, private collection, Paris. Dates after 1459.

1217 LONGHI, ROBERTO. "Una crocifissione di Benozzo giovine."
 <u>Paragone</u> 11, no. 123 (1960):3-7, 4 b&w and 1 color illus.
 [Reprinted in <u>Fatti</u> <u>di</u> <u>Masolino</u> <u>e</u> <u>di</u> <u>Masaccio</u> <u>e</u> <u>altri</u> <u>studi</u>
 <u>sul</u> <u>quattrocento</u> (Florence: Sansoni, 1975), pp. 123-27.]
 Attribution of panel, private collection, Paris, from
 Gozzoli's youth, ca. 1450.

1218 LUPI, C. "I restauri delle pitture del Camposanto urbano di
 Pisa." <u>Rivista</u> <u>d'arte</u> 6, no. 1 (1909):55-59.
 Publishes documents of restorations done in 1665-70 on
 frescoes.

1219 MANGHI, ARISTO. "Per gli affreschi di Benozzo Gozzoli."
 <u>Bullettino</u> <u>pisano</u> <u>d'arte</u> <u>e</u> <u>di</u> <u>storia</u> 1, no. 8 (1913):187-88.
 Report of declining condition of frescoes.

1220 MARINANGELI, BONAVENTURA. "Descrizione e memorie della
 Chiesa e del Convento di San Francesco in Montefalco."
 <u>Miscellanea</u> <u>francescana</u> 14, no. 5 (1913):129-53.
 A chronology of church, based upon documents. Section
 for 1452 includes documents concerning Gozzoli's cycle.

1221 MENGIN, URBAIN. "La chapelle du Palais des Médicis a
 Florence et sa décoration par Benozzo Gozzoli." <u>Revue</u> <u>de</u>
 <u>l'art</u> <u>ancien</u> <u>et</u> <u>moderne</u> 25, no. 146 (1909):367-84, 12 illus.
 Frescoes examined in light of political development and
 history of Medici. Notes portraints of young Lorenzo il
 Magnifico and John Paleologus.

1222 MESNIL, GIACOMO. "Sigismondo Malatesta e Galeazzo Maria
 Sforza in un affresco del Gozzoli." <u>Rassegna</u> <u>d'arte</u> 9, no.
 5 (1909):74-75, 2 illus.
 Identifies two figures in Medici Chapel, Florence.

1223 NESSI, SILVESTRO. "Un restauro di Benozzo a Montefalco."
 <u>Commentari</u> 16, no. 3-4 (1965):222-24, 2 illus.
 Image of Saint Chiara for her tomb in Sta. Chiara,
 Montefalco, restored by Gozzoli in 1452.

1224 _____. "La vita di Sa. Francesco dipinta da Benozzo Gozzoli
 a Montefalco." <u>Miscellanea</u> <u>francescana</u> 61, no. 4
 (1961):467-92, 7 illus.
 Study of Gozzoli's literary sources. Historical
 background.

1225 PACCHIONI, G[UGLIELMO]. "Un affresco del Gozzoli in San
 Paolo fuori le mura." <u>L'arte</u> 12 (1909):447.
 Attribution of head of Saint Gregory, ca. 1458.

Benozzo Gozzoli

1226 _____. "Gli inizi artistici di Benozzo Gozzoli." L'arte 13
(1910):423-42, 11 illus.
Investigation of early efforts, before 1459. Discusses
work as assistant in Fra Angelico's fresco cycles in Orvieto
and Rome, cycle in S. Fortunato, Montefalco, and other works.

1227 PADOA, ANNA. "Benozzo ante 1450." Commentari 20, no. 1-2
(1969):52-62, 12 illus.
Attributes various works to artist's early period, in
1440s. Traces influence not only of Angelico but of other
Florentine artists.

1228 _____. "Note su un San Girolamo Penitente di Benozzo."
Antichità viva 19, no. 3 (1980):14-19, 6 illus.
Publishes panel in Museo Bardini, Florence, ca. 1495-97.
Suggests influence of Savonarola. Also tentatively suggests
identifications of Master Esiguo with Benozzo's son Alessio.
English summary.

1229 _____. "Una precisazione sulla collaborazione di Benozzo
agli affreschi del convento di San Marco." Antichità viva
8, no. 2 (1969):9-13, 7 illus.
Attributes parts of a Crucifixion, S. Marco, Florence,
ca. 1442-44.

1230 PAPINI, ROBERTO. "Il deperimento delle pitture murali nel
Camposanto di Pisa." Bollettino d'arte 3, no. 12
(1909):441-57, 9 illus.
Presents problems and proposed solutions to disintegra-
tion of frescoes. Discusses condition of works by Gozzoli.
History of previous restorations.

1231 _____. "Due opere di Benozzo Gozzoli." Bollettino d'arte
15, no. 1 (1921):36-38, 3 illus.
Publishes works recently uncovered from Benozzo's period
in Rome, 1456-58. Includes Madonna, now SS. Domenico e Sisto,
Rome, and Head of Christ from the monastery of Sta. Chiara,
Piperno (now Palazzo Venezia, Rome). Both identified with
works mentioned by Vasari.

1232 _____. "Dai disegni di Benozzo Gozzoli." L'arte 13
(1910):288-91, 1 illus.
Reviews attributions to Gozzoli and attributes to him
unpublished study of heads, Uffizi, Florence, and another draw-
ing, Windsor Castle, attributed to Angelico by Berenson (entry
370).

1233 _____. "L'opera di Benozzo Gozzoli in Santa Rosa di
Viterbo." L'arte 13 (1910):35-42, 9 illus.
Discusses cycle of life of Saint Francis, commissioned
1453. Compositions preserved in drawings made by Francesco
Sabatini in 1632.

1234 POUNCEY, PHILIP. "A Drawing by Benozzo Gozzoli for his
 Fresco-cycle at Viterbo." Burlington Magazine 89, no. 526
 (1947):9-13, 1 illus.
 Associates drawings in British Museum and Dresden as
 halves of same sheet. Identifies as scene of life of Sta.
 Rosa, from lost cycle by Gozzoli at Viterbo, 1453.

1235 _____. "An Eyewitness Account of Benozzo's Fresco-cycle at
 Viterbo." Burlington Magazine 89, no. 529 (1947):98.
 Publishes description of 1632 of Gozzoli's works.

1236 RICCI, CORRADO. "Benozzo Gozzoli: La pala della compagnia
 della Purificazione." Rivista d'arte 2, no. 1 (1904):1-12,
 3 illus.
 Discusses altar, now National Gallery, London, documented
 in 1461. Proposes Miracle of S. Domenico, Brera, Milan; and
 Miracle of S. Zanobi, Kann Collection (now Kaiser Friedrich
 Museum, Berlin), as parts of predella. Appends documents con-
 tracting for altarpiece and describing parts.

1237 ROSSI, ATTILIO. "Un affresco di Benozzo Gozzoli." L'arte 5
 (1902):252-53, 1 illus.
 Publishes Madonna and Saints in outside tabernacle, Via
 della Tribuna di Campitelli, Rome. Dates ca. 1447.

1238 SANPAOLESI, PIERO. "Le sinopie del Camposanto di Pisa."
 Bollettino d'arte 33, no. 1 (1948):34-43, 17 illus.
 Publishes recently uncovered sinopie, including some by
 Gozzoli. Bibliography on Composanto.

1239 SHAPLEY, FERN RUSK. "A Predella Panel by Benozzo Gozzoli."
 Gazette des beaux arts 39, no. 999 (1952):77-88, 6 illus.
 Recent acquisition by Kress Collection, National Gallery,
 Washington, illutrating three scenes of Saint John Baptist.
 Associates with dismembered altar for confraternity of Puri-
 fication of Virgin, Florence. Appends English translation of
 contract for altar, 1461.

1240 SHELL, CURTIS. "Gozzoli, Benozzo." In Encyclopedia of
 World Art. Vol. 6. London: McGraw Hill, 1962, col. 665.
 Brief survey of life and works. Brief bibliography.

 SORTAIS, GASTON. Le mâitre e l'élève: Fra Angelico and
 Benozzo Gozzoli. See entry 657.

1241 STIENNON, JEAN. "L'iconographie de Saint Augustin d'après
 Benozzo Gozzoli et les Croisiers de Huy. Deux
 interprétations contemporaines et divergentes." Bulletin
 del'Institut historique belge de Rome 27 (1952):235-48.
 Discusses manuscript in library of University of Liège.

Benozzo Gozzoli

1242　SUPINO, IGINO BENVENUTO. Il Camposanto di Pisa. Florence:
　　　Fratelli Alinari, 1896, 317 pp., many illus.
　　　　Includes lengthy description of frescoes by Gozzoli with
　　critical history.

1243　_____. "Le opere minori di Benozzo Gozzoli a Pisa."
　　　Archivio storico dell'arte 7 (1894):233-48, 6 illus.
　　　　Discusses works done by Gozzoli in Pisa, other than major
　　project of Camposanto frescoes. Reviews related documents.

1244　TANGHERONI, MARCO, and TACCA, MARIO DEL. "Il tabernacolo
　　　campestre di Légoli affrescato da Benozzo Gozzoli."
　　　Antichità pisane 1, no. 2 (1974):36-41, 4 illus.
　　　　Comments regarding strategic location of tabernacle in
　　Légoli. Describes frescoes as examples of Gozzoli's late
　　style. Makes plea for restoration.

1245　TOSI, G. "L'edicola 'della visitazione' presso
　　　Castelfiorentino, dipinta da Benozzo Gozzoli." Miscellanea
　　　storica della Valdelsa 6, no. 3 (1898):204-16, 1 illus.
　　　　Publishes recently rediscovered and restored cycle. De-
　　scribes and dates early in artist's career.

1246　VAVASOUR-ELDER, IRENE. "Un dipinto poco conosciuto di
　　　Benozzo Gozzoli in Val d'Elsa." Rassegna d'arte 13, no. 1
　　　(1913):20, 1 illus.
　　　　Madonna and Saints, S. Andrea, San Gimignano. Signed and
　　dated 1466.

　　　VENTURI, ADOLFO. "Beato Angelico e Benozzo Gozzoli." See
　　　entry 723.

1247　VIGO, PIETRO. "Un affresco di Benozzo Gozzoli in San
　　　Gimignano ed un raffronto." Miscellanea storica della
　　　Valdelsa 16, no. 1 (1908):58-60.
　　　　Discusses St. Sebastian, in S. Agostino nella Terra, San
　　Gimignano.

1248　WUNDERLICH, SILVIA. "A Fifteenth-century Florentine Draw-
　　　ing." Print Collector's Quarterly 24, no. 3 (1937):319-21,
　　　2 illus.
　　　　Publishes recent acquisition by Cleveland Museum of Art
　　of drawing closely associated with Gozzoli.

GREGORIO DI CECCO (act. 1389-1423)

1249　CORTI, GINO. "La compagnia di Taddeo di Bartolo e Gregorio
　　　di Cecco, con altri documenti inediti." Mitteilungen des
　　　kunsthistorischen Institutes in Florenz 25, no. 3
　　　(1981):373-77.

Publishes documents from Archivio di Stato, Siena, including one concerning partnership between two artists, established in 1421.

1250 EDGELL, G[EORGE] H[AROLD]. "A Tabernacle by Gregorio di
 Cecco." Bulletin of the Museum of Fine Arts, Boston 42, no.
 249 (1944):53-56, 3 illus.
 Attributes tabernacle with Annunciation and Crucifixion
 to Sienese painter, documented from 1389-1423, adopted son of
 Taddeo di Bartolo.

1251 NERI LUSANNA, ENRICA. "Un episodio di collaborazione tra
 sculturi e pittori nella Siena del primo quattrocento." La
 Madonna del Magnificat di Sant'Agostino." Mitteilungen des
 kunsthistorischen Institutes in Florenz 25, no. 3
 (1981):325-40, 17 illus.
 Polyptych of 1420, Museo dell'Opera del Duomo, Siena,
 with work by Gregorio and others.

GUALTIERI DI GIOVANNI (act. 1389-1445)

1252 BERENSON, BERNARD. "A Reconstruction of Gualtieri di
 Giovanni." International Studio 97, no. 403 (1930):67-71,
 12 illus.
 Lists works attributable to Gualtieri and his associates,
 who executed frescoes in Chapel of the Virgin, Duomo, Siena,
 ca. 1410.

FILIPPO LIPPI (ca. 1406-69)

Books and Dissertations

1253 BALDANZA, FERDINANDO. Delle pitture di Fra Filippo Lippi
 nel coro della cattedrale di Prato e de' loro restauri.
 Prato: Per i fr. Giachetti, 1835, 59 pp., 5 illus.
 Reviews history of works, describes each one, adds chapters on other works by Lippi in Prato and on works by Fra
 Diamante and Filippino.

1254 BARGELLINI, PIERO. L'amorosa vicenda dei Lippi. Rome: Del
 Turco, 1951, 251 pp., 93 b&w and 4 color illus.
 Reconstructs life of artist, with special attention to
 his personal life, which feels should not be ignored or exaggerated but considered as part of his soul and art.

1255 FADALTI, P. GHERARDO, and DE NEGRI, MARINELLA. Fra Filippo
 Lippi. Florence: Ediz. Roseti del Carmelo, 1971, 47 pp.,
 41 illus.
 Small book providing illustrations of oeuvre. Outlines
 life and career.

Filippo Lippi

1256 MARCHINI, GIUSEPPE. *Filippo Lippi*. Milan: Electa
 editrice, 1975, 262 pp., 186 b&w and 24 color illus.
 Full monograph with review of works and of specific
 issues. Catalog of works, lost works, and drawings. Chron-
 ology, bibliography, and index. Illustrations include many
 sharp and useful details.

1257 MENDELSOHN, HENRIETTE. *Fra Filippo Lippi*. Berlin: Julius
 Bard, 1909, 283 pp., 44 illus.
 Background material, survey of works from early mythical
 period, to realism, to maturity and late period. Concerned
 with questions of attribution and collaboration. Appendix on
 erroneously attributed drawings. Documents. Chronology, list
 of lost works, geographical index, and index of names.

1258 MENGIN, URBAIN. *Les deux Lippi*. Paris: Librairie Plon,
 1932, 258 pp., 32 illus.
 General survey of each artist's life and career with
 descriptions of works. Chronological table, list of works by
 location. Index.
 Review: K.C., *Burlington Magazine* 63, no. 365 (1933):93.

1259 OERTEL, ROBERT. *Fra Filippo Lippi*. Vienna: Schroll, 1942,
 77 pp., 125 b&w and 2 color illus.
 Monograph considering life, work, and position in early
 Renaissance art. Considers iconography, role of patrons.
 Fully illustrated, with notes on plates.

1260 PITTALUGA, MARY. *Fra Filippo Lippi*. Florence: Del Turco,
 1949, 248 pp., 210 b&w and 4 color illus.
 Monograph discussing artist's career and work chronolog-
 ically, emphasizing style. Large section of appended material
 with annotations, individual documents, lists of works, works
 by his circle and lost works. Bibliography.
 Review: Charles de Tolnay, *Gazette des beaux arts* 36,
 no. 992-994 (1949):310-11.

1261 RUDA, JEFFREY. "Filippo Lippi Studies: Naturalism, Style,
 and Iconography in Early Renaissance Art." Ph.D. disserta-
 tion, Harvard University, 1979, 187 pp., 90 illus. New
 York: Garland, 1982.
 Concerned with "expressive content" of paintings, focus-
 ing on relationship of style and iconography, and on early
 Renaissance naturalism. Includes chapters on artist's inter-
 national contacts and iconographic sources, on attribution and
 dating questions, on the relation of style and iconography, and
 on drawings.

1262 STRUTT, EDWARD C. *Fra Filippo Lippi*. London: George Bell
 & Sons, 1901, 225 pp., 56 illus. Reprint. New York: AMS
 Press, 1972.

Surveys career, to reconstruct personality of man and artist. Bibliography, chronology of life, genealogy, documents, geographical catalog of works, and index.
Review: Alessandro Chiappelli, Nuova antologia (1 December 1904).

1263 SUPINO, I.B. Les deux Lippi. Translated by J. de Crozals. Florence: Alinari, 1904, 199 pp., 80 b&w and 1 color illus. Double monograph, reviewing careers of father and son.

1264 _____. Fra Filippo Lippi. Florence: Fratelli Alinari, 1902, 130 pp., 58 illus.
Major early scholarly monograph dealing with Lippi's career divided into periods in Florence, Prato, and Spoleto. Bibliography. Introduction deals with his life, character, and earlier critics. Introduces some new documentary material.
Review: A. Fraschetti, Rassegna bibliografica dell'arte italiana 5, no. 3-6 (1902):55.

1265 ULMANN, HERMANN. "Fra Filippo Lippi und Fra Diamante als Lehrer Sandro Botticellis." Ph.D. dissertation, University of Breslau, 1890, 65 pp.
Examination of later style of Lippi and of Fra Diamante, seen as formative influences on the style of Botticelli. Surveys sources and literature. Chapters on choir of Prato, Duomo, some later panel paintings, frescoes in Spoleto, Fra Diamante's work in the Sistine Chapel, and Fra Diamante's Birth of Christ, Louvre.

Articles and Booklets

1266 AMES-LEWIS, FRANCIS. "Fra Filippo Lippi and Flanders." Zeitschrift für Kunstgeschichte 42, no. 4 (1979):255-73, 16 illus.
Hypothesizes visit by Lippi to Flanders. Discusses visual evidence, referring mostly to works of Campin and his uncle.

1267 BADIANI, ANGIOLO. "I pentimenti di Fra Filippo Lippi." Archivio storico pratese 14 (1936):97-101.
Notes evidence of several changes made in Lippi's frescoes in choir of Duomo, Prato.

1268 _____. "I restauri del Duomo di Prato. II: La ripulitura degli affreschi di Fra Filippo Lippi nella cappella maggiore." Archivio storico pratese 14 (1936):1-9, 1 illus.
Account of cleaning.

1269 BERENSON, BERNARD. "Fra Angelico, Fra Filippo Lippi e la cronologia." Bollettino d'arte 26, no. 1 (1932):1-22, 19 illus.; no. 2 (1932):49-66, 16 b&w and 1 color illus.

Filippo Lippi

Analyzes tondo of <u>Adoration</u>, Cook Collection (now National Gallery, Washington). Discusses Lippi's early works and his relation to Angelico. Original article attributes tondo to both artists, but 1949 postscript in 1970 reprint (entry 88), pp. 199-243 gives to Lippi only.

1270 . "Three Drawings by Fra Filippo Lippi." <u>Old</u> <u>Master</u> <u>Drawings</u> 7, no. 26 (1932):16-18, 7 illus.
Three sketches, not included in author's <u>Drawings</u> <u>of</u> <u>the</u> <u>Florentine</u> <u>Painters</u> (entry 370), here given to Lippi.

1271 BODE, WILHELM [VON]. "Ein Frauenbildnis von Fra Filippo Lippi. Neuerwerbung des Kaiser-Friedrich-Museums." <u>Jahrbuch</u> <u>der</u> <u>preussischen</u> <u>Kunstsammlungen</u> 34, no. 2 (1913):97-98, 1 illus.
Publishes profile portrait. Attributes to Lippi, ca. 1440.

1272 BOMBE, WALTER. "Urkunden über ein verschollenes Altarbild Filippo Lippis." <u>Repertorium</u> <u>für</u> <u>Kunstwissenschaft</u> 34 (1911):115-18.
Documents of 1450-51 regarding a <u>Madonna</u> <u>and</u> <u>Saints</u> formerly in S. Domenico Vecchio, Perugia.

1273 BORSOOK, EVE. "Fra Filippo Lippi and the Murals for Prato Cathedral." <u>Mitteilungen</u> <u>des</u> <u>kunsthistorischen</u> <u>Institutes</u> <u>in</u> <u>Florenz</u> 19, no. 1 (1975):1-148, 69 illus.
Study of the history of the cycle, from time of commission through execution, based on 551 documents, which are included. Chronology. Bibliography.

1274 BRECK, JOSEPH. "A Double Portrait by Fra Filippo Lippi." <u>Art</u> <u>in</u> <u>America</u> 2, no. 1 (1913):44-55, 2 illus.
First detailed discussion and attribution of painting (now Metropolitan Museum of Art, New York). Identifies figures as connected to Scolari family.

1275 CAIOLI, PAOLO. "Un altro squardo sulla vita di Fra Filippo Lippi." <u>Carmelus</u> 5 (1958):30-72, 3 illus.
Reviews life, in detail, and some works of artist. Includes numerous documentary texts, including some previously unpublished.

1276 CARMICHAEL, MONTGOMERY. "Fra Lippo Lippi's Portrait." <u>Burlington</u> <u>Magazine</u> 21, no. 112 (1912):194-200, 3 illus.
Identifies kneeling ecclesiastic in <u>Coronation</u>, Accademia, Florence, as Canon Francesco Maringhi, the patron, rather than as self-portrait of the artist, as is traditionally thought.

1277 CHIAPPELLI, ALESSANDRO. "Fra Filippo Lippi." In Arte nel
 rinascimento. Rome: Casa editrice Alberto Stock, 1925,
 pp. 382-94.
 Discusses elements of Lippi's character and their rela-
 tion to his art. Observations on the individual nature of his
 style, as different from Masaccio's.

1278 COLASANTI, ARDUINO. "Nuovi dipinti di Filippo e di Filippino
 Lippi." L'arte 6 (1903):299-304, 7 illus.
 Publishes Madonna with Angels, acquired by Harnisch Col-
 lection, Philadelphia. Dates mid-1450s.

1279 DAVIES, MARTIN. "Fra Filippo Lippi's Annunciation and Seven
 Saints." Critica d'arte 8, no. 5 (1950):356-63, 4 illus.
 Proposes date of 1448 for pendant pictures, National
 Gallery, London. Connects to Medici family through device of
 three feathers in diamond ring on Annunciation and through
 choice of seven Saints. May honor expected birth of Lorenzo
 the Magnificent.

1280 DEGENHART, BERNHARD. "Ein Niello-entwurf des Fra Filippo
 Lippi." In Festschrift Ulrich Middeldorf. Edited by Antje
 Kosegarten and Peter Tigler. Berlin: Walter de Gruyter,
 1968, pp. 155-57, 2 illus.
 Sees Lippi's drawing of Crucifixion, British Museum,
 London, as design for niello, Bargello, Florence, ca. 1450.

1281 FAUSTI, LUIGI. "Le pitture di Fra Filippo Lippi nel Duomo
 di Spoleto." Archivio per la storia ecclesiastica
 dell'Umbria 2 (1915):1-36, 8 illus. Reprint. Spoleto:
 Ediz. dell'ente rocca di Spoleto, 1970.
 Pronounces importance of cycle, considers Lippi's life
 and circumstances in Prato.

1282 FIOCCO, GIUSEPPE. "Filippo Lippi a Padova." Rivista d'arte
 18 (1936):25-44, 7 illus.
 Attempts to define Lippi's early career, especially dur-
 ing his sojourn in Padua, ca. 1432-37. Makes several attribu-
 tions, notes works by Domenico di Bartolo and Squarcione that
 show his influence. Appends documents.

1283 FISCHEL, OSKAR. "Die Predella zur Krönung Maria von Fra
 Filippo Lippi." Amtliche Berichte aus den Königl.
 Kunstsammlungen, Berlin 33, no. 7 (1912):171-74, 3 illus.
 Publishes predella with a miracle scene of infancy of
 Saint. Associates with Coronation from S. Ambrogio, Florence
 (now Uffizi), on basis of drawing, Windsor Castle, with drapery
 studies for main panel and for this scene.

1284 FUSCO, LAURIE. "An Unpublished Madonna and Child by Fra
 Filippo Lippi." J. Paul Getty Museum Journal 10 (1982):1-
 16, 26 illus.

Filippo Lippi

Discusses painting from Utah Museum of Fine Arts, Salt Lake City, cleaned at Getty Museum. Affirms attribution, dates 1437-38, compares to other contemporary Madonnas. Analyzes architectural details and pointed lunette format. Suggests is painting mentioned by Vasari as in Palazzo Vecchio, Florence.

1285 GAMBA, CARLO. "Un Fra Filippo Lippi dimenticato nel cuore di Firenze." Rivista d'arte 26 (1950):207-10, 3 illus.
Calls attention to little-known Crucifixion, S. Gaetano, Florence.

1286 GIGLIOLI, ODOARDO H. "Una pittura ignota di Fra Filippo Lippi." Dedalo 6, no. 3 (1925-26):553-59, 6 illus.
Publishes Annunciation, private collection, ca. 1437. Probably one mentioned by Vasari as over door in Palazzo Vecchio, Florence. English summary.

1287 LAVIN, MARILYN ARONBERG. "The Joy of the Bridegroom's Friend: Smiling Faces in Fra Filippo, Raphael, and Leonardo." In Art the Ape of Nature: Studies in Honor of H.W. Janson. Edited by M. Barasch and L.F. Sandler. P. Egan, coordinating editor. New York and Englewood Cliffs, N.J.: Abrams, Prentice Hall, 1981, pp. 193-210, 9 illus.
Interpretation of Lippi's Madonna and Child with Angels, Uffizi, Florence, as representing themes of marital union between Christ and Mary-Ecclesia, with Angel rejoicing at coming salvation. Also discusses works by Raphael and Leonardo with similar iconography.

1288 MARCHINI, GIUSEPPE. "Una curiosità sul Lippi." Archivio storico pratese 51, no. 2 (1975):171-75, 2 illus.
On back of well-known letter written by Michelozzo and Donatello is inscription by Filippo Lippi to Giovanni di Francesco, regarding money owed, dated 1455.

1289 _____. "La vetrata e il suo restauro." Mitteilungen des kunsthistorischen Institutes in Florenz 19, no. 1 (1975):181-96, 13 b&w and 1 color illus.
Describes restoration to stained glass window of choir, Duomo, Prato. Considers possible participation of Filippo Lippi.

1290 MENDELSOHN, HENRIETTE. "Die Predelle Fra Filippos im Kaiser Friedrich Museum und ihr gegenstück." Monatshefte für Kunstwissenschaft 6 (1913):476-79, 2 illus.
Rejects ideas that panel in Berlin relates to Coronation, Louvre, and that illustrates scene of Saint Ambrosius and the bees. Dates in artist's mature period.

1291 _____. "Zum Predellenbild des Fra Filippo im Kaiser-Friedrich-Museum." Repertorium für Kunstwissenschaft 30 (1907):485-89.

Discusses iconography of panel of Miracle of Saint. Rejects theory identifying it as predella panel for Coronation, Accademia, Florence (now Uffizi). Dates as contemporary to frescoes in Prato.

1292 MENGIN, URBAIN. "Fra Filippo Lippi a Spolète." Revue de l'art 56, no. 2 (1929):11-28, 9 illus.
Describes program by Lippi and assistants at Duomo, Spoleto, 1466-69. Reviews documents.

1293 MENTION, ELIZABETH. "Conservation Report on the Madonna and Child by Fra Filippo Lippi." J. Paul Getty Museum Journal 10 (1982):17-20, 3 illus.
Describes process of cleaning and restoring panel. Analyzes paint content and application.

1294 MIDDELDORF, ULRICH. "Korrekturen Filippino Lippis in einem Bild aus der Werkstatt seines Vaters." In Festschrift Kurt Bauch. Munich: Deutscher Kunstverlag, 1957, pp. 171-76, 4 illus. [Reprinted in Raccolta di scritti [Collected writings], vol. 2 (Florence: Studio per edizioni scelte, 1980), pp. 217-23.]
Identifies hand of Filippino Lippi in some details of Nativity with Saints, Lippi shop, Galleria Comunale, Prato.

1295 MILANESI, GAETANO. "Fra Filippo Lippi." L'arte 3, no. 4 (1877):289-96, 4 illus.; 4, no. 1 (1878):5-9, 3 illus.
Reviews unpublished documents about Lippi's life, particularly some concerning Lucrezia Buti.

1296 NEUMEYER, ALFRED. Filippo Lippi: Anbetung des Kindes. Stuttgart: Philipp Reclam Jun, 1964, 32 pp., 16 illus.
Pamphlet analyzing Adoration in Berlin. Sections on historical background, analysis of painting, life of Lippi. Excerpts from documents and sources.

1297 ORLANDI, STEFANO. "Su una tavola dipinta da Fra Filippo Lippi per Antonio del Branca nel febbraio 1451." Rivista d'arte 29 (1954):199-201.
Publishes new document regarding arguments over payments for altarpiece for S. Domenico, Perugia.

1298 PARRONCHI, ALESSANDRO. "Luogo d'origine dell'Annunciazione Mond." Paragone 15, no. 179 (1964):42-48, 2 illus.
Associates Annunciation, now Palazzo Barberini, Rome, with lost work from Ospedale Vecchio delle Donne, Florence, mentioned by early sources as a work by Castagno. Attributes to Lippi.

1299 PITTALUGA, MARY. "Lippi, Filippo and Filippino." In Encyclopedia of World Art. Vol. 9. London: McGraw Hill, 1964, col. 257-66, 14 b&w and 4 color illus.

Filippo Lippi

Summary of career as known through documents. Definition
of elements and development of style. Arranges chronology.
Reviews sources and critical evaluations. Bibliography.

1300　POGGI, GIOVANNI. "Di due tavole di fra Filippo Lippi nella
raccolta Cook a Richmond." Rivista d'arte 4, no. 1-2
(1906):39-40.
Reviews recent literature concerning panels in Cook Col-
lection of Saints Bernard and Michael, sides of a triptych
destined for the King of Naples.

1301　_____. "Di una Madonna di Fra Filippo Lippi." Rassegna
d'arte 8, no. 3 (1908):43-44, 6 illus.
Publishes Madonna and Child, Palazzo Riccardi, Florence.

1302　_____. "Sulla data dell'affresco di fra Filippo nel
chiostro del Carmine." Rivista d'arte 18 (1936):95-106.
Calculates date of Confirmation of Rule as 1432. In-
cludes various documents.

*1303　POMPILI, LUIGI. L'ultima opera di Fra Filippo Lippi.
Spoleto: Accademia spoletina, 1957, 26 pp.
Source: Répertoire d'art et d'archéologie (1957).

1304　PUDELKO, GEORG. "The Early Work of Fra Filippo Lippi." Art
Bulletin 18, no. 1 (1936):104-12, 6 illus.
Ascribes several works, including Confirmation of Rule
from Carmine, Florence, to Lippi's early period. Emphasizes
relation to Masaccio.

1305　_____. "Per la datazione delle opere di Fra Filippo Lippi."
Rivista d'arte 18 (1936):45-76, 6 illus.
Chronology of Lippi's works, mostly of 1440s. Based on
Berenson's ideas (entry 1269), which the author modifies.

1306　[RAGGHIANTI, CARLO L[UDOVICO].] "Intorno a Filippo Lippi."
Critica d'arte 3, no. 4-6 (1938):xxii-xxv, 6 illus.
Reviews various works, some attributed to the young
Filippo Lippi, and reassigns them to Domenico di Bartolo,
Uccello, and Giovanni di Francesco.

1307　REGOLI, GIGETTA DALLI. "Appunti e verifiche (Filippo Lippi,
Fra' Bartolomeo)." Critica d'arte 34, no. 104 (1969):43-52,
9 illus.
Attribution of various drawings in Uffizi, Florence.
Includes a seated figure, which dates ca. 1455-60, and relates
to Funeral of St. Stephen, Duomo, Prato, as well as to two
other figure studies.

1308　_____. "Un disegno giovanile di Filippo Lippi." Critica
d'arte 7, no. 39 (1960):199-205, 6 illus.

Reviews state of research on Lippi drawings, comments on several attributions, and adds attribution of drapery study, Uffizi, Florence, usually attributed to Lorenzo di Credi. Dates ca. 1440.

1309 REINACH, SALOMON. "An Italian Primitive at Cherbourg." International Studio 92, no. 383 (1929):25-28, 6 illus.
 Publishes Entombment attributed to Lippi. Includes other examples of subject, unusual in quattrocento.

1310 RUDA, JEFFREY. "A 1934 Building Programme for S. Lorenzo in Florence." Burlington Magazine 120, no. 903 (1978):358-61.
 Publishes document concerning construction of chapels in S. Lorenzo. Suggests that Lippi's Annunciation does not fit into this program and may have been made as organ shutters. Appends documents.

1311 _____. "The National Gallery Tondo of the Adoration of the Magi and the Early Style of Filippo Lippi." Studies in the History of Art (National Gallery of Art) 7 (1975):7-39, 30 b&w and 1 color illus.
 Investigates attribution and dating. Postulates several stages of work, by Lippi and a follower of Fra Angelico, from mid-1430s to 1450s.

1312 SALMI, MARIO. "La giovinezza di Fra Filippo Lippi." Rivista d'arte 18 (1936):1-24, 10 illus.
 Assigns works to Lippi's early phase in the 1430s. Emphasizes influence of Masaccio. Includes Confirmation of Rule, Carmine, Florence, and Madonna and Angels, Castello Sforzesco, Milan.

1313 SCHOTTMULLER, FRIDA. "Ein Predellenbild des Fra Filippo Lippi im Kaiser-Friedrich Museum." Jahrbuch der preussischen Kunstsammlungen 28 (1907):34-38, 2 illus.
 Attributes work and identifies scene as miracle of bees in Saint Ambrosius legend. Dates in 1440s, associates with Coronation of Virgin, Accademia, Florence (now Uffizi).

1314 SHELL, CURTIS. "The Early Style of Fra Filippo Lippi and the Prato Master." Art Bulletin 43, no. 3 (1961):197-209, 32 illus.
 Removes from Lippi's oeuvre three works thought by others to illustrate his early style. Dates in 1440s. Associates rejected works with the artist of frescoes in Chapel of Assumption, Duomo, Prato.

1315 STRAUSS, ERNST. "Bemerkungen zum Kolorismus zweier Gemälde der Münchener Pinakothek." Festschrift Kurt Badt, 1961. [Reprinted in Koloritgeschichtliche Untersuchungen zur Malerei seit Giotto (Munich: Deutscher Kunstverlag, 1972), pp. 60-72.]

Filippo Lippi

Includes study of color and light, of application of
pigment, and of line in Lippi's Annunciation.

1316 TINTORI, LEONETTO. "Conservazione, tecnica e restauro degli
affreschi." Mitteilungen des kunsthistorischen Institutes
in Florenz 19, no. 1 (1975):149-80, 27 illus.
Account of 1969-72 restoration of Lippi's frescoes,
choir, Duomo, Prato. Analysis of technique of frescoes reveals
free use of secco pigments, most of which remain only in
traces. Many diagrams.

1317 TOESCA, PIETRO. "Una Madonna di Filippo Lippi." L'arte 35,
no. 2 (1932):104-9, 2 illus.
Attribution of work in private collection, Nice. Dates
after 1437.

1318 _____. "Una tavola di Filippo Lippi." Bollettino d'arte
11, no. 5-7 (1917):105-10, 4 illus.
Publication of Tarquinia Madonna, Museo Nazionale
Tarquiniense, Corneto. Dated 1437.

1319 TOLNAY, CHARLES DE. "The Autobiographic Aspect of Fra
Filippo Lippi's Virgins." Gazette des beaux arts 39, no.
1001 (1952):253-64, 6 illus.
Identifies infants in some of Lippi's Madonnas as self-
portraits, and Virgins as portraits of Lucrezia Buti. Discus-
ses secularization of images, defines paintings as "personal
confession." French translation.

1320 VAN MARLE, RAIMOND. "Eine unbekannte Madonna von Fra
Filippo Lippi." Pantheon 7 (March 1931):134, 1 color illus.
Publishes work, Goudstikker Collection, Amsterdam.
Dates before 1437.

1321 VENTURI, ADOLFO. "Ancora una Annunciazione di Filippo
Lippi." L'arte 27 (1924):167-68, 1 illus.
Publishes work, Langton Douglas Collection, London.

1322 _____. "Un prezioso frammento sconosciuto di Filippo
Lippi." L'arte 28 (1925):174-76, 1 illus.
Attributes of predella panel, École des Beaux Arts, Nice,
representing the death of a bishop.

1323 VENTURI, LIONELLO. "Contributi a Filippo Lippi." L'arte
35, no. 5 (1932):407-17, 2 illus.
Supports attribution of Madonna Enthroned, Rosenfield
Collection, New York. Notes influence of Fra Angelico. Also
attributes fragment of Madonna and Child, Blumenthal Collec-
tion, New York.

1324 _____. "Lo sviluppo artistico di Filippo Lippi." L'arte
36, no. 1 (1933):39-45, 5 illus.

Discusses Lippi's development in terms of influences of
Masaccio and Angelico. Disagrees with Berenson's chronology
(entry 1269).

1325 VENTURINI-PAPARI, TITO. "La tecnica di Filippo e Filippino
 Lippi: Fra Filippo Lippi e la sua opera a Spoleto." In
 Saggi e lezioni sull'arte sacra. Rome: Istituto beato
 Angelico di studi per l'arte sacra, 1944, pp. 103-21.
 Enthusiastic review of works in Spoleto, cleaned in
 1920s. Believes better in quality than generally believed.

1326 VOLPE, CARLO. "In margine a un Filippo Lippi." Paragone 7,
 no. 83 (1956):38-45, 1 illus.
 Attribution of Pietà, Museo di Castelvecchio, Verona, to
 Lippi, before 1437. Rejects attributions to Fra Angelico and
 Domenico Veneziano.

1327 WITT, ANTHONY DE. "Un affresco di Filippo Lippi nel
 chiostro del Carmine." Dedalo 12, no. 8 (1932):585-93,
 4 illus.
 Attributes Confirmation of Rule, Carmine, Florence, and
 places early in Lippi's career.

1328 ZANOCCO, RIZIERI. "Un nuovo documento su Fra Filippo Lippi
 a Padova." Rivista d'arte 18 (1936):107-9.
 Document of 1434 regarding Lippi's activity in Padua.

LORENZO MONACO (ca. 1370-1425)

Books and Dissertation

1329 EISENBERG, MARVIN J. "The Origins and Development of the
 Early Style of Lorenzo Monaco." 2 vols. Ph.D. disserta-
 tion, Princeton University, 1954, 342 pp., 91 illus.
 Dissertation aimed at clarifying early works, ca. 1390-
 1404. Study of twenty works, rejecting other attributions.
 Divides into three groups. Considers origins of style, rela-
 tion to contemporary currents, and relation to artist's mature
 style. Bibliography.

1330 GOLZIO, VINCENZO. Lorenzo Monaco: L'unificazione della
 tradizione senese con la fiorentina e il Gotico. Rome:
 Biblioteca d'arte editrice, 1931, 74 pp., 54 illus.
 Includes chapters on artistic traditions at beginning of
 fifteenth century in Siena and in Florence. Discussion of
 artist's career. Adds several attributions. Brief bibliog-
 raphy, indexes.

1331 SIRÉN, OSVALD. Don Lorenzo Monaco. Zur Kunstgeschichte des
 Auslandes, 33. Strassburg: Heitz, 1905, 198 pp., 63 illus.

Lorenzo Monaco

Basic monograph on the artist. Covers career, mostly chronologically, with additional chapters on various themes (miniatures, Madonnas, etc.), and sections on artistic personality and school. Appends documents, lists of works, and school works. Indexes.
Review: Wilhelm Suida, Monatshefte für Kunstwissenschaft 1, no. 4 (1908):305-6.

Articles

1332 AMERIO, ROSALBA. "Lorenzo Monaco." In Encyclopedia of World Art. Vol. 9. London: McGraw Hill, 1964, col. 337-40, 4 b&w and 2 color illus.
Traces stylistic development in manuscripts and paintings, noting various attributions. Bibliography.

1333 BAUMAN, GUY CAESAR. "The Miracle of Plautilla's Veil in Princeton's Beheading of Saint Paul." Record of the Art Museum, Princeton University 36, no. 1 (1977):3-11, 7 illus.
Discusses visual and literary sources of predella attributed to Lorenzo Monaco. Identifies female figure as Saint Plautilla.

1334 BELLOSI, LUCIANO. "Da Spinello Aretino a Lorenzo Monaco." Paragone 16, no. 187 (1965):18-43, 40 b&w and 1 color illus.
In a discussion of late trecento painting, considers Spinello's influence on Lorenzo Monaco's art.

1335 BERENSON, BERNHARD. "Un nuovo Lorenzo Monaco." Rivista d'arte 6, no. 1 (1909):3-6, 2 illus.
Attribution of Annunciation, Fornari Collection, Fabriano, previously attributed to Francesco di Gentile, which may belong to lost triptych for Carmine, Florence. Also mentions some attributions to Pietro di Domenico.

1336 BIAGI, LUIGI. "Note su alcuni quadri della Pinacoteca Vaticana." L'arte 18 (1915):228-31, 2 illus.
Examines works in collection associated with Lorenzo Monaco. Assigns most to followers, except for two small panels, Miracle of S. Benedetto and St. Anthony Abbot and St. Paul Hermit.

1337 CIARANFI, ANNA MARIA. "Lorenzo Monaco miniatore." L'arte 35, no. 4 (1932):285-317; no. 5 (1932):379-99, 36 illus.
Publication of manuscripts from different moments in artist's career. Discusses their relationship to his paintings. Adds some new attributions.

1338 DAVIES, MARTIN. "Lorenzo Monaco's Coronation of the Virgin in London." Critica d'arte 8, no. 3 (1949):202-10, 14 illus.

Asserts that two panels of Adoring Saints and Coronation
of the Virgin, National Gallery, London, are from same altar-
piece, possibly from convent of S. Benedetto fuori della Porta
a Pinti, near Florence. Also associates several other small
panels with predella.

1339 EISENBERG, MARVIN J. "A Crucifix and a Man of Sorrows by
 Lorenzo Monaco." Art Quarterly 18, no. 1 (1955):45-49, 6
 illus.
 Discusses two little noticed works: a cut-out painted
cross, Sta. Maria della Vertighe, Monte San Savino, and a
fragmentary detached fresco of the Man of Sorrows, in the
refectory of the Ognissanti, Florence.

1340 . "An Early Altarpiece by Lorenzo Monaco." Art
 Bulletin 39, no. 1 (1957):49-52, 10 illus.
 Publishes triptych of Madonna and Saints in Biblioteca
Comunale, Pescia. Affirms attribution, dates 1390s.
 Letter: Mirella Levi d'Ancona, Art Bulletin 41, no. 1
(1959):128-29.

1341 . "Un frammento smarrito dell'Annunciazione di Lorenzo
 Monaco nell'Accademia di Firenze." Bollettino d'arte 41,
 no. 4 (1956):333-35, 3 illus.
 Lost tondo, formerly in Artaud de Montor Collection,
attributed to Lorenzo Monaco, ca. 1409, and identified as
fragment of Annunciation, Accademia, Florence.

1342 . "Some Monastic and Liturgical Allusions in an Early
 Work of Lorenzo Monaco." In Monasticism and the Arts.
 Edited by Timothy Gregory Verdon. Syracuse: Syracuse Uni-
 versity Press, 1984, pp. 271-89, 8 illus.
 Interprets altarpiece with Agony in the Garden,
Accademia, Florence, as a visual parallel to monastic prac-
tices. Work done ca. 1395-1400 for Camaldolite order, Sta.
Maria degli Angeli, Florence. Associates with liturgy for
Compline and Matins, especially on Maundy Thursday.

1343 GIOLLI, RAFFAELLO. "Alcune tavole del Pisano." Rivista
 d'arte 8, no. 1-2 (1912):25-28, 3 illus.
 In an article on works in minor churches in Pisa, in-
cludes Madonna and Angels, S. Ermete, dated 1412, which attrib-
utes to Lorenzo Monaco, and Madonna by Turino Vanni in Rigoli.

1344 GONZALEZ-PALACIOS, ALVAR. "Indagini su Lorenzo Monaco."
 Paragone 21, no. 241 (1970):27-36, 17 illus.
 Discusses origins of Lorenzo Monaco. Various attribu-
tions, including Madonna and Saints, Musée Jacquemart Andrée,
Paris, ca. 1380, and Crucifixion, Lehman Collection, New York,
ca. 1406.

Lorenzo Monaco

1345 GRONAU, H.D. "The Earliest Works of Lorenzo Monaco."
 Burlington Magazine 92, no. 568 (1950):183-88, 6 illus.; 92,
 no. 569 (1950):217-22, 15 illus.
 Collects dispersed fragments of altarpiece from S.
 Gaggio, Florence, which attributes to Lorenzo Monaco, 1390-91.
 Makes additional attributions including manuscripts and draw-
 ing. Influence of Giotto.

1346 JURLARO, ROSARIO. "L'autorittrato di Lorenzo Monaco in un
 codice della Biblioteca Arcivescovile di Brindisi?" L'arte
 57, no. 3 (1958):243-46, 6 illus.
 Description of manuscript entitled Vite patrum with rep-
 resentations and accounts of lives of monastic and hermit
 Saints. Illuminations by four different hands identified.
 Suggests Lorenzo Monaco as one of four, and figure of
 Carmaldolese monk as a self-portrait.

1347 LAZAREFF, VITTORE. "Una Madonna di Lorenzo Monaco a Mosca."
 L'arte 27 (1924):124-26, 1 illus.
 Publishes Madonna, Museo Rumiantzeff, Moscow. Dates ca.
 1400.

1348 LEVI D'ANCONA, MIRELLA. "Some New Attributions to Lorenzo
 Monaco." Art Bulletin 40, no. 3 (1958):175-91, 25 illus.
 Reviews artist's career attempting to establish chronol-
 ogy of works. Numerous new attributions, particularly of min-
 iatures. Appendix on critical opinions on choirbooks of school
 of Angeli. New documents.
 Letter: Marvin J. Eisenberg, Art Bulletin 41, no. 1
 (1959):127.

1349 MEISS, MILLARD. "Four Panels by Lorenzo Monaco."
 Burlington Magazine 100, no. 663 (1958):191-96, 14 illus.;
 no. 667 (1958):359.
 Discussion of little-known panels, three at Wildenstein,
 New York, and one in unknown location, representing Abraham,
 Noah, Moses, and David. Dates ca. 1406-10. (All four now
 Metropolitan Museum, New York.) Addendum suggests courtroom of
 Mercanzia, Florence, as original location.

1350 MONTEBELLO, GUY-PHILIPPE DE. "Four Prophets by Lorenzo
 Monaco." Bulletin of the Metropolitan Museum of Art 25, no.
 4 (1966):155-69, 20 b&w and 1 color illus.
 Discusses panels representing Noah, Abraham, Moses and
 David, ca. 1406. Excellent condition allows study of tech-
 nique. Postulates that were part of a larger ensemble, possi-
 bly in a courtroom.

1351 PUDELKO, GEORG. "The Stylistic Development of Lorenzo
 Monaco." Burlington Magazine 73, no. 429 (1938):237-48,
 13 illus.; 74, no. 431 (1940):76-81, 4 illus.

Traces changing emphases in artist's lyrical style, noting linear and Gothic phases and citing influence of Sienese and Florentine trends, and of Ghiberti's sculpture.

1352 PUJMANOVÁ, OLGA. "Italian Primitives in Czechoslovak Collections." Burlington Magazine 119, no. 893 (1977):536-51, 20 illus.
 Includes a discussion of Lorenzo Monaco's Lamentation, National Gallery, Prague. Connects to panels of Agony in Garden and Three Maries, Louvre. Dated 1408. Also discusses panels of St. Bartholomew and St. John the Baptist, attributed to Paolo da Visso.

1353 _____. "Lorenzo Monaco v Národní galerii v Praze" [Lorenzo Monaco in the National Gallery, Prague]. Umeni 25, no. 1 (1977):35-43, 5 illus.
 In Czech with summary in Italian. Associates Lamentation, attributed to Lorenzo Monaco, in National Gallery, Prague, with two panels in Louvre, Paris, dated 1408. Reconstructs as triptych.

1354 ROBINSON, FREDERICK B. "A Painting in the Late Giottesque Tradition." Museum of Fine Arts Bulletin, Springfield, Massachusetts 25, no. 2 (1958-59):1-4, 3 illus.
 Attributes recently purchased Madonna in Glory, with Crucifixion at top, to Lorenzo Monaco. Discusses iconography.

1355 ROSENTHAL, ERWIN. "Una pittura di Lorenzo Monaco scoperta recentemente." Commentari 7, no. 2 (1956):71-77, 14 illus.
 Publication and attribution of manuscript page of Christ Giving the Keys to St. Peter. Dates late 1390s.

1356 SANDBERG-VAVALÀ, EVELYN. "Reconstruction of a Predella." Art in America 27, no. 3 (1939):105-11, 5 illus.
 Connects panels of Nativity, Berlin, Crucifixion of St. Peter, Walters Gallery, Baltimore, and Beheading of St. Paul, Museum, Princeton. Attributes to Lorenzo Monaco, and discusses other recent additions to his oeuvre.

1357 _____. "Lorenzo Monaco." In Studies in the Florentine Churches. I: Pre-Renaissance period. Florence: Olschki, 1959, pp. 232-47, 4 illus.
 Studies style of artist through works in Florentine churches. Notes influences, development. Indexes.

1358 SIRÉN, OSVALD. "Opere sconsciute di Lorenzo Monaco." Rassegna d'arte 9, no. 2 (1909):33-36, 5 illus.
 Publishes works noticed since publication of author's monograph on artist (entry 1331). Includes two frescoes from the Chiostro delle Oblate; Madonna and a scene from the lives of Saint Francis and Saint Nicholas, Magazzino degli Uffizi;

Lorenzo Monaco

Annunciation, Fornari Collection, Fabriano; and Madonna, Musée
Masson, Amiens. Lists additional works.

1359 TOESCA, PIETRO. "Nuove opere di don Lorenzo Monaco."
 L'arte 7 (1904):171-74, 2 illus.
 Attributes Madonna, Pinacoteca, Bologna, and Christ at
 Gethsemane, Uffizi, Florence. Dates both before 1410.

1360 ZERI, FEDERICO. "Aggiunta a una primizia di Lorenzo
 Monaco." Bollettino d'arte 51, no. 3-4 (1966):150-51, 2
 illus.
 Adds to Gronau's reconstructions of triptych from S.
 Gaggio, Florence (entry 1345), a panel now in the Santa Barbara
 Museum of Art, representing the Martyrdom of S. Gaggio. Dates
 ca. 1394-95.

1361 _____. "Investigations into the Early Period of Lorenzo
 Monaco." Burlington Magazine 106, no. 741 (1964):554-58, 7
 illus.; 107, no. 742 (1965):3-11, 14 illus.
 Revises some ideas of Gronau (entry 1345). Adds various
 new attributions and reconstructions.

 LORENZO DI NICCOLO (act. ca. 1390-before 1420)

Dissertation

1362 GEALT, ADELHEID MARIA MEDICUS. "Lorenzo di Niccolo." Ph.D.
 dissertation, Indiana University, 1979, 162 pp., 43 illus.
 First monograph on artist. Reconstructs oeuvre based on
 Coronation, S. Marco, Florence. Catalog of works, appendixes
 on literature, documents, and rejected attributions.
 Bibliography.

Articles

1363 COLE, BRUCE. "A New Work by the Young Lorenzo di Niccolò."
 Art Quarterly 33, no. 2 (1970):114-19, 4 illus.
 Attributes painted cross in S. Domenico, Prato, to
 Lorenzo di Niccolo and suggests may be one done in 1395 for
 Francesco di Marco Datini.

1364 FAHY, EVERETT. "On Lorenzo di Niccolo." Apollo 108, no.
 202 (1978):374-81, 16 illus.
 Attempts to clarify the oeuvre of the artist whose works
 are entangled with those of Niccolo Gerini. Deletes some
 attributions made by Berenson.

1365 SIRÉN, OSVALD. "Gli affreschi nel Paradiso degli Alberti,
 Lorenzo di Niccolò e Mariotto di Nardo." L'arte 11
 (1908):179-96, 16 illus.

Lorenzo da Viterbo

Publishes recently restored cycle in convent of Sta.
Birgitta, Bandini (near Florence), decorated in early 1400s.
Mostly by Lorenzo di Niccolo. Separates out works of Mariotto
di Nardo. Lists works of each master.

1366 _____. "Italian Pictures of the Fourteenth Century in the
Jarves Collection." Art in America 4, no. 4 (1916):207-23,
10 illus.
Includes attributions of triptych, ca. 1402, and two
pairs of Saints to Lorenzo di Niccolo.

1367 _____. "Lorenzo di Niccolo." Burlington Magazine 36, no.
203 (1920):72-78, 3 illus.
Attributes S. Giovanni Gualberto and His Enemy before the
Crucifix in S. Miniato, Wyer Collection. Dates ca. 1400.
Surveys artist's career and style. Lists other works.

1368 TARTUFERI, ANGELO. "Spinello Aretino in San Michele
Visdomini a Firenze (e alcune osservazioni su Lorenzo di
Niccolo)." Paragone 34, no. 395 (1983):3-18, 22 illus.
Publishes recently restored vault with frescoes done by
Spinello late in career, with assistance of Lorenzo di Niccolo.
Comments on latter's relation to Spinello and other artists.

1369 WATSON, PAUL F., and KIRKHAM, VICTORIA. "Amore e Virtù:
Two Salvers Depicting Boccaccio's 'Commedia delle Ninfe
Fiorentine' in the Metropolitan Museum." Metropolitan
Museum Journal 10 (1975):35-50, 11 illus.
Iconographic analysis of two works attributed to Lorenzo
di Niccolo, ca. 1410. Seen to depict events from Boccaccio
allegorizing love and virtue.

LORENZO DA VITERBO (1437-ca. 1476)

Dissertation

*1370 HAAS, C. "Beiträge zu Lorenzo da Viterbo." Ph.D.
dissertation, University of Vienna, 1978, 244 pp.
Source: Répertoire d'art et d'archéologie (1980).

Articles

1371 GRIGIONI, CARLO. "Un documento romano sul pittore Lorenzo
da Viterbo." L'arte 31 (1928):113-15.
Publishes document establishing that in 1462 artist was
living in Rome and was already a master. Contradicts theory
that born in 1444.

1372 LONGHI, ROBERTO. "Primizie di Lorenzo da Viterbo." Vita
artistica 1, no. 9-10 (1926):109-14, 5 illus.

Lorenzo da Viterbo

Attributes frescoes in Palazzo Orsini, Tagliacozzo, 1464, as early works, dependent on Gozzoli. Rejects attribution to Andrea Delitio. Discusses relation of Lorenzo to Antoniazzo Romano.

1373 ODDI, GIUSEPPE. "La cappella della Verità in Viterbo." Arte e storia 5, no. 10 (1886):76-77; no. 13 (1886):91-93.
Discusses chapel decorated by Lorenzo da Viterbo in 1469, and admired by Raphael. Influenced by Gozzoli's work in Sta. Rosa, Viterbo.

1374 RICCI, CORRADO. "Lorenzo da Viterbo." Archivio storico dell'arte 1 (1888):26-34, 60-67, 2 illus.
Discusses in particular works in Chiesa della Verità, Viterbo. History of church and of Cappella Mazzatosta, with frescoes dated 1469. Reviews early sources, including Nicola della Tuccia's Cronaca di Viterbo. Relationship to Gozzoli.

1375 ZERI, FEDERICO. "Una pala d'altare di Lorenzo da Viterbo." Bollettino d'arte 38, no. 1 (1953):38-44, 6 illus.
Publishes recently restored panel of Madonna and Saints, S. Michele, Cerveteri. Signed and dated 1471.

ZANOBI MACHIAVELLI (1418-79)

1376 BACCI, PELEO. "Zanobi Machiavelli a Pisa." Rivista d'arte 10, no. 1-2 (1917-18):125-27.
Publishes documents of 1475-76 concerning artist's activity.

1377 BERENSON, BERNARD. "Zanobi Macchiavelli." Burlington Magazine 92, no. 573 (1950):345-49, 11 illus.
Makes various attributions. Discusses relation to Lippi and others.

1378 BERTOLINI CAMPETTI, LICIA. "Resti di affreschi nell'ex-convento di Santo Croce in Fossabanda." Antichità pisane 1, no. 3 (1974):25-28, 3 illus.
Attributes recently uncovered fragments to Zanobi Machiavelli, ca. 1473.

1379 MATTEOLI, ANNA. "Aggiunte a Zanobi Machiavelli." Bollettino della Accademia degli enteleti della città di San Miniato 33 (1970-71):137-45, 3 illus.
Study of small panel of Madonna Enthroned, private collection, exhibited in 1969 at S. Miniato, Pisa. Notes close relationship to Gozzoli. Suggests chronology for artist with list of selected works.

1380 POGGI, GIOVANNI. "Zanobi di Iacopo Machiavelli pittore." Rivista d'arte 9, no. 1 (1916):67-69.
Publishes documents of 1457-80.

1381 REINACH, SALOMON. "Un tableau de Machiavelli au Musée
 National de Dublin." Gazette des beaux arts 23, no. 514
 (1900):278-82, 1 illus.
 Publishes signed Madonna and Saints. Dates after 1466.

1382 SALMI, M[ARIO]. "Zanobi Machiavelli e il 'Compagno del
 Pesellino.'" Rivista d'arte 9, no. 1 (1916):49-56, 4 illus.
 Reconstruction of oeuvre and stylistic deveopment of
 little-appreciated artist. Thinks works attributed to
 "Compagno di Pesellino" are his late works (see entry 183).

 MARIOTTO DI CRISTOFANO (1393-1457)

1383 AZZI, GIUSTINIANO DEGLI. "Documenti su artisti aretini e
 non aretini lavoranti in Arezzo." Vasari 4, no. 1-2
 (1931):49-69.
 Publishes several fifteenth-century notices, including
 references to Mariotto di Cristofano, the son of Giovanni
 d'Angelo di Balduccio.

1384 BOSKOVITS, MIKLÒS. "Mariotto di Cristofano: Un contributo
 all'ambiente culturale di Masaccio giovane." Arte illustrata
 2, no. 13-14 (1969):4-13, 11 illus.
 Suggests that artist's works around 1420 were important
 influence on Masaccio. Makes several attributions.

1385 COHN, WERNER. "Maestri sconosciuti del quattrocento
 fiorentino: I. Mariotto di Cristofano." Bollettino d'arte
 43, no. 1 (1958):64-68, 7 illus.
 Publishes new documents identifying Resurrection and
 Marriage of St. Catherine, both Accademia, Florence, as works
 by Mariotto for Ospedale di S. Matteo. Also attributes other
 works.

1386 FREMANTLE, RICHARD. "Note sulla parentela di Mariotto di
 Cristofano con la famiglia di Masaccio." Antichità viva 17,
 no. 3 (1978):52-53.
 Documents of 1420-35, regarding Masaccio's stepfather and
 Mariotto di Cristofano, who married Masaccio's stepsister.

 MARIOTTO DI NARDO (1394-1431)

1387 BOSKOVITS, MIKLÒS. "Mariotto di Nardo e la formazione del
 linguaggio tardo-gotico a Firenze negli anni intorno al
 1400." Antichità viva 7, no. 6 (1968):21-31, 17 illus.
 Considerations regarding role of Mariotto's influence on
 Ghiberti.

1388 _____. "Sull'attività giovanile di Mariotto di Nardo."
 Antichità viva 7, no. 5 (1968):3-13, 18 illus.

Mariotto di Nardo

Attributes and discusses various works of 1380s and 1390s. Sees earliest period as most important.

1389 EISENBERG, MARVIN J. "An Addition to a Group of Panels by Mariotto di Nardo." Record of the Art Museum, Princeton University 18, no. 2 (1959):61-64, 2 illus.
Associates additional panel, Kiss of Judas, Longhi Collection, with group published in earlier article (see entry 1391). Attributes to Mariotto di Nardo.

1390 _____. "The Coronation of the Virgin by Mariotto di Nardo." Minneapolis Institute of Arts Bulletin 55 (1966):9-24, 10 b&w and 1 color illus.
Discusses theme, history, style, and iconography of painting, ca. 1408, from S. Stefano in Pane, near Florence.

1391 _____. "A Flagellation by Mariotto di Nardo and Some Related Panels." Record of the Art Museum, Princeton University 8, no. 1 (1949):6-14, 7 illus.
Associates panel with six others, problably from same altarpiece.

1392 _____. "A Partial Reconstruction of a Predella by Mariotto di Nardo." Allen Memorial Art Museum Bulletin 9, no. 1 (1951):9-16, 5 illus.
Predella panel of Adoration of the Magi associated with Adoration of Shepherds, Lanckoronski Collection. Dated ca. 1400-1420.

1393 MORIONDO, M. "Mariotto di Nardo." Bollettino d'arte 37, no. 4 (1952):351, 1 illus.
Publishes a lunette with St. Matthew and Two Angels, Accademia, Florence, documented in 1413.

1394 POUNCEY, PHILIP. "An Initial Letter by Mariotto di Nardo." Burlington Magazine 88, no. 516 (1946):71-72, 1 illus.
Attribution of sheet, British Museum, which is an underpainting of a miniature.

1395 SALMI, MARIO. "Lorenzo Ghiberti e Mariotto di Nardo." Rivista d'arte 30 (1955):147-52, 3 illus.
Identifies Mariotto di Nardo as painter who accompanied Ghiberti to Pesaro in 1400, mentioned in latter's Commentari.

SIRÉN, OSVALD. "Gli affreschi nel Paradiso degli Alberti, Lorenzo di Niccolo e Mariotto di Nardo." See entry 1365.

1396 ZERI, FEDERICO. "An Addition to Mariotto di Nardo." Journal of the Walters Art Gallery 27-28 (1964-65):74-79, 5 illus.
Panel of Four Saints, dated ca. 1380, associated with three panels sold at Christie's, London.

FRA' MARINO ANGELI (ca. 1400-ca. 1470)

1397 CROCETTI, GIUSEPPE. "Fra' Marino Angeli da Santa Vittoria, pittore quattrocentesco." Notizie da Palazzo Albani 7, no. 1 (1978):38-60, 9 illus.; 8, no. 2 (1979):27-53, 18 illus.
 Reconstructs career of artist, gathers documents from various sources, and makes attributions. Includes catalog of works.

MARTINO DI BARTOLOMMEO (act. 1389-1434/5)

1398 BERENSON, B[ERNARD]. Notes on Tuscan Painters of the Trecento in the Staedel Institut at Frankfurt." Staedel Jahrbuch 5 (1926):17-29, 22 illus.
 Includes some attributions to Martino di Bartolommeo and a list of works in other collections to be attributed to him. Also an attribution to Lorenzo Monaco.

1399 BERTI, LUCIANO. "Martino di Bartolommeo." Bollettino d'arte 37, no. 3 (1952):256-58, 1 illus.
 Publishes Assumption, Curia Vescovile, Cortona. Dates ca. 1408.

1400 COOR, GERTRUDE. "A Note on Some Predella Paintings by Martino di Bartolommeo." Philadelphia Museum Bulletin 56, no. 268 (1961):56-60, 6 illus.
 Identifies subject matter of four panels as scenes from life of Saint Barnabas. Associates with Crucifixion, Kress Collection, New York, and suggests formed predella to Madonna and Saints, Pinacoteca, Siena. Dates ca. 1410.

1401 CRISTIANI TESTI, MARIA LAURA. "Essemplo, modello, natura, fantasia nella cultura artistica toscana del '300." Critica d'arte 43, no. 157-59, (1978):47-72, 35 illus.
 In a study of Pisan culture and artistic ambience, includes investigation of Martino di Bartolommeo's frescoes, S. Giovanni, Cascina.

1402 GAILLARD, EMILE. "Un triptyque qui n'en est pas un." Visages de l'ain 13 (1951):39-43, 3 illus.
 Attributes two panels, grouped erroneously with another into a triptych now in museum at Brou, to Martino di Bartolommeo, ca. 1430.

1403 SEYMOUR, CHARLES, Jr. "'Fatto di sua mano.' Another Look at the Fonte Gaia Drawing Fragments in London and New York." In Festschrift Ulrich Middeldorf. Vol. 1. Edited by Antje Kosegarten and Peter Tigler. Berlin: Walter de Gruyter & Co., 1968, pp. 93-105, 7 illus.

Martino di Bartolommeo

Two fragments of design for Quercia's Fonte Gaia from 1409, tentatively attributed to Martino di Bartolommeo. Discussion of contract procedures. Sees drawing as a legal entity.

1404 VAVASOUR-ELDER, IRENE. "Pitture senesi inediti." Balzana 1, no. 3 (1927):111-16, 4 illus.
Includes Madonna by Martino di Bartolommeo, Naumberg Collection, New York.

MASACCIO (1401-28)

Books and Dissertations

1405 BECK, JAMES, with the collaboration of GINO CORTI. Masaccio, the Documents. Villa I Tatti, Harvard University Center for Italian Renaissance Studies, Publications, 4. Locust Valley, N.Y.: J.J. Augustin, 1978, 60 pp.
Gathers all known material including some new documents. Provides summaries and commentaries. Appends related documents regarding Masaccio's works, artists with whom he associated, and his family.

1406 BERTI, LUCIANO. Masaccio. University Park, Pa. and London: Pennsylvania State University Press, 1967, 195 pp., 138 b&w and 24 color illus. [Italian ed. Milan: Istituto editoriale italiano, 1964.]
Extensive monograph including chapters on "problems and viewpoints," artist's biography, "origins and encounters," as well as discussions of individual works. Notes, diagrams, comparative material, brief catalog, bibliography, index.
Review: Creighton Gilbert, Journal of Aesthetics and Art Criticism 27, no. 4 (1969):465-66.

1407 BERTI, LUCIANO, and VOLPONI, PAOLO. L'opera completa di Masaccio. Classici dell'arte, 24. Milan: Rizzoli, 1968, 104 pp., 78 b&w and 72 color illus.
Reviews major critical opinions, essential bibliography, and documentary information. Detailed catalog of works and of attributed works.

1408 BOLOGNA, FERDINANDO. Masaccio: La cappella Brancacci. Milan: Fratelli Fabbri, 1969, 72 pp., 23 b&w and 21 color illus.
Volume of large illustrations, with very brief introductory text on history of painting, history of chapel, and critical fortunes. Brief bibliography.

1409 CASTELNUOVO-TEDESCO, LISBETH. "The Brancacci Chapel in Florence." Ph.D. dissertation, University of California, Los Angeles, 1971, 154 pp.

Studies iconography of Saint Peter cycle, using fifteenth-century texts and considering political references. Sees pro-papal attitude. Suggests Leonardo Bruni as author of program.

1410 CINELLI, BARBARA, and MAZZOCCA, FERNANDO. Fortuna visiva di
 Masaccio nella grafica e nella fotografia. Florence:
 Studio per edizioni scelte, 1979, 83 pp., 75 illus.
 Exhibition of reproductions, dating 1760-1964, of works
 by Masaccio. Investigates various interpretations of his art.
 Includes books, engravings, articles, and photographs.

1411 COLE, BRUCE. Masaccio and the Art of Early Renaissance
 Florence. Bloomington: Indiana University Press, 1980, 268
 pp., 114 illus.
 Examines Florentine painting from 1375 to 1430, with
 emphasis on stylistic developments and on the career of
 Masaccio. Selected bibliography, index.
 Review: Francis Ames-Lewis, Burlington Magazine 124, no.
 950 (1982):300-301.

1412 CREUTZ, MAX. "Masaccio: Ein versuch zur stilistischen und
 chronologischen Einordnung seiner Werke." Ph.D. disserta-
 tion, University of Berlin, 1901, 68 pp.
 Attempts to define Masaccio's own style, as distinct from
 Masolino. Particular attention to Brancacci Chapel, Florence,
 and S. Clemente frescoes, Rome. Generous attributions to
 Masaccio.

1413 DEBOLD-VON KRITTER, ASTRID. "Studien zum Petruszyklus in
 der Brancaccikapelle." Ph.D. dissertation, University of
 Berlin, 1975, 293 pp., 245 illus.
 Provides scene-by-scene textual and iconographic analy-
 sis of cycle. Considers cycle as a cycle, themes, and relation
 to contemporary politics and church philosophy. Records con-
 temporary responses. Appendix of related hymns and prayers.
 Catalog of cycles and group scenes of Saint Peter.

1414 EINEM, HERBERT VON. Masaccios 'Zingroschen.' Cologne and
 Opladen: Westdeutscher Verlag, 1967, 83 pp., 21 illus.
 Iconographic analysis of Tribute Money. Examines bib-
 lical text and earlier representations in various media. Re-
 lates to general historical circumstances and interprets as
 support for papacy in general. Includes English summaries and
 discussion.

1415 HERTLEIN, EDGAR. Masaccios Trinität: Kunst, Geschichte und
 Politik der Frührenaisance in Florenz. Pocket Library of
 Studies in Art, 24. Florence: Olschki, 1979, 266 pp., 79
 illus.
 Provides in-depth study of Trinity, Sta. Maria Novella,
 Florence, concluding with a political interpretation of work as
 a Guelph republic symbol. Sections on style, iconography,

patrons of frescoes, and on the political situation of Florence in relation to the rest of Italy and Europe. Index.

1416 KNUDTZON, FREDERIK G. En brochure om Masaccio. Copenhagen: Tryde, 1900, 90 pp., 26 illus.
Monograph that attempts to distinguish Masaccio from Masolino. Reviews earlier literature. Chapters on Brancacci Chapel, Carmine, Florence, and frescoes in S. Clemente, Rome, on drawings after lost Sagra and on portrait of Masaccio, Uffizi, Florence.
Review: A[dolfo] V[enturi], L'arte 4 (1901):127.

1417 _____. Masaccio og den fiorentinske malerkonst paa hans tid [Masaccio and Florentine painting of his time]. Copenhagen: Jacob Lund, 1875, 246 pp. Reprint. Copenhagen: F.G. Knudtzons Bogtrykkeri, 1975.
In Danish. Publication of monographic doctoral dissertation with chapters on art of era, on Antonio Veneziano, on Castiglione d'Olana and S. Clemente, Rome, on Brancacci Chapel, Carmine, Florence, and on art following Masaccio.

1418 LINDBERG, HENRIK. To the Problem of Masolino and Masaccio. 2 vols. Stockholm: Kungl. boktrykeriet, P.A. Norstedt & Söner, 1931, 224 pp., 123 illus.
Lengthy attempt to distinguish styles of two artists. Expands Masolino's oeuvre. Reviews early sources, establishes methodology and applies to specific works. Lengthy bibliography. Careful distinction between documented works and attributions.
Review: M[ario] S[almi], Rivista d'arte 14 (1932): 243-45.

1419 MESNIL, JACQUES. Masaccio et les débuts de la renaissance. The Hague: Martinus Nijhoff, 1927, 148 pp., 61 illus.
Volume devoted to defining Masaccio's art and its importance. Discusses Giotto and state of art ca. 1400, devotes several chapters to Masaccio's career, and several to aspects of Renaissance art, including perspective, composition, Ghiberti, and the antique. Plates include a variety of comparative material.

1420 PARRONCHI, ALESSANDRO. Masaccio. Florence: Sadea, 1966, 39 pp., 11 b&w and 80 color illus.
Provides brief introduction for collection of small color illustrations. Outlines life and career and critical opinions. Several perspective reconstructions. Bibliography.

1421 PITTALUGA, MARY. Masaccio. Florence: Le Monnier, 1935, 196 pp., 55 illus.
Reviews works, including much information on earlier scholarship. Lists documents, certain works, lost works,

and works by Masolino attributed to Masaccio. Extensive
bibliography.
> Review: Robert Oertel, Zeitschrift für Kunstgeschichte 5
(1936):65-68.

1422 PROCACCI, UGO. All the Paintings of Masaccio. Translated
by Paul Colacicchi. The Complete Library of World Art, 6.
New York: Hawthorn Books, 1962, 50 pp., 88 b&w and 4 color
illus. [Italian ed. Tutta la pittura di Masaccio,
Biblioteca d'arte Rizzoli, 3 (Milan: Rizzoli, 1951).]
> Survey of artist's life and work. Catalog of works.
Lists lost works, attributed works, and locations. Selected
critical excerpts, brief bibliography.

1423 SALMI, MARIO. Masaccio. 2d ed. Milan: Hoepli, 1948, 255
pp., 222 illus.
> Expansion of monograph first published in 1932. Surveys
works and discusses a number of more general issues, including
relation to Masolino, followers, stylistic characteristics, and
humanism. Brief bibliography, survey of critical writings,
chronology of works, lists of lost and attributed works.
Lengthy notes on plates. Amply illustrated, many details.
> Review: Mary Pittaluga, Rivista d'arte 26 (1950):229-31.

1424 SCHMARSOW, AUGUST. Masaccio Studien. 5 vols. Kassel:
Th.G. Fisher & Co., 1895-99, 522 pp., 132 illus.
> A survey of career, mostly devoted to big fresco proj-
ects. Last chapter considers development of wall painting,
Giotto to Masaccio. Concerned with differentiating from
Masolino. Attributes many works to Masaccio, including fres-
coes in S. Clemente, Rome, parts of triptych from Sta. Maria
Maggiore, Madonna, Bremen Museum, and most of Brancacci Chapel,
Carmine, Florence.

1425 _____. Masolino and Masaccio. Leipzig: Im Selbstverlag
des Verfassers, 1928, 254 pp.
> Chapter on each artist and one on S. Clemente cycle,
Rome, of which attributes parts to Masaccio.

1426 SOMARÉ, ENRICO. Masaccio. Milan: Bottega di poesia, 1924,
235 pp., 56 illus.
> Introductory essay on Masaccio's historical importance
and career. Large section of plates, now somewhat outdated.
Sections of documents and sources, including both editions of
Vasari's life juxtaposed. Selections from critical writings
from Alberti to early twentieth century, review of various
attributions, lists of certain works and lost works.
Bibliography.

1427 STEINBART, KURT. Masaccio. Vienna: Anton Schroll, 1948,
87 pp., 114 b&w and 4 color illus.

Masaccio

General background to Masaccio's art, biography, and survey of works. List of lost works, bibliography. Large corpus of illustrations.
Review: Robert Oertel, Zeitschrift für Kunstgeschichte 14 (1951):167-73, 1 illus.

1428　WASSERMANN, GERTRUD. Masaccio und Masolino. Probleme einer Zeitenwende und ihre schöpferische Gestaltung. Zur Kunstgeschichte des Auslandes, 134. Strassburg: Heitz, 1935, 90 pp., 16 illus.
Attempts to distinguish hands of two artists, discussing primarily cycles in S. Clemente, Rome, and Brancacci Chapel, Carmine, Florence, in which sees close collaboration.
Review: Robert Oertel, Zeitschrift für Kunstgeschichte 5 (1936):65-68.

1429　WATKINS, LAW BRADLEY. "The Brancacci Chapel Frescoes: Meaning and Use." Ph.D. dissertation, University of Michigan, 1976, 372 pp.
Interprets cycle through available evidence and in relation to other Tuscan cycles, deemphasizing external historical events. Relates to theme of Saint Peter's spiritual ascent. Appendices concern other interpretations and transcribe documents and sources.

1430　ZNAMEROVSKAJA, T.P. Problemy kvatročento i tvorčestvo Masačăo [Masaccio and quattrocento problems]. Leningrad: Leningradskogo Universiteta, 1975, 175 pp., 33 illus.
In Russian. Presents background of history and society of early 1400s. Discussion of artists' works in contect of changing style. Bibliography.

Articles and Booklets

1431　AMORY, DITA. "Masaccio's Explusion from Paradise: A Recollection of Antiquity." Marsyas 20 (1979-80):7-10, 7 illus.
Proposes that figure of Adam in fresco has classical source, specifically in hunter from Meleager Sarcophagus, Campo Santo, Pisa.

1432　BACCHI, GIUSEPPE. "Gli affreschi della Sagra di Masaccio." Rivista storica carmelitana 1, no. 2 (1929):107-12.
Reviews history of fresco in Carmine, Florence, with relevant documents and sources. Gives account of attempts to uncover remains. Describes fragments by other artists uncovered during restoration.

1433　＿＿＿＿. "La Cappella Brancacci." Rivista storica carmelitana 1, no. 2 (1929):55-68, 2 illus.

Reviews historical information regarding chapel, from construction to eighteenth century, including documentary material and comments by various early sources.

1434 BALDINI, UMBERTO. "Masaccio." In Encyclopedia of World Art. Vol. 9. London: McGraw Hill, 1964, col. 509-20, 8 b&w and 4 color illus.
 Surveys career, with detailed attention to scholarly opinions on attributions and chronology. Bibliography.

1435 BECK, JAMES H. "Fatti di Masaccio. . . ." In In Memoriam Otto J. Brendel: Essays in Archaeology and the Humanities. Edited by Larissa Bonfante and Helva von Heintze. Mainz: Verlag Philipp von Zabern, 1976, pp. 211-14, 5 illus.
 Rejects Masolino's authorship of head of Christ in Tribute Money, Brancacci Chapel, Florence, and attributes to Masaccio. Also attributes all of Madonna and St. Anne, Uffizi, Florence, to Masaccio. Attributes Madonna, Palazzo Vecchio, Florence, to Andrea di Giusto.

1436 ____. "Masaccio Humanized." Art News 74, no. 3 (1975):92-93, 1 illus.
 Notes document of 5 June 1425 for Masaccio's gilding of a pair of candlesticks. Supports attribution of S. Giovenale altarpiece, Uffizi, Florence, to Masaccio.

1437 ____. "Masaccio's Early Career as a Sculptor." Art Bulletin 53, no. 2 (1971):177-95, 27 illus.
 Suggests that Masaccio may have attempted some sculpture, particularly in terracotta. Attributes stucco Coronation, Sta. Maria Nuova, Florence, to him, rejecting attribution to Dello Delli or Bicci di Lorenzo. Includes documents.

1438 ____. "Una Prospettiva . . . di mano di Masaccio." In Studies in Late Medieval and Renaissance Painting in Honor of Millard Meiss. Edited by Irving Lavin and John Plummer. New York: New York University Press, 1977, pp. 48-53, 7 illus.
 Discusses Healing of Lunatic Boy, Johnson Collection, Philadelphia. Hypothesizes that begun by Masaccio and finished by Francesco d'Antonio.

1439 BEENKEN, HERMANN. "Masaccio." Belvedere 9-10, no. 8 (1926):167-78, 8 illus.
 General essay on Masaccio's ideal style and its importance. Compares to Giotto.

1440 ____. "Masaccios und Masolinos Fresken von S. Clemente in Rom." Belvedere 11, no. 7 (1932):7-13; 8 (1932):39-44, 12 illus.
 Divides frescoes between two artists, attempting to show differences in their styles.

Masaccio

1441 _____. "Noch Einmal: Masaccio-Masolino." Zeitschrift für
bildende Kunst 65 (1931-32):219-20.
Response to Stechow's article on Madonna from Novoli and
St. Julian, Badia, Settimo (entry 1547). Rereads a document
that Stechow cites and suggests work may have been part of
altarpiece for Sta. Maria Maggiore.

1442 _____. "Zum Werke des Masaccio. I. Das Fünfmännerbildnis
im Louvre." Zeitschrift für bildende Kunst 63 (1929-
30):112-19, 11 illus.
Attributes group portrait, Louvre, to Masaccio. Theory
contradicts Vasari's comments in 1568, but follows other
sixteenth-century sources.

1443 _____. "Zum Werke des Masaccio. II. Die Altarbilder für
S. Maria Maggiore in Florenz." Zeitschrift für bildende
Kunst 63 (1929-30):156-65, 10 illus.
Studies various hands in altarpiece. Reviews earlier
attributions. Attributes Madonna from Sta. Maria in Novoli and
St. Julian from Badia, Settimo, to Masaccio.

1444 BERENSON, BERNHARD. "La Madonna pisana di Masaccio."
Rassegna d'arte 8, no. 5 (1908):81-85, 7 illus.
Discusses Madonna, Sutton Collection, Brant Broughton,
England (now National Gallery, London). Attributes to Masaccio
and establishes as central panel of Pisa altarpiece.

1445 _____. "A New Masaccio." Art in America 18, no. 2
(1930):45-53, 4 illus. [Also published in Dedalo 10, no. 6
(1929):331-36.]
Publishes Madonna of Humility at Duveen, Paris (now
National Gallery, Washington). Attributes to Masaccio and
dates ca. 1425.

1446 _____. "La scoperta di un dipinto di Masaccio." Rassegna
d'arte 7, no. 9 (1907):139.
Brief paragraph noting Madonna in Sutton Collection,
Brant Broughton, England (now National Gallery, London).

1447 BERTI, LUCIANO. "Donatello e Masaccio." Antichità viva 5,
no. 3 (1966):3-12, 14 b&w and 1 color illus.
Illustrates Masaccio's debt to Donatello, both in general
terms and by comparing specific details, particularly in early
works.

1448 _____. "Masaccio a S. Giovenale di Cascia." Acropoli 2,
no. 2 (1961-62):149-65, 1 b&w and 6 color illus.
Study of triptych dated 1422, in context of culture of
its time. Diagrams pictorial space. First publication of
color illustrations.

1449 _____. "Masaccio 1422." Commentari 12, no. 2 (1961):84-
107, 26 illus.

Publishes triptych in S. Giovenale a Cascia, Regello, dated 1422. Attributes to Masaccio. Examines consequences for dating of Masaccio's other works and for understanding of his relation to Masolino.

1450 _____ . "Das Trinitäs-Fresko des Masaccio." In Santa Maria Novella: Kirche, Kloster und Kreuzgänge. Edited by Umberto Baldini. Stuttgart: Urachhaus, 1982, pp. 127-33, 1 b&w and 5 color illus. [Italian ed. Florence: Nardini, 1981.] Brief text accompanying color plates and details.

1451 BERTI-TOESCA, ELENA. "Per la Sagra di Masaccio." Arti figurative, 1, no. 3 (1945):148-50, 2 illus. Publishes two drawings considered to be after Masaccio's lost Sagra, destroyed 1610.

1452 BOECK, WILHELM. "Die 'Erfinder der Perspektive.'" Repertorium für Kunstwissenschaft 52 (1931):145-47, 1 illus. Discusses various theories concerning Portrait of Five Men, Louvre. Sees contributions of both Uccello and Masaccio.

1453 BORSOOK, EVE. "A Note on Masaccio in Pisa." Burlington Magazine 103, no. 699 (1961):212-15, 9 illus. Suggests sculpture of Giovanni Pisano as a factor in Masaccio's development.

1454 BOSKOVITZ, MIKLÒS. "'Giotto Born Again.' Beiträge zu den Quellen Masaccios." Zeitschrift für Kunstgeschichte 29, no. 1 (1966):51-66, 15 illus. Study of Masaccio's relation to the trecento. Examples of sources for specific motifs in his work.

1455 BRAHAM, ALLAN. "Emperor Sigismund and the Santa Maria Maggiore Altar-piece." Burlington Magazine 122, no. 923 (1980):106-12, 10 illus. Discusses possible portrayals of Emperor Sigismund in altarpiece. Interprets as allegory of healing of the schism in the church.

1456 BROCKHAUS, HEINRICH. "Die Brancacci-Kapelle in Florenz." Mitteilungen des kunsthistorischen Institutes in Florenz 3 (March 1930):160-82, 7 illus. Lack of portraits of Brancacci family in Brancacci Chapel, Carmine, Florence, linked to their political differences with Cosimo de Medici. Some portraits were included and later destroyed.

1457 CAIOLI, PAOLO. "Masaccio e i carmelitani." Rivista storica carmelitana 1, no. 2 (1929):69-87, 9 illus. Praises works done for Carmelites: Brancacci Chapel and Sagra in Carmine, Florence, and Pisa altarpiece. Art and faith intertwined.

Masaccio

1458 CARNESECCHI, CARLO. "Messer Felice Brancacci." Miscellanea
 d'arte 1, no. 10-11 (1903):190-92.
 Gathers historical facts regarding Brancacci family,
 especially Felice, as given in documents of time.

1459 CARRÀ, CARLO. "Impressioni su Masaccio." Vasari 4, no. 1-2
 (1931):12-19.
 Essay on importance of Masaccio's frescoes in the
 Brancacci Chapel, Carmine, Florence.

1460 CHIAPPELLI, ALESSANDRO. "Masaccio e Filippino." In Arte del
 rinascimento. Rome: Casa editrice Alberto Stock, 1925,
 pp. 133-36.
 Enthusiastic essay on Masaccio's revolutionary importance.

1461 _____. "Per la ricerca di un dipinto di Masaccio (1918)."
 In Arte del rinascimento. Rome: Casa editrice Alberto
 Stock, 1925, pp. 133-36.
 Discusses lost Sagra, Carmine, Florence, which a comment of
 Cinelli (1686) suggests might still somehow exist. Urges search.

1462 CHIARINI, MARCO. "Una citazione della Sagra di Masaccio nel
 Ghirlandaio." Paragone 13, no. 149 (1962):53-56, 3 illus.
 Sixteenth-century drawing, Museum, Folkestone, after
 Masaccio's Sagra indicates that composition was source for
 Ghirlandaio's Resurrection of a Child, Sta. Trinità, Florence.

1463 CLARK, KENNETH. "An Early Quattrocento Triptych from Santa
 Maria Maggiore, Rome." Burlington Magazine 93, no. 584
 (1951):339-47, 18 illus.
 Fundamental reconstruction of work including panels of
 Saints recently acquired by National Gallery, London. Attrib-
 utes most parts to Masolino, but panel of SS. Jerome and
 Baptist to Masaccio.
 Letter: John Pope-Hennessy, Burlington Magazine 94, no.
 586 (1952):31-32.

1464 COOLIDGE, JOHN. "Further Observations on Masaccio's
 Trinity." Art Bulletin 48, no. 3-4 (1966):382-84, 8 illus.
 Proposes that bay of Sta. Maria Novella, Florence,
 acquired freestanding altar ca. 1422-25. Floor slab and
 Trinity fresco added shortly after and original altar removed
 in sixteenth century.

1465 D'ANCONA, PAOLO. "La tavola di Masaccio ora nella R.
 Galleria di Belle Arti." Miscellanea d'arte 1, no. 10-11
 (1903):174-77, 1 illus.
 Distinguishes two hands in Madonna and St. Anne, now
 Uffizi, suggesting collaboration with Masolino.

1466 DELABORDE, HENRI. "Des oeuvres et de la manière de Masaccio."
 Gazette des beaux arts 14, no. 5 (1876):369-84, 4 illus.

Definition of Masaccio's revolutionary and realistic style. Description of Brancacci frescoes, Carmine, Florence, attributions of some others. Influence on later artists.

1467 DEL BADIA, JODOCO. "Tommaso di Giovanni di San Giovanni detto Masaccio e Giovanni suo fratello." Rassegna nazionale 134, no. 1 (1903):137-46.
 Documents and early sources concerning Masaccio and his brother Giovanni, including catasto declarations dating up to late in the fifteenth century.

1468 DEL BRAVO, CARLO. "Nicchia con crocifisso e statue." In Essays Presented to Myron P. Gilmore. Edited by Sergio Bertelli and Gloria Ramakus. Vol. 2. Florence: La nuova Italia editrice, 1978, pp. 131-32.
 Postulates that Trinity meant to resemble sculpture in a niche in wall of church. Unlike narrative images elsewhere in Masaccio.

1469 DEMPSEY, CHARLES. "Masaccio's Trinity: Altarpiece or Tomb?" Art Bulletin 54, no. 3 (1972):279-81, 1 illus.
 Interprets fresco as tomb ensemble, citing various precedents and parallels.

1470 EINEM, HERBERT VON. "Zur Deutung von Masaccios Zingroschen." Acta historiae artium 13, no. 3 (1967): 187-90.
 Iconographical interpretation of Tribute Money in terms of cycle of Saint Peter and of historical context. Relation to ideas of papacy.

1471 FERRI, PASQUALE NERINO. "Disegni attribuiti a Masaccio nella R. Galleria di Firenze." In Masaccio: Ricordo delle onoranze. Florence: Bernardo Seeber, 1904, pp. 61-64, 4 illus.
 Evaluates various drawings sometimes attributed to Masaccio, with reasons for rejecting.

1472 _____. "I disegni di Masaccio." Miscellanea d'arte 1, no. 10-11 (1903):177-81, 3 illus.
 Rejects all drawings attributed to Masaccio. Catalogs by location.

1473 FIOCCO, GIUSEPPE. "La Sagra di Masaccio." Rivista storica carmelitana 1, no. 2 (1929):103-6, 3 illus.
 Sees reflections of lost fresco from Carmine, Florence, in Bicci's Consacrazione della Chiesa di S. Egidio and in sixteenth-century drawing, Uffizi, Florence. Another drawing, Venice, Accademia, may be after painting by Lippi in Carmine mentioned by Vasari.

1474 FREMANTLE, RICHARD. "Masaccio e l'Angelico." Antichità viva 9, no. 6 (1970):39-49, 36 illus.

Masaccio

> Attributes <u>Madonna</u>, location unknown, to Masaccio as an
> early work. Rejects Berti's attribution to Angelico (entry
> 671). Also notes Masaccio's later influence on Angelico. Eng-
> lish summary.

1475 ____. "Masaccio e l'antico." <u>Critica d'arte</u> 34, no. 103
> (1969):39-56, 73 illus.
> Compares specific motifs in Masaccio and ancient art as
> examples of painter's direct interest in antiquity. Most exam-
> ples from Brancacci Chapel frescoes.

1476 ____. "Riferimenti a membri della famiglia Brancacci da
> parte dello stesso notaio Filippo di Cristofano." <u>Antichità</u>
> <u>viva</u> 17, no. 3 (1978):50-52.
> Publishes documents, 1410-48.

1477 ____. "Some Documents Concerning Masaccio and his Mother's
> Second Family." <u>Burlington Magazine</u> 115, no. 845
> (1973):516-18.
> Three documents of 1417-18 concerning the will of
> Masaccio's stepfather.

1478 GARDNER VON TEUFFEL, CHRISTA. "Masaccio and the Pisa Altar-
> piece: A New Approach." <u>Jahrbuch der Berliner Museen</u> 19
> (1977):23-68, 25 illus.
> Detailed study of patronage, reconstruction and iconogra-
> phy of Pisa altarpiece, based on reexamination of known docu-
> ments and publication of some new ones. Numerous detailed
> photographs, diagram of reconstruction.

1479 GIGLIOLI, ODOARDO H. "Masaccio incompreso." <u>Rivista</u>
> <u>storica carmelitana</u> 1, no. 2 (1929):88-93, 3 illus.
> Reviews Masaccio's early critical misfortunes. Cites a
> variety of errors, neglect, misunderstandings, and misattribu-
> tions from seventeenth century on.

1480 ____. "Masaccio--saggio di bibliografia ragionata."
> <u>Bollettino del Reale Istituto nazionale di archeologia e</u>
> <u>storia dell'arte</u> 3, no. 4-5 (1929):55-101, 1 illus.
> Annotated bibliography of works on and related to
> Masaccio. Organized into twenty-nine sections covering various
> types of publications and specific issues. Index of names.

1481 GILBERT, CREIGHTON. "The Drawings Now Associated with
> Masaccio's Sagra." <u>Storia dell'arte</u> 3 (July-
> September 1969):260-78, 7 illus.
> Dissociates from Masaccio five drawings usually thought
> to be copies directly after his lost <u>Sagra</u> and connects them
> more closely to Ghirlandaio.

1482 GOFFEN, RONA. "Masaccio's <u>Trinity</u> and the Letter to
> Hebrews." In <u>Santa Maria Novella: Un convento nella città:</u>

Studi e fonte. Memorie domenicane, 11, 1980, pp. 489-504, 3
illus.
Uses text of letter to Hebrews to explain the fresco, as
both warning and encouraging the worshipper.

1483 HENDY, PHILIP. Masaccio: Frescoes in Florence. Greenwich,
Conn.: New York Graphic Society, UNESCO, 1956, 22 pp., 6
b&w and 32 color illus.
Large colorplates of frescoes, Brancacci Chapel, Carmine,
and Trinity, Sta. Maria Novella, Florence, with introductory
text. Chronological chart regarding chapel.
Review: Ulrich Weisstein, Art Journal 17, no. 3
(1958):331-32.

1484 JANSON, H.W. "Ground Plan and Elevation in Masaccio's
Trinity Fresco." In Essays in the History of Art Presented
to Rudolf Wittkower. London: Phaidon, 1967, pp. 83-88, 8
illus. [Reprinted in Sixteen Studies (New York: Abrams,
n.d.), pp. 213-28.
Investigation of spatial construction of Trinity, Sta.
Maria Novella, Florence, using the palmo. Rejects ideas of
Kern (entry 486).

1485 JOHANSEN, P. Masolino, Masaccio und Tabitha. Copenhagen:
Levin & Munksgaard, 1935, 7 pp., 1 illus.
Considers question of attribution of Tabitha fresco,
Brancacci Chapel, Carmine, Florence. Gives both artists a
share.

1486 KERN, G. JOSEPH. "Das Dreifaltigkeitsfresko von S. Maria
Novella: Eine Perspektivisch-Architekturgeschichtliche
Studie." Jahrbuch der preussischen Kunstsammlungen 34
(1913):36-58, 18 illus.
Reconstruction of architectural setting in Masaccio's
fresco. Hypothesizes that Brunelleschi painted architecture.
Diagrams.

1487 LANYI, JENÖ. "The Louvre Portrait of Five Florentines."
Burlington Magazine 84, no. 493 (1944):87-95, 8 illus.
Proposes that Louvre panel is an assemblage of copies of
five original portraits, possibly all from Masaccio's lost
Sagra, Carmine, Florence.

1488 LAVAGNINO, EMILIO. "Masaccio: 'Dicesi è morto a Roma.'"
Emporium 97, no. 479 (1943):96-112, 12 illus.
Investigates why Masaccio left Brancacci project to go to
Rome. Proposes that Martin V summoned to work in Lateran.
Addresses chronology of works of both Masolino and Masaccio.

1489 LINNENKAMP, ROLF. "Zu Massaccios Dreifaltigkeit in S. Maria
Novella zu Florenz." Pantheon 25, no. 2 (1967):126-27.

Masaccio

Comments concerning Kern's reconstruction of architec-
tural space in painting (entry 1486).

1490 LONGHI, ROBERTO. "Gli affreschi del Carmine. Masaccio e
Dante." Paragone 1, no. 9 (1950):3-7. [Also published as
Masaccio: la Cappella Brancacci a Firenze (Milan: Amilcare
Pizzi, 1949). Reprinted in Fatti di Masolino e di Masaccio
e altri studi sul quattrocento (Florence: Sansoni, 1975),
pp. 67-70.]
Summarizes course of activity in chapel. Suggests
Masaccio thinking of figures also emerging from shadows in
Dante.

1491 _____. "Fatti di Masolino e Masaccio." Critica d'arte 5,
no. 3-4 (1940):145-91, 71 illus. [Reprinted in Fatti di
Masolino e di Masaccio e altri studi sul quattrocento
(Florence: Sansoni, 1975), pp. 3-65.]
Fundamental study of different character of two artists.
Analysis of contributions to Brancacci frescoes in Carmine,
Florence, Madonna and St. Anne in Uffizi, Florence, S. Clemente
frescoes in Rome, and other works. Discussion of reciprocal
influence. Relation to Angelico, whom sees as influenced by
Masaccio. Extensive notes touching on many artists of early
fifteenth century: Andrea di Giusto, Master of the Bambino
Vispo, Master of 1419, Master of the Griggs Crucifixion,
Arcangelo di Cola, Francesco d'Antonio, Paolo Schiavo, Sassetta,
Domenico di Bartolo, and Gentile.

1492 _____. "Presenza di Masaccio nel trittico della Neve."
Paragone 3, no. 25 (1952):8-16, 7 illus. [Reprinted in
Fatti di Masolino e di Masaccio e altri studi sul
quattrocento (Florence: Sansoni, 1975), pp. 77-84.]
Reconstruction of dispersed parts of triptych from Sta.
Maria Maggiore, Rome. Speculations regarding its history.
Panel with Sts. Jerome and John Baptist, National Gallery,
London, attributed to Masaccio, ca. 1425.

1493 _____. "Recupero di un Masaccio." Paragone 1, no. 5
(1950):3-5, 3 illus. [Reprinted in Fatti di Masolino e di
Masaccio e altri studi sul quattrocento (Florence: Sansoni,
1975), pp. 71-73.]
Publishes and attributes Madonna and Child, ca. 1426,
recently acquired by Uffizi, Florence.

1494 MAGHERINI-GRAZIANI, G. "Memorie e pitture di Masaccio in
San Giovanni di Valdarno e nei dintorni." In Masaccio:
Ricordo delle onoranze. Florence: Bernardo Seeber, 1904,
pp. 73-119, 32 illus.
Describes area, mentions works Masaccio might have known,
executed, or influenced. Attributes Enthroned Madonna with
Sts. Michael and John the Baptist. Detailed footnotes.

1495 MARRAI, B. "Gli affreschi della cappella Brancacci al
 Carmine." Arte e storia 10, no. 8 (1891):59-60.
 Reviews different opinions regarding attributions to
 Masolino and Masaccio. Discusses form of halo in works of two
 as method for distinguishing styles.

1496 _____. "Masolino e Masaccio." Miscellanea d'arte 1, no.
 10-11 (1903):164-74, 3 illus.
 Essay on differences between the two artists, especially
 as seen in Brancacci Chapel, Carmine, Florence. Characterizes
 Masaccio as innovative.

1497 MATHER, FRANK JEWETT, Jr. "The Problem of the Brancacci
 Chapel Historically Considered." Art Bulletin 26, no. 3
 (1944):175-87, 2 illus.
 Affirms, on basis of historical evidence rather than
 visual, that all frescoes in chapel are by Masaccio or Filippino
 Lippi, none by Masolino. Appendix traces career of Masaccio.
 Letter: Millard Meiss, Art Bulletin 26, no. 4
 (1944):274-77.

1498 MAURER, EMIL "Masaccio-Cavallini-Spätantike." In Ars auro
 prior: Studia Ioanni Bialostocki sexagenario dedicata.
 Warsaw: Panstwowe Wydawnictwo Naukowe, 1981, pp. 155-60, 4
 illus.
 Early Christian frescoes in S. Paolo fuori le Mura, Rome,
 now known through seventeenth-century copies, presented as
 sources for Masaccio's Tribute Money.

1499 _____. "Masaccio: 'Von Himmel gefallen?'" Neue zuercher
 Zeitung (6 April 1969):51-52, 2 illus.
 Essay on sources for Masaccio. Cites Giotto and also
 fifth-century fresco of Joseph and His Brothers, S. Paolo fuori
 le Mura, Rome, restored by Cavallini in ca. 1280-90.

1500 MAZZONI, GUIDO. "Epigrammi su Masaccio." Miscellanea
 d'arte 1, no. 10-11 (1903):193-95.
 Verses in different editions of Vasari's life of
 Masaccio, by Annibale Caro and Fabio Segni.

1501 MEISS, MILLARD. "The Altered Programm of the Santa Maria
 Maggiore Altarpiece." In Studien zur toskanischen Kunst:
 Festschrift für Ludwig Heinrich Heydenreich. Munich:
 Prestel Verlag, 1963, pp. 169-90, 28 illus.
 Study of various panels of altarpiece, revealing some
 rearrangement and alteration in its panels of Saints, which
 apparently honor Pope Martin V. Discusses progress of execu-
 tion. Appendix on Masolino's lost Calling of Andrew and Peter
 from Brancacci Chapel, Carmine, Florence.

1502 _____. "London's New Masaccio." Art News 51, no. 2
 (1952):24-25, 6 illus.

Masaccio

 Recent acquisition by National Gallery, London, of two
panels by Masaccio and Masolino. Dates ca. 1423, earlier than
Clark (entry 1463). Concurs with Clark's reconstruction of
Sta. Maria Maggiore altarpiece.

1503 . "Masaccio and the Early Renaissance: The Circular
 Plan." In Studies in Western Art. Vol. 2, The Renaissance
 and Mannerism. Acts of the Twentieth International Congress
 of the History of Art. Princeton, 1963, pp. 123-45, 26
 illus. [Reprinted with postscript in The Painter's Choice:
 Problems in the Interpretation of Renaissance Art (New York:
 Harper & Row, 1976), pp. 63-81.]
 Relates composition of Masaccio's Tribute Money both to a
tradition of arc-shaped compositions in ancient, early Chris-
tian, and Byzantine art and to the idea of the circle as per-
fect form, seen particularly in early fifteenth-century
architecture. Examines earlier and later examples and their
symbolic meaning.

1504 MELANI, ALFREDO. "Un desco da parto del Masaccio?" Arte e
 storia 23, no. 22-23 (1904):145.
 Describes desco da parto, Kaiser-Friedrich Museum,
Berlin, noting various mentions of it by earlier scholars.

1505 MELLER, PETER. "La Cappella Brancacci: Problemi
 ritrattistici ed iconografici." Acropoli 1, no. 3
 (1960-61):186-227, 24 b&w and 13 color illus.; no. 4
 (1960-61):273-312, 55 b&w and 11 color illus.
 Lengthy examination of portraits represented by Masolino,
Masaccio, and Filippino Lippi in the chapel. Comparison with
works in various media, identifications of some figures, and
discussion of development of portrait style during the Renais-
sance and of contemporary politics.

1506 MESNIL, JACQUES. "La data della morte di Masaccio." Rivista
 d'arte 8, no. 1-2 (1912):31-34.
 Corrects Magherini-Graziani's reading of a document as
bearing Masaccio's signature (entry 1494). Cannot establish
his date of death more precisely than between July 1427 and
early 1429.

1507 . "Die Kunstlehre der Frührenaissance im Werke
 Masaccios." Vorträge der Bibliothek Warburg (1925-26):122-
 46, 14 illus.
 Importance of element of perspective as part of inno-
vative character of Masaccio's art. Numerous bibliographic
references.

1508 . "Masaccio et la théorie de la perspective." Revue
 de l'art ancien et moderne 35, no. 179 (1914):145-56, 7
 illus.

Asserts that linear perspective, as used by Masaccio, gives work cohesiveness. Works with perspective errors should not be attributed to him.

1509 _____. "Masaccio and the Antique." Burlington Magazine 48, no. 275 (1926):91-98, 8 illus.
Contrary to general opinion, asserts importance of antique to Masaccio, in addition to study of nature. Cites Venus Pudica type as inspiration for Eve in Expulsion, Brancacci Chapel, Carmine, Florence. Also notes classical elements in architectural and ornamental details. Idea of proportionality also an antique influence.

1510 _____. "Per la storia della capella Brancacci." Rivista d'arte 8, no. 1-2 (1912):34-40.
A variety of documents coming from archives of Carmine, Florence, regarding various objects and activity in chapel, mostly sixteenth through eighteenth centuries.

1511 _____. "Vues nouvelles sur l'art de Masaccio." Revue de l'art 62, no. 2 (1932):145-62, 9 illus.
Cites Gerini's Madonna, Figline, as precursor to Masaccio's Madonna and St. Anne. Rejects Masolino as Masaccio's first master. Reviews recent literature, ascribes Chapel of St. Catherine, S. Clemente, Rome, to Masolino. Praises Masaccio's use of perspective. English summary.

1512 MINUNNO COSTAGLIOLA, G. "Un altra ipotesi sul rapporto Masolino-Masaccio." Annali della facoltà di lettera e filosofia dell'Università di Bari 17 (1974):251-86, 13 illus.
Discusses division of hands in Carmine, Florence, and S. Clemente, Rome.

1513 MOLHO, ANTHONY. "The Brancacci Chapel: Studies in Its Iconography and History." Journal of the Warburg and Courtauld Institutes 40 (1977):50-98.
Iconography of chapel related to contemporary ecclesiastical questions. History of Brancacci family and chapel. Masolino's whereabouts in the 1420s.

1514 OERTEL, ROBERT. "Die Frühwerke des Masaccio." Marburger Jahrbuch für Kunstwissenschaft 7 (1933):191-289, 50 illus.
Attributes a generous number of works to Masaccio's early period, including several usually attributed to Masolino: Madonnas in Bremen and Munich, St. Anne altarpiece, Raising of Tabitha, and others. Discusses space, perspective, and questions of chronology.

1515 _____. "Masaccio und die Geschichte der Freskotechnik." Jahrbuch der preussischen Kunstsammlungen 55, no. 4 (1934):229-40, 4 illus.

Masaccio

> Hypothesizes that Masaccio's frescoes still done without
> cartoons, but with other innovations in preparation. Rejects
> idea of Masolino's participation in Brancacci Chapel, Carmine,
> Florence.

1516 OFFNER, RICHARD. "Light on Masaccio's Classicism." Studies
 in the History of Art Dedicated to William E. Suida on His
 Eightieth Birthday. London: Phaidon Press for the Samuel
 H. Kress Foundation, 1959, pp. 66-72, 9 illus.
 Postulates Roman paintings as source for Masaccio's sys-
 tem of lighting. Suggests some possible direct imitations from
 specific classical models.

1517 PANTINI, ROMUALDO. "Arte retrospettiva: Nel V centenario
 di Masaccio: La cappella della passione in S. Clemente a
 Roma." Emporium 19 (1904):31-52, 27 illus.
 Attributes St. Catherine cycle, S. Clemente, Rome, to
 Masaccio. Discusses previous opinions.

1518 _____. "Masaccio." Connoisseur 21, no. 81 (1908):25-28, 5
 illus.; no. 82 (1908):87-90, 4 illus.
 Survey of Masaccio's style. Discusses Brancacci Chapel,
 Carmine, Florence. Attributes St. Catherine cycle, S. Clemente,
 Rome, to him. Considers relation to ideas of Alberti.

1519 PARRONCHI, ALESSANDRO. "Prospettiva in Donatello e
 Masaccio." Rassegna della istruzione artistica 1, no. 2
 (1966):29-42, 15 illus.
 Demonstrates examples of Masaccio's perspective, espe-
 cially in scenes of Brancacci Chapel.

1520 _____. "Sulla perduta Annunciazione di Masaccio. Ricerche
 e proposte." Studi urbinati 40 (1966):167-77, 8 illus.
 Hypothesizes reflection of lost work by Masaccio for S.
 Niccolo, Florence, in a sixteenth-century Annunciation from
 Medici villa, Seravezze, and in a drawing by Perino del Vaga,
 Uffizi, Florence.

1521 PITTALUGA, MARY. "La critica e i valori romantici di
 Masaccio." L'arte 33, no. 2 (1930):139-64, 5 illus.
 Study of nineteenth-century interpretations of Masaccio's
 classical and romantic qualities.

1522 _____. "Masaccio e Vasari." Rivista storica carmelitana 1,
 no. 2 (1929):94-98, 2 illus.
 Discusses various aspects of Vasari's view of Masaccio,
 including distortions stemming from attempt to make him fit
 into cinquecento conception of progress.

1523 POGGI, GIOVANNI. "La tavola di Masaccio nel Carmine di
 Pisa." Miscellanea d'arte 1, no. 10-11 (1903):182-88, 3
 illus.

Reviews descriptions and various known, scattered parts
of altar. First publication of St. Paul, Museo Civico, Pisa.
Possible attribution to Andrea di Giusto of St. Paul and of St.
Andrew, Lanckoronski Collection.

1524 POLZER, JOSEPH. "The Anatomy of Masaccio's Holy Trinity."
 Jahrbuch der Berliner Museen 13 (1971):18-59, 28 illus.
 Detailed study of the technical process of the fresco,
with many photographs demonstrating the working processes.
Discusses problem of perspective reconstruction and concludes
that cannot be measured mathematically.

1525 _____. "Masaccio and the Late Antique." Art Bulletin 53,
 no. 1 (1971):36-40, 3 illus.
 Lost late antique fresco of St. Paul Preaching to the
Hebrews from Old St. Paul's, Rome, suggested as source for
Tribute Money. Suggests early presence of Masaccio in Rome.

1526 PROCACCI, UGO. "Documenti e ricerche sopra Masaccio e la
 sua famiglia." Rivista d'arte 14 (1932):489-503; 17
 (1935):91-111.
 Publishes forty-four documents of 1364 to 1451, without
commentary. Establishes family name as Cassai.

1527 _____. "L'incendio della chiesa del Carmine del 1771: (La
 Sagra di Masaccio--Gli affreschi della Cappella di San
 Giovanni)." Rivista d'arte 14 (1932):141-232, 22 illus.
 Extensive study of documents concerning fire and restora-
tion of church. Also much earlier documentary material regard-
ing situation before fire. Postulates that some of Sagra may
remain.

1528 _____. Masaccio. Florence: Olschki, 1980, 23 pp.
 Surveys Masaccio's life. Rejects many accepted early
associations with Masolino. Proposes chronology.

1529 _____. "Nuove testimonianze su Masaccio." Commentari 27,
 no. 3-4 (1976):223-37.
 Various hypotheses regarding chronology of Masaccio's
activities and work, as well as Masolino's. Dates trip to Rome
and work in S. Clemente and on Sta. Maria Maggiore altarpiece
not before 1428. Dates Trinity in 1426 or early 1427.

1530 _____. "Sulla cronologia delle opere di Masaccio e di
 Masolino tra il 1425 e il 1428." Rivista d'arte 28
 (1953):3-55.
 Attempts to trace activity of artists in Brancacci Chapel
and in S. Clemente, and work on Sta. Maria Maggiore altarpiece.
Includes new documentation, particularly regarding Masolino's
trip to Hungary in 1425-27.

Masaccio

1531 _____. "Il Vasari e la conservazione degli affreschi della
Cappella Brancacci al Carmine e della Trinità in Santa Maria
Novella." In Scritti di storia dell'arte in onore di Lionello
Venturi. Vol. 1. Rome: De Luca, 1956, pp. 211-22.
　　　Describes how Vasari's praise of Masaccio's frescoes
helped them survive various remodeling campaigns in seventeenth
and eighteenth centuries.

1532 SALMI, MARIO. "L'autoritratto di Masaccio nella cappella
Brancacci." Rivista storica carmelitana 1, no. 2 (1929):99-
102, 4 illus.
　　　Rejects Vasari's identification of figure in Tribute
Money, Brancacci Chapel, Carmine, Florence, as self-portrait.
Suggests another head, in scene of St. Peter Enthroned, as a
self-portrait.

1533 _____. "Gli scomparti della pala di Santa Maria Maggiore
acquistati dalla 'National Gallery.'" Commentari 3, no. 1
(1952):14-21, 7 illus.
　　　Reviews various constructions and attributions of parts
of altarpiece. Attributes panel with Baptist and St. Jerome,
National Gallery, London, to Masaccio. Suggests is his last
work, ca. 1428.

1534 _____. "Masaccio e Vincenzo Foppa." In Vizantija:
Festschrift V. N. Lazarev. Moscow: Nauka, 1973, pp. 499-
504, 4 illus. [Reprinted in Commentari 25, no. 1-2
(1974):24-28.]
　　　General and specific examples of Foppa's dependence on
Masaccio cited.

1535 SCALVANTI, O. "Un pensiero sull'arte di Masaccio." In
Masaccio: ricordo delle onoranze. Florence: Bernardo
Seeber, 1904, pp. 65-71.
　　　Enthusiastic praise of artist, especially for qualities
of figura and prospettiva.

1536 SCHAEFFER, EMIL. "Das Bildnis des Giovanni Bicci de' Medici
in den Uffizen." Zeitschrift für bildende Kunst 13
(1902):40-42, 2 illus.
　　　Rejects attribution of portrait to Zanobi Strozzi and
suggests Masaccio.

1537 _____. "Zur Geschichte der Brancacci-Kapelle." Repertorium
für Kunstwissenschaft 27 (1904):54-56.
　　　Publishes description of chapel by an anonymous writer of
the eighteenth century.

1538 SCHLEGEL, URSULA. "Observations on Masaccio's Trinity Fresco
in Santa Maria Novella." Art Bulletin 45, no. 1 (1963):19-
33, 11 illus.

Proposes reconstruction of fresco, independent from an
altar-table. Dates before 1426, and interprets as representa-
tion of Golgotha chapel in Jerusalem.
Letter: Charles de Tolnay, Art Bulletin 45, no. 2
(1963):177.

1539 SCHMARSOW, AUGUST. "Frammenti di una predella di Masaccio."
L'arte 10 (1907):209-17, 4 illus.
Attributes four small scenes, Museo Cristiano, Vatican,
to Masaccio, rather than to Gentile da Fabriano, rejecting
Siren's proposal (entry 59).

1540 _____. "Masaccios Heilung der mondsüchtigen Knaben in
Philadelphia, U.S.A." Belvedere 12 (May 1928):103-16, 4
illus.
Attributes Healing of Lunatic Boy, Johnson Collection,
Philadelphia, to Masaccio. Cites architecture as reflecting
Brunelleschi's designs for cathedral dome.

1541 _____. "Masolino oder Masaccio in Neapel?" Repertorium für
Kunstwissenschaft 44 (1924):289-92.
Attributes panels of Assumption and Founding of Sta.
Maria Maggiore to Masaccio.

1542 _____. "Neue Beiträge zu Masolino und Masaccio." Belvedere
7, no. 6 (1925):145-57, 11 illus.
Reviews various attributions to both artists and makes
attributions, giving numerous works to Masaccio.

1543 _____. "Zur Masolino-Masaccio-Forschung." Kunstchronik und
Kunstliteratur 64 (April 1930):1-3.
Rejects various attributions made by Stechow (entry
1547). Gives predella of St. Julian, Horne Collection,
Florence, to Pesello.

1544 SELLHEIM, RUDOLF. "Die Madonna mit der Schahãda." In
Festschrift Werner Caskel zum siebzigsten geburtstag 5 März
1966. Edited by Erwin Graf. Leiden: E.J. Brill, 1968, pp.
308-15, 1 illus.
Study of the sources and meaning of the Arabic lettering
on the halo of Masaccio's S. Giovenale Madonna, Uffizi,
Florence.

1545 SHEARMAN, JOHN. "Masaccio's Pisa Altar-piece: An Alterna-
tive Reconstruction." Burlington Magazine 108, no. 762
(1966):449-55, 8 illus.
Reconstructs altarpiece with Madonna and (missing) Saints
originally on same panel, not as separate parts of a polyptych.
Discusses development of sacra conversazione theme.

1546 SIMSON, OTTO VON. "Über die Bedeutung von Masaccios
Trinitätsfresko in S. Maria Novella." Jahrbuch der Berliner
Museen 8 (1966):119-59, 25 illus.

Masaccio

Symbolism of fresco. Discusses particularly representa-
tions of Throne of Grace, here seen to have been given first
monumental treatment. Traces concept, with eschatological and
mortuary themes. Perspective of painting seen to invite viewer
into dialogue. English summary.

1547 STECHOW, WOLFGANG. "Zum Masolino-Masaccio-Problem."
 Kunstchronik und Kunstliteratur 63 (February 1930):125-27, 2
 illus.
 Examines three panels in style close to Masaccio: St.
 Julian, Settimo, and predella panels from Museo Ingres,
 Montauban, and Horne Collection, Florence. Discusses uncer-
 tainties regarding authorship and original location of altar-
 piece. Believes panels cannot all be from Sta. Maria Maggiore
 altar.

1548 STUBBLEBINE, JAMES H.; GIBBONS, MARY; COSSA, FRANK; SITT,
 SHARON; and CHAPMAN, GEORGE. "Early Masaccio: A Hypothet-
 ical, Lost Madonna and a Disattribution." Art Bulletin 62,
 no. 2 (1980):217-25, 9 illus.
 Postulates a lost painting by Masaccio, from before 1422,
 based on its hypothetical reflections in several works. Op-
 poses attribution of S. Giovenale Madonna, Uffizi, Florence, to
 Masaccio.
 Letters: Keith Cristiansen and Antonette F. Dennison,
 Art Bulletin 63, no. 2 (1981):312-13.

1549 SUIDA, W[ILHELM]. "L'altare di Masaccio già nel Carmine a
 Pisa." L'arte 9 (1906):125-27, 3 illus.
 Partially reconstructs Pisa altarpiece, adding Cruci-
 fixion, Museo di Capodimonte, Naples, to other known fragments.

1550 TANFANI-CENTOFANTI, L. "Documenti." Miscellanea d'arte 1,
 no. 10-11 (1903):188-89.
 Reprint of documents published elsewhere, to accompany
 article on Masaccio's Pisa altarpiece by Giovanni Poggi (entry
 1523).

1551 TOLNAY, CHARLES DE. "Note sur l'iconographie des fresques
 de la Chapelle Brancacci." Studi in onore di Giusta Nicco
 Fasola. Arte lombarda 10 (1965):69-74, 5 illus.
 Suggests that entrance pilasters to chapel originally
 planned to have more scenes from Genesis (in addition to
 Temptation and Expulsion), rather than Saint Peter scenes later
 added by Filippino Lippi.

1552 _____ . "Renaissance d'une fresque." L'oeil 37 (January
 1958):36-41, 10 b&w and 1 color illus.
 Interprets newly restored Trinity, as expression of new
 values of early quattrocento Florence.

1553 TRENKLER, ERNST. "Beiträge zur Masaccio-Forschung." Wiener
Jahrbuch für Kunstgeschichte 8 (1932):7-16, 10 illus.
Reviews problem of division of hands of Masolino and
Masaccio. Attributes Raising of Tabitha, St. Peter Preaching,
and Fall of Man to Masaccio as well as chapel in S. Clemente,
Rome. Examines perspective construction of scenes.

1554 VAYER, I[AJOS]. "Deux portraits du Felice Brancacci." Acta
historiae artium 21, no. 1-2 (1975):3-13, 8 illus.
Differentiates styles of Masaccio and Masolino in
Brancacci Chapel, Carmine, Florence, particularly by analyzing
two portraits identified as donor.

1555 _____. "Porträtprobleme in Masaccios Kunst." Jahrbuch des
kunsthistorischen Institutes der Universität Graz 7
(1972):29-49, 7 illus.
Identifies portraits of members of Brancacci family in
Brancacci Chapel frescoes, Carmine, Florence. Discusses his-
torical tradition of donor portraits.

1556 VENTURI, LIONELLO. "A Madonna by Masaccio." Burlington
Magazine 57, no. 328 (1930):21-27, 2 illus.
Discusses Madonna, Duveen Brothers, New York, recently
attributed to Masaccio by Berenson (entry 1445). Notes plastic
form, lack of ornament.

1557 WATKINS, LAW B. "Technical Observations on the Frescoes of
the Brancacci Chapel." Mitteilungen des kunsthistorischen
Institutes in Florenz 17, no. 1 (1973):65-74, 7 illus.
Reconstruction of original size and shape of window and
of chapel. Suggests that window lunette area contained two
scenes: Denial and Weeping of Peter. Examines frescoed
pilasters and notes close collaboration between Masolino and
Masaccio. Outlines giornate and discusses attributions of
minor areas.

1558 WELLIVER, WARMAN. "Narrative Method and Narrative Form in
Masaccio's Tribute Money." Art Quarterly 1, no. 1
(1977):40-58, 16 illus.
Painting analyzed as employing new narrative device,
visible in poses of figures, for illustrating complicated story
in unified scene.

MASOLINO (1383-1440 or 1447)
(See also Masaccio)

Books

1559 MICHELETTI, EMMA. Masolino da Panicale. Milan: Istituto
editoriale italiano, 1959, 59 pp., 64 b&w and 23 color
illus.

Masolino

Substantial monograph with review of life and work, cata-
log of works, lists of lost and attributed works, and chrono-
logical bibliography.

1560　TOESCA, PIETRO. Masolino da Panicale. Bergamo: Istituto
italiano d'arti grafiche, 1908, 72 pp., 78 illus.
　　　Early monograph. Reviews earlier art and art of
Masaccio, in process of presenting Masolino's oeuvre. Index.

1561　VAYER, LAJOS. Masolino és Roma: Mecénas és müvész a
Reneszansz kezdetén [Masolino and Rome: Patron and artist
at the beginning of the Renaissance]. Budapest:
Képzömüvészeti Alap Kiadóvallalata, 1962, 354 pp., 240
b&w and 15 color illus.
　　　In Hungarian. Discussion centers around works in S.
Clemente, Rome, with excursions into other periods of Masolino's
career, related cycles by other artists, the iconography of
Saint Catherine, and the art and culture of Rome.
　　　Review: Tibor Kardos, Lajos Elekes, Andor Pigler,
György Szekely, and Lajor Vayer, Musveszettoreneti Ertesito 11
(1962):60-74.

Articles and Booklets

1562　ARASSE, DANIEL. "Espace pictural et image religieuse: Le
point de vue de Masolino sur la perspective." In La
prospettiva rinascimentale: Codificazioni e trasgressioni.
Edited by Marisa Dalai Emiliani. Milan: Centro Di, 1980,
pp. 137-50, 9 illus.
　　　Considers systems of compositional organization and
spatial juxtaposition in Masolino. Diagrams.

1563　_____. "Structure de l'espace dans l'art de Masolino da
Panicale." L'information d'histoire de l'art 12, no. 5
(1967):223-24.
　　　Discusses tension between old and new ideas in spatial
organization of Masolino's works.

1564　ARGENTI, M. Masolino da Panicale: Il battistero di
Castiglione Olona. Bergamo: Monumenta longobardica, 1975,
10 pp., 25 b&w and 17 color illus.
　　　Collection of excellent, oversize photographs of cycle,
including overall views and details. Introduction by Francesco
Rossi. Brief description of baptistery and of Masolino's life.
Bibliography.

1565　BALDINI, UMBERTO. "Masolino." In Encyclopedia of World
Art. Vol. 9. London: McGraw Hill, 1964, col. 574-78, 6
b&w and 2 color illus.
　　　Reviews facts of life and activity, relation to other
artists. Bibliography.

1566 BELLOSI, LUCIANO. "A proposito del disegno dell'Albertina (dal Ghiberti a Masolino)." In Lorenzo Ghiberti nel suo tempo. Vol. 1. Atti del Convegno internazionale di studi, 1978. Florence: Olschki, 1980, pp. 135-46, 12 illus.
　　Reattributes drawing of studies for a Flagellation, Albertina, Vienna, to Masolino, rather than Ghiberti. Compares to Masolino's sinopie in S. Clemente, Rome.

1567 BERENSON, BERNARD. "The Annunciation by Masolino." Art in America 4, no. 6 (1916):305-11, 1 illus.
　　Asserts attribution of Annunciation, Goldman Collection (now National Gallery, Washington), to Masolino. Dates early in artist's career.

1568 _____. "Quelques peintures méconnues de Masolino da Panicale." Gazette des beaux arts 27, no. 536 (1902):89-99, 4 illus. [English ed. in Study and Criticism of Italian Art (London: G. Bell & Sons, 1902), pp. 77-89.]
　　Mentions Annunciation, Gosford House; Madonna, Bremen; and fragments of decorations in Palazzo Castiglioni, Castiglione d'Olona. Also illustrates and discusses Madonna, Munich, fresco of Madonna and Angels, S. Stefano, Empoli, and fresco of Christ in Tomb, Baptistery, Empoli.

1569 _____. "Una predella di Masolino nel Museo Ingres a Montauban." Dedalo 3, no. 3 (1922-23):633-35, 2 illus.
　　Publishes predella with scene of Saint Julian.

1570 BORENIUS, TANCRED. "The Annunciation, by Masolino." Burlington Magazine 29, no. 158 (1916):45, 1 illus.
　　First publication of painting recently sold into an American Collection (now National Gallery, Washington).

1571 CAGNOLA, GUIDO. "Un affresco inedito di Masolino da Panicale." Rassegna d'arte 4, no. 5 (1904):75-76, 1 illus.
　　Attribution of landscape in Palazzo Castiglioni, Castiglione Olona.

1572 COLE, BRUCE. "A Reconstruction of Masolino's True Cross Cycle in Santo Stefano, Empoli." Mitteilungen des kunsthistorischen Institutes in Florenz 13, nos. 3-4 (1968):289-300, 12 illus.
　　Reconstruction, on basis of surviving sinopie, of frescoes of 1424 destroyed in 1792. Seen to derive from Agnolo Gaddi's cycle in Sta. Croce, Florence, with significant increase in unity and drama.

1573 FREMANTLE, RICHARD. "Some New Masolino Documents." Burlington Magazine 117, no. 871 (1975):658-59.
　　Publishes five new documents, dating from 1422 to 1428, from the papers of the Florentine notary Niccolo Gentiluzzi,

concerning Masolino's activities and his belated emancipation from his father.

1574 GENGARO, MARIA LUISA. "Masolino e Pisanello in Lombardia e a Milano." Arte lombarda 12, no. 2 (1967):25-32, 11 illus.
Fresco fragments from Casa Borromeo, Milan, show impact of Masolino (and Pisanello) on Lombard art.

1575 GNOLI, UMBERTO. "L'affresco di Masolino a Todi." Bollettino d'arte 8, no. 5 (1914):175-76, 1 illus.
Discovery of document of 1432 confirms Perkins attribution of fresco, S. Fortunato, Todi, to Masolino (entry 1589).

1576 IKUTA, MADOKA. "Gli affreschi della cappella di S. Caterina nella chiesa di S. Clemente a Roma." Annuario, Istituto giapponese di cultura in Roma 8 (1970-71):73-99, 28 illus.
Studies cycle, which attributes mostly to Masolino ca. 1428-31. Suggests sinopie and fresco of central horizontal section of Crucifixion were done by assistant, following designs by Masaccio.

1577 JONES, ROGER. "Masolino at the Colosseum?" Burlington Magazine 122, no. 923 (1980):121-22, 6 illus.
Demonstrates Masolino's use of motifs from painted stucco decor on entrance passages of Colosseum for frescoes in S. Clemente, Rome.

1578 KIEL, HANNA. "Una proposta per Masolino 'disegnatore.'" In Scritti di storia dell'arte in onore di Ugo Procacci. Vol. 1. Milan: Electa, 1977, pp. 196-99, 7 illus.
Attributes pen drawing of fantastic landscape, Codex Vallardi, Louvre, to Masolino. Sees as prepatory study for fresco in Palazzo Branda Castiglioni, Castiglione d'Olona, ca. 1435.

1579 MANCA, JOSEPH. "La 'natura morta' di Masolino a Palazzo Branda di Castiglione Olona." Prospettiva 25 (April 1981):45-46, 3 illus.
Attributes still life in palazzo to Masolino in 1430s, rather than to Paolo Schiavo. Constitutes early example of still life in Renaissance.

1580 MARCACCIOLI CASTIGLIONI, ANNA. "Nota per Palazzo Branda Castiglioni di Castiglione Olona." Arte lombarda 61 (1982):32, 1 illus.
Publishes discovery of date of 14 October 1423 for frescoes by Masolino in Camera del Cardinale of palace.

1581 MARTINI, ALBERTO. Masolino a Castiglione d'Olona. Milan: Fratelli, 8 pp., 30 color illus.
Brief introduction to lavish color plates of fresco cycle, including details, room views, foldouts, and diagram.

1582 MESNIL, JACQUES. "Les fresques de l'église San Clemente a
 Rome." Beaux arts 5, no. 9 (1927):139-41, 3 illus.
 Attributes Crucifixion and scenes of Saint Catherine to
 Masolino, rather than Masaccio. Dates after 1430, according to
 costumes.

1583 ____. "Masolino ou Masaccio." Gazette des beaux arts 2
 (October 1929):206-9, 2 illus.
 Attributes Resurrection of Tabitha, Brancacci Chapel,
 Carmine, Florence, to Masolino, on basis of perspective con-
 struction, which resembles that of Banquet of Herod,
 Castiglione d'Olona. English summary.

1584 MORASSI, ANTONIO. "Die Fresken des Masolino im Baptisterium
 von Castiglione d'Olona." Pantheon 19 (March 1937):72-79, 8
 illus.
 Presents frescoes of 1435 after 1936 cleaning. Sees
 influence of Masaccio. Rejects idea of collaboration with
 Lombard artists. English summary.

1585 OERTEL, ROBERT. "Eine Madonna dell'Umilità von Masolino."
 Die Kunst 47, no. 1 (1949):1-5, 4 b&w and 1 color illus.
 Publishes Madonna of Humility, from Contini Collection,
 Florence, now Point Collection, attributed to Masolino. Dates
 1410-20.

1586 OFFNER, RICHARD. "Un pannello di Masolino a San Giuliano a
 Settimo." Dedalo 3, no. 3 (1922-23):636-41, 2 illus.
 Attribution of figure of Saint Julian, Pieve di San
 Giuliano, Settimo. Dates ca. 1430.

1587 ____. "A Saint Jerome by Masolino." Art in America 8, no.
 2 (1920):68-76, 1 illus.
 Attributes St. Jerome, Mather Collection (now University
 Art Museum, Princeton). Dates 1423-26. Compares to figures in
 Brancacci Chapel, Carmine, Florence.

1588 PARRONCHI, ALESSANDRO. "Postilla sul neo-gaddismo degli
 anni 1423-25." Paragone 12, no. 137 (1961):19-26, 7 illus.
 Influence of trompe l'oeil still life niches in Taddeo
 Gaddi's work on Masolino's frescoes in S. Stefano, Empoli, and
 especially in S. Clemente, Rome.

1589 PERKINS, F. MASON. "Un dipinto sconosciuto di Masolino da
 Panicale." Rassegna d'arte 7, no. 12 (1907):184-86, 4
 illus.
 Publishes fresco of Madonna and Child with Two Angels,
 S. Fortunato, Todi. Detailed photographs.

1590 POGGI, GIOVANNI. "Masolino e la Compagnia della Croce in
 Empoli." Rivista d'arte 3, no. 2 (1905):46-53, 1 illus.

Masolino

Documents regarding society and its chapel and oratorio
in S. Stefano, Empoli. Indicates Masolino at work there in
1424. Reconstructs later history of compagnia and its struc-
tures from documents through seventeenth century.

1591 POPE-HENNESSY, JOHN. "A Predella Panel by Masolino."
 Burlington Magazine 82, no. 479 (1943):30-31, 1 illus.
 Attribution of Marriage of the Virgin (lost at sea).
From same predella as Death of the Virgin, Vatican.

1592 ROLFS, WILHELM. "Eine Italienische Vorlage Grünewalds."
 Repertorium für Kunstwissenschaft 42 (1920):227-37, 5 illus.
 Discusses scene of Founding of Sta. Maria Maggiore,
Naples, as source for Grunewald's work. Attributes to Masolino.

1593 SALMI, MARIO. "Gli affreschi nella Collegiata di
 Castiglione Olona." Dedalo 8, no. 1 (1927-28):227-44,
 16 illus.; 9, no. 1 (1928-29):3-29, 22 illus.
 Photographs and discussion of recently cleaned scenes of
life of the Virgin, in the vault, by Masolino. Examines walls
of apsidal chapel, attributes some scenes to Paolo Schiavo,
some to anonymous figure close to Pesellino.

1594 _____. "Masolino da Panicale nella Collegiata di
 Castiglione Olona." In Jean Alazard: Souvenirs et
 mélanges. Paris: Henri Laurens, editeur, 1963,
 pp. 213-17.
 Discusses new documentary evidence dating Masolino's
activity in Collegiata after 1431, perhaps 1435, as hypothe-
sized earlier.

1595 _____. "An Unpublished Masolino." Art in America 18, no. 4
 (1930):186-204, 16 illus.
 Attribution of Crucifixion from parish church in Monte
Castello (near Pisa). Supports attribution of cycle in S.
Clemente, Rome, to Masolino, ca. 1428-31.

1596 SIMPSON, W.A. "Cardinal Giordano Orsini († 1438) as a
 Prince of the Church and a Patron of the Arts." Journal of
 the Warburg and Courtauld Institutes 29 (1966):135-59.
 Publishes new documents including two descriptions of
uomini famosi cycle in Monte Giordano, which can now be
attributed to Masolino with certainty and connected with
Cardinal Orsini.

1597 TATLOCK, R.R. "Notes on Various Works of Art: Masolino."
 Burlington Magazine 40, no. 228 (1922):139, 1 illus.
 Attribution of Madonna and Child, Art Museum, Worcester.

1598 TOESCA, PIETRO. Affreschi di Masolino a Castiglione Olona.
 2d ed. Collezione Silvana, 3. Milan: Amilcare Pizzi,
 1957, 11 pp., 32 color illus.

Introductory text, bibliography note, for corpus of large color illustrations.

1599 ____. "Frammento di un trittico di Masolino." Bollettino d'arte 17, no. 1 (1923):3-6, 4 illus.
Attributes Madonna, Pieve di Sta. Maria Novoli, to Masolino. Associates with other fragments, including St. Julian, Uffizi, Florence.

1600 URBANI, GIOVANNI. "Restauro di affreschi nella cappella di S. Caterina a S. Clemente in Roma." Bollettino dell Istituto centrale del restauro 21-22 (1955):13-20, 28 illus.
Corpus of photographs of restoration on fresco cycle, with many details and brief text.

1601 VALENTINER, WILHELM R. "Eine Verkündigung Masolinos." Pantheon 8 (October 1931):413-16, 2 illus.
Publishes two panels of Annunciation, Duveen Collection, New York. Notes influence of Fra Angelico. Dates ca. 1432. English summary.

1602 VAYER L[AJOS]. "Analecta iconographica masoliniana." Acta historiae artium 11, no. 3-4 (1965):217-39, 13 illus.
Addresses several iconographic and critical problems in Masolino, including arrangement of Apostles, in S. Clemente, Rome, identification of pope on wing of Sta. Maria Maggiore polyptych as Gregory I, attribution of lost Orsini cycle, and content of Nativity, Castiglione d'Olona.

1603 ____. "Rekonstrukcija programmy cikla fresok Mazolino da Panikale v bazilike San Klemente v Rime" [The Program of the fresco cycle by Masolino in the basilica of San Clemente in Rome]. In Vizantija. Festschrift V.N. Lazarev. Moscow: Nauka, 1973, pp. 438-49, 3 illus.
In Russian. Iconographic study of chapel.

1604 VENTURI, LIONELLO. "Contributi a Masolino, a Lorenzo Salimbeni e a Jacopo Bellini." L'arte 33, no. 2 (1930):165-90, 9 illus.
Publishes paintings in American collections. Attributes several to Masolino, including Crucifixion, Griggs Collection, New York, Four Saints, Johnson Collection, Philadelphia, and Trinity, Institute of Arts, Detroit. Attributes Annunciation, Friedsam Collection, New York, to Salimbeni.

1605 VITZTHUM, GEORG. "Ein Stadtbild im Baptisterium von Castiglione d'Olona." In Festschrift zum Sechzigsten Geburtstag von Paul Clemen. Bonn: Friedrich Cohen; Dusseldorf: L. Schwann, 1926, pp. 401-11, 3 illus.
Discusses cityscape in Masolino's Annunciation to Zacharias. Identifies as Rome. Notes North Italian influence.

Masolino

1606 WAKAYAMA, EIKO M.L. "Iconografia ritrattistica negli
 affreschi a Castiglione Olona." Arte lombarda 36 (1972):56-
 61, 83-87, 20 illus.
 Identifies a variety of figures in scenes by Masolino as
 contemporaries of Cardinal Branda Castiglione.

1607 ____. "'Novità' di Masolino a Castiglione Olona." Arte
 lombarda 16 (1971):1-16, 13 illus.
 Analyzes frescoes in baptistery. Relates to Alberti's
 Treatise on Painting. Constructs perspective of Feast of
 Herod.

1608 ____. "Il programma iconografico degli affreschi di
 Masolino a Castiglione Olona." Arte lombarda 50 (1978):
 20-32, 22 illus.
 Analyzes cycle done for Cardinal Branda da Castiglione.
 Considers placement of scenes, notes contrasts illustrated
 between temporal and spiritual. Finds some sources in ideas of
 Orthodox church, which Cardinal was then trying to unite with
 the Roman.

1609 ____. "La prospettiva come strumento di visualizzazione
 dell'istoria: Il caso di Masolino." In La prospettiva
 rinascimentale: Codificazioni e trasgressioni. Edited by
 Marisa Dalai Emiliani. Milan: Centro Di, 1980, pp. 151-63,
 7 illus.
 Various perspective schemes in Masolino's work, analyzed
 in terms of religious and symbolic significance.

1610 WICKHOFF, FRANZ. "Die Fresken den Katherinenkapelle in S.
 Clemente zu Rom: Ein Beitrag zu ihrer Datierung."
 Zeitschrift für bildende Kunst 24 (1889):301-10, 2 illus.
 Attributes cycle to Masolino, dates 1446-50. Notes in-
 fluence of Pisanello.

1611 WOLTERS, CHRISTIAN. "Über den Erhaltungszustand einer
 Madonna von Masolino." Kunstchronik 9, no. 2 (1956):33-35,
 10 illus.
 Madonna and Child, property of Italian government, at-
 tributed to Masolino, ca. 1410-20. Illustrations concern con-
 dition, include X-rays and details.

 MASTER OF THE ARTE DELLA LANA "CORONATION"
 (act. late fourteenth-early fifteenth century)

1612 COLE, BRUCE. "A New Work by the Master of the Arte della
 Lana Coronation." Burlington Magazine 110, no. 781
 (1968):215-16, 3 illus.
 Attribution of Madonna at the Convento delle Suore
 Oblati, Careggi, to the Florentine master. Rejects identifica-
 tion of artist with Lorenzo di Niccolo.

MASTER OF THE BAMBINO VISPO. See STARNINA

MASTER OF THE BARBERINI PANELS;
FRA CARNEVALE (act. 1445-84)

Book and Dissertation

1613 STRAUSS, MONICA. "The Master of the Barberini Panels: Fra
Carnevale." Ph.D. dissertation, New York University, 1979,
313 pp., 205 illus.
Identifies Fra Carnevale as Master of the Barberini
panels. Discusses Annunciation, National Gallery, Washington,
portrait of Frederick III, Uffizi, Florence, and Barberini
Panels in Metropolitan Museum, New York, and Museum of Fine
Arts, Boston. Includes section on Fra Carnevale as an archi-
tect. Bibliography. Appendix with documents.

1614 ZERI, FEDERICO. Due dipinti, la filologia, e un nome: Il
maestro delle tavole Barberini. Turin: Einaudi, 1961, 131
pp., 77 b&w and 5 color illus.
Reviews earlier discussions of problem of Barberini
group, particularly Offner's (entry 1622). Discusses relation
of paintings to Domenico Veneziano and to Boccati. Deals with
Domenico di Bartolo, Gerolamo di Giovanni, Lippi, and others.
Identifies artist as Giovanni Angelo di Antonio da Camerino.

Articles

1615 ANGELIS, LAURA DE, and CONTI, ALESSANDRO. "Un libro antico
della sagrestia di Sant'Ambrogio." Annali della Scuola
normale superiore di Pisa 6, no. 1 (1976):97-109, 1 illus.
Documents (1439-58) concerning Lippi's Coronation,
Uffizi, Florence, intended for high altar of S. Ambrogio,
Florence. Includes mention of Fra Carnevale as assistant to
Lippi. Identifies with Barberini Master and attributes angels
in Coronation to him.

1616 BOMBE, WALTER. "A propos de la Communion des Apôtres de
Josse Van Gent a Urbin." Cahiers de Belgique 3, no. 7
(1930):236-42, 8 illus.
Includes publication of six figures of apostles that he
suggests came from one of wings of altar now in Palazzo Ducale,
Urbino. Attributes to Fra Carnevale.

1617 CHRISTIANSEN, KEITH. "For Fra Carnevale." Apollo 109, no.
205 (1979):198-201, 5 illus.
Uses new documents to identify Barberini Master as Fra
Carnevale and connects panels of the life of the Virgin in
Museum of Fine Arts, Boston, and Metropolitan Museum, New York,
to altarpiece in Sta. Maria della Bella in Urbino, mentioned by
Vasari.

Master of the Barberini Panels; Fra Carnevale

1618 CUNNINGHAM, C.C. "A Great Renaissance Panel." Bulletin of
 the Museum of Fine Arts, Boston 35, no. 210 (1937):46-50, 5
 illus.
 Publishes recently acquired Presentation of the Virgin.
 Describes history of the painting and its eclectic style.
 Suggests possible attribution to Fra Carnevale. Notes variety
 of influences, strong Umbrian element, and connection with
 Lorenzo da Viterbo.

1619 F[RIZZONI], G. "Notizie." Archivo storico dell'arte 8
 (1895):393-406.
 Includes a notice rejecting attribution of Barberini
 panels to Fra Carnevale.

1620 MEISS, MILLARD. "Contributions to Two Elusive Masters."
 Burlington Magazine 103, no. 695 (1961):57-66, 14 illus.
 Discusses art and works of Master of the Orange Cloister,
 emphasizing relation to Domenico Veneziano. Attributes to
 Barberini Master a portait of Frederick III, Uffizi, Florence.

1621 MELLER, PETER, and HOKIN, JEANNE. "The Barberini Master as
 a Draughtsman?" Master Drawings 20, no. 3 (1982):239-46, 9
 illus.
 Sees drawing, National Museum, Stockholm, of all'antica
 nudes, as close in style to Barberini Master. Considers to be
 workshop pattern sheet, possibly by Fra Carnevale.

1622 OFFNER, RICHARD. "The Barberini Panels and their Painter."
 In Medieval Studies in Memory of A. Kingsley Porter. Edited
 by Wilhelm R.W. Koehler. Vol. 1. Cambridge, Mass.:
 Harvard University Press, 1939, pp. 205-53, 39 illus.
 Detailed study of features of the Barberini panels. Dis-
 cusses relation to Florentine and North Italian art and to
 Domenico Veneziano, Piero, and Lippi. Attributes Annunciation,
 Kress Collection (now National Gallery, Washington) and Cruci-
 fixion, on art market, to same hand. Does not identify with
 any known name.

1623 PARRONCHI, ALESSANDRO. "Leon Battista Alberti as a
 Painter." Burlington Magazine 104, no. 712 (1962):280-86,
 15 illus. [Reprinted in Studi su la dolce prospettiva
 (Milan: Martello, 1964), pp. 437-67.]
 Identifies Alberti as Master of the Barberini panels.
 Dates panels ca. 1443, interprets formations in clouds as
 Alberti's personal emblem of winged eye.

1624 RICHTER, GEORGE MARTIN. "Rehabilitation of Fra Carnevale."
 Art Quarterly 3, no. 4 (1940):311-24, 10 illus.
 Attribution of a group of works, including Barberini
 panels (ca. 1470s) and Annunciation, Washington, National Gal-
 lery, (ca. 1450-55) to Fra Carnevale. Identifies artist as
 native of Marches.

1625 SWARZENSKI, GEORG. "The Master of the Barberini Panels:
 Bramante." <u>Bulletin</u> <u>of</u> <u>the</u> <u>Museum</u> <u>of</u> <u>Fine</u> <u>Arts,</u> <u>Boston</u> 38,
 no. 230 (1940):90–97, 18 illus.
 Attributes panels to Bramante's early period as a painter
 in Urbino. Emphasizes similarities to a print after a design
 by Bramante.

1626 WEHLE, HARRY B. "A Painting Attributed to Fra Carnevale."
 <u>Bulletin</u> <u>of</u> <u>the</u> <u>Metropolitan</u> <u>Museum</u> 31, no. 3 (1936):59–66,
 3 illus.
 Acquisiton of the <u>Birth</u> <u>of</u> <u>the</u> <u>Virgin</u>, formerly in the
 Barberini Palace, Rome. Artist worked in Urbino, probably
 visited Florence, and may be identified with Fra Carnevale.

 <u>MASTER</u> <u>OF</u> <u>THE</u> <u>BEATA</u> <u>SERAFINA</u>
 (act. early fifteenth century)

1627 ROTONDI, PASQUALE. "Il Maestro della Beata Serafina." In
 <u>Scritti</u> <u>di</u> <u>storia</u> <u>dell'arte</u> <u>in</u> <u>onore</u> <u>di</u> <u>Mario</u> <u>Salmi</u>. Vol.
 2. Rome: DeLuca, 1962, pp. 163–74, 14 illus.
 Gathers works attributable to an artist active in the
 Marches, early 1400s. Notes influence of Gentile and of North
 Italian painters.

<u>MASTER</u> <u>OF</u> <u>THE</u> <u>CARRAND</u> <u>TRIPTYCH</u>. See <u>GIOVANNI</u> <u>DI</u> <u>FRANCESCO</u>

<u>MASTER</u> <u>OF</u> <u>THE</u> <u>CASTELLO</u> <u>NATIVITY</u> (act. ca. 1445–75)

1628 LIPMAN, JEAN. "Three Profile Portraits by the Master of the
 Castello <u>Nativity</u>." <u>Art</u> <u>in</u> <u>America</u> 24, no. 3 (1936):110–26,
 6 illus.
 Attributes female portraits in Lehman Collection, New
 York; Bache Collection, New York; and Gardner Museum, Boston,
 to Master of the Castello <u>Nativity</u>. Dates ca. 1455, ca. 1465,
 and ca. 1465, respectively. Reviews literature on artist and
 history of painting's attributions.

1629 MEISS, MILLARD. "A Lunette by the Master of the Castello
 <u>Nativity</u>." <u>Gazette</u> <u>des</u> <u>beaux</u> <u>arts</u> 70, no. 1185 (1967):
 213–18, 7 illus.
 Attribution of <u>God</u> <u>the</u> <u>Father</u> <u>and</u> <u>Angels</u>, Alte
 Pinakothek, Munich. Suggests perhaps originally connected to
 <u>Adoration</u>, Johnson Collection, Philadelphia.

1630 PROCACCI, UGO. "Opere sconosciute d'arte toscana." <u>Rivista</u>
 <u>d'arte</u> 17, no. 4 (1935):405–11, 5 illus.
 <u>Madonna</u> <u>and</u> <u>Saints</u>, SS. Giusto e Clemente, Faltugnano,
 attributed to Master of the Castello <u>Nativity</u>.

Master of the Castello Nativity

1631 SALMI, MARIO. "La Madonna dantesca nel Museo di Livorno e
 il Maestro della Natività Castello." Liburni civitas 9
 (1938):217-56, 32 illus.
 Study of career of Master of the Castello Nativity,
 reviewing numerous attributions and previous literature. Notes
 influence of a wide variety of artists on his style. Dates
 Madonna in Livorno ca. 1465-70.

1632 VALENTINER, W[ILHELM] R. "Andrea dell'Aquila, Painter and
 Sculptor." Art Bulletin 19, no. 4 (1937):503-36, 43 illus.
 Reconstructs career. Attributes works grouped under name
 of Master of the Castello Nativity to him.

 MASTER OF 1419 (act. early fifteenth century)

1633 FRANCIS, HENRY S. "Master of 1419." Bulletin of the
 Cleveland Museum of Art 43, no. 10 (1956):211-13, 1 color
 illus.
 Publishes Madonna and Child, probably center of a
 triptych, inscribed with date 1419. Style close to Masolino.

1634 NICOLSON, BENEDICT. "The Master of 1419." Burlington
 Magazine 96, no. 615 (1954):181, 1 illus.
 Publishes new photograph of Madonna of 1419, formerly
 Crawshay Collection.

1635 POUNCEY, PHILIP. "A New Panel by the Master of 1419."
 Burlington Magazine 96, no. 618 (1954):291-92, 2 illus.
 Panel of St. Julien, St. James Major and Angel, attrib-
 uted to Master of 1419.

 MASTER OF THE GRIGGS CRUCIFIXION. See GIOVANNI TOSCANI

 MASTER OF THE INNOCENTI (act. early fifteenth century)

1636 COLETTI, LUIGI. "Il Maestro degli Innocenti." Arte veneta
 2 (1948):30-40, 16 illus.
 Constructs career of artist, who did cycle of works in S.
 Caterino, Treviso. Suggests Umbrian origin, close to Salimbeni.

 MASTER OF THE KARLSRUHE ADORATION (act. ca. 1440-60)

1637 GAMBA, CARLO. "Di alcuni quadri di Paolo Uccello o della
 sua scuola." Rivista d'arte 6, no. 1 (1909):19-30, 6
 illus.
 Discusses Scenes from Monastic Legends, Uffizi, Florence.
 Attributes to Uccello School, by same hand as Nativity,
 Karlsruhe Gallery.

1638 KOCKS, DIRK. "Die Erlösung im Adventus." Jahrbuch der
staatlichen Kunstsammlungen in Baden-Württemberg 11
(1974):121-36, 7 illus.
Discusses iconography of Adoration, Staatliche
Kunsthalle, Karlsruhe, attributed to the Master of the
Karlsruhe Adoration.

1639 PUDELKO, GEORG. "Der Meister der Anbetung in Karlsruhe, ein
Schüler Paolo Uccellos." In Adolph Goldschmidt zu seinem
siebenzigsten Geburtstag. Berlin: Würfel, 1935, pp. 123-
30, 5 illus.
Attributes various works to artist, including Adoration
in Staatliche Kunsthalle, Karlsruhe, and Thebaid, Accademia,
Florence.

MASTER OF THE MADONNA DI ALVITO
(act. 3d quarter fifteenth century)

1640 MALTESE, CORRADO. "Aggiunta al Maestro della Madonna di
Alvito." In Arte in Europe: Scritti di storia dell'arte in
onore di Edoardo Arslan. 2 vols. Milan: Artipo, 1966, pp.
405-6, 2 illus.
Attributes frescoes in Alatri.

1641 _____. "Il Maestro della Madonna di Alvito." Bollettino
d'arte 48, no. 3 (1963):239-44, 13 illus.
Attributes works in Lazio, particularly frescoes in vari-
ous buildings in Alatri, ca. 1460, to hand of master.

MASTER OF THE ORANGE CLOISTER (act. 1430s)

1642 ALMEIDA, OTÍLIA. "Breves notas sobre a atribução, a um
mestre português, dos frescos do Claustro degli Aranci, da
Badia de Florençe." Boletim do Museu nacional de arte
antiga, Lisbon 4, no. 1 (1959):33-42, 9 illus.
Attributes cycle in Orange Cloister, Badia, Florence, to
Portuguese Giovanni da Consalvo. Notes influence especially of
Fra Angelico.

1643 CHIARINI, MARCO. "Il maestro del Chiostro degli Aranci:
'Giovanni di Consalvo' portoghese." Proporzioni 4 (1963):1-
24, 42 illus.
Identifies painter of cycle in Badia, Florence, 1436-39,
with Portuguese artist. Discusses relationship to contemporary
Florentine art and Jan Van Eyck. Bibliography.

1644 _____. "Di un maestro 'elusivo' e di un contributo." Arte
antica e moderna 13-16 (1961). [Published as Studi di
storia dell'arte: Raccolta di saggi dedicati a Roberto

Master of the Orange Cloister

Longhi in occasione del suo settantesimo compleanno (Florence: Sansoni, 1961), pp. 134–37, 3 b&w and 1 color illus.]
Discusses fresco cycle in the Badia, Florence, by the Master of the Orange Cloister, identified with Giovanni di Consalvo. Dates ca. 1430s.

1645 HENDERSON, NATALIE ROSENBERG. "Reflections on the Chiostro degli Aranci." Art Quarterly 32, no. 4 (1969):393–410, 22 illus.
Recently uncovered sinopie in Orange Cloister, Badia, Florence, reveal influence of Spinello Aretino. First design, as seen in sinopie, modernized and dramatized in final works.

MEISS, MILLARD. "Contributions to Two Elusive Masters." See entry 1620.

1646 NEUMEYER, ALFRED. "Die Fresken im 'Chiostro degli Aranci' der Badia Florentina." Jahrbuch der preussischen Kunstsammlungen 48, no. 1–2 (1927):25–42, 7 illus. [Reprinted in Gesammelte Schriften (Munich: W. Fink, 1977).]
Fundamental study of cycle. Includes section on early written sources, iconography of individual scenes, and place in development of Florentine art.

MASTER OF THE OSSERVANZA (act. 2 quarter fifteenth century)

1647 CARLI, ENZO. "A Resurrection by the Master of the Osservanza." Translated by Lawrence A. Wilson. Art Quarterly 23, no. 4 (1960):333–40, 3 illus.
Publishes Resurrection recently acquired by Institute of Arts, Detroit. Final section of scattered predella illustrating the Passion of Christ. Dates ca. 1445. Notes influence of Sano di Pietro.

_____. Sassetta e il Maestro dell' Osservanza. See entry 1958.

1648 ERFFA, HANS MARTIN VON. "Der Nürnberger Stadtpatron auf italienischen Gemälden." Mitteilungen des kunsthistorischen Institutes in Florenz 20, no. 1 (1976):1–12, 8 illus.
Establishes that Pietà, Monte dei Paschi, Siena, by Master of the Osservanza, was donated by Peter Volckamer of Nuremberg in ca. 1432–33. Painting includes Saint Sebald, patron saint of Nuremberg, and Volckamer coat of arms.

1649 GRAZIANI, ALBERTO. "Il Maestro dell'Osservanza." Proporzioni 2 (1948):75–88, 33 illus.
Written in 1942, published posthumously with postilla by Roberto Longhi. Distinguishes style of Master of the Osservanza from that of Sassetta and attributes a large number of works to

his hand, including St. Anthony altarpiece, which is here
reconstructed.

1650 SCAPECCHI, PIERO. "Quattrocentisti senesi nelle Marche. Il
 polittico di Sant'Antonio abate del Maestro dell'Osservanza."
 Arte cristiana 71, no. 698 (1983):287-90, 4 illus.
 Reconstructs altarpiece from fragments. Postulates that
 was originally in the Marches near Macerata. Comments on
 importance of presence of Sienese artists in region.

1651 ZERI, FEDERICO. "Il Maestro dell'Osservanza: Una
 Crocefissione." Paragone 5, no. 49 (1954):43-44, 1 illus.
 Attributes Crucifixion, known only through photograph,
 ca. 1440-45.

 MASTER OF PRATOVECCHIO. See GIOVANNI DI FRANCESCO

 MASTER OF SAINTS QUIRICO AND GIULITTA
 (act. 2 quarter fifteenth century)

1652 LONGHI, ROBERTO. "Un incontro col 'Maestro dei Santi
 Quirico e Giulitta.'" Paragone 16, no. 185 (1965):40-43, 3
 illus. [Reprinted in Fatti di Masolino e di Masaccio e
 altri studi sul quattrocento (Florence: Sansoni, 1975),
 pp. 139-42.]
 Florentine master of three panels with legend of SS.
 Quirico and Giulitta, Parry Collection, Gloucester, also pro-
 posed as artist of Madonna with Sts. Sebastian and Leonard,
 private collection, Bologna.

1653 PADOA RIZZO, ANNA. "Ancora sul 'Maestro dei Santi Quirico e
 Giuletta.'" Antichità viva 20, no. 2 (1981):5-7, 4 illus.
 Attributes Madonna and Saints and Angels, location un-
 known, to master. Rejects identification with Battista di
 Gerio. English summary.

1654 VOLPE, CARLO. "Alcune restituzioni al Maestro dei Santi
 Quirico e Giulitta." In Quaderni di Emblema, 2. Bergamo:
 Emblema editrice, 1973, pp. 17-21, 12 illus.
 Various attributions to this anonymous Florentine master.

 MASTER OF THE SHERMAN PREDELLA (act. ca. 1420-40)

1655 LONGHI, ROBERT. "'Me Pinxit': Il 'Maestro della Predella
 Sherman.'" Proporzioni 2 (1948):161-62, 3 illus.
 [Reprinted in Fatti di Masolino e di Masaccio e altri studi
 sul quattrocento (Florence: Sansoni, 1975), pp. 93-94.]

Master of the Sherman Predella

Argues that painter was student of Lorenzo Monaco, active 1430s. Attributes lunette, formerly private collection, Florence, and Crucifixion, formerly Museum, Arezzo.

1656 _____. "Un nuovo numero del 'Maestro della Predella Sherman.'" Paragone 18, no. 211 (1967):38-40, 2 color illus. [Reprinted in Fatti di Masolino e di Masaccio e altri studi sul quattrocento (Florence: Sansoni, 1975), pp. 95-96.]
Attribution of Crucifixion triptych, private collection, Florence. Dates 1420-25.

MASTER OF STAFFOLO (act. ca. 1425-50)

1657 DONNINI, GIAMPIERO. "Un affresco quattrocentesco in S. Domenico di Fabriano." Notizie da Palazzo Albani 6, no. 1 (1977):9-10, 2 illus.
Publishes recently restored work, Christ at the Column between St. Agnes and Madonna. Suggests possible attribution to the Master of Staffolo, ca. 1430s.

1658 _____. "Contributi al Maestro di Staffolo." Commentari 22, no. 2-3 (1971):172-75, 2 illus.
Attribution of Madonna Enthroned, Palazzo Baravelli, Fabriano. Dates in 1430s. Suggests chronology for artist.

1659 _____. "Due aggiunte al Maestro di Staffolo." Notizie da Palazzo Albani 3, no. 2-3 (1974):31-35, 4 illus.
Attributes St. Apollonia, Art Museum, St. Louis, and fresco with Saints, from S. Onofrio, Fabriano.

1660 _____. "Una 'Pietà e Santi' del Maestro di Staffolo." Notizie da Palazzo Albani 5, no. 2 (1976):33-34, 2 illus.
Attribution of fresco, S. Onofrio, Fabriano.

OTTAVIANO NELLI (ca. 1375-ca. 1446)

1661 BONFATTI, LUIGI. Elogi e documenti reguardanti Ottaviano di Martino Nelli, pittore eugubino. Foligno: Pietro Sgarglia, 1873, 28 pp.
A compilation of various writings by or edited by Bonfatti. Includes an essay on Nelli's fresco of Madonna and Child, Sta. Maria Nuova, Gubbio, by Austen H. Layard (see entry 1671); extracts from Art chrétien by A.F. Rio, and a section of memorie originali concerning Nelli, by author, which takes form of a chronological list of known information about him, including documentary material.

1662 CALZINI, E. "Notizie: Alcuni affreschi di Ottaviano Nelli venduti?" Rassegna bibliografica dell'arte italiana 1, no. 3-4 (1898):95-96; no. 5-6 (1898):132.

Reports on frescoes in a house in Gubbio, which attributes to Nelli, recently sold and now in unknown location.

1663 _____. "Un' altra pittura del Nelli in Urbino." Rassegna bibliografica dell'arte italiana 2, no. 5-6 (1899):109-14.
Describes and attributes fresco in Oratorio di S. Gaetano, Urbino, with Madonna and Child. Desribes, attributes. Dates ca. 1428-32.

1664 _____. "Per un pittore umbro." Rassegna bibliografica dell'arte italiana 1, no. 11-12 (1898):225-29.
Discusses Madonna and Child, Bordonaro Collection, Palermo. Attributes to Nelli, compares to Madonna, Sta. Maria Nuova, Gubbio, and to other works.

1665 CRISTOFANI, GIUSTINO. "Un trittico fabrianese ed il polittico di Ottaviano Nelli alla mostra di Perugia." Augusta Perusia 2, no. 5-6 (1907):72-76, 2 illus.
Description of Nelli's polyptych from Pietralunga, dated 1403, early in his career.

1666 DONNINI, GIAMPIERO. "Un ciclo a fresco giovanile di Ottaviano Nelli." Antichità viva 11, no. 3 (1972):3-9, 8 illus.
Attributes cycle in Oratorio di Sta. Maria della Piaggiola, Fossato di Vico, traditionally ascribed to Ottaviano's father, Martino Nelli. Dates ca. 1405.

1667 G[NOLI], U[MBERTO]. "Affreschi del Nelli in Fano." Rassegna d'arte umbra 2, no. 1 (1911):10-15, 5 illus.
Publishes recent restorations at S. Domenico, Fano, including two groups attributable to Nelli. One represents legend of Lazarus and Magdalen, the other scenes from life of Saint Dominic with Trinity lunette at top.

1668 _____. "A Picture of Ottaviano Nelli." Art in America 9, no. 1 (1920):21-23, 1 illus.
Attribution of Adoration of the Magi, Museum of Art, Worcester.

1669 _____. "Una tavola sconosciuta di Ottaviano Nelli." Rassegna d'arte 11, no. 4 (1911):76, 1 illus.
Publishes Madonna and Child with Angels, Fabbri Collection, Rome.

1670 GUALANDI, MICHELANGELO. Entry in Nuova raccolta di lettere sulla pittura, scultura ed architettura scritte da più celebre personaggi dei secoli XV. a XIX (con note ed illustrazioni). Bologna: A spese dell'editore ed annotare, 1844, pp. 7-14.
Publication of letter of 1434 from Ottaviano Nelli to Catterina Duchessa d'Urbino.

Ottaviano Nelli

1671 LAYARD, A.H. The Madonna and Saints, Painted in Fresco by
Ottaviano Nelli in the Church of S. Maria Nuova at Gubbio.
London: Arundel Society, 1857, 13 pp., 1 illus.
Description of painting, plus some comments on Nelli's
life and career. Reprinted in entry 1661.

1672 MAZZATINTI, G[IUSEPPE]. "A proposito dell'affresco di
Ottaviano Nelli nella chiesa di S. Agostino a Gubbio."
Rassegna bibliografica dell'arte italiana 7, no. 10-12
(1904):188-90.
Discusses recently uncovered Last Judgment. Rejects
various observations made about it and about school of Gubbio,
primarily those of Pio Cenci, in Miscellanea di storia
ecclesiastica 2, no. 3 (1904):79-91.

1673 _____. "Documenti per la storia delle arti a Gubbio."
Archivio storico per le Marche e per l'Umbria 3, no. 9-10
(1886):1-47.
Collection of documents from 1315 to 1504, including some
concerning a number of minor painters and a large number re-
garding Ottaviano Nelli, dating from 1400 to 1476.

1674 OFFNER, RICHARD. "An Ottaviano Nelli in the Worcester
Museum." Art in America 9, no. 1 (1920):23-24, 1 illus.
Discusses Adoration of Magi. Dates ca. 1415-20.

1675 ROLI, RENATO. "Considerazioni sull'opera di Ottaviano
Nelli." Arte antica e moderna 13-16 (1961). [Published as
Studi di storia dell'arte: Raccolta di saggi dedicati a
Roberto Longhi in occasione del suo settantesimo compleanno
(Florence: Sansoni, 1961), pp. 114-24, 9 illus.]
Considers the origins and early style of Nelli. Rejects
attribution of fresco in S. Francesco, Montefalco. Reconstruc-
tion of altarpiece from S. Francesco, Gubbio, and attributions
of other works.

1676 _____. "Un dossale di Ottaviano Nelli." Arte antica e
moderna 30 (April-June 1965):165-68, 3 illus.
Publishes work with three scenes on one panel, location
unknown. Dates ca. 1420. Also published Madonna, Rome,
Palazzo Venezia.

1677 ROSSI, FRANCESCO. "Un ciclo di affreschi allegorici di
Ottaviano Nelli." Arte antica e moderna 34-36 (April-
December 1966):197-208, 21 illus.
Reconstruction of cycle of monochrome frescoes of Virtues
and Vices, from Palazzo Beni, Gubbio. Some fragments now in
Cagnola Collection, Gazzada. Dates ca. 1430s.

1678 SALMI, MARIO. "Gli affreschi del Palazzo Trinci a Foligno."
Bollettino d'arte 13, no. 9-12 (1919):139-80, 20 illus.

First thorough study of recently restored works. In-
cludes chapel decorated by Nelli, completed 1424. Several
cycles by unknown artists, possibly including Giovanni di
Corraduccio. Includes discussion of iconography of secular
themes. Appendix with epigrams included in cycles.

1679 SANTI, FRANCESCO. "Un capolavoro giovanile di Ottaviano
Nelli." Arte antica e moderna 12 (October–December
1960):373–84, 39 illus.
Fresco cycle of Life of Virgin in apse of S. Francesco,
Gubbio. Dates ca. 1413. Discusses early career of artist.

1680 SCATASSA, ERCOLE. "Per Ottaviano Nelli di Gubbio." Rassegna
bibliografica dell'arte italiana 11, no. 11–12 (1908):205–6.
Publishes several documents concerning Nelli's activity
that were incorrectly reported by earlier writers.

NERI DI BICCI (1419–91)

Book

1681 NERI DI BICCI. Le ricordanze (10 Marzo 1453 – 24 April
1475). Edited by by Bruno Santi. Pisa: Marlin, 1976,
526 pp.
Transcription of lengthy account book of Florentine
painter. Entries annotated, works of art located when pos-
sible. Descriptive introduction, elaborate and useful index.
Review: Eve Borsook, Art Bulletin 61, no. 2 (1979):313–
313–18.

Articles

1682 BORENIUS, TANCRED. "Notes on Various Works of Art: A
Madonna by Neri di Bicci." Burlington Magazine 42, no. 239
(1923):92–97, 1 illus.
Publishes painting, Gore Collection. Dates late in art-
ist's career.

1683 COLASANTI, ARDUINO. "Opere d'arte ignote o poco note."
Bollettino d'arte 4, no. 5 (1910):184–92, 7 illus.
Includes attribution of Madonna and Saints, S. Sisto,
Viterbo, to Neri di Bicci.

1684 _____. "Un quadro di Neri di Bicci a Gubbio." Rivista
d'arte 2, no. 3–4 (1904):74–80, 2 illus.
Attributes Madonna, Pinacoteca, Gubbio. Influence of
Lippi.

1685 COMSTOCK, HELEN. "An Attribution to Neri di Bicci."
Connoisseur 110, no. 485 (1942):60–61, 1 illus.

Neri di Bicci

Attribution of <u>Madonna</u> <u>and</u> <u>Child</u> <u>with</u> <u>Angels</u> at Lilienfeld Galleries.

1686 LAGET, ELISABETH. "Contribution aux recherches sur les <u>Ricordanze</u> de Neri di Bicci: Un panneau de 1454 fragmenté au XXe siecle." <u>Annali</u> <u>della</u> <u>Scuola</u> <u>normale</u> <u>superiore</u> <u>di</u> <u>Pisa</u>, 3, no. 1 (1973):189–93, 2 illus.
 Joins lost fragments of <u>Madonna</u> <u>with</u> <u>Four</u> <u>Saints</u>, known primarily from photographs. Identifies with panel of 1454 mentioned in Neri's <u>Ricordanze</u>.

1687 MSERIANTZ, MARIA. "Two New Panels by Neri di Bicci." <u>Burlington</u> <u>Magazine</u> 62, no. 362 (1933):222–28, 4 illus.
 Attributes two panels of 1460s in State Museum of Fine Arts, Moscow: <u>Madonna</u> <u>della</u> <u>Cintola</u>, and earlier <u>Madonna</u> <u>with</u> <u>the</u> <u>Child</u> <u>holding</u> <u>a</u> <u>Pomegranate</u>.

1688 POGGI, G[IOVANNI]. "Le ricordanze di Neri di Bicci (1453–75)." <u>Il</u> <u>Vasari</u> 1 (1927–28):317–38; 3 (1930):133–53, 222–34; 4 (1931):189–202.
 Publication of entries from 1453 to 1456 from Neri's account book. Annotations.

1689 SANTI, BRUNO. "Dalle <u>Ricordanze</u> di Neri di Bicci." <u>Annali</u> <u>della</u> <u>Scuola</u> <u>normale</u> <u>superiore</u> <u>di</u> <u>Pisa</u> 3, no. 1 (1973):169–88, 10 illus.
 Attempts to reconstruct painter's career, with reference to the few surviving works.

1690 SKAUG, ERLING. "Neri di Bicci's <u>Madonna</u> <u>and</u> <u>Child</u> <u>Enthroned</u> <u>with</u> <u>Two</u> <u>Saints</u> <u>and</u> <u>Donor</u>, Uffizi Gallery, Florence. Materials, Technique and Restoration." <u>Acta</u> <u>ad</u> <u>archaeologiam</u> <u>et</u> <u>artium</u> <u>historiam</u> <u>pertinenta</u> 8 (1978):223–35, 14 illus.
 Account of restoration to panel painting completely submerged in flood of 1966. Analysis of materials. Diagrams, detailed photos.

1691 STECHOW, WOLFGANG. "Neri di Bicci: A Correction." <u>Allen</u> <u>Memorial</u> <u>Art</u> <u>Museum</u> <u>Bulletin</u> 19, no. 2 (1962):102.
 Accepts Cohn's provenance and dating of <u>St.</u> <u>James</u>, from SS. Annunziata, Florence, as in mid-1440s (entry 118).

1692 ZLAMALIK, VINKO. "Neri di Bicci u Staroj Galeriji" [Neri di Bicci in the Gallery of Zagreb]. <u>Bulletin:</u> <u>Institut</u> <u>za</u> <u>likovne</u> <u>umjetnosti.</u> <u>Jugoslavenske</u> <u>akademija</u> <u>Znanosti</u> <u>i</u> <u>umjetndsti</u> 7, no. 2 (1959):195–98, 2 illus.
 In Serbo-Croatian. Reviews works in Zagreb that have been attributed to Neri. Rejects two and accepts <u>Madonna</u>. English summary.

NICOLA DA BONIFAZIO (act. 1st half fifteenth century)

1693 CANUTI, FIORENZO. "Una famiglia di pittore senesi in Città
 della Pieve." La Diana 4, no. 3 (1929):227-38, 5 illus.
 Documents of 1412-54 regarding a family headed by Nicola
 da Bonifazio, who settled in Città della Pieve. Attributes
 Crucifixion. Draws family tree.

NICOLA D'ULISSE DA SIENA (act. 1451-70)

1694 CHELAZZI DINI, GIULIETTA. "Lorenzo Vecchietta, Priamo della
 Quercia, Nicola da Siena: Nuove osservazioni sulla Divina
 Commedia Yates Thompson 36." In Jacopo della Quercia fra
 Gotico e rinascimento. Edited by Giulietta Chelazzi Dini.
 Atti del Convegno di studi, 1975. Siena: Centro Di, 1977,
 pp. 203-28, 40 illus.
 Attributes manuscript in the British Library to Nicola
 d'Ulisse da Siena. Dates ca. 1438-47.

1695 MORINI, ADOLFO. "Gli affreschi di Nicola da Siena nel coro
 monastico di S. Antonio Abate in Cascia." Rassegna d'arte
 senese 6, no. 2-3 (1910):31-35, 4 illus.
 Publishes cycle of life of Christ, dated 1461, by an
 unknown Nicola da Siena, in S. Antonio Abate, Cascia. Dis-
 cusses retardataire style, imitating Duccio.

 TOSCANO, BRUNO. "Bartolomeo di Tommaso e Nicola da Siena."
 See entry 787.

NICOLA FIORENTINO. See DELLO DELLI

OLIVUCCIO DI CICCARELLO (ca. 1365-1438)

1696 GIANANDREA, A[NTONIO]. Olivuccio di Ciccarello: Pittore
 marchigiano del secolo XV." Nuova rivista misena 3, no. 12
 (1890):179-87. [Also published as separate booklet, with
 documents. Jesi: Tip. Niccola Pierdicchi, 1891, 19 pp.]
 Reconstructs life of artist.

ONOFRIO DA FABRIANO (act. 1463)

1697 MALAGUZZI-VALERI, F[RANCESCO]. "Un affresco di Onofrio da
 Fabriano." Cronache d'arte 3, no. 6 (1926):309-10, 1 illus.
 Attributes fresco of the ordination of a monk, documented
 1463, S. Michele in Bosco, Bologna.

Paolo da Visso

PAOLO DA VISSO (act. 1437-81)

1698 VITALINI SACCONI, GIUSEPPE. "Paolo da Visso. Proposte per
un catalogo." Commentari 23, no. 1-2 (1972):31-43, 15 illus.
Surveys works, dating 1430s through 1470s. Notes influ-
ence of Bartolommeo di Tommaso da Foligno and of Sienese.

1699 ZERI, FEDERICO. "Aggiunte a Paolo da Visso." In Diari di
lavoro, 2. Turin: Einaudi, 1976, pp. 51-54, 8 illus.
Various attributions. Emphasizes relationship to Sienese
artists.

PELLEGRINO DI GIOVANNI DI ANTONIO (act. 1425-37)

1700 CHRISTIANSEN, KEITH. "'Peregrinus' and Perugian Painting in
the Fifteenth Century." Burlington Magazine 123, no. 939
(1981):353-55, 3 illus.
Attributes St. Michael, Museum of Fine Arts, Boston.
Notes influence of Gentile.

1701 PARRONCHI, ALESSANDRO. "Peregrinus pinsit." Commentari 26,
no. 1-2 (1975):3-13, 11 illus.
Reconstruction of polyptych centered around Madonna,
Victoria and Albert Museum, London, signed and dated 1428.
Identifies artist as Perugian Pellegrino di Giovanni di Antonio.
Makes additional attributions to artist.

1702 RUSSELL, FRANCIS. "Two Italian Madonnas." Burlington
Magazine 120, no. 900 (1978):152-55, 2 illus.
Includes Madonna, Victoria and Albert Museum, London,
here given to Perugian Pellegrino di Antonio.

FRANCESCO PESELLINO (1422-57)

Book

1703 WEISBACH, WERNER. Francesco Pesellino und die Romantik der
Frührenaissance. Berlin: Bruno Cassirer, 1901, 133 pp., 54
illus.
Lavish monograph surveying Pesellino's work and his art
in terms of a "romantic" trend. Defines trend, surveys work,
discusses artist's style and development. Appendixes on in-
fluence, documents for Pistoia altar, and list of works. Index.

Articles

1704 BACCI, PELEO. "La Trinità del Pesellino della National
Gallery di Londra (nuovi documenti)." Rivista d'arte 2, no.
8-9 (1904):160-77, 1 illus.

Documents of 1455-66, concerning activities of Pesellino and of Lippi.

1705 BERENSON, BERNARD. "Alcuni disegni che si ricollegano alla Trinità del Pesellino." L'arte 35, no. 5 (1932):357-77, 12 illus.
Reattributes works given to Compagno di Pesellino to Pesellino and to others, including Lorenzo di Credi and Perugino. Also publishes two drawings attributed to Pesellino, connected with Trinity, National Gallery, London.

1706 _____. "Un Annunciazione del Pesellino." Rassegna d'arte 5, no. 3 (1905):42-43, 2 illus.
Publishes work, Parry Collection Highnam Court.

1707 _____. "A Miniature Altar-piece by Pesellino at Empoli." Revue archéologique 40, no. 1 (1902):191-95, 1 illus.
Attribution of small panel in gallery of Collegiata, Empoli. Placed earliest in artist's career.

1708 BOECK, W[ILHELM]. "Ein Frauenbildnis des Francesco Pesellino." Berliner Museen: Berichte aus den preussischen Kunstsammlungen 52, no. 1 (1931):7-10, 2 illus.
Attributes profile portrait to Pesellino. Rejects attribution to Lippi.

1709 BORENIUS, TANCRED. "Further Light on the Pesellino Altarpiece." Burlington Magazine 55, no. 318 (1929):145, 2 illus.
Publishes drawing after the figure of Saint Jerome in Pesellino's Trinity, National Gallery, London, which facilitates reconstruction of its original appearance by reproducing lost lower portion of the figure.

1710 _____. "The Pesellino Altarpiece." Burlington Magazine 54, no. 312 (1929):140-46, 5 illus.
Acquisition by National Gallery, London, of Sts. Zeno and Jerome, missing fragment of Pesellino's Trinity altarpiece. Predella remains in Warburg Collection, New York. Recommends insertion of modern reconstructed portion to complete main group.

1711 _____. "The Pesellino Altarpiece: A Postscript." Burlington Magazine 54, no. 314 (1929):223-24, 4 illus.
Publishes four panels of predella of Pesellino Trinity altarpiece, Warburg Collection, New York, which illustrate scenes from lives of Saints represented in main panel.

1712 _____. "A Pesellino Resurrected." Apollo 3, no. 18 (1926):327, 1 color illus.
Publishes Madonna and Child with Saints, Holford Collection, Dorchester, on occasion of removal of overpainting from background.

Francesco Pesellino

1713 CHIAPPELLI, ALESSANDRO. "Un nuovo documento sul Pesellino."
 Rivista d'arte 6, no. 5-6 (1909):314-19.
 Document of 1457 regarding London Trinity and contribu-
 tions of Pesellino, Lippi, and Piero di Lorenzo.

1714 CUST, LIONEL, and FRY, ROGER E. "Notes on Paintings in the
 Royal Collections. XIV: A Group of Two Saints, S. Giacomo
 and S. Mamante, Painted by Pesellino." Burlington Magazine
 16, no. 80 (1909):124-28, 1 illus.
 Reconstruction of Pesellino's Trinity altar and its his-
 tory. Includes summary of documents published by Peleo Bacci
 (entry 1704).

1715 GIGLIOLI, ODOARDO H. "Relazioni tra un quadretto attribuito
 a Pier Francesco Fiorentino e un disegno di Pesellino."
 Rivista d'arte 13 (1931):520-23, 2 illus.
 Composition of drawing by Pesellino, Uffizi, Florence, of
 Marriage of St. Catherine, seen to reappear in a painting of
 lesser quality at Sotheby's, London, wrongly attributed to Pier
 Francesco Fiorentino.

1716 [GOODWIN, BLAKE-MORE]. "Pesellino's Masterpiece." Museum
 News, Toledo Museum of Art 110 (December 1945):1-26, 16 b&w
 and 1 color illus.
 Publishes Madonna and Child with St. John, recently
 acquired. Compares to other works by Pesellino. Dates ca.
 1455. Bibliography.

1717 GRONAU, GIORGIO. "In margine a Francesco Pesellino."
 Rivista d'arte 20 (1938):123-46, 6 illus.
 Documents of 1450s published with corrections. Attrib-
 utes Trinity, National Gallery, London, mostly to Pesellino,
 with two figures on left and predella given to Lippi. Several
 other works also attributed to Pesellino.

1718 HENDY, PHILIP. "Pesellino." Burlington Magazine 53, no.
 305 (1928):67-74, 5 illus.
 Attempts to sort out works to be attributed to Pesellino,
 including some of those attributed by Mary Logan (Berenson) to
 Compagno di Pesellino (entry 183).

1719 HENNIKER-HEATON, RAYMOND. "A Predella by Pesellino."
 Burlington Magazine 49, no. 283 (1926):155-61, 5 illus.
 Three panels, Palazzo Doria, Rome, and Museum of Art,
 Worcester, illuminating life of Saint Sylvester, seen to form a
 predella.

1720 LONGHI, ROBERTO. "F. Pesellino, B. Zaganelli, 'Maestro
 Esiguo.'" Vita artistica 2, no. 4 (1927):65-69, 3 illus.
 Attributions of various works in Museum Chambéry, includ-
 ing a profile portrait and a triptych with Pietà attributed to
 Pesellino, ca. 1440-45.

1721 MACKOWSKY, HANS. "The Masters of the 'Pesellino Trinity.'"
Burlington Magazine 57, no. 332 (1930):212-23, 5 illus.
Distinguishes hands of Filippo Lippi, Fra Diamante, and
Piero di Lorenzo (Compagno di Pesellino) in altar, National
Gallery, London. Associates additional works with Piero di
Lorenzo.

1722 _____. "Die Verkündigung und die Verlobung der heiligen
Katharina von Francesco Pesellino." Zeitschrift für
bildende Kunst 10 (1898/99):81-85, 4 illus.
Reviews literature and attributions to artist. Adds
Annunciation, Museo Poldi Pezzoli, Milan, and drawings of Mar-
riage of St. Catherine, Uffizi, Florence.

1723 PERKINS, F. MASON. "La tavola complementare della predella
del Pesellino nella Galleria Doria." L'arte 19 (1916):70-
71, 3 illus.
Associates predella panels with scenes from life of Saint
Sylvester, Galleria Doria, Rome, with one in Gentner Collection
(now Museum of Art, Worcester). All attributed to Pesellino.

1724 S., E.S. "The Miracle of Saint Silvester." Bulletin of the
Worcester Art Museum 17, no. 1 (1926):3-15, 6 illus.
Discusses predella panel of Miracle of St. Sylvester, by
Pesellino. Dates ca. 1440. Includes extract of life of Saint
Sylvester from Golden Legend.

1725 SCHARF, ALFRED. "Zur Kunst des Francesco Pesellino."
Pantheon 14 (July 1934):211-20, 12 illus.
Overview of artist, with discussion especially of
Trinity, National Gallery, London, and of various influences.
English summary.

1726 SCHLEGEL, URSULA. "Ein Madonnenbild des Francesco Pesellino
in der Landesgalerie Hannover." Niederdeutsche Beiträge zur
Kunstgeschichte 2 (1962):172-78, 6 illus.
Rejects attribution of work to Lippi. Attributes to
Pesellino, ca. 1450.

1727 TOESCA, PIETRO. "Francesco Pesellino miniatore." Dedalo
12, no. 2 (1932):85-91, 6 illus.
Attribution of Mars page from Silio Italico, Biblioteca
Marciana, Venice. Dates between 1447-55.

1728 VENTURI, ADOLFO. "Quadretti ignoti del Pesellino nella
galleria di Le Mans." L'arte 27 (1924):1-3, 2 illus.
Publishes two predella panels, Death of Absalom and the
Last Days of David.

1729 WEISBACH, WERNER. "Studien zu Pesellino und Botticelli."
Jahrbuch der preussischen Kunstsammlungen 29 (1908):1-19, 6
illus.

Francesco Pesellino

 Publishes <u>Crucifixion</u>, Kaiser–Friedrich Museum, Berlin,
which places early. Also discusses authorship of London <u>Trinity</u>
in light of new documents.

<u>PIERO DELLA FRANCESCA</u> (ca. 1420–92)

<u>Books</u> <u>and</u> <u>Dissertations</u>

1730 ALAZARD, JEAN. <u>Piero della Francesca</u>. Paris: Librairie
 Plon, 1948, 60 pp., 30 illus.
 Rather brief overview of life and works. Concludes with
comments on general characteristics of his art and its influence.
Bibliographical note.

1731 BATTISTI, EUGENIO. <u>Piero della Francesca</u>. 2 vols. Milan:
 Istituto editoriale italiano, 1971, 776 pp., 521 b&w and 50
 color illus.
 Lengthy modern monograph covering all aspects of Piero's
art. First volume discusses his career in its various phases,
with numerous illustrations, including details and diagrams.
Second volume includes catalog of works, comparative figures,
sources and documents, complete chronological bibliography, and
indexes.
 Review: Corrado Verga, <u>Arte lombarda</u> 17, no. 37
(1972):161–64.

1732 BERENSON, BERNARD. <u>Piero della Francesca or the Ineloquent</u>
 <u>in Art</u>. New York: Macmillan, 1954, 44 pp., 48 illus.
 [Italian ed. <u>Piero della Francesca o dell'arte non eloquente</u>
 (Florence: Electa, 1950).]
 Investigates reasons for upsurge of interest in Piero in
preceding twenty-five years. Compares to other artists with
and without similar "ineloquent" (mute and inexpressive)
qualities.

1733 BIANCONI, PIERO. <u>All the Paintings of Piero della</u>
 <u>Francesca</u>. Translated by Paul Colacicchi. Complete Library
 of World Art, 5. New York: Hawthorn Books, 1962, 81 pp.,
 182 illus. [Italian ed. <u>Tutta la pittura di Piero della</u>
 <u>Francesca</u> (Milan: Rizzoli, 1962.]
 Condensed reference book. Includes survey of artist's
life and work, brief section on theoretical treatises, and
chronology. Catalog, with comments. List of lost and attrib-
uted works, geographical list; section of excerpts from crit-
ical writings; and brief bibliography.

1734 BORRA, POMPEO. <u>Piero della Francesca</u>. Milan: Istituto
 editoriale italiano, 1950, 71 pp., 108 b&w and 29 color
 illus.

Analyzes Piero's style for its independent validity, not in relation to period. Describes form of each work. Biographical summary at end. Plates include many details. Text in French and English.

1735 BUSIGNANI, ALBERTO. Piero della Francesca. Translated by Pearl Sanders. New York: Grosset & Dunlap, 1968, 39 pp., 7 b&w and 80 color illus. [Italian ed. Florence: Sadea, 1976.]
Text includes section on life and works. Discusses influences and character of his art. Bibliography. Brief notes on the plates.

1736 CLARK, KENNETH. Piero della Francesca. 2d ed. London and New York: Phaidon, 1969, 239 pp., 210 b&w and 7 color illus.
Lengthy introductory essay covering all aspects of Piero's career and art, notes on plates. Comparative material.
Review: Giles Robertson, Art Quarterly 34, no. 3 (1971):356-58.

1737 DAVIS, MARGARET DALY. "Piero della Francesca: A Study of His Tratto d'Abaco and Libellus de quinque Corporibus Regularibus." Ph.D. dissertation, University of North Carolina, 1976, 216 pp., 85 illus.
Studies Piero's two treatises in context of mathematical studies in Renaissance. Considers sources, relation to Piero's De prospectiva pingendi and to writings of Pacioli. Traces dissemination of Piero's ideas.

1738 _____. Piero della Francesca's Mathematical Treatises: The "Tratto d'Abaco" and "Libellus de quinque corporibus Regularibus." Ravenna: Longo editore, 1977, 181 pp., 36 illus.
Study of Piero's purely mathematical works and their influence on theory and practice of art. Traces sources of works and their relation to treatise on perspective. Italian summary.

1739 DE VECCHI, PIER LUIGI. The Complete Paintings of Piero della Francesca. Introduction by Peter Murray. Classics of the World's Great Art, 9. New York: Harry N. Abrams, 1970, 112 pp., 110 b&w and 64 color illus. [Italian ed. Milan: Rizzoli, 1967, with introduction by Oreste del Buono.]
Outline of artist's critical history, bibliography, and brief biography. Detailed catalog of works. Indexes to subjects, titles, and topography. Appendix on drawings and writings.

1740 EVELYN [E. MARINI-FRANCESCHI]. Piero della Francesca: Monarca della pittura ai suoi di. Città di Castello: S. Lapi, 1912, 180 pp., 11 illus.

Piero della Francesca

Monograph divided into two parts: the first discusses historical background, Piero's genealogy, and the development of his career in various cultural settings, ending with chapters on his writing, his influence, and his personality. The second part deals with aspects of his art (such as landscape) and several major works.

1741 FOCILLON, HENRI. <u>Piero</u> <u>della</u> <u>Francesca</u>. Paris: Armand Colin, 1952, 190 pp., 80 illus.
Monograph dealing with issues and problems as much as works. Includes discussions of such topics as perspective and Alberti. Discusses relation to Fouquet. Also includes survey of critical opinions, brief bibliography, and text of Vasari's life of Piero.
Review: André Chastel, <u>Critique</u> 8 (1952):320-30.

1742 FORMAGGIO, DINO. <u>Piero</u> <u>della</u> <u>Francesca</u>. Milan and Verona: Mondadori, 1957, 202 pp., 138 illus.
Discusses perspective in context of quattrocento art. Piero's biography and works reviewed in relation to culture. Brief bibliography.

1743 GILBERT, CREIGHTON. <u>Change</u> <u>in</u> <u>Piero</u> <u>della</u> <u>Francesca</u>. Locust Valley, N.Y.: J.J. Augustin, for the Institute for Fine Arts, New York University, 1968, 130 pp., 52 illus.
Investigates artist's work with special attention to chronology and to changes in his style. Lists works in tentative order. Discusses critical approaches, artist's work habits, and stylistic variations and phases.
Review: Giles Robertson, <u>Art</u> <u>Quarterly</u> 34, no. 3 (1971):356-58.

1744 GINZBURG, CARLO. <u>Indagini</u> <u>su</u> <u>Piero</u>. Turin: Einaudi, 1981, 134 pp., 94 b&w and 1 color illus.
Studies Piero's <u>Baptism</u>, National Gallery, London, the fresco cycle in S. Francesco, Arezzo, and the <u>Flagellation</u>, Palazzo Ducale, Urbino. Emphasis on historical circumstances and patrons to interpret iconography.
Review: Eve Borsook, <u>Burlington</u> <u>Magazine</u> 125, no. 960 (1983):163-65.

1745 GRABER, HANS. <u>Piero</u> <u>della</u> <u>Francesca</u>. Basil: Benno Schwabe & Co., 1922, 43 pp., 68 illus.
Brief review of life, work (notes on plates), and style.

1746 HENDY, PHILIP. <u>Piero</u> <u>della</u> <u>Francesca</u> <u>and</u> <u>the</u> <u>Early</u> <u>Renais</u>-<u>sance</u>. New York: Macmillan, 1968, 248 pp., 67 b&w and 34 color illus.
An investigation, intended for the general reader, of artist's place in development of Renaissance, emphasizing his relation to other artists and schools.

Review: Cecil H. Cough, Apollo 91, no. 98 (1970):278-89, 10 illus.

1747 LAVIN, MARILYN ARONBERG. Piero della Francesca: The Flagellation. Art in Context. London: Allen Lane, Penguin Press; New York: Viking, 1972, 109 pp., 58 illus.
Analysis of sources and content of work. Interprets composition as representing a consalotory theme, with scene separated into background area relating to mystical and eternal realm of Flagellation and foreground setting with contemporary figures.
Review: Bruce Cole, Burlington Magazine 115, no. 848 (1973):749-50.

1748 ____. Piero della Francesca's "Baptism of Christ." Yale Publications in the History of Art, 29. New Haven and London: Yale University Press, 1981, 202 pp., 64 b&w and 1 color illus.
Analyzes work in terms of "naturalistic geometry" and "iconic narrative," as elements expressing liturgy of 6 January. Discusses setting, figure groups, liturgical and exegetical interpretations, and history of altarpiece. Redates to late 1450s or 1460s. Appendix by B.A.R. Carter on geometric structure, mathematical interpretation. Bibliography, index.
Review: Gail L. Geiger, Burlington Magazine 125, no. 962 (1983):301.

1749 LONGHI, ROBERTO. Piero della Francesca. Translated by Leonard Penlock. London and New York: Frederick Warne & Co., 1930, 176 pp., 184 illus. [Italian ed. Rome: Valori Plastici, 1927.]
Translation of most of first edition of definitive monograph. Reviews career. Gives biographical notice, bibliography, list of works ascribed, list of lost works, brief notes on the plates.

1750 ____. Piero della Francesca (1927), con aggiunte fino al 1962. 3d ed. Florence: Sansoni, 1963, 269 pp., 236 b&w and 22 color illus. Reprint. 1975.
Includes full text of original monograph of 1927 (entry 1749) plus preface to edtion of 1942 and new preface. Adds essay on Piero in Arezzo, new notes, bibliography, and critical history. Various indexes.

1751 PICHI, GIOVANNI FELICE. La vita e le opere di Piero della Francesca. Preface by Vincenzo Funghini. Sansepolcro: Tip. Becamorti & Boncompagni, 1892, 207 pp.
Lengthy first part surveys Piero's career chronologically. Second part considers his followers and descendants, and his writings. Sees artist as representative of scuola pura scientifica.

Piero della Francesca

1752 PIERO DELLA FRANCESCA. De prospectiva pingendi. Edited by
 G. Nicco Fasola. Florence: Sansoni, 1942, 218 pp., 80
 illus.
 Definitive edition of Italian manuscript, in Palatinate
 Library, Parma, of treatise on uses of perspective for paint-
 ers. Introductory chapters concern perspective in the art and
 criticism of the Renaissance, and aspects of Piero's writing.

1753 ____. De prospectiva pingendi. Edited by C. Winterberg.
 2 vols. Strassburg: Heitz, 1899, 268 pp., 81 illus.
 Definitive edition of Latin text of Piero's treatise in
 Ambrosiana, Milan, with German translation. Introductory
 essay.
 Review: G. Fogolari, L'arte 12 (1909):129-31.

1754 ____. Tratti d'abaco. Edited by by Gino Arrighi. Pisa:
 Domus Galileana, 1970, 270 pp.
 Publishes manuscript of Piero's mathematical treatise
 with critical history and review of contents. Many diagrams.
 See entries 1737 and 1738.

1755 SALMI, MARIO. Piero della Francesca e il Palazzo Ducale di
 Urbino. Florence: Le Monnier, 1945, 143 pp., 75 illus.
 Argues for Piero's influence on Laurana's design of
 Palazzo Ducale. Describes relation to Alberti. Index.
 Review: Ulrich Middeldorf, Art Bulletin 29, no. 2
 (1947):141-43.

1756 ____. La pittura di Piero della Francesca. Novara:
 Istituto geografico De Agostini, 1979, 224 pp., 230 b&w and
 56 color illus.
 Lavishly illustrated monograph with many details and
 diagrams. Opening chapter on various facts and hypotheses
 about artist's life and activity; survey of works. Discussion
 of his spirituality. Much supportive material including bio-
 graphical data, chronology of lost and surviving works, and
 bibliography. Appendixes on architecture, treatises, and the
 Bacci family of Arezzo.
 Review: Roberto Salvini, Zeitschrift für Kunstgeschichte
 43, no. 4 (1980):426-29.

1757 SCHNEIDER, LAURIE MARIE. "The Iconography of Piero della
 Francesca's Frescoes Dealing with the Story of the True
 Cross in the Church of San Francesco in Arezzo." Ph.D.
 dissertation, Columbia University, 1967, 221 pp., 96 illus.
 Iconographic analysis of cycle on historical, liturgical,
 and typological levels. Studies precedents in Agnolo Gaddi,
 Cenni, and Masolino. Bibliography.

1758 SIEBENHÜNER, HERBERT. "Über den kolorismus der
 Frührenaissance: Vornehmlich dargestellt an dem 'trattato
 della pittura' des L.B. Alberti und an einem werke des Piero

della Francesca." Ph.D. dissertation, University of
Leipzig, 1935, 70 pp.
Includes structural analysis of Piero's St. Jerome. Dis-
cusses Alberti's ideas on color in spatial setups in painting.
Analyzes color of St. Jerome.

1759 VENTURI, ADOLFO. Piero della Francesca. Florence:
Alinari, 1922, 85 pp., 72 illus.
Fairly general survey of life and works. Chronology.
Lists of works, collaborative and school works, and lost works.

1760 VENTURI, LIONELLO. Piero della Francesca. Translated by
James Emmons. The Taste of Our Time, 6. Geneva: Skira,
1954, 127 pp., 3 b&w and 54 color illus.
General survey of Piero's life, style, and works. Select
bibliography. Index of names with biographical notes.

1761 WATERS, W.G. Piero della Francesca. London: George Bell &
Sons, 1901, 146 pp., 38 illus.
Early, rather general monograph, including chronological
table, brief biography, and examination of works. Chapters on
artist's writings and on his influence. Catalog of works,
arranged geographically, index.

1762 WITTING, FELIX. Piero dei Franceschi: Eine kunsthistorische
Studie. Strassburg: Heitz, 1898, 196 pp., 15 illus.
First critical monograph on artist, reviewing sources and
analyzing works chronologically. Concluding essays discuss
influence and nature of his art.
Review: W. Weisbach, Repertorium für Kunstwissenschaft
22 (1899):72-77.

Articles and Booklets

*1763 AGNOLETTI, ERCOLE. La Madonna della Misericordia e il
Battesimo di Cristo di Piero della Francesca. Sansepolcro,
1977, 47 pp.
Source: Répertoire d'art et d'archéologie (1981).

1764 ALPATOV, MICHAEL. "Les fresques de Piero della Francesca a
Arezzo: Sémantique et stilistique." Commentari 14, no. 1
(1963):17-38, 18 illus.
Study of order of scenes in True Cross cycle, S.
Francesco, Arezzo. Finds correspondences within them, and
various layers of meaning beyond the narrative. Sees their
style as echoing iconography.

1765 ABORE POPESCU, G., and GHEORGHE, M. "Classification dans
l'oeuvre de Piero della Francesca." In First International
Conference on Automatic Processing of Art History Data and
Documents. Vol. 2. Florence, Villa I Tatti and Pisa,

Artists

Piero della Francesca

Scuola normale superiore. Pisa: Scuola normale superiore, 1979, pp. 289-315.
Experiment in classifying works of art by assigning values to certain characteristics: execution, technique, support (panel, wall, canons), location, and data (signature, date, completedness). Includes charts, numerical formulas, and methods of comparison.

1766 ARRIGHI, GINO. "Arte e matematica in Piero della Francesca." Commentari 27, no. 3-4 (1976):248-51.
Discusses mathematical writings, especially Trattato d'abaco. Examines consequences of Piero's mathematical knowledge on his works of art, in terms of their formal order.

1767 _____. "Attorno a una denuncia vasariana di plagio." In Vasari storiografico e artista. Atti del Congresso internazionale nel IV centenario della morte, 1974. Florence: Istituto nazionale di studi sul rinascimento, 1976, pp. 479-83.
Asserts truth of Vasari's claim that Pacioli plagiarized Piero's Trattato d'abaco.

1768 _____. "Piero della Francesca e Luca Pacioli: Rassegna della questione del 'plagio' e nuova valutazioni." Atti della Fondazione Giorgio Ronchi 23, no. 5 (1968):613-25.
Reviews question of Pacioli's borrowings from Piero, summarizing earlier opinions.

1769 _____. "Piero della Francesca matematico." Atti e memorie della Accademia Petrarca 39 (1968-69):144-51.
Discusses De prospectiva pingendi and De corporibus regularibus.

1770 AUBERT, ANDREAS. "Bemerkungen über das Altarwerk des Piero dei Franceschi in Perugia." Zeitschrift für bildende Kunst 10 (1898-99):263-66, 2 illus.
Reconstructs altarpiece from Perugia. Rejects Witting's hypothesis that Annunciation later in date (entry 1762).

1771 BAROLSKY, PAUL. "Piero's Native Wit." Source: Notes in the History of Art 1, no. 2 (1982):21-22, 2 illus.
Points out that braying ass in Piero's Nativity, National Gallery, London, forms a trio with two singing angels.

1772 BATTISTI, EUGENIO. "Bramante, Piero e Pacioli ad Urbino." In Studi bramanteschi. Atti del Congresso internazionale, 1970. Rome: DeLuca, 1974, pp. 267-82, 22 illus.
Proposes collaboration of Bramante in design of architectural background of altarpiece, Brera, Milan. Also suggests relationship to ideas of Pacioli. Discusses other aspects of painting, including original placement. Diagrams. Documents.

1773 BECK, JAMES. "Una data per Piero della Francesca."
 Prospettiva 15 (October 1978):53.
 Rereads a document regarding Misericordia altarpiece,
 Pinacoteca, Sansepolcro, indicating that was close to finished
 by 1455 rather than 1454.

1774 BODE, WILHELM VON. "Der Hl. Hieronymus in hügliger
 Landschaft von Piero della Francesca." Jahrbuch der
 preussischen Kunstsammlungen 45 (1924):201-5, 4 illus.
 Attribution of painting, as early work.

1775 BOMBE, WALTER. "Zur Genesis des Auferstehungsfreskos von
 Piero della Francesca im Stadthause zu Sansepolcro."
 Repertorium für Kunstwissenschaft 32 (1909):331-32.
 Publishes document on Resurrection, Pinacoteca,
 Sansepolcro, regarding commission and function as a civic
 emblem.

1776 BORGO, LUDOVICO. "New Questions for Piero's Flagellation."
 Burlington Magazine 121, no. 918 (1979):547-53, 11 b&w and 1
 color illus.
 Identifies foreground figures as members of the Sanhedrin.
 Letters: Marilyn Aronberg Lavin, Burlington Magazine
 121, no. 921 (1979):801, and Cecil H. Clough, Burlington
 Magazine 122, no. 929 (1980):574-75.

1777 BOTTARI, STEFANO. "Piero della Francesca." In Encyclopedia
 of World Art. Vol. 11. London: McGraw Hill, 1966, col.
 342-55, 7 b&w and 4 color illus.
 Surveys artist's work, career, and writings. Reviews
 critical literature. Bibliography.

1778 BRANDI, CESARE. "Restauri a Piero della Francesca."
 Bollettino d'arte 39, no. 3 (1954):241-58, 38 illus.
 Account of restorations on Flagellation and Madonna di
 Senigallia in Palazzo Ducale, Urbino, and polyptych, National
 Gallery, Perugia. Many photographs of details and work in
 progress.

1779 BRISSON, DAVID W. "Piero della Francesca's Egg Again." Art
 Bulletin 62, no. 2 (1980):284-86, 3 illus.
 Uses biologist's classification to demonstrate that
 chicken's egg was used as a model for the egg in the altar-
 piece, Brera, Milan.

1780 BROCONE, RUTH B. WARNER. "An Analysis of the Perspective in
 Piero della Francesca's Flagellation." Oakland Review 1
 (1968):37-50, 15 illus.
 Examines Carter and Wittkower's analysis of painting in
 Palazzo Ducale, Urbino (entry 1903), finding several discrepan-
 cies. Postulates that plan was subjected to a double fore-
 shortening. Finds various ratios and dimensions corresponding
 to theories of harmonious proportions.

Piero della Francesca

1781 CALVESI, MAURIZIO. "Sistema degli equivalenti ed equivalenze
 del sistema in Piero della Francesca." Storia dell'arte 24-
 25 (May-December 1975):83-110.
 Wide-ranging essay concerning theoretical and iconolog-
 ical significance of character of Piero's works. Issues of
 perspective, symmetry, and proportions. Relates to various
 philosophical approaches. Discusses individual works.

1782 CARLI, ENZO. "Visto da vicino: La pala di Piero della
 Francesca nella Pinacoteca di Brera." Emporium 88, no. 527
 (1938):238-56, 17 illus.
 Brief introduction to corpus of photographs of altar.
 Many details.

1783 CASALINI, FERNANDO. "Corrispondenze fra teoria e pratica
 nell'opera di Piero della Francesca." L'arte 2 (1968):62-
 95, 26 illus.
 Investigates relationship between theory in De
 prospettiva pingendi and the perspective treatment of Piero's
 paintings, using both geometric and architectural processes.
 Diagrams.

1784 CASARA, GIUSEPPINO. "Piero della Francesca e i fondamenti
 geometrici." Atti e memorie della Accademia Petrarca 32
 (1942-44).
 Studies ideas of De prospettiva pingendi in relation to
 earlier treatises on subject and as revealed in Piero's paint-
 ings. Sees geometric qualities as foundation for harmony in
 works.
 Review: Palma Viardo, Emporium 106, no. 633-34
 (1947):99-100.

1785 CINQUINI, ADOLFO. "Piero della Francesca a Urbino e i
 ritratti degli Uffizi." L'arte 9 (1906):56.
 Dates Urbino diptych, Uffizi, Florence, between 1461 and
 1465 on basis of poetic composition by Ferabò that establishes
 existence of works before 1466.

1786 CLARK, KENNETH. "Piero della Francesca's St. Augustine
 Altarpiece." Burlington Magazine 89, no. 533 (1947):20-29,
 9 illus.
 Identifies panel of St. Augustine, Museum of Antique Art,
 Lisbon, as one of lateral Saints of S. Agostino altarpiece.
 Sees hand of assistant in some areas.
 Letters: Roberto Longhi and Millard Meiss, Burlington
 Magazine 89, no. 535 (1947):285-86.

1787 CLOUGH, C[ECIL] H[OLDSWORTH]. "Federigo da Montefeltro's
 Artistic Patronage." Journal of the Royal Society of Arts
 126, no. 5268 (1978):718-34, 14 illus.
 Includes discussion of framing and classical sources of
 portrait diptych, Uffizi, Florence, and of original location in

Audience Room, Palazzo Ducale, Urbino, of portraits and
Flagellation.

1788 COCKE, RICHARD. "Piero della Francesca and the Development
of Italian Lancscape Painting." Burlington Magazine 122, no.
930 (1980):627-31, 4 illus.
 Piero's interest in Flemish landscape, seen particularly
in the recently cleaned St. Jerome, Berlin, and its influence.
Attention to works by Domenico Veneziano and Jan van Eyck.

1789 CONTI, ALESSANDRO. "Francesco Petrarca e Madonna Laura:
Uno strano ritratto." Prospettiva 5 (April 1976):57-61, 7
illus.
 Traces historical fortunes of Piero's diptych, Uffizi,
Florence, reviewing changes of title, location, and attribution.

1790 CRISTIANI TESTI, MARIA LAURA. "La conoscenza dell'arte con
gli strumenti elettronici." Critica d'arte 43, no. 160-62
(1978):14-25, 32 illus.
 Presents methods for studying art with computers. Among
other examples, examines Piero's Flagellation as studied by
T. Sanobini Leoni.

1791 D'ANCONA, PAOLO. Piero della Francesca: Il ciclo affrescato
della Santa Croce nella chiesa di S. Francesco in Arezzo.
2d ed. Milan: Silvana, 1980, 33 pp., 7 b&w and 27 color
illus.
 Brief introductory essay in Italian, French, English, and
German, to color plates. Sections on career and style and then
on this cycle.

1792 DAVIES, ELTON M., and SNYDER, DEAN. "Piero della Francesca's
Madonna of Urbino: A Further Examination." Gazette des
beaux arts 75, no. 1215 (1970):193-210, 11 illus.
 Surveys historical context of altarpiece, and dates ca.
1472-74. Examines "quantitative aspects," including human
proportions, perspective, and divisions of the picture plane,
as well as aesthetic impact. Identifies portraits of infant
Guidobaldo, Fra Pacioli, and self-portrait. Diagrams,
bibliography.

1793 DAVIES, MARTIN. "Some Notes on Piero della Francesca's St.
Michael." Burlington Magazine 109, no. 766 (1967):28-31, 2
illus.
 Panel recently cleaned. Suggests flanked scenes of Coro-
nation of Virgin. Photos include detail.

1794 DEL VITA, ALESSANDRO. "La battaglia di Anghiari rappresentata
da Piero della Francesca?" Vasari 17, no. 2-3 (1959):
106-11.
 Battle scenes in Piero's True Cross cycle, S. Francesco,
Arezzo, seen as also recalling the battle at Anghiari, 1440.

Piero della Francesca

1795 _____. "Notizie sulla famiglia e sulla madre di Pier della
Francesca." Vasari 5, no. 1-2 (1932):57-79.
Republishes, with additional notes and comments, informa-
tion regarding family of Piero, which appeared in 1916 (entry
1796). Also reprints article by Girolamo Mancini from
Bollettino d'arte, 1918 (entry 1839), with comments by editors
and Del Vita's final reply.

1796 _____. "Notizie sulla famiglia e sulla madre di Pier della
Francesca." Bollettino d'arte 10, no. 9-10 (1916):273-75.
Documents from Comune di Arezzo regarding painters' rela-
tives. Believes name should be della Francesca, after his
mother, not dei Franceschi.

1797 _____. "Il volto di Pier della Francesca." Rassegna d'arte
antica e moderna 7 (1920):109-12, 5 illus.
Suggests possible self-portrait of Piero in various of
his works, including Misericordia Madonna, and Resurrection in
Pinacoteca, Sansepolcro, and Visit of Sheba, S. Francesco,
Arezzo.

1798 EGMOND, WARREN VON. "A Second Manuscript of Piero della
Francesca's Trattato d'Abaco." Manuscripta 24, no. 3
(1980):155-63.
Identifies manuscript in Biblioteca Nazionale, Florence,
as a late fifteenth-century copy of Piero's treatise, much
abbreviated and altered.

1799 EVELYN [E. MARINI-FRANCESCHI]. "Alcune notizie inedite su
Piero della Francesca." L'arte 16 (1913):471-73.
Publishes documents from Sansepolcro, indicating work
done there at various times. Also some documents regarding
Maestro Antonio di Anghiari, contemporary of Piero, working in
Sansepolcro, who may have influenced him.

1800 FEUDALE, CAROLINE. "Iconography of the Madonna de Parto."
Marsyas 7 (1954-57):8-24, 12 illus.
Discussion of theme, revived in fresco attributed to
Piero, Cappella del Cimitero, Monterchi, which combines several
philosophical ideas to represent "bodily and spiritual glorifi-
cation." Investigates doctrinal tradition of concept.

1801 FUNGHINI, L.V. "Scoperta d'un pregevole dipinto a
Monterchi." Arte e storia 8, no. 3 (1889):23.
Announces discovery of Piero della Francesca's fresco of
Madonna del Parto, Cappella del Cimitero.

1802 GILBERT, CREIGHTON. "'The Egg Reopened' Again." Art
Bulletin 56, no. 2 (1974):252-58.
Refutes view that egg in Piero's altarpiece, Brera,
Milan, is an ostrich's. Suggests interpretation as Leda's egg,
symbolic of divine birth.

Letter: Millard Meiss, Art Bulletin 57, no. 1
(1975):116.

1803 _____. "New Evidence for the Date of Piero della Francesca's
Count and Countess of Urbino." Marsyas 1 (1941):41-53, 2
illus.
Dates portrait, Uffizi, Florence, after the death of the
Countess in 1472, based partly on inscription that refers to
her in past tense. Appendix regarding poem by Ferabo, which
believes does not correspond to portrait. See entry 217.

1804 _____. "On Subject and Not-Subject in Italian Renaissance
Pictures." Art Bulletin 34, no. 3 (1952):202-16, 12 illus.
Seeks to establish existence of some works without sym-
bolic context. Includes discussion of Piero's Flagellation, in
which three foreground figures are seen as bystanders with no
further identity. Contrasts to the unique symbolic features of
church setting and egg in the altarpiece, Brera, Milan.
Letters: Paul D. Running, Art Bulletin 35, no. 1
(1953):85-86, and Mirella Levi d'Ancona, Art Bulletin 35, no. 4
(1953):329-30.

1805 _____. "Piero della Francesca's Flagellation: The Figures
in the Foreground." Art Bulletin 53, no. 1 (1971):41-51, 5
illus.
Interprets group, according to lost inscription, as rep-
resenting Jews and Gentiles who gathered together with Pilate
and Herod.
Letter: Marilyn Aronberg Lavin, Art Bulletin 53, no. 3
(1971):283-84.

*1806 GIORNI, BRUNO. La Madonna del parto di "Piero della
Francesca" e la chiesa di Momentana. Sansepolcro, 1977,
56 pp.
Source: Répertoire d'art et d'archéologie (1981).

1807 GIOSEFFI, DECIO. "Introduzione all'arte, introduzione a
Piero (Piero della Francesca 1974)." Art in Friuli, arte a
Trieste 4 (1980):9-28, 4 illus.
Semiological discussion, noting degree to which Piero's
art is not understood.

1808 GIUNTI, LUIGI. "Piero della Francesca dal Borgo San
Sepolcro: Saggio critico." Arte e storia 6, no. 27
(1887):205-7; no. 28 (1887):214-16; no. 29 (1887):222-23.
Reviews critical attitudes to Piero, including those of
Vasari and Lanzi (entries 17 and 148). Extols his historical
importance as artist and theorist. Considers qustion of
Pacioli's plagiarism.
Letter: Augusto Vernarecci, Arte e storia 6, no. 30
(1887):229-30.

Piero della Francesca

1809 GNOLI, UMBERTO. "Una tavola sconosciuta di Piero della
 Francesca." Dedalo 11, no. 1 (1930-31):133, 1 illus.
 Publishes Madonna with Angels, in private collection, and
 attributes to Piero, ca. 1470.

1810 GOLDNER, GEORGE. "Notes on the Iconography of Piero della
 Francesca's Annunciation in Arezzo." Art Bulletin 56, no. 3
 (1974):342-44, 2 illus.
 Ties meaning of Annunciation to scene of Jew Drawn from
 Well thereby integrating into cycle, S. Francesco, Arezzo.
 Note on possible relationship between Dream of Constantine and
 Burial of the Wood.
 Letters: Mark J. Zucker and Keith Christiansen, Art
 Bulletin 57, no. 2 (1975):303-5.

1811 GOMBRICH, E[RNST] H. "The Repentance of Judas in Piero
 della Francesca's Flagellation of Christ." Journal of the
 Warburg and Courtauld Institutes 22 (1959):172, 2 illus.
 Reiterates idea that bystanders in painting, Palazzo
 Ducale, Urbino, may represent Judas throwing money at the
 elders. Theory reinforced by drawing of similar grouping in
 Albertina, Vienna, attributed to Tura circle.

1812 GORE, FREDERICK. Frederick Gore on Piero della Francesca's
 "The Baptism." Edited by by Carel Wright. Painters on
 Painting. London: Cassell, 1969, 32 pp., 32 b&w and 1
 color illus.
 Description of Piero's work written by a twentieth-
 century painter. Considers scientific naturalism of style,
 sources, particularly in Byzantine art, and Platonic influ-
 ences. Sees as resolution of thesis/antithesis of scientific
 naturalism and Christianity.

1813 GOUMA-PETERSON, THALIA. "Piero della Francesca's Flagella-
 tion: An Historical Interpretation." Storia dell'arte 28
 (September-December 1976):217-33, 21 illus.
 Postulates that theme of painting refers to specific
 events that occurred after the fall of Constantine. Identifies
 Pilate as portrait of John Paleologus and three foreground
 figures as Greek ambassador, Western prince, and Christian
 athlete of virtue. Sees influence of Cardinal Bessarion's
 ideas attempting to engage Federico in a crusade.

1814 GRIGIONI, CARLO. "Un soggiorno ignorato di Piero della
 Francesca in Rimini." Rassegna bibliografica dell'arte
 italiana 12, no. 7-9 (1909):118-21.
 Publishes document establishing Piero's presence in
 Rimini in 1482. No known works connected to this trip.

1815 GRONAU, GEORG. "Piero della Francesca (c. 1416-1492)." Old
 Master Drawings 4, no. 16 (1930):58-60, 3 illus.

Piero della Francesca

Attribution of study for a figure of David, National
Museum, Stockholm, originally from Vasari's collection.

1816 _____. "Piero della Francesca oder Piero dei Franceschi?"
Repertorium für Kunstwissenschaft 23 (1900):392–94.
 Traces variations in references to artist in fifteenth
and sixteenth centuries. Documents of mid-fifteenth century.

*1817 GUZZO, A. "La 'sublime metrica' di Piero della Francesca e
la 'divina proporzione.'" Atti e memorie della Accademia
Petrarca 40 (1970–72):55–82.
 Source: Répertoire d'art et d'archéologie (1977).

1818 HARZEN, E. "Uber den Maler Pietro degli Franceschi und
seinen vermeintlichen Plagiarus, den Franziskanermönch Luca
Pacioli." Archiv für die zeichnenden Kunst (1856):231–44.
 First discussion of possibility of mathematician Pacioli's
plagiarism from Piero's mathematical writing.

1819 HOFFMAN, JOSEPH. "Piero della Francesca's Flagellation: A
Reading from Jewish History." Zeitschrift für Kunstgeschichte
44, no. 4 (1981):340–57, 19 illus.
 Reviews various interpretations of three foreground fig-
ures in painting, Palazzo Ducale, Urbino. Proposes a new one,
of debate on acceptance of Messiah by the Christians and Jews.
Sees figures as representing a bearded nonrepentant Jew, a bald
converted Jew, and a judge.

1820 JANITSCHEK, HUBERT. "Des Piero degli Franceschi drei Bücher
von der Perspective." Kunstchronik 13, no. 42 (1878):
670–74.
 Compares known manuscripts of treatise on perspective.
Refers to question of Pacioli's plagiarism and to Piero's
relation to Alberti.

1821 JAYAWARDENE, S.A. "The Trattato d'Abaco of Piero della
Francesca." In Cultural Aspects of the Italian Renaissance:
Essays in Honor of Paul Oskar Kristeller. Edited by Cecil H.
Clough. New York: Alfred F. Zambelli, 1976, pp. 229–43.
 Analysis of book on practical arithmetic, made up of a
collection of problems, using algebra. Analyzes section by
section. Classifies types of problems included and gives exam-
ples. Finds unusual in that includes geometry problems. Sees
as source for Pacioli.

1822 JORDAN, M. "Der Vermisste Traktat des Piero della Francesca
über die Fünf Regelmässigen Körper." Jahrbuch der
preussischen Kunstsammlungen 1 (1880):112–18.
 Upon discovery of text of Libellus de quinque corporibus
regularibus in Vatican Library, discusses ideas of Piero and
Pacioli. Publishes excerpts and parallels in writings of
Pacioli, establishing truth of Vasari's statement that Pacioli
plagiarized Piero's text.

Piero della Francesca

1823 KAHSNITZ, RAINER. "Zur Verkündigung im Zyklus der
 Kreuzlegende bei Piero della Francesca." In Schülerfestgabe
 für Herbert von Einem zum 16. Februar 1965. Bonn:
 Kunsthistorisches Institut der Universität, 1965, pp. 112-
 37, 14 illus.
 Iconographical study of Annunciation fresco, S.
 Francesco, Arezzo, and its relation to iconography of other
 scenes in the True Cross cycle.

1824 KRONIG, WOLFGANG. "Das Auferstehungsbild des Piero della
 Francesca." Münster 4, no. 3-4 (1951):71-74, 1 illus.
 Iconographical analysis of Resurrection, Pinacoteca,
 Sansepolcro, which sees Christ as victorious over death.

1825 ____. "La Resurrezione di Piero della Francesca." Arte
 antica e moderna 8 (October-December 1959):428-32, 3 illus.
 Essay on work emphasizing its perfect unity of artistic
 form and spiritual content.

1826 LACLOTTE, MICHEL. "Le portrait de Sigismond Malatesta par
 Piero della Francesca." Revue du Louvre et des musées de
 France 28, no. 4 (1978):255-66, 18 b&w and 1 color illus.
 Louvre's acquisition of panel, ca. 1450-51. Relates to
 fresco in Rimini. Discusses influence of medals and of earlier
 profile portraits.

1827 LAUTS, JAN. "A Note on Piero della Francesca's Lost Ferrara
 Frescoes." Burlington Magazine 95, no. 602 (1953):166, 2
 illus.
 Proposes Battle Scenes, circle of Dosso Dossi, in Walters
 Art Gallery, Baltimore, and National Gallery, London, as re-
 flections of Piero's lost works from Palazzo d'Este, Ferrara.

1828 ____. "Zu Piero dei Franceschis verlorenen Fresken in
 Ferrara." Zeitschrift für Kunstgeschichte 10 (1941-42):67-
 72, 5 illus.
 Postulates reflections on Piero's frescoes in Ferrara in
 Battle Scene, National Gallery, London, which attributes to a
 Ferrarese master, ca. 1520, and in Dosso's Battle, Palazzo
 Strozzi, Florence.

 LAVIN, MARILYN ARONBERG. "The Altar of Corpus Domini in
 Urbino: Paolo Uccello, Joos van Ghent, Piero della
 Francesca." See entry 2116.

1829 ____. "Piero della Francesca's Flagellation: The Triumph
 of Christian Glory." Art Bulletin 50, no. 4 (1968):321-42,
 42 illus.
 Interpretation of painting as illustrating enlightenment
 of foreground figures on meaning of Flagellation. Discusses

sources, setting (with reconstruction), previous interpreta-
tions, and identification of figures. Sees contemporary and
Biblical subjects as interwoven. Diagrams, bibliography.

1830 _____. "Piero della Francesca's Fresco of Sigismondo Pandolfo
Malatesta before St. Sigismund: Theoi Athanatoi Kai Tei
Polei." Art Bulletin 56, no. 3 (1974):345-74, 35 illus.
Iconographic study. Describes work's function as a polit-
ical manifesto, indicating donor's dedication to God and state.
Diagrams, appendix on physical history.
Letter: Maria Rzepińska, Art Bulletin 57, no. 4
(1975):606-7.

1831 _____. "Piero della Francesca's Montefeltro Altarpiece: A
Pledge of Fidelity." Art Bulletin 51, no. 4 (1969):367-71,
5 illus.
Setting of altarpiece, Brera, Milan, seen to suggest
theme of Mary-Ecclesia, the church as institution. Interprets
Federico, kneeling in armor, as pledging protection and devotion.

1832 LINDEKENS, RENÉ. "Analyse sémiotique d'une fresque de Piero
della Francesca: La légende de la vraie croix." Canadian
Journal of Research in Semiotics 4, no. 3 (1976):3-21, 10
illus.
Analyzes structure of cycle of frescoes, which is not
chronological, but axiological. Diagrams.

1833 LONGHI, ROBERTO. "La 'fortuna storica' di Piero della
Francesca dal 1427 al 1962." Paragone 14, no. 159 (1963):
3-26. [Reprinted in Piero della Francesca (1927), con
aggiunte fino al 1962 Florence: Sansoni, 1963).]
Survey of critical writings on artist.

1834 _____. "Piero dei Franceschi e lo sviluppo della pittura
veneziana." L'arte 17 (1914):198-221, 241-56, 13 illus.
Seminal article on transmission of ideas from central
Italy to Venice. Central role of Piero, as artist combining
form and color. Influence on Antonello da Messina and Giovanni
Bellini.

1835 _____. Piero della Francesca. Florence: Alinari, 1956,
unpaginated, 18 illus.
Group of three booklets with essays and notes, one on
major panel paintings, two on Arezzo cycle.

1836 _____. Piero della Francesca. La leggenda della Croce:
Affreschi in S. Francesco d'Arezzo, parete sinistra. Milan:
Sidera, 1955, 12 pp., 33 color illus.
Very brief description of style on one wall of cycle in
choir of S. Francesco. Notes influence of Masaccio. Large,
numerous color illustrations, with details. Reproduces part of
text of Golden Legend.

Piero della Francesca

1837 ____. "Piero in Arezzo." Paragone 1, no. 11 (1950):3-16,
3 illus. [Reprinted in Opere Completa 3 (1963):81-92.
Shorter version published as booklet (Milan: Sidera, 1951),
and reprinted in Fatti di Masolino e di Masaccio e altri
studi sul quattrocento (Florence: Sansoni, 1975), 183-92.
English ed. London: Oxford University Press, 1949, 23 pp.,
14 illus.]
Describes cycle. Considers architectural backgrounds,
compositional devices, and some artistic sources.

1838 MALTESE, CORRADO. "Architettura 'ficta' 1472 circa." In
Studi bramanteschi. Atti del Convegno internazionale, 1970.
Rome: DeLuca, 1974, pp. 283-92, 3 illus.
Analyzes contradictions between geometry of architectural
structure and the arrangement of light and shadows in Piero's
altarpiece, Brera, Milan. Indicates light comes from an open-
ing in the vault. Suggests a full-scale (shortened in depth)
model was used. Diagrams.

1839 MANCINI, GIROLAMO. "La madre di Pier della Francesca."
Bollettino d'arte 12, no. 1-4 (1918):61-63.
Discussion concerning family and family name of Piero.
Rejects ideas of Del Vita (entry 1795).

1840 ____. "L'opera De corporibus regularibus de Pietro
Franceschi detto della Francesca usurpata da fra Luca
Pacioli." Atti della R. Accademia dei lincei. Classe
scienze morali, storiche e filologiche. Memorie, 5th ser.
14, 1909 (1915):441-660.
Lengthy discussion of treatise with appendixes on Piero's
name and other writings, followed by transcription of entire
Latin text.

1841 MARINESCO, CONSTANTIN. "Échos byzantins dans l'oeuvre de
Piero della Francesca." Bulletin de la Société nationale
des antiquaires de France (1958):192-203, 6 illus.
Relates a variety of motifs in Piero to Byzantine prece-
dents in art and texts. Object in altarpiece, Brera, Milan,
identified as a pearl.

1842 ____. "Thèmes et types iconographiques d'origine byzantine
dans l'oeuvre de Pisanello, Filarete et Piero della
Francesca." Comptes rendus des séances de l'Académie des
inscriptions et belles lettres, Paris 2 (October 1958):
284-87.
Discusses Byzantine motifs in Piero's work, inspired by
contact with Greek Cardinal Bessarion, friend of Duke Federigo.
Makes comparisons with Byzantine manuscripts. Identifies ob-
ject in altarpiece, Brera, Milan, as pearl.

MARINI-FRANCESCHI, E. See EVELYN, entries 1740 and 1799.

Piero della Francesca

1843 MASSÈRA, A.F. "Per la data dell'affresco riminese di Pier
 della Francesca." Arte e storia 32 (15 July 1913):199-202.
 Accepts date of 1451 rather than 1446 for fresco, Duomo,
 Rimini.

1844 MEISS, MILLARD. "Addendum Ovologicum." Art Bulletin 36,
 no. 3 (1954):221-22, 8 illus. [Reprinted in The Painter's
 Choice: Problems in the Interpretation of Renaissance Art
 (New York: Harper & Row, 1976), with revisions, within pp.
 105-29.]
 Evidence supporting identification of egg in Piero's
 altarpiece, Brera, Milan, as an ostrich egg. Also adds an
 example of an inscription on Madonna with Sleeping Child by
 Neri di Bicci.

1845 _____. "A Documented Altarpiece by Piero della Francesca."
 Art Bulletin 23, no. 1 (1941):53-68, 17 illus. [Reprinted
 in The Painter's Choice: Problems in the Interpretation of
 Renaissance Art (New York: Harper & Row, 1976), pp. 82-104,
 with postscript and without appendixes.]
 Associates three panels with Saints in National Gallery,
 London, Frick Collection, New York, and Poldi Pezzoli, Milan,
 with polyptych for S. Agostino, Borgo S. Sepolchro, 1454-69.
 Appendixes regarding panels in Liechtenstein and Lehman Collec-
 tions and documents.

1846 _____. "Not an Ostrich Egg?" Art Bulletin 57, no. 1
 (1975):116.
 Reasserts identification of egg in Piero's altarpiece,
 Brera, Milan, as that of an ostrich. Rejects ideas of Gilbert
 (entry 1802) and accepts those of Ragusa (entry 1866).

1847 _____. "Ovum Struthionis: Symbol and Allusion in Piero
 della Francesca's Montefeltro altarpiece." In Studies in
 Art and Literature for Belle da Costa Greene. Princeton:
 Princeton University Press, 1954, pp. 92-101, 12 illus.
 [Reprinted with "Addendum Ovologicum" in The Painter's
 Choice: Problems in the Interpretation of Renaissance Art
 (New York: Harper & Row, 1976), pp. 105-29, with revisions
 and postscript.]
 Identifies egg in Piero's altarpiece, Brera, Milan, as
 that of an ostrich. Traces history and connotation of ostrich
 eggs, and earlier representations. Also suggests a particular
 allusion here to the birth of Count Federigo's son.

1848 _____. La Sacra Conversazione di Piero della Francesca.
 Quaderni di Brera, 1. Florence: Centro Di, 1971, 12 pp.,
 29 illus. [Extracts reprinted in The Painter's Choice:
 Problems in the Interpretation of Renaissance Art (New York:
 Harper & Row, 1976), pp. 142-47.]

Piero della Francesca

> Reviews recent discussions on various aspects of the
> altarpiece, Brera, Milan, particularly its iconography, but
> also its date and original arrangement.

1849 MEISS, MILLARD, and THEODORE G. JONES. "Once Again Piero
della Francesca's Montelfeltro Altarpiece." Art Bulletin
48, no. 2 (1966):203-6, 10 illus. [Reprinted in The
Painter's Choice: Problems in the Interpretation of
Renaissance Art (New York: Harper & Row, 1976), pp. 130-41,
with postscript.]
Reconstruction of plan of church represented in altar-
piece, Brera, Milan, establishing that figures in nave forty-
five feet in front of apse. Suggests was painted for church of
S. Donato, Urbino.

1850 MEISS, MILLARD, and TINTORI, LIONELLO. "Additional Observa-
tions on Italian Mural Technique." Art Bulletin 46, no. 3
(1964):377-80, 11 illus.
Includes statement regarding probable use of sinopie by
Piero at S. Francesco, Arezzo, and additional information re-
garding order of work and division of sections of frescoes in
cycle.

1851 MELANI, ALFREDO. "Nuovi affreschi di Pier della Francesca
ad Arezzo." Arte e storia 23, no. 19-20 (1904):127.
Attribution of some fresco fragments, Sta. Maria della
Grazie, near Arezzo. Urges their conservation.

1852 MÜNTZ, EUGÈNE. "Andrea Mantegna e Piero della Francesca:
Studio sulla predella della pala di San Zeno." Archivio
storico dell'arte 2 (1889):273-778, 3 illus.
Sees influence of Piero's Resurrection, Pinacoteca,
Sansepolcro, on predella panel by Mantegna of same subject
matter.

1853 _____. "Un nouveau manuscrit du traité de perspective de
Piero della Francesca." In Les archives des arts: Recueil
de documents inédits ou peu connus. Paris: Librairie de
l'art, 1890, pp. 23-27.
Concerns sixteenth-century version of treatise,
Bibliothèque Nationale, Paris.

1854 MURATOVA, XENIA. "A Piero della Francesca for the Louvre."
Burlington Magazine 120, no. 908 (1978):781-82, 1 illus.
Portrait of Sigismondo Malatesta acquired by Louvre from
Contini Bonacossi Collection. Exhibited at Louvre with mate-
rials relating to Piero and to Malatesta.

1855 MURRAY, PETER. "A Note on the Iconography of Piero della
Francesca." In Festschrift Ulrich Middeldorf. Edited by
Antje Kosegarten and Peter Tigler. Berlin: De Gruyter,
1968, pp. 175-79, 1 illus.

Piero della Francesca

Identifies three figures in Flagellation, Palazzo Ducale, Urbino, as representing Jews and Gentiles, kings and princes, clergy and laity, together with one angelic figure. Compares to iconography found in fresco cycle, S. Francesco, Arezzo, and altarpiece, Brera, Milan. Relates to sacre rappresentazioni.

1856 NAUMANN, FRANCIS M. "New Light on Some Old Perspective Problems and Piero's Egg for the Dozenth Time." Iris: Notes on the History of Art 1 (February 1982):3-5, 4 illus.
 Postulates that apse in Piero's altarpiece, Brera, Milan is depicted in accelerated, or "false," perspective, and that therefore the egg is the size of a chicken's egg and hangs directly above the Virgin.

1857 OERTEL, ROBERT. "Petri de Burgo opus." In Studies in Late Medieval and Renaissance Painting in Honor of Millard Meiss. Edited by Irving Lavin and John Plummer. New York: New York University Press, 1977, pp. 342-51, 6 illus.
 Attributes newly cleaned Landscape with Penitent St. Jerome, Berlin, Staatliche Gemäldegalerie to Piero, ca. 1450, with rest of painting.

1858 PARRONCHI, ALESSANDRO. "Paolo o Piero?" Arte antica e moderna 13-16 (1961):138-47, 11 illus. [Reprinted in Studi su la dolce prospettiva (Milan: Martello, 1964), pp. 533-48.]
 Drawing of chalice, Uffizi, Florence, usually attributed to Uccello, here attributed to Piero della Francesca.

1859 _____. "Ricostruzione della Pala dei Montefeltro." Storia dell'arte 28 (September-December 1976):235-48, 19 illus.
 Postulates the Flagellation, Palazzo Ducale, Urbino, once formed part of the predella of the altarpiece Brera, Milan. Compares perspective angles of two works. Also associates six panels of apostles, attributed to Joos van Ghent, Palazzo Ducale, Urbino, with same altar.

1860 PICHI, GIO[VANNI] FELICE. "A proposito delle opere di Piero della Francesca." Arte e storia 12, no. 8 (1893):60-61.
 Notes various attributions and locations for works by Piero, and Fra Carnevale, correcting numerous factual details.

1861 _____. "La resurrezione come viene rappresentata da Giovanni Pisano e da Piero della Francesca." Arte e storia 11, no. 26 (1892):202-3.
 Sees Piero's painting, Pinacoteca, Sansepolcro, as representing Christ as triumphal liberator. Differentiates from traditional type, which shows Christ rising. Compares to Giovanni Pisano relief, Duomo, Arezzo.

1862 PITTARELLI, GIULIO. "Intorno al libro "De prospectiva pingendi' di Pier dei Franceschi." In Atti del Congresso

Piero della Francesca

internazionale di scienze storiche 12, 1903. Rome: Tip.
della R. Accademia dei lincei, 1904, pp. 251-66.
Examination of Piero as the author of the first complete
treatise on perspective. Reviews various early sources who
give him credit. Reviews important points of treatise.

1863 PODRO, MICHAEL I. _Piero della Francesca's 'Legend of the_
True Cross.' Newcastle upon Tyne: University of Newcastle
upon Tyne, 1974, 20 pp., 8 illus.
Interpretation of cycle from point of view of its orig-
inal purpose as decoration of a family burial chapel, which
gives the scenes a unity greater than that found in formal
arrangement.

1864 POPE, ARTHUR. "A Small Crucifixion by Piero della Francesca."
Art in America 5, no. 5 (1917):217-20, 1 illus.
Publishes work in Hamilton Collection, Great Neck (for-
merly Colonna Collection, Rome). Dates ca. 1460-65.

1865 POSTI, CESARE. "Di un dipinto a fresco (secolo XV) nella
chiesa cattedrale di Ancona." _Le Marche_ 7, no. 2
(1907):127-36.
Publishes documents regarding fresco by Piero recorded by
Vasari, which indicate that work was covered in 1586-87 during
restoration.

1866 RAGUSA, ISA. "The Egg Reopened." _Art Bulletin_ 53, no. 4
(1971):435-43, 10 illus.
Supports identification of egg in Piero's altarpiece,
Brera, Milan, as ostrich egg, particularly by comparison with
Adoration fresco on tomb in S. Francesco, Lodi.

1867 RICCI, CORRADO. "Note d'arte 1: Affreschi di Pier della
Francesca in Ferrara." _Bollettino d'arte_ 7, no. 6
(1913):197-202, 2 illus.
Attribution of frescoes of _St. Christopher_ and _St._
Sebastian, Pinacoteca, Ferrara.

1868 ROBERTSON, D.S. "The Inscription of Piero della Francesca's
St. Michael." _Burlington Magazine_ 95, no. 602 (1953):170.
Suggests that last word of inscription on panel in
National Gallery, London, may have been MICHA rather than
mysterious LVCHA.

1869 ROTONDI, PASQUALE. "Osservazioni sul dittico di Piero della
Francesca agli Uffizi." In _Studi offerti a Giovanni Incisa_
della Rocchetta. Miscellanea della Società romana di storia
patria, 23. Rome: Presso la società alla Biblioteca
Vallicelliana, 1973, pp. 473-77.
Examination of portraits reveals that image of Federico
painted at a different moment from rest of diptych. Suggests
was altered and incorporated into diptych later.

1870 RZEPÍNSKA, MARIA. "The Peculiar Grayhounds of Sigismondo
 Malatesta. An Attempt to Interpret the Fresco of Piero
 della Francesca in Rimini.' L'arte 4, no. 13 (1971):45-65,
 8 illus. [Polish version in Rocznik Historii Sztuki 9
 (1973):7-29, 12 illus.]
 Fresco of Sigismondo seen as key to mysterious iconogra-
 phy of Tempio Malatestiano. Traces the intertwining symbolism
 of dogs, and of opposing and complementary pairs. Relation to
 Platonic and Christian doctrines.

1871 SALMI, MARIO. "L'affresco di Sansepolcro." Bollettino
 d'arte 40, no. 3 (1955):230-36, 14 b&w and 1 color illus.
 Rejects attribution to Piero of newly discovered St.
 Julian, ex-chiesa di Sta. Chiara, Sansepolcro. Suggests Lorenzo
 di Lendinara, ca. 1454-60.

1872 _____. "I Bacci di Arezzo nel sec. XV e la loro cappella
 nella chiesa di S. Francesco." Rivista d'arte 9, no. 3
 (1916):224-37, 3 illus.
 Concerns history and genealogy of family responsible for
 Piero's cycle in S. Francesco, Arezzo. Postulates presence of
 their portraits in Piero's frescoes. Documents.

1873 _____. "La bibbia di Borso d'Este e Piero della Francesca."
 La rinascita 6, no. 32-33 (1943):365-82, 21 illus.
 Study of book, Biblioteca Estense, Modena, decorated
 1455-61. Finds echoes of Piero's style that clarify Piero's
 work in Ferrara, ca. 1448.

1874 _____. "Un'ipotesi su Piero della Francesca." Arti
 figurative 3, no. 2-4 (1947):78-84, 12 illus.
 Suggests a strong influence of Fra Angelico on the young
 Piero, preceding that of Domenico Veneziano. Attributes
 Madonna, Cook Collection, Richmond, to Piero's youth.

1875 _____. "Perche 'Piero della Francesca?'" Commentari 27,
 no. 1 (1976):121-26.
 Studies versions of Piero's name and various scholarly
 discussions. Notes that artist referred to self as Pietro del
 Borgo. Appends document of 1416.

1876 SANGIORGI, FERT. "Ipotesi sulla collocazione originaria
 della Pala di Brera." Commentari 24, no. 3 (1973):211-16, 3
 illus.
 Hypothesizes that egg in altarpiece is a levitating one,
 symbolizing assumption of Virgin, and that painting was in
 Chapel of the Assumption, S. Francesco, Urbino, where Battista
 Sforza was buried.
 Review: Alessandro Parronchi, La nazione, 22 September
 1973.

Piero della Francesca

1877 SCHNEIDER, LAURIE. "The Iconography of Piero della
 Francesca's Frescoes Illustrating the Legend of the True
 Cross San Francesco in Arezzo." Art Quarterly 32, no. 1
 (1969):23-48, 22 illus.
 Examines cycle as a philosophical whole, with historical,
 liturgical, and typological juxtapositions and correspondences.

1878 SERRACINO INGLOTT, PIERO. "Morte feconda: In occasione del
 restauro della Pala Montefeltro di Piero della Francesca."
 Arte cristiana 69, no. 682 (1981):293-96, 9 illus.
 Reviews various aspects of condition and iconography of
 painting, Brera, Milan, after its recent restoration. Empha-
 sizes aspects of themes of death and regeneration.

1879 SHEARMAN, JOHN. "The Logic and Realism of Piero della
 Francesca." In Festschrift Ulrich Middeldorf. Edited by
 Antje Kosegarten and Peter Tigler. Berlin: De Gruyter,
 1968, pp. 180-86, 3 illus.
 Reconstructs altarpiece, Brera, Milan, placing figures in
 the nave rather than in or near the apse. Appendix on date and
 original site of work. Dates ca. 1466.

1880 SIEBENHUNER, HERBERT. "Die Bedeutung des Rimini-freskos und
 der Geisselung Christi des Piero della Francesca."
 Kunstchronik 7, no. 5 (1954):124-26.
 Summary of talk given at Zentral Institut für
 Kunstgeschichte, Munich. Identifies figures in Piero's Flagel-
 lation, Palazzo Ducale, Urbino, as Emperor John Paleologus and
 Count Guidantonio. Associates with fresco of Sigismond at
 Rimini.

*1881 SIGHINOLFI, I. "Sigismondo Malatesta e Piero della
 Francesca." Resto del Carlino, 7 June 1913 and 17
 July 1913.
 Dates fresco, Tempio Malatestiano, Rimini, 1446 (accord-
 ing to review in L'arte 17 [1914]:237).

1882 SITTE, CAMMILLO. "Die Perspektivlehre des Piero degli
 Franceschi." Mitteilungen des Österreichischen Museum für
 Kunst und Industrie 14 (1879):325-29.
 Reviews contents of De Prospectiva pingendi.

1883 TANNER, MARIE. "Concordia in Piero della Francesca's
 Baptism of Christ." Art Quarterly 35, no. 1 (1972):1-20,
 15 illus.
 Investigates unusual iconographic elements in Piero's
 Baptism, National Gallery, London. Proposes an allusion to the
 unity of the Western Church as attempted by the Council of
 Florence. Dates ca. 1440.

1884 TAVANTI, UMBERTO. "Scoperta di affreschi di Pier della
 Francesca ad Arezzo." L'arte 9 (1906):305-6.

Announces discovery of fragments of large frescoes of life of S. Domenico, possibly by Piero, from Sta. Maria delle Grazie, Arezzo.

1885 TERENZI, MARCELLO. "Le armature di Piero della Francesca." Commentari 21, no. 3 (1970):219-23, 9 illus.
 Armor in Piero's altarpiece, Brera, Milan, and in battle scenes, S. Francesco, Arezzo, compared to actual contemporary examples.

1886 TINTORI, LEONETTO. "Restaurierung von Fresken des Piero della Francesca in Arezzo." Du 36, no. 427 (1976):32-35, 6 b&w and 1 color illus.
 Describes processes of restoration of cycle in S. Francesco, Arezzo, particularly of Salomon and the Queen of Sheba.

1887 TOLNAY, CHARLES DE. "Conceptions religieuses dans la peinture de Piero della Francesca." Arte antica e moderna 23 (July-September 1963):205-41, 49 b&w and 2 color illus. Reprint. Florence: Tip. color, 1963.
 Attempts to define character of faith as expressed by Piero's style. Sees many profane items as having a religious significance. Notes calm assurance and divine harmony in his works.

1888 _____. "La Résurrection du Christ par Piero della Francesca. Essai d'interprétation." Gazette des beaux arts 43, no. 1020 (1954):35-40, 2 illus. [Italian version in Corvina 26 (1953):97-100, 1 illus.]
 Risen Christ, Pinacoteca, Sansepolcro, represented as patron of Borgo San Sepolcro and as enacting rite of rebirth of spring. English translation.

1889 TRAVERSO, GIULIANA. Il numero in Piero della Francesca d'Arezzo. Milan: Salto, 1950, 19 pp., 7 illus.
 Study of mathematical concepts, particularly geometrical schemes and proportions. Considers architecture of S. Francesco, lines in compositions. Diagrams.

1890 VAGNETTI, LUIGI. "Riflessioni sul De prospectiva pingendi." Commentari 26, no. 1-2 (1975):14-55, 25 illus.
 Reviews contents, critical fortunes, and impact of treatise on theory and art.

1891 VENTURI, ADOLFO. "L'ambiente artistico urbinate nella seconda metà del quattrocento." L'arte 20 (1917):259-93, 33 illus.; 21 (1918):27-43, 23 illus.
 Includes general discussion of works done by Piero in Urbino and consideration of his influence.

Piero della Francesca

1892 _____. "Frammenti di polittico di Piero della Francesca nella Galleria Liechtenstein di Vienna." L'arte 24 (1921):152-54, 2 illus.
Publishes panels with saints Chiara and Domenico. Dates close to Sinigallia Madonna.

1893 _____. "Un quadro di Piero della Francesca in America." L'arte 21 (1918):3-4, 1 illus.
Presents Crucifixion, Hamilton Collection, Great Neck, probably done just before 1452.

1894 VENTURI, LIONELLO. "Un opere giovanile di Piero della Francesca." L'arte 8 (1905):127-28, 1 illus.
Publishes photograph of little-known Madonna and Child, Villamarina Collection, Rome.

1895 VERGA, CORRADO. "L'architettura nella Flagellazione di Urbino." Critica d'arte 41, no. 145 (1976):7-19; no. 147 (1976):31-44; no. 148-49 (1976):52-59; no. 150 (1976):25-34, 13 illus.
Detailed geometric and proportional analysis of architectural elements in fresco. Relates to ideas of architects. Dates after 1470s. Many diagrams.

1896 _____. "Competenze di architettura militare in Piero della Francesca." In Studi castellani in onore di Piero Gazzola. Vol. 1. Rome: Istituto italiano dei Castelli, 1979, pp. 173-92, 7 illus.
Reviews Piero's rather limited interest in military architecture, including his role as master of fortifications for Borgo San Sepolcro, beginning 1474. Gathers examples of fortifications in his paintings. English summary.

1897 VICKERS, MICHAEL. "Theodosius, Justinian, or Heraclius?" Art Bulletin 58, no. 2 (1976):281-82, 2 illus.
Composition of drawing of Byzantine Rider, University Library, Budapest, perhaps after statue in Constantinople, seen as source for figure of Heraclius in Piero's fresco in S. Francesco, Arezzo.

1898 WARBURG, ABY. "Piero della Francescas Constantinschlact in der Aquarellkopie des Johann Anton Ramboux." In L'Italia e l'arte straniera. Atti del X Congresso internazionale di storia dell'arte in Roma (1912). Rome: 1922, pp. 326-27. Reprint. Nendeln: Kraus, 1978. [Article reprinted in Gesammelte Schriften, vol. 1 (Leipzig and Berlin: B.G. Teubner, 1932), pp. 251-54, 389-91.]
Publishes copies made in nineteenth century of Battle of Constantine, S. Francesco, Arezzo.

1899 WEISBACH, WERNER. "Ein verschollenes Selstbildniss des Pietro della Francesca." Repertorium für Kunstwissenschaft 23 (1900):388-91.

Pietro di Giovanni d'Ambrogio

History of a supposed self-portrait in Marini Franceschi
Collection.

WELLIVER, WARMAN. "The Symbolic Architecture of Domenico
Veneziano and Piero della Francesca." See entry 1006.

1900 WIDMER, BERTHE. "Eine geschichte des Physiologus auf einem
Madonnenbild der Brera." Zeitschrift für Religions- und
Geistesgeschichte 15, no. 4 (1963):313-30, 2 illus.
 Iconographic study of Piero's altarpiece, Brera, Milan,
including identification of egg as a pearl.

1901 WINTERBERG, [C.]. "Die Tractat des Piero de' Franceschi
über die fünf regelmässigen Körper, und Luca Pacioli.
Repertorium für Kunstwissenschaft 5 (1882):33-41, 4 illus.
 Discusses Pacioli's plagiarism.

1902 WITTGENS, FERNANDA. "Una noterella sul trattato De
prospectiva pingendi di Piero della Francesca." In Studi in
onore di Carlo Castiglione. Milan: Dott. A. Giuffrè, 1957,
pp. 865-73.
 Argues that manuscript in Ambrosiana, Milan, of Piero's
Latin version of De prospectiva pingendi is original, preceding
Italian version in Parma.

1903 WITTKOWER, R., and CARTER, B.A.R. "The Perspective of Piero
della Francesca's Flagellation." Journal of the Warburg and
Courtauld Institutes 16 (1953):292-302, 9 illus.
 Reconstruction of hall in painting in Palazzo Ducale,
Urbino, and determination of unit of measurement governing it.
Postulates that Piero mapped out design as if real architec-
ture. Reconstructs original plan and elevation. Sees as in-
fused with mathematical symbolism.

1904 ZIPPEL, GIUSEPPE. "Piero della Francesca a Rome." Rassegna
d'arte 19, no. 5-6 (1919):81-94, 7 illus.
 Documents that author reads as establishing presence of
Piero in Rome in 1458-59, to do work in Vatican for Pius II.
Also publishes documents from early seventies. Postulates
involvement in Biblioteca Greca, Vatican, and in Melozzo's
fresco, Sixtus IV and Platina, and suggests other attributions.

PIETRO DI GIOVANNI D'AMBROGIO (1409/10-1448)

1905 BRANDI, CESARE. "Pietro di Giovanni di Ambrogio." Arti 5,
no. 3 (1943):129-38, 26 illus.
 Reviews style, noting relation to Sienese art and evi-
dence of influence of Florentine art of early fifteenth cen-
tury. List of attributions.

Pietro di Giovanni d'Ambrogio

1906 COMSTOCK, HELEN. "A Sienese Quattrocentist." Connoisseur
 97, no. 417 (1936):280, 1 illus.
 Attribution of Madonna, MacDonald Collection, to Pietro
 di Giovanni Ambrosi.

1907 GREGORI, MINA. "Un' opera giovanile di Pietro di Giovanni
 d'Ambrogio." Paragone 7, no. 75 (1956):46-51, 3 illus.
 Reconstruction of career, rejecting ideas of Brandi
 (entry 1905). Attributes Madonna, formerly Bottenweiser
 Collection, Berlin, derived from Sassetta.

1908 TOESCA, ILARIA. "Un affresco di Pietro di Giovanni
 d'Ambrogio." Paragone 7, no. 75 (1956):51, 1 illus.
 Publishes Madonna and Saints, dated 1446, Palazzo
 Pubblico, Siena.

1909 _____. Pietro di Giovanni Ambrosi: Una miniatura."
 Paragone 2, no. 23 (1951):27-28, 1 illus.
 Attribution of page, Biblioteca Trivulziana, Milan, ca.
 1446-47.

1910 VOLPE, CARLO. "Ancora su Pietro di Giovanni d'Ambrogio."
 Paragone 14, no. 165 (1963):36-40, 5 b&w and 1 color illus.
 Attributes a triptych, private collection. Dates late in
 artist's career. Relates to Sassetta.

1911 _____. "Per Pietro di Giovanni d'Ambrogio." Paragone 7,
 no. 75 (1956):51-55, 1 illus.
 Attribution of Madonna and Saints, private collection.
 Discusses artist's late style.

 PIETRO DA MONTEPULCIANO (act. early fifteenth century)

1912 LONGHI, ROBERTO. "Una Coronazione della Vergine di Pietro
 di Domenico da Montepulciano." Vita artistica 2, no. 1
 (1927):18-20, 1 illus.
 Publishes work, private collection, Rome. Discusses
 artist's development, noting Venetian and Marchigian factors.

1913 PATRIZI, IRNERIO. "Un affresco di Pietro da Montepulciano."
 Paragone 5, no. 51 (1954):26-32, 3 illus.
 Publishes Madonna fresco, Sta. Maria di Castelnuovo,
 Recanati. Reviews scholarship on artist.

1914 ROTONDI, PASQUALE. "Un'opera sconosciuta di Pietro da
 Montepulciano." Bollettino d'arte 32, no. 4 (1938):173-81,
 10 illus.
 Publishes recently restored polyptych, Altidona, Chiesa
 Parrochiale. Dates before 1418. Detailed photos.

Lorenzo Salimbeni; Jacopo Salimbeni

PRIAMO DELLA QUERCIA (act. 1426-67)

1915 BATTISTINI, MARIO. "Maestro Priamo della Quercia e il
 quadro di S. Antonio di Volterra." Rassegna d'arte 19, no.
 11-12 (1919):233.
 Documentary evidence confirms attribution of panel to
 Priamo, and records his presence in Volterra from 1440-53.

1916 DE NICOLA, GIACOMO. "Studi sull'arte senese: Priamo della
 Quercia." Rassegna d'arte 18, no. 5-6 (1918):69-74; no. 9-
 10 (1918):153-54, 6 illus.
 Examines various attributions to and works by Priamo.
 Reattributes to Andrea di Giusto a Madonna, Gallery, Volterra,
 which was mistakenly associated with a document regarding Priamo.
 Appendix publishes two additional works, both of 1450, in the
 Gallery, Volterra.

1917 RICCI, CORRADO. "Volterra, pitture senese." Rassegna
 d'arte senese 1, no. 1 (1905):23-26.
 Publishes document of 1442 regarding Madonna, S. Michele,
 Volterra, by Priamo della Quercia.

MARCO DI BARTOLOMMEO RUSTICHI (1392/3-1457)

1918 COHN, WERNER. "Un codice inedito con disegni di Marco di
 Bartolommeo Rustichi." Rivista d'arte 32 (1957):57-76, 14
 illus.
 Attribution of drawings from codex of De civitate Dei
 written in 1433. Appends documents.

LORENZO SALIMBENI (ca. 1374-1420)
JACOPO SALIMBENI (act. 1416-27)

Books

1919 ROSSI, ALBERTO. I Salimbeni. Milan: Electa editrice,
 1976, 234 pp., 184 b&w and 24 color illus.
 Monograph on works by brothers, including chapter on
 background, discussion of fresco cycles, catalog of works, list
 of rejected attributions, bibliography, and indexes.
 Review: Giampiero Donnini, Antichità viva 16, no. 2
 (1977):66-69, 7 illus.

1920 ZAMPETTI, PIETRO. Gli affreschi di Lorenzo e Jacopo
 Salimbeni nell'Oratorio di San Giovanni di Urbino. Collana
 di studi archeologici ed artistici marchigiana, 7. Urbino:
 Istituto statale d'arte, 1956, 51 pp., 22 illus.
 Essay on fresco cycle, discussing question of intertwined
 styles of two brothers. Defines Lorenzo as more linear

Lorenzo Salimbeni; Jacopo Salimbeni

International Gothic hand; Jacopo as more roughly expressive and modern. Bibliography.

Articles

1921 ALEANDRI, VITTORIO. "Scoperta di affreschi nella chiesa parrochiale del Castello di Colleluce presso Sanseverino Marche." Arte e storia 12, no. 22 (1893):174.
 Description of two frescoes, Madonna with God the Father and Saints and Crucifix, attributed to Salimbeni.

1922 ____. "Sulla famiglia dei pittori Lorenzo e Giacomo di Salimbene da S. Severino-Marche." Arte e storia 20, no. 13 (1901):81-82.
 Publication of new document of 1420 and construction of Salimbeni family tree.

1923 COLASANTI, ARDUINO. "Lorenzo e Iacopo Salimbeni da Sanserverino." Bollettino d'arte 4, no. 11-12 (1910):409-57, 34 illus.
 Fundamental article attempting to distinguish hands of two brothers. Examines major works, including fresco cycles in Oratorio di S. Giovanni Battista, Urbino, Crypt of S. Lorenzo, Sanseverino, and the Duomo Vecchio, Sanseverino. Diagrams, detailed illustrations.

1924 ____. "Spigolature marchigiane: Giovanni Santi; imitatore catalano di Gentile da Fabriano; Lorenzo Salimbeni da Sanseverino." Rassegna d'arte 16, no. 11-12 (1916):223-31, 4 illus.
 Includes fresco fragments by Lorenzo Salimbeni in Sta. Maria di Mercato, Sanseverino. Signature and date of 1407.

1925 DUNFORD, PENELOPE A. "Iconography of the Frescoes in the Oratorio di S. Giovanni at Urbino." Journal of the Warburg and Courtauld Institutes 36 (1973):367-73, 10 illus.
 Argues that content of cycle by Salimbeni brothers is completely dependent on an anonymous life of Saint John, translated ca. 1300.

1926 GHERARDINI, ANNA. "Lorenzo e Jacopo Salimbeni da Sanseverino." L'arte 57, no. 1 (1958):3-11; no. 2 (1958):121-142, 26 illus.
 Defines position and style of artists and their relation to Gentile. Lists documentary references. Chronological description of major works, annotated list (by location) of attributed ones.

1927 GNOLI, U[MBERTO]. "Lorenzo e Iacopo Salimbeni (appunti iconografici)." Rassegna d'arte umbra 2, no. 1 (1911):1-7.

Lorenzo Salimbeni; Jacopo Salimbeni

Primarily commenting on ideas published by Colasanti (entry 1923) regarding content of a number of works. Proposes new reading of inscription in baptistery of Duomo Vecchio, Sanseverino, which eliminates participation of Olivuccio.

1928 GRASSI, LUIGI. "Dipinti ignoti di Lorenzo Salimbeni e dell'Alamanno." Critica d'arte 9, no. 1 (1950):59–69, 4 illus.
S. Stephen, Pinacoteca, Vatican, attributed to Lorenzo Salimbeni.

1929 MARCHINI, GIUSEPPE. "Lorenzo Salimbeni, 1406." Commentari 17, no. 4 (1966):282–89, 11 b&w and 1 color illus.
Discusses recently discovered frescoes in Collegiata, San Ginesio. Signed and dated. Analyzes artistic character of artist.

1930 PACHIARONI, RAOUL. "Nuovi documenti su Lorenzo Salimbeni e la sua famiglia." Paragone 34, no. 399 (1983):61–71.
Publishes documents from archives in Sanseverino. Draws family tree.

1931 ROSSI, ALBERTO. "Un nuovo reperto di London Salimbeni." Notizie da Palazzo Albani 7, no. 2 (1978):34–38, 8 illus.
Attribution of Tree of Jesse fresco, Oratorio dei Fratelli Becchetti, Fabriano. Work recently cleaned. Dates shortly after 1404.

1932 _____. "Qualche considerazione sui fratelli Lorenzo e Jacopo Salimbeni e qualche inedito di Lorenzo d'Alessandro." Studi maceratesi 5 (1971):233–41, 10 illus.
Considers problem of early development of Salimbeni brothers. Dates their participation in Saint John Evangelist cycle, Duomo Vecchio, Sanseverino, ca. 1400, earlier than usually thought. Then makes several attributions to Lorenzo d'Alessandro.

1933 SANDBERG-VAVALÀ, EVELYN. "A Story of St. Jerome." Burlington Magazine 68, no. 395 (1936):95–96, 3 illus.
Predella, Arens Collection, Vienna, illustrating novitiate of the lion, attributed to Salimbeni brothers, late in their career.

1934 SCHIFF, ROBERTO. "Ritrovamento di un dipinto di Lorenzo Salimbeni di Sanseverino." L'arte 10 (1907):375–77, 1 illus.
Publishes scene of life of Saint Catherine, Palazzo Mediceo, Pisa.

1935 SERRACINO INGLOTT, PETER, and KANG, MATTHAEA. "Il ciclo benedettino di Norcia riscoperto." Arte cristiana 70, no. 961 (1982):235–46, 19 illus.

Lorenzo Salimbeni; Jacopo Salimbeni

Recently uncovered works in Sta. Scolastica, Norcia.
Attributes to Salimbeni, 1411-12, and Master of the Strauss
Madonna. Discusses Benedictine iconography.

1936 VARESE, R. "Una postilla per l'Oratorio di San Giovanni
Battista in Urbino." Notizie da Palazzo Albani 10, no. 1
(1981):7-14, 15 illus.
Notes influence of Tuscan art and impact on Uccello.

1937 VENTURI, LIONELLO. "Nella Galleria Nazionale delle Marche."
Bollettino d'arte 8, no. 10 (1914):305-27, 17 illus.
Reviews various works in collection including several by
Salimbeni brothers.

SANO DI PIETRO (1406-81)

Book and Dissertation

1938 GAILLARD, ÉMILE. Un peintre siennois au XVe siècle: Sano
di Pietro: 1406-1481. Chambéry: M. Dardel, 1923, 215 pp.,
40 b&w and 1 color illus.
Basic monograph covering life and dated works, with atten-
tion to documentary material and earlier scholarship. Chapters
on manuscript illuminations, characteristics of style, ancona
of 1444 in Accademia, Siena, and on artist's significance.
Chronological table, geographic catalog, and bibliography.
Review: Jean Alazard, Revue de l'art 1 (1927):270-72, 1
illus.

1939 TRÜBNER, JORG. Die stilistiche Entwicklung der Tafelbilder
des Sano di Pietro (1405-1481). Strassburg: Heitz, 1925,
98 pp.
Publication of dissertation for Würzburg. Examines
artist's work in a chronological order, mostly by decades, with
short essays on major works. Catalog of additional works,
dated and undated, added at end.

Articles and Booklet

1940 ARSLAN, WART. "Tre miniature di Sano di Pietro." Rivista
d'arte 13 (1931):222-25, 3 illus.
Publishes three illustrations in an antiphonary, Museo
Civico, Bologna.

1941 B[ORENIUS], T[ANCRED]. "The Sermon of San Bernardino."
Burlington Magazine 60, no. 347 (1932):116-19, 1 illus.
Attributes panel of scene in American private collection
to Sano di Pietro. Dates ca. 1452.

1942 _____. "A Madonna by Sano di Pietro." Apollo 5, no. 28
(1927):172-73, 1 color illus.
Publishes Madonna with Saints and Angels, Bachstitz
Collection.

1943 CAVIGGIOLI, A[URÉ]. "Tre fondi-oro." Arte figurativa antica e
moderna 12 (November-December 1954):29-33, 4 b&w and 3 color
illus.
Publishes, among other items, Madonna by Sano di Pietro,
in a private collection, Milan.

1944 CUST, LIONEL, and DOUGLAS, LANGTON. "Pictures in the Royal
Collections. Article II." Burlington Magazine 5, no. 16
(1904):349-51, 2 illus.
Includes mention of Madonna with Saints and Angels by
Sano di Pietro.

1945 EISENBERG, MARVIN. "An Antiphonal Page of the Sienese
Quattrocento." In Hortus Imaginum: Essays in Western Art.
Edited by Robert Enggass and Marilyn Stokstad. University
of Kansas Humanistic Studies, 45. Lawrence: University of
Kansas, 1974, pp. 51-55, 5 illus.
Attributes page from antiphonal, in J.B. Speed Art Mu-
seum, Louisville, to Sano di Pietro.

1946 _____. "The First Altar-piece for the 'Cappella de' Signori'
of the Palazzo Pubblica in Siena--'Tales Figure Sunt Adeo
Pulcre.'" Burlington Magazine 123, no. 936 (1981):134-48,
17 illus.
Proposes reconstruction of now dispersed altarpiece for
main chapel of the Palazzo Pubblico, Siena. Sees as a conglom-
erate of fourteenth- and fifteenth-century elements. Discusses
predella by Sano di Pietro.

1947 GAILLARD, ÉMILE. "The Burial of St. Martha by Sano di
Pietro." Burlington Magazine 40, no. 230 (1922):237-38, 1
illus.
Identifies subject of panel, Arthur Lehman Collection,
New York.

1948 HERMANIN, FEDERICO. "Un trittico di Sano di Pietro a
Bolsena." Rassegna d'arte senese 2, no. 2 (1906):47-51, 3
illus.
Pieces of a triptych dispersed within Sta. Cristina,
Bolsena, attributed to Sano.

1949 MISCIATELLI, PIERO. "Due quadri inediti di scuola senese."
Rassegna d'arte senese 5, no. 4 (1909):93-97, 2 illus.
Publishes Head of S. Bernardino, Misciatelli Collection,
Rome, attributed to Sano di Pietro, after 1450.

Sano di Pietro

1950 _____. "Una tavola sconosciuta di Sano di Pietro."
Rassegna d'arte senese 3, no. 2 (1907):35, 1 illus.
 Publishes Madonna, Misciatelli Collection, Rome.

1951 OLCOTT, LUCY. "Un dipinto di Sano di Pietro." Rassegna
d'arte 7, no. 6 (1907):87, 1 illus.
 Brief paragraph identifying Madonna by Sano now incorpo-
rated in panel by Francia, S. Vitale, Bologna.

1952 _____. "Un quadro attribuito a Salvanello." Rassegna
d'arte 4, no. 9 (1904):141-42, 1 illus.
 Attribution of St. George and the Dragon, S. Cristoforo,
Siena, to Sano di Pietro.

1953 SAPORI, FRANCESCO. "Appunti intorno a Sano di Pietro:
Miniatore senese del secolo XV." Rassegna d'arte 15, no. 10
(1915):218-23, 8 illus.
 Examines Sano as a miniaturist, particularly miniatures
of antiphonary in Duomo, Siena.

1954 STORELLI, ENZO. Una tavola di Sano di Pietro senese nella
Pinacoteca di Gualdo Tadino. Assisi: Tip. Porziuncola,
1968, 31 pp., 7 illus.
 Booklet concerning Coronation of Virgin. Discusses crit-
ical history, iconography of two Saints, identified as Saints
Jerome and Beato Giovanni Colombrai. Dates ca. 1445, earlier
than usual.

1955 VILIGIARDI, ARTURO. "L'Incoronazione della Vergine nel
Palazzo della Signoria." Rassegna d'arte senese 12, no. 1-4
(1919):21-24, 1 illus.
 Fresco signed by Sano di Pietro in Siena. Critics disa-
gree over possible contributions by other artists, including
Domenico di Bartolo. Here seen as finished and mostly executed
by Sano.

1956 ZDEKAUER, LODOVICO. "Sano di Pietro e Messer Cione di Ravi,
Conte di Lattaia (1470-73)." Bullettino senese di storia
patria 11 (1904):140-50. [Also published in Arte antica
senese (Siena: 1904)].
 Documents from book of Cione di Ravi. Includes refer-
ences to payments to Sano for an altarpiece.

 SASSETTA (ca. 1400-1452)

Books

1957 BERENSON, BERNHARD. A Sienese Painter of the Franciscan
Legend. London: J.M. Dent Sons, 1909, 86 pp., 26 illus.
[Reprinted from Burlington Magazine 3, no. 8 (1903):3-35, 10
illus.; no. 9 (1903):171-84, 3 illus.]

Sassetta's paintings seen as appropriate to teachings of Saint Francis. Describes nine scattered panels of altarpiece, which sees as embodying Saint's spirit. Compares to Ciotto's cycle in Assisi and to Far Eastern art. Part 2 surveys artist's career, other works, and his influence.

1958 CARLI, ENZO. Sassetta e il Maestro dell' Osservanza.
 Milan: Martello, 1957, 137 pp., 173 b&w and 45 color illus.
 Monographic format discussing and separating oeuvres of two masters. Appends list of works given to each. Bibliography. Many detailed photographs.
 Review: Carlo Volpe, Arte antica e moderna 1 (1958):84.

1959 POPE-HENNESSY, JOHN. Sassetta. London: Chatto & Windus,
 1939, 239 pp, 50 illus.
 Scholarly monograph with particular attention to the various developmental phases of Sassetta's style. Divides career into three phases. Appendices on (1) school (brief looks at Vecchietta, Sano di Pietro, Pietro di Giovanni d'Ambrogio, Pellegrino di Mariano, and a number of anonymous masters); and (2) wrong attributions. Geographical list of paintings by Sassetta and school; lengthy bibliography. Notes include documentary material.
 Review: R. Langton Douglas, Burlington Magazine 75, no. 188 (1939):130-34, 5 illus.

Articles

1960 BAUCH, KURT. "Christus am Kreuz und der heilige
 Franziskus." In Eine Gabe der Freunde für Carl Georg Heise.
 Edited by Erich Meyer. Berlin: Gebr. Mann, 1950, pp. 103-12, 4 illus.
 Painting, Von Preuschen Collection, Stuttgart, attributed to Sassetta. Presents iconographic analysis. Notes similarities in composition to Fra Angelico's fresco Crucifixion with St. Dominic, S. Marco, Florence. Associates with Sassetta's Saint Francis scenes and reconstructs group.

1961 BERENSON, B[ERNHARD]. "Scoperte e primizie artistiche."
 Rassegna d'arte 4, no. 8 (1904):125-26; no. 9 (1904):142.
 Reviews new discoveries, including works by Sassetta and his school.

1962 BERENSON, MARY LOGAN. "Il Sassetta e la leggenda di S.
 Antonio Abate." Rassegna d'arte 11, no. 12 (1911):202-03, 3 illus.
 Attribution of four panels (Ourosoff Collection, Austria; Jarves Collection, New Haven; and Galleria Civica, Siena) to Sassetta.

Sassetta

1963 BODE, W[ILHELM] V[ON]. "Ein neuerworbenes Gemälde Sasettas im
 Kaiser Friedrich Museum. Berliner Museen--Berichte aus den
 preussischen Kunstsammlungen 45, no. 3 (1924):58-60, 2
 illus.
 Announces recently acquired panel, relating to Saint
 Francis, attributed to Sassetta. Discusses possible subjects.

1964 BRAHAM, ALLAN. "Reconstructing Sassetta's Sansepolcro
 Altar-piece." Burlington Magazine 120, no. 903 (1978):386-
 90, 8 illus.
 Suggests arrangement for altarpiece, based on seven
 scenes in National Gallery, London.

1965 CAGNOLA, GUIDO. "Un dipinto inedito del Sassetta."
 Rassegna d'arte 6, no. 4 (1906):63.
 Notice regarding work in Trivulzio Collection, Milan.

1966 CARLI, ENZO. "Sassetta's Borgo San Sepolcro Altarpiece."
 Burlington Magazine 93, no. 578 (1951):145-52, 10 illus.
 Reconstruction of work commissioned in 1437 for church of
 S. Francesco. Publishes central Madonna with Six Angels and
 Two Standing Saints, private collection. Reviews history of
 altarpiece.

1967 CHIARINI, MARCO. "Sassetta." In Encyclopedia of World Art.
 Vol. 12. London: McGraw Hill, 1966, col. 730-31.
 Brief review of career and works. Artist seen as great-
 est representative of fifteenth-century Sienese painting.
 Brief bibliography.

1968 CLARK, KENNETH. "Seven Sassettas for the National Gallery."
 Burlington Magazine 66, no. 385 (1935):153-54, 6 illus.
 Recent acquisition of scenes of life of Saint Francis,
 1437-44, by National Gallery, London.

1969 DELIUS, RUDOLF VON. "Die ewige Wiederkehr der Stile."
 Kunst 61 (1929-30):226, 1 illus.
 Discusses Sassetta's St. Anthony in the Wilderness, ca.
 1444.

1970 DE NICOLA, GIACOMO. "Sassetta between 1423 and 1433."
 Burlington Magazine 23, no. 124 (1913):207-15, 13 illus.;
 no. 125 (1913):276-83, 4 illus.; no. 126 (1913):332-36, 3
 illus.
 Discussion of origins and early style, through analysis
 of ancona of 1423-26 for Arte della Lana, Madonna della Neve,
 1430-32, and S. Martino Crucifix, 1433 (all in fragments in
 various collections).

1971 DOUGLAS, LANGTON. "A Forgotten Painter." Burlington
 Magazine 1, no. 3 (1903):306-19, 4 illus.

Survey of career of Sassetta, heretofore almost over-
looked. Examines several works, noting influence of Simone
Martini, and impact particularly on later Umbrian and Sienese
artists.

1972 _____. "A Note on Recent Criticism of the Art of Sassetta."
Burlington Magazine 3, no. 10 (1903):265-75, 7 illus.
Comments on article by Berenson (entry 1957) and by
F. Mason Perkins ["Andrea Vanni," Burlington Magazine 1, no. 6
(1903)]. Asserts Sassetta's role in design of Quercia's Fonte
Gaia, his influence on Umbrian painting, and his authorship of
the Annunciation, S. Pietro Ovile, Siena.

1973 FRIEDMANN, HERBERT. "Symbolic Meanings in Sassetta's
Journey of the Magi." Gazette des beaux arts 48, no. 1055
(1956):143-56, 6 illus.
Studies iconography of birds in panel in Metropolitan
Museum, New York. Includes cranes, ostriches, goldfinches, and
falcon.

1974 FRY, ROGER. "The Journey of the Three Kings by Sassetta."
Burlington Magazine 22, no. 117 (1912):131, 1 color illus.
Publishes painting in collection of Marchioness of Crewe.
Attributes to Sassetta rather than Uccello.

1975 GENGARO, MARIALUISA. "Il primitivo del quattrocento senese:
Stefano di Giovanni detto il Sassetta." La Diana 8, no. 1
(1933):5-32, 11 illus.
Sees Sassetta as example of "primitivo" in Sienese art.
Emphasizes differences from Giovanni di Paolo. Lists of
accepted works and uncertain works, by location, with lengthy
bibliography for each.

1976 GRASSI, LUIGI. "Un dipinto del Sassetta." Arte antica e
moderna 4 (October-December 1958):345-53, 2 illus.
Publishes little-known Castelli-Miganelli Virgin and
Child, now private collection. Reviews various arguments re-
garding attributions to Sassetta.

1977 GRONAU, GEORG. "On Some Drawings of the Sienese Schools."
Old Master Drawings 7, no. 25 (1932):1-2, 3 illus.
Notes rarity of Sienese drawings before sixteenth cen-
tury. Publishes three, including Franciscan Saint, National
Museum, Stockholm, here attributed to Sassetta.

1978 LAURENT, M.H. "Documenti vaticani intorno alla Madonna
della Neve del Sassetta." Bullettino senese di storia
patria 42, no. 3 (1935):257-66.
Publishes four lengthy documents, dating 1430-32, orig-
inally from archives of convent of S. Francesco, Siena.

Sassetta

1979 MASSERON, ALEXANDER. "Jacqueline de Settesoli aux
 funérailles de saint François d'Assise d'après un tableau de
 Sassetta." Études franciscaines 1 (1950):329-36.
 Iconographic study of elements in Sassetta's scene from
 polyptych of 1437 for Borgo San Sepolcro.

1980 MORAN, GORDAN. "The Original Provenance of the Predella
 Panel by Stefano di Giovanni (Sassetta) in the National
 Gallery of Victoria--A Hypothesis." Art Bulletin of
 Victoria 21 (1980):33-36, 3 illus.
 Publishes Burning of Jan Hus, National Gallery of
 Victoria, Melbourne. Believes Arte della Lana altar originally
 from Carmine, Siena. Discusses Carmelite iconography.

1981 PERKINS, F. M[ASON]. "A proposito della pala del Sassetta a
 Chiusidino." Rassegna d'arte 13, no. 2 (1913):40.
 Associates Gabriel, Scuola Comunale, Massa Marittima,
 with altarpiece at Chiusidino.

1982 ____. "Alcune opere d'arte ignorate." Rassegna d'arte 18,
 no. 7-8 (1918):105-15, 12 illus.
 Includes Madonna by Sassetta, Hendecourt Collection,
 Paris, and several works of Sassetta's school.

1983 ____. "Alcuni Sassetta inediti." Rassegna d'arte 6, no. 2
 (1906):31.
 Publishes four works, Museo Cristiano, Vatican.

1984 ____. "Un altro quadro del Sassetta." Rassegna d'arte 4,
 no. 10 (1904):156, 1 illus.
 Publishes and attributes work in church of Castello of
 Basciano, near Siena.

1985 ____. "Un quadro sconosciuto del Sassetta." Rassegna
 d'arte 4, no. 5 (1904):76-77, 1 illus.
 Attribution of Madonna, Duomo, Grosseto.

1986 ____. "La pala d'altare del dell Sassetta a Chiusdino."
 Rassegna d'arte 12, no. 12 (1912):196, 1 illus.
 Publishes Madonna and Saints, ca. 1430-32.

1987 ____. "Quattro tavole inedite del Sassetta." Rassegna
 d'arte 7, no. 3 (1907):45-46, 3 illus.
 Includes two scenes of Saints in Platt Collection,
 Englewood, and St. Martin, Galleria Saracini, Siena.

1988 PIETRASANTA, ALEXANDRA. "A 'lavorii rimasti' by Stefano di
 Giovanni called Sassetta." Connoisseur 177, no. 712
 (1971):95-99, 7 illus.
 Panels of St. Francis and St. Bartholomew, Pinacoteca,
 Siena, attributed to Sassetta. St. Francis completed by Sano
 di Pietro.

1989 POPE-HENNESSY, JOHN. "A Passion Predella by Sassetta."
 Burlington Magazine 73, no. 425 (1938):48-51, 3 illus.
 Publishes Agony in the Garden, Lady Catherine Ashburnham
 Collection, and Betrayal of Christ, Davenport Bromley Collec-
 tion. From a predella to which Christ Carrying Cross, Insti-
 tute of Arts, Detroit, also belonged.

1990 ____. "Rethinking Sassetta." Burlington Magazine 98, no.
 643 (1956):364-70, 6 illus.
 Reviews research on Sassetta since author's monograph of
 1939 (entry 1959), and comments on numerous works. Special
 attention to St. Anthony panels, which attributes to Sassetta
 and an assistant. Accepts identification of Sano di Pietro
 with Osservanza Master.

1991 SALMI, MARIO. "Un dipinto del Sassetta." La Diana 2, no. 1
 (1927):52-54, 2 illus.
 Publishes Christ Entering Jerusalem, Pinacoteca Stuard,
 Parma.

1992 ____. "Il Sassetta di San Martino." Commentari 17, no. 1-
 3 (1966):73-82, 12 illus.
 Crucifix painted in 1433 reconstructed from fragments
 surviving in Chigi Saracini Collection, Siena. Compares to
 Sienese and Florentine figures in similar positions. Suggests
 Masacciesque origin.

1993 SCAPECCHI, PIERO. "La rimozione e lo smembramento della
 pala del Sassetta di Borgo San Sepolcro." Prospettiva 20
 (January 1980):57-58.
 New documents indicating that altarpiece in Franciscan
 church was dismembered and replaced between 1578 and 1583,
 rather than in eighteenth century, as previously suggested.

1994 SCHOENBURG-WALDENBURG, GRAZIA. "Problemi proposti da un
 messale della Biblioteca di Siena." Commentari 26, no. 3-4
 (1975):267-75, 6 illus.
 Attributes to Sassetta a Crucifixion in missal,
 Biblioteca Comunale degli Intronati, Siena. Dates ca. 1435-40.

1995 SCHOTTMULLER, [FRIEDA]. "Sassettas Gemälde: Die Messe des
 Hl. Franz." Amtliche Berichte aus den königl.
 Kunstsammlungen, Berlin 31, no. 6 (1910):145-48, 1 illus.
 General background of Sassetta. Review of literature.
 Presents Saint Francis scene, mentions location of other works.

1996 SEYMOUR, CHARLES, Jr. "The Jarves 'Sassettas' and the Saint
 Anthony Altarpiece." Journal of the Walters Art Gallery 15-
 16 (1952-53):30-46, 97, 12 illus.
 Conservation work on two panels of life of Saint Anthony,
 usually attributed to Sassetta. Suggests contain hands of two
 different artists. Illustrates restoration work, enlarged
 details.

Sassetta

1997 SIRÉN, OSVALD. "A Triptych by Sassetta." Art in America 5,
 no. 4 (1917):206-9, 1 illus.
 Publishes triptych in private collection, with Adoration
 of Shepherds and Sts. John Baptist and Bartholomew. Believes
 to be early work by Sassetta, ca. 1430.

1998 VAN MARLE, RAIMOND. "Quadri senesi sconosciuti." La Diana
 4, no. 4 (1929):307-10, 10 illus.
 Includes a mention of Madonna, Steinmeyer Collection,
 Lucerne, with attributes to Sassetta.

1999 WATERHOUSE, ELLIS K. "Sassetta and the Legend of St. Anthony
 Abbot." Burlington Magazine 59, no. 342 (1931):108-13, 7
 illus.
 Reviews Sassetta's Saint Anthony scenes as a group, with
 particular attention to their content. Suggests flanked a full
 length Saint Anthony. Dates 1426-28.

2000 WYLD, MARTIN, and PLESTERS, JOYCE. "Some Panels from
 Sassetta's Sansepolcro Altarpiece." National Gallery
 Technical Bulletin 1 (September 1977):3-17, 16 b&w and 2
 color illus.
 Account of restoration and technical analysis of seven
 panels, 1437-44. Detailed photos, diagrams.

2001 ZERI, FEDERICO. "Ricerche sul Sassetta: La pala dell'Arte
 della Lana (1423-1426)." In Quaderni di emblema, 2.
 Bergamo: Emblema editrice, 1973, pp. 22-34, 15 b&w and 1
 color illus.
 Explores possible Florentine factors in Sassetta's early
 work, especially his relation to Massaccio. Publishes Miracle
 of Host panel from altarpiece, private collection. Also attrib-
 utes two landscapes, Pinacoteca, Siena, usually attributed to
 Ambrogio Lorenzetti, to Sassetta and associates with same
 altarpiece.

2002 _____. "Towards a Reconstruction of Sassetta's Arte della
 Lana Triptych (1423-6)." Burlington Magazine 98, no. 635
 (1956):36-41, 5 illus.
 Dissociates two panels of Annunciation, Pinacoteca
 Comunale, Massa Marittima, and Yale University Art Gallery, New
 Haven, from Madonna della Neve, Contini-Bonacossi Collection,
 Florence. Publishes St. Anthony Abbot, private collection,
 Florence. Believes all three to come from Arte della Lana
 triptych of 1423-26. Influence of Masolino.

PAOLO SCHIAVO (1397-1478)

2003 BERTI, LUCIANO. "Note brevi su inediti toscani."
 Bollettino d'arte 38, no. 4 (1953):278-79, 1 illus.

Includes <u>Stigmatization</u> <u>of</u> <u>St.</u> <u>Francis</u>, by Paolo Schiavo, Sta. Lucia alla Sala, Florence. Dates before 1436.

2004 _____. "Note brevi su inediti toscani." <u>Bollettino</u> <u>d'arte</u> 37, no. 2 (1952):178-81, 2 illus.
Publishes <u>Crucifixion</u>, Sta. Maria delle Grazie, Stia, dating after 1427, and <u>Trinity</u>, Certosa del Galluzzo, Florence, ca. 1420.

2005 BOLOGNA, FERDINANDO. "Due 'Santi' di Paolo Schiavo." <u>Paragone</u> 6, no. 65 (1955):36-40, 1 illus.
Two panels of <u>St.</u> <u>Jerome</u> and <u>St.</u> <u>Lawrence</u>, Museum, Bonn, associated with various other panels. Reconstructs a polyptych of ca. 1427-28. Notes relation to Masolino.

2006 LINNENKAMP, ROLF. "Opera sconosciuta di Paolo Schiavo a Castellaccio." <u>Rivista</u> <u>d'arte</u> 33 (1958):27-33, 4 illus.
Attribution of paintings in <u>fresco-secco</u>, in the ex-oratorio di S. Michele.

2007 PADOA RIZZO, ANNA. "Aggiunte a Paolo Schiavo." <u>Antichità</u> <u>viva</u> 14, no. 6 (1975):3-8, 14 illus.
Publishes works in Sta. Barbara, Castelnuovo d'Elsa, ca. 1460-65. Notes influence of Domenico Veneziano. Dates artist's activity at Castiglione Olona, ca. 1438-39.

2008 POUNCEY, PHILIP. "A Painted Frame by Paolo Schiavo." <u>Burlington</u> <u>Magazine</u> 88, no. 522 (1946):228, 3 illus.
Short note attributing painted figures on frame of a Donatellesque <u>Virgin</u> <u>and</u> <u>Child</u> relief, Victoria and Albert Museum, London, ca. 1430s.

2009 ROBINSON, FREDERICK B. "A Marriage Chest Frontal." <u>Museum</u> <u>of</u> <u>Fine</u> <u>Arts</u> <u>Bulletin,</u> <u>Springfield,</u> <u>Mass.</u> 28, no. 3 (1962):1-4, 1 illus.
Publishes cassone illustrating story of Callisto. Accepts attribution to Paolo Schiavo. Reviews literature on work, as well as content of scene.

<u>PARRI</u> <u>SPINELLI</u> (1387-1453)

Book <u>and</u> Dissertation

2010 VASARI, GIORGIO. <u>Vita</u> <u>di</u> <u>Parri</u> <u>Spinelli,</u> <u>pittore</u> <u>aretino,</u> <u>con</u> <u>una</u> <u>introduzione,</u> <u>note</u> <u>e</u> <u>bibliografia</u> <u>di</u> <u>Mario</u> <u>Salmi.</u>
Florence: R. Bemporad & figlio, 1914, 51 pp., 8 illus.
Edition of biography of 1568 with introduction concerning character of artist's style. Annotations to Vasari's text. Chronological list of works, documents, and bibliography.

Parri Spinelli

2011 ZUCKER, MARK J. "Parri Spinelli: Aretine Painter of the
 Fifteenth Century." Ph.D. dissertation, Columbia Univer-
 sity, 1973, 439 pp., 233 illus.
 Interprets Spinelli as important representative of late
 Gothic art, working often in a personal and eccentric style.
 Surveys works, discusses drawings. Postscript on artist's
 mental state. Appendixes on metalworking and on use of
 polygonal halo. Lengthy catalogs of paintings and drawings,
 rejected and lost works. Bibliography.

Articles

2012 DEL VITA, ALESSANDRO. "Gli affreschi scoperti in San
 Domenico di Arezzo." Bollettino d'arte 22, no. 9
 (1929):385-98, 12 illus.
 Includes small frescoed medallions by Parri Spinelli,
 published for first time.

2013 _____. "Documenti su due pitture di Parri di Spinello."
 Rassegna d'arte 13, no. 5 (1913):84-86, 2 illus.
 Documents regarding two images of the Madonna della
 Misericordia in Arezzo (Pinacoteca and Palazzo di Fraternità)
 establish their dates at 1436 and 1448, contrary to Vasari.

2014 DONATI, PIER PAOLO. "Notizie e appunti su Parri Spinelli."
 Antichità viva 3, no. 1 (1964):15-23, 8 b&w and 3 color
 illus.
 Reviews state of research on Parri Spinelli. Critical
 opinions, documentary information and chronology.

2015 _____. "Sull'attività giovanile dei due Spinello."
 Commentari 17, no. 1-3 (1966):56-72, 19 illus.
 Makes various suggestions for attributions to Parri's
 unknown early years (before mid-1430s). Discusses trip to
 Florence, relation to various artists.

2016 REFICE, CLAUDIA. "Parri Spinelli nell'arte fiorentina del
 sec. XV." Commentari 2, no. 3-4 (1951):196-200, 13 illus.
 Argues for greater importance of Parri than judged by
 recent critics. Supports Vasari's more positive view. Ana-
 lyzes several works and relates to various currents of time.

2017 SALMI, MARIO. "Documenti su Parri Spinelli." L'arte 16
 (1913):61-64.
 Publishes documents that correct Milanesi and Vasari,
 regarding Parri's date of birth (1387) and state of health;
 documents of 1435 and 1437 regarding the Fraternità della
 Misericordia, and a record of his death and burial at age 66.

2018 SIRÉN, OSVALD. "A Late Gothic Poet of Line." Burlington
 Magazine 24, no. 132 (1914):323-30, 10 illus.; 25, no. 133

(1914):15-24, 13 illus. [Reprinted in Siren, Essentials in Art (New York and London: John Lane, 1920)].
Analysis of frescoes in the church of the Misericordia, Figline, and of a group of similar works from ca. 1410-20. Also discusses a group of later works, mostly large altarpieces, by same master, characterized as a "tender lyric poet." Identifies all as works of Parri Spinelli. Appends list of his works.

2019 _____. "Pictures by Parri Spinelli." Burlington Magazine 49, no. 282 (1926):117-24, 8 illus.
Madonna and Saints, Pennsylvania Museum, Philadelphia, attributed to Parri Spinelli. Associates several works and distinguishes from those associated with Master of the Bambino Vispo, whom author had earlier identified as same artist (entry 2018). Also separates out work of master of frescoes in Misericordia, Figline.

2020 VIRCH, CLAUS. "A Page from Vasari's Book of Drawings." Bulletin of the Metropolitan Museum of Art 19, no. 7 (1961):185-93, 11 b&w and 1 color illus.
Attributes drawing, Metropolitan Museum, New York, after Giotto's Navicella, to Parri Spinelli, and associates with Vasari's book.

2021 ZUCKER, MARK J. "Spinelli's Lost Annunciation to the Virgin and Other Aretine Annunciations of the Fourteenth and Fifteenth Centuries." Art Bulletin 57, no. 2 (1975):186-95, 14 illus.
Reconstruction and analysis of lost painting and discussion of iconographical tradition, including Piero's Annunciation, S. Francesco, Arezzo.

2022 _____. "A New Drawing by Parri Spinelli and an Old One by Spinello." Master Drawings 7, no. 4 (1969):400-04, 3 illus.; 8, no. 3 (1970):295.
Recently uncovered sketch, on verso of sheet by Spinello Aretino, in Morgan Library, New York, attributed to Parri Spinelli. Dates ca. 1420s, corrects to 1430s.

2023 _____. "Vasari and Parri Spinelli: A Study of Renaissance and Modern Attitudes towards the Personality of Artists." Gazette des beaux arts 93, no. 1324-25 (1979):199-206.
Examination of views of Vasari and modern critics of artist as mentally infirm. Denies adequacy of data to prove diagnosis, and claims inappropriateness of using style of work to confirm it.

Starnina; Master of the Bambino Vispo

STARNINA (act. 1380's-1413);
MASTER OF THE BAMBINO VISPO

Books

2024 PROCACCI, UGO. Gherardo Starnina. Florence, 1936.
[Reprinted from Rivista d'arte 15 (1933):151-90, 22 illus.;
17 (1935):333-84, 43 illus.; 18 (1936):77-94.]
Articles that constitute a monograph on artist. Reviews
scholarship, discusses works, particularly frescoes in Carmine,
Florence, and in Castellani Chapel, Sta. Croce, Florence, and
panel of Thebaid, Uffizi, Florence. Outlines sources and in-
fluence, works in Spain. Bibliographic survey, list of attri-
butions. Documents.

2025 SYRE, CORNELIA. Studien zum "Maestro del Bambino Vispo" und
Starnina. Bonn: Rudolf Habelt, 1979, 202 pp., 154 illus.
Publication of dissertation for Freiburg im Bresgau,
1977. Monograph on major works and career of Starnina. Begins
with study of and reconstruction of fragmented altarpiece of
St. Lawrence. Investigates problem of Starnina in Spain. Ex-
amines additional attributions. Sections on workshop, circle
and followers. Documents, index.

Articles and Booklet

2026 BOLOGNA, FERDINANDO. "Un altro pannello del 'retablo' del
Salvatore a Toledo: Antonio Veneziano o Gherardo Starnina."
Prospettiva, 2 (July 1975):43-52, 12 illus.
Panel of S. Taddeo, Vassar College Art Gallery,
Poughkeepsie, associated with two in Cathedral, Toledo.
Attributes to Starnina and distinguishes his style from Antonio
Veneziano.

2027 BORENIUS, TANCRED. "Two Angels Making Music." Burlington
Magazine 24, no. 131 (1914):247, 1 illus.
Publishes work, Benson Collection, which attributes to
school of Lorenzo Monaco, perhaps the Master of the Bambino
Vispo.

2028 BOSKOVITS, MIKLÒS. "Il Maestro del Bambino Vispo: Gherardo
Sassetta o Miguel Alcañiz?" Paragone 26, no. 307 (1975):3-
15, 33 illus.
Asserts that Master of Bambino Vispo should be identified
with Miguel Alcañiz rather than Starnina.

2029 COLASANTI, ARDUINO. "Quadri fiorentini inediti." Bollettino
d'arte 27, no. 8 (1934):337-50, 9 illus.
Publishes various works in Palazzo Colonna, Rome, includ-
ing Martyrdom of St. Lawrence, which attributes to Master of
Bambino Vispo and relates to other works.

2030 DE SARALEGUI, LEANDRO. "Miguel Alcañiz ¿ es el maestro de
 Gil y Pujades." In "Comentarios sobre algunos pintores y
 pinturas de Valencia." Archivo español de arte 26
 (1953):237-42, 3 illus.
 Identifes Maestro de Gil with Miguel Alcañiz, who might
 also be Master of Bambino Vispo. Traces career of artist,
 especially altarpiece of the Legend of St. Michael, Musée, Lyon.

2031 GAMBA, CARLO. "Induzioni sullo Starnina." Rivista d'arte
 14 (1932):55-74, 16 illus.
 Reviews sparse information on artist. Attributes details
 of Castellani Chapel, Sta. Croce, Florence, and Thebaid,
 Uffizi, Florence. Sees style reflected in works in Museo
 Nazionale, Valencia, attributed to Lorenzo Zaragoza.

2032 GIGLIOLI, ODOARDO H. "Su alcuni affreschi perduti dello
 Starnina." Rivista d'arte 3, no. 1 (1905):17-21.
 Document of 1408 regarding work in S. Stefano, Empoli.

2033 GILBERT, CREIGHTON. "The Patron of Starnina's Frescoes."
 In Studies in Late Medieval and Renaissance Painting in
 Honor of Millard Meiss. Edited by Irving Lavin and John
 Plummer. New York: New York University Press, 1977,
 pp. 185-91.
 Chapel of St. Jerome in Carmine, Florence, actually pa-
 tronized by Guidone di Pagni and his son Tommaso, not by mem-
 bers of the wealthy Pugliese family. Reexamines documents and
 adds new information from notebook of Gregorio Dati.

2034 HÉRIARD DUBREUIL, M., and RESSORT, C. "Aspetti fiorentini
 della pittura valenzana intorno al 1400 (II)." Antichità
 viva 18, no. 3 (1979):9-20, 24 illus.
 Attributes four predella scenes, Collado, and Resurrec-
 tion, location unknown, to Starnina circle ca. 1400. Notes
 other works that show Starnina's influence and attributes Last
 Judgment, Alte Pinacothek, Munich, to him. English summary.

2035 IÑIQUEZ, DIEGO ANGULO. "La pintura trecentista en Toledo."
 Archivo español de arte y arqueologia 7 (1931):23-29, 14
 illus.
 Publishes panels from Cathedral, Toledo, originally part
 of a retable. Suggests attribution to Starnina. Notes simi-
 larities to Masolino.

2036 LONGHI, ROBERTO. "Un'aggiunta al 'Maestro del Bambino Vispo'
 (Miguel Alcañiz?)." Paragone 16, no. 185 (1965):38-40, 7
 illus. [Reprinted in Fatti di Masolino e di Massaccio e
 altri studi sul quattrocento (Florence: Sansoni, 1975),
 pp. 87-88.]
 Identifies Master of Bambino Vispo with Valentian painter
 Miguel Alcañiz. Attributes Madonna of Humility, private col-
 lection, Rome, ca. 1410s.

Starnina; Master of the Bambino Vispo

2037 MATHER, FRANK JEWETT, Jr. "A Starnina Attribution." Art in
 America 1, no. 3 (1913):179-80, 2 illus.
 Publishes St. Paul, recently acquired by Johnson Collec-
 tion, Philadelphia.

2038 OERTEL, ROBERT. "Der Laurentius-altar aus dem florentiner
 Dom: Zu einem Werk des Maestro del Bambino Vispo." In
 Studien zur toskanischen Kunst. Festschrift für Ludwig
 Heinrich Heydenreich. Munich: Prestel Verlag, 1963, pp.
 205-20, 9 illus.
 Reconstructs polyptych, 1422, from panels in a variety of
 collections. Discusses possible location in church.

2039 PERKINS, F. MASON. "Some Recent Acquisitions of the Fogg
 Museum." Art in America 10, no. 1 (1921):43-45, 6 illus.
 Attributes to the Master of the Bambino Vispo Assumption
 of the Virgin, Fogg Art Museum, Cambridge, which comes from the
 same altarpiece as Dormition, Johnson Collection, Philadelphia.
 Also attributes three paintings in Museum of Fine Arts, Boston,
 to same artist. Mentions Nativity, Bicci di Lorenzo, also in
 Fogg.

2040 PROCACCI, UGO. "Relazione dei lavori eseguiti nella chiesa
 del Carmine di Firenze per la ricerca di antichi affreschi."
 Bollettino d'arte 27, no. 7 (1934):327-34, 9 illus.
 Account of restoration in Carmine, Florence. Fragments
 by Lippo Fiorentino and Starnina uncovered.

2041 PUDELKO, GEORG. "The Maestro del Bambino Vispo." Art in
 America 26, no. 2 (1938):47-63, 6 illus.
 Examines works and establishes position of master in
 early fifteenth-century Florence. Sees as representative of
 International Gothic style. Discusses probably early influence
 of Valencian school and relationship with Lorenzo Monaco. Or-
 ganizes oeuvre into three periods.

2042 S., E.S. "Notes on a Madonna and child of the Early Fif-
 teenth Century." Bulletin of the Worcester Art Museum 17,
 no. 4 (1926):86-88, 2 illus.
 Publishes work attributed to Master of the Bambino Vispo.

2043 SALVINI, ROBERTO. "Agnolo Gaddi e il supposto Starnina."
 In Giotto e giotteschi in Santa Croce. Florence: Città di
 vita, 1966, p. 443-58, 19 illus.
 Discussion of hands of Agnolo Gaddi and assistants in
 True Cross cycle in Cappella Maggiore, Sta. Croce, Florence.
 Sees contributions by Starnina in Castellani Chapel, 1383-94,
 and in other works.

2044 _____. "Per la cronologia e per il catalogo di un discepolo
 di Agnolo Gaddi." Bollettino d'arte 29, no. 6 (1935):279-
 94, 14 illus.

Starnina; Master of the Bambino Vispo

Gathers a group of works together under authorship of
"Compagno d'Agnolo." Rejects identification with Starnina.
Distinguishes from another hand called "Pseudo Campagno."

2045 SCHMARSOW, AUGUST. "Gherardo Starnina in Ispagna." Arte e
storia 30, no. 7 (1911):205-06.
Records notices, some already published, regarding
Starnina's visit to Valencia, 1398-1401. Gives texts of
documents.

2046 _____. Wer ist Gherardo Starnina? Ein Beitrag zur
vorgeschichte der Italienischen Renaissance. Leipzig:
Abhandlung der Phil.-hist. class. der K. Sachsichsen
Gesellschaft der Wissenscaften, 29, 1912, 37 pp., 8 illus.
Attributes frescoes, Castellani Chapel, Sta. Croce,
Florence, and panels of Sts. Julien and Nicholas, Pinakothek,
Munich, to Starnina.

2047 SIRÉN, OSVALD. "Florentiner Trecentozeichnungen." Jahrbuch
der preussischen Kunstsammlungen 27 (1906):208-23, 7 illus.
In an article concerning fourteenth-century works, in-
cludes a sheet in Albertina, Vienna, attributed to Pietro di
Domenico, who identifies with Master of Bambino Vispo. Discus-
ses other related works.

2048 SRICCHIA SANTORO, FIORELLA. "Sul soggiorno spagnolo di
Gherardo Starnina e sull'identià del 'Maestro del Bambino
Vispo.'" Prospettiva 6 (July 1976):11-29, 41 illus.
Identifies Master of Bambino Vispo as Starnina and not as
Miguel Alcañiz (who may have collaborated with him in
Valencia). Reviews Starnina's other works in Italy. Publishes
document of 1408 locating Alcañiz in Spain.

2049 TOSI, LUIGIA MARIA. "Gli affreschi della cappella
Castellani in Santa Croce." Bollettino d'arte 23, no. 12
(1930):538-54, 10 illus.
Discussions of various hands in project of 1383-90,
directed by Agnolo Gaddi. Rejects possible collaboration of
Starnina.

2050 VEGUE Y GOLDONI, A. "La dotación de Pedro Fernández de
Burgos ne la Catedral de Toledo y Gerardo Starnina." Archivo
español de arte y arqueologia 6 (1930):277-79.
Documentation possibly relating to Starnina in Spain.

2051 _____. "Gerardo Starnina in Toledo." Archivo español de
arte y arqueologia 6 (1930):199-203.
Supports possibility of Starnina's presence in Spain, as
mentioned by Vasari.

2052 VOLPE, CARLO. "Per il completamento dell'altare di San
Lorenzo del Maestro del Bambino Vispo." Mitteilungen des

Starnina; Master of the Bambino Vispo

kunsthistorischen Institutes in Florenz 17, no. 2-3
(1973):347-60, 11 illus.
Altar commissioned 1422 for Cappella di San Lorenzo,
Duomo, Florence. Adds two predella panels to known fragment.
Rejects identification of master with Miguel Alcañiz.

2053 WAADENOIJEN, JEANNE VAN. "Ghiberti and the Origin of his
International Style." In Lorenzo Ghiberti nel suo tempo.
Vol. 1. Atti del Convegno internazionale di studi, 1978.
Florence: Olschki, 1980, 81-87.
Attributes appearance of International Style in Florence,
in Ghiberti and Lorenzo Monaco, to Starnina's return from
Spain. Identifies Starnina with Master of Bambino Vispo.

2054 _____. "A Proposal for Starnina: Exit the Maestro del
Bambino Vispo?" Burlington Magazine 116, no. 851 (1974):82-
91, 11 illus.
Identifies the Master of the Bambino Vispo with Starnina;
analyzes fresco fragments by Starnina; suggest earlier dating
for works attributed to Master of Bambino Vispo.

2055 WULFF, OSKAR. "Nachlese zur Starnina-Frage." In
Italienische Studien: Paul Schubring zum 60. Geburtstag
gewidmet. Leipzig: Karl W. Hiersemann, 1929, pp. 156-90,
12 illus.
Gathers works, mostly Madonna and Child groups, by a
single hand, who identifies with Starnina. Reviews other re-
lated works and questions chronology.

STEFANO D'ANTONIO DI VANNI (act. ca. 1440-83)

2056 BATTISTINI, MARIO. "Stefano di Antonio di Vanni da Firenze
dipinge nella chiesa di S. Michele di Volterra." L'arte 23
(1920):24-26.
Attributes Madonna in Pinacoteca, Volterra, usually at-
tributed to Priamo della Quercia. Publishes documents regard-
ing artist's presence in Volterra.

2057 COHN, WERNER. "Maestri sconosciuti del quattrocento
fiorentino. II. Stefano d'Antonio." Bollettino d'arte 44,
no. 1 (1959):61-68, 7 illus.
Reconstructs career and publishes documents regarding
painter active ca. 1440-83.

2058 KENT, F.W. "Art Historical Gleanings from the Florentine
Archives." Australian Journal of Art 2 (1980):47-49.
Includes publication of letter of 1464 regarding Floren-
tine Stefano d'Antonio, in Volterra at time.

2059 MARRAI, D.B. "Scoperta di un affresco nel R. Istituto di
Belle Arti di Firenze." Bollettino d'arte 1, no. 1
(1907):25-26, 2 illus.

Zanobi Strozzi

Publishes <u>Last</u> <u>Supper</u>, recently uncovered, in <u>terre</u> <u>verde</u>. Attributes to Stefano d'Antonio di Vanni.

ZANOBI STROZZI (1412-68)

2060 DAL POGGETTO, MARIA GRAZIA CIARDI DUPRÉ. "Note sulla miniatura fiorentina del quattrocento, in particolare su Zanobi Strozzi." <u>Antichità</u> <u>viva</u> 12, no. 4 (1973):3-10, 15 b&w and 1 color illus.
 Attribution of <u>Book</u> <u>of</u> <u>Hours</u>, Biblioteca Civica, Bergamo, to Zanobi Strozzi, ca. 1453-54. Rejects attribution to Lombard school. Also attributes another <u>Book</u> <u>of</u> <u>Hours</u> to shop of Mariano del Buono, second half of fifteenth century. English summary.

2061 D'ANCONA, PAOLO. "Un ignoto collaboratore del beato Angelico: (Zanobi Strozzi)." <u>L'arte</u> 11 (1908):81-95, 10 illus.
 Fundamental attempt to define character and career of Strozzi. Various attributions. Compares and contrasts to Fra Angelico. Appends documents.

2062 GHIDIGLIA QUINTAVALLE, AUGUSTA. "La 'croce per morti' di Zanobi Strozzi." <u>Bollettino</u> <u>d'arte</u> 45, no. 1-2 (1960):68-72, 10 illus.
 Attribution of painted cross, Chiesa Parrocchiale, Mocogno. Relates to Fra Angelico.

2063 LEVI D'ANCONA, MIRELLA. "La pala del 1436 di Zanobi Strozzi." <u>Rivista</u> <u>d'arte</u> 35 (1960):103-06.
 Discusses documents of 1434-49 referring to an altar by Strozzi. Rejects previous identification of this altarpiece with one now in S. Marco, Florence.

2064 _____. "Zanobi Strozzi Reconsidered." <u>Bibliofilia</u> 61, no. 1 (1959):1-38, 17 illus.
 Reorders artist's career through review of documents and publication of some new ones.
 Review: Licia Ragghianti-Collobi, "Considerazioni su Zanobi Strozzi 'riconsiderato.'" <u>Critica</u> <u>d'arte</u> 6, no. 36 (1959):417-28, 26 illus.

2065 RAGGHIANTI-COLLOBI, LICIA. "Zanobi Strozzi pittore." <u>Critica</u> <u>d'arte</u> 8, no. 6 (1950):454-73, 18 illus.; 9, no. 1 (1950):17-27, 29 illus.
 Study of artistic development of painter beyond his early dependence on Fra Angelico. Emphasizes his wide interests and importance. New attributions included (see also entry 2064, review).

Matteo Torelli

MATTEO TORELLI (1365-1442)

*2066 AMES-LEWIS, FRANCIS. "The Library and Manuscripts of Piero di Cosimo de' Medici." Ph.D. dissertation, Courtauld Institute, 1977, 540 pp.
Includes discussion of works by Torelli. Source: RILA (1980).

2067 LEVI D'ANCONA, MIRELLA. "Matteo Torelli." Commentari 9, no. 4 (1958):244-58, 12 illus.
Traces career of artist, close collaborator of Lorenzo Monaco. Uses new documentary material. Attributes works, including many miniatures, attempting to separate from Lorenzo Monaco.

2068 PANTELIĆ, MARIJA. "Povijesna podloga iluminacije Hrvojeva Misala." Slovo 20 (1970):39-96, 45 illus.
Discusses Missal of Hervoire. Suggests attribution to Torelli.

GIOVANNI TOSCANI; MASTER OF THE GRIGGS CRUCIFIXION
(act. ca. 1420-30)

2069 BELLOSI, LUCIANO. "Il Maestro della Crocifissione Griggs: Giovanni Toscani." Paragone 17, no. 193 (1966):44-58, 19 b&w and 1 color illus.
Reconstructs career of master, identifies with Giovanni Toscani. Related to various artists and trends of 1400-1430.

2070 EISENBERG, MARVIN. "The Penitent St. Jerome by Giovanni Toscani." Burlington Magazine 118, no. 878 (1976):275-83, 13 illus.
Attribution of panel, The Art Museum, Princeton University. Dates ca. 1426-30, compares to Griggs Crucifixion, Metropolitan Museum, New York, and to Massaccio. Postscript regarding sale catalog that places painting in collection of Robert Browning in 1850s.

2071 FRIEDMANN, HERBERT. "The Coral Amulet." Gallery Notes, Buffalo Fine Arts Academy, Albright Art Gallery 12, no. 1 (1947):21-26, 2 illus.
Interpretation of coral amulet on child in Madonna and Child, by Master of the Griggs Crucifixion, as symbolic of fecundity and protection against disease.

2072 PADOA RIZZO, ANNA. "Sul polittico della Cappella Ardinghelli in Santa Trinita, di Giovanni Toscani." Antichità viva 21, no. 1 (1982):5-10, 7 illus.
Reconstructs altarpiece based on description by Bernardo Davanzati (1740) and on documents. Postulates two levels, with reliquary in center. English summary.

PAOLO UCCELLO (1396/97-1475)

Books

2073 BOECK, WILHELM. Paolo Uccello: Der florentiner Meister und
 sein Werk. Berlin: G. Grote'sche Verlagsbuchhandlung,
 1939, 131 pp., 60 illus.
 Early scholarly monograph with chapters on life, Gothic
 (early) style, perspective (mature) style and painterly (late)
 style, and on artist's personality. Appendixes on history of
 criticism, bibliography, and documents. Annotated list of
 works. Lists of attributed works, lost works, and drawings.
 Review: S.L. Faison, Jr., Art Bulletin 22, no. 4
 (1940):282-84.

2074 CARLI, ENZO. All the Paintings of Paolo Uccello. Trans-
 lated by M. Fitzallan. Complete Library of World Art, 22.
 New York: Hawthorn Books, 1963, 78 pp., 128 b&w and 3 color
 illus. [Italian eds. Biblioteca d'arte Rizzoli, 17. Milan:
 Rizzoli, 1954, and 1959.]
 Introductory essay on artist's life, followed by notes on
 plates. Includes lost works, attributions, selections from
 critical writings, index of locations, and brief bibliography.

2075 D'ANCONA, PAOLO. Paolo Uccello. Translated by Elizabeth
 Andres. London: Oldbourne Press, 1960, 23 pp., 46 b&w and
 49 color illus. [Italian ed. Milan: Silvana, 1957.]
 General overview, brief bibliography. Plates include
 many large color details.

2076 PARRONCHI, ALESSANDRO. Paolo Uccello. Bologna:
 Massimiliano Boni, 1974, 128 pp., 213 b&w and 1 color illus.
 Monograph organized by brief sections on specific works
 or problems. Extensively illustrated, with many detailed and
 many comparative illustrations. Index and bibliography.

2077 PITTALUGA, MARY. Paolo Uccello. Rome: Tumminelli, 1946,
 23 pp., 56 illus.
 Brief essay surveying Uccello's career. Summary
 bibliography.

2078 POPE-HENNESSY, JOHN. Paolo Uccello: Complete Edition. 2d
 ed. London and New York: Phaidon, 1969, 188 pp., 169 b&w
 and 6 color illus.
 Introductory essay, catalog of works, with reviews of
 scholarship, sections on other attributed works, lost works,
 and drawings. Indexes of places and names.
 Review: Creighton Gilbert, Art Quarterly 33, no. 4
 (1970):441-43.

 SALMI, MARIO. Paolo Uccello, Andrea del Castagno, Domenico
 Veneziano. See entry 208.

Paolo Uccello

2079 SCHEFER, JEAN LOUIS. Le déluge, la peste: Paolo Uccello.
 Paris: Galilée, 1976, 154 pp., 8 illus.
 Interprets Flood, Sta. Maria Novella, Florence, as uni-
 versal symbolic message. Chapters deal with various sections
 of its content.

2080 SINDONA, ENIO. Paolo Uccello. Milan: Istituto editoriale
 italiano, 1957, 68 pp., 96 b&w and 28 color illus.
 Chapters deal with philosophy and political history of
 time, life and works, and art of Uccello. Lists works chrono-
 logically with bibliographical references. Lists of attribu-
 tions and lost works. Bibliography.

2081 SOMARÉ, ENRICO. Paolo Uccello. Translated into French by
 Annette and Simone David. Milan: Editions de l'esame,
 1949, 45 pp., 84 illus. [Italian ed. 1949.]
 Introductory essay, biographical summary, chronological
 list, lists of lost and attributed works, and bibliography.
 Large plates.

2082 SOUPAULT, PHILIPPE. Paolo Uccello. Paris: Les editions
 Rieder, 1929, 59 pp., 60 illus.
 Discusses artist as rather little known and misunderstood
 because of legend regarding interest in perspective. Considers
 the character of his art and his "poetic" attitude. Sees as
 forerunner of some modern ideas.

2083 TONGIORGI TOMASI, LUCIA. L'opera completa di Paolo Uccello.
 Introduction by Ennio Flaiano. Classici dell'arte, 46.
 Milan: Rizzoli, 1971, 104 pp., 160 b&w and 64 color illus.
 Detailed catalog with general introduction, survey of
 critical writings, bibliography, and documentation. Fully
 illustrated. Sections on drawings and attributed works.
 Indexes.

Articles and Booklets

2084 AMES-LEWIS, FRANCIS. "A Portrait of Leon Battista Alberti
 by Uccello?" Burlington Magazine 116, no. 851 (1974):103-4,
 3 illus.
 Identifies figure in fresco of Flood, Sta. Maria Novella,
 as Alberti. Suggests was included as reference to influence of
 Della pittura.

2085 BALDINI, UMBERTO. "L'orologio di Paolo Uccello nel Duomo di
 Firenze." Commentari 21, no. 1-2 (1970):44-50, 16 illus.
 Reconstruction of various versions and reworking of
 Uccello's clock face, Duomo, Florence. Reviews documents,
 considers information provided by recent restoration.
 Diagrams.

2086 BECK, JAMES. "Paolo Uccello and the Paris St. George, 1465.
 Unpublished Documents: 1452, 1465, 1474." Gazette des
 beaux arts 93, no. 1320 (1979):1-5, 2 illus.
 Affirms attribution of panel in Musée Jacquemart-André,
 Paris, and associates with document of 1465. Rejects attribu-
 tion of St. George in National Gallery, London. Additional
 documents.

2087 _____. "Uccello's Apprenticeship with Ghiberti."
 Burlington Magazine 122, no. 933 (1980):837.
 Seventeenth-century compilation of documents includes
 item placing Uccello in Ghiberti's shop ca. 1412-16, later than
 previously supposed.

2088 BERTI, LUCIANO. "Una nuova Madonna e degli appunti su un
 grande maestro." Pantheon 19, no. 6 (1961):298-309, 12
 illus.
 Attribution of Madonna and Child, private collection,
 Florence. Dates between 1452 and 1456. Discusses Uccello's
 development. English summary.

2089 BOCCIA, LIONELLO G. "Le armature di Paolo Uccello." L'arte
 11-12 (1970):55-91, 20 illus.
 Compares armor in Uccello's paintings, primarily battle
 scenes, with contemporary examples. Redates panels of Battle
 of San Romano to 1435-40, placing panel in Louvre, Paris,
 latest. English summary.

2090 BOECK, WILHELM. "Drawings by Paolo Uccello." Old Master
 Drawings 8, no. 29 (1933):1-3, 4 illus.
 Four new attributions to Uccello, from early and late
 phases of his career. Lists nine drawings attributable to
 artist.

2091 _____. "Ein Früwerk von Paolo Uccello." Pantheon 8
 (July 1931):276-81, 5 illus.
 Attributes Scenes from Monastic Legends, Uffizi,
 Florence. Dates 1410s, noting influences of Lorenzo Monaco and
 Sienese landscapes. English summary.

2092 _____. "Uccello-Studien." Zeitschrift für Kunstgeschichte
 2 (1933):249-75, 20 illus.
 A monographic essay concerned with chronological develop-
 ment of style through various phases. Sections on portraits
 and on artistic personality. Lists works in tentative chrono-
 logical order. Summarizes documentary information.

2093 BORSOOK, EVE. "L'Hawkwood d'Uccello et la Vie de Fabius
 Maximus de Plutarque." Revue de l'art 55 (1982):44-51,
 11 illus.

Paolo Uccello

Importance of translation of Plutarch's life of Roman general for Uccello's fresco, Duomo, Florence. Figure seen as representing republican and ancient ideals.

2094 BOTTICELLI, GUIDO, and GIOVANNONI, SABINO. "L'orologio di Paolo Uccello nel Duomo fiorentino." Critica d'arte 44, no. 166-68 (1979):177-81, 6 illus.
Study of perspective scheme of Uccello's fresco, Duomo, Florence, on basis of recent restoration, which reveals a change in its construction in course of 1443.

2095 BROMMELLE, NORMAN. "St. George and the Dragon." Museums Journal 59, no. 4 (1959):87-95, 2 illus.
Description of condition and cleaning of picture, National Gallery, London. Discusses use of canvas and technique of the painting.

2096 CALZINI, E. "Di un'alcova dei Montefeltro nel Museo di Urbino." Rassegna bibliografica dell'arte italiana 15, no. 11-12 (1912):157-58.
Recent discovery of fragmentary works, attributed to Uccello, 1465-68.

2097 CAMPANI, EUGENIO G. "Uccello's Story of Noah in the Chiostro Verde." Translated by Ella St. Leger. Burlington Magazine 17, no. 88 (1910):203-10, 8 illus.
Reports restoration of frescoes in 1909, revealing cartoons underneath. Describes contents.

2098 CARRÀ, C. "Paolo Uccello costruttore." In Pittura metafisica. Florence: Vallecchi, 1945, pp. 187-202.
Essay on Uccello's significance, interpreting his work as representing intellectual freedom.

2099 C[AVIGGIOLI], A[URÉ]. "Una fronte di cassone di Paolo Uccello. Arte figurative antica e moderna 7 (January-February 1954):28-29, 4 b&w and 1 color illus.
Panel showing besieged city, formerly Bellini Collection, Florence, attributed to Uccello.

2100 CRISTIANI TESTI, MARIA LAURA. "Panoramica a volo d'uccello. La battaglia di S. Romano." Critica d'arte 46, no. 175-77 (1981):3-47, 71 illus.
Reconstructs original arrangement of Uccello's three battle scenes, one a single wall, through analysis of interrelated perspectival and compositional schemes. Many diagrams.

2101 DAVIES, MARTIN. "Uccello's St. George in London." Burlington Magazine 101, no. 678-79 (1959):309-14, 12 illus.
Recent acquisition by National Gallery, London. Discusses iconography, attribution, dates ca. 1460.

2102 DEGENHART, BERNHARD, and SCHMITT, ANNEGRIT. "Uccello:
 Wiederherstellung einer Zeichnung." Albertina Studien 1,
 no. 3 (1963):101-17, 17 illus.
 Reconstructs drawing of fighting men and animals from two
 halves in Albertina, Vienna, and Museum, Dijon. Attributes to
 Uccello. Discusses relation to model books.

2103 DE JONGH, JOHANNA. "Un nouveau portrait de Dante." Gazette
 des beaux arts 30, no. 556 (1903):313-17, 5 illus.
 Reviews fourteenth- and fifteenth century Florentine
 portraits of Dante and identifies standing man in Uccello's
 Flood, Sta. Maria Novella, Florence, as an additional example.

2104 EISLER, COLIN. "A Portrait of L.B. Alberti." Burlington
 Magazine 116, no. 858 (1974):529-30.
 Cites Alberti's association with Sta. Maria Novella and
 with marine subjects as reasons for the inclusion of his por-
 trait in Uccello's Flood, Sta. Maria Novella, Florence.

2105 FIOCCO, GIUSEPPE. "Un affresco di Paolo Uccello nel
 Veneto?" Bollettino d'arte 17, no. 5 (1923):193-96,
 3 illus.
 Attributes fragmentary work in S. Gottardo, Asolo, to
 artist's early period.

2106 _____. "I giganti di Paolo Uccello." Rivista d'arte 17
 (1935):385-404, 12 illus.
 Cites various works that reflect Uccello's series for the
 Casa Vitaliani, Padua. Probably represented heroes.

2107 FRANCASTEL, PIERRE. "Un mystère parisien illustré par
 Uccello: Le Miracle de l'Hostie d'Urbino." Revue
 archéologique 39 (April-June 1952):180-91.
 Postulates subject of Uccello's predella, Palazzo Ducale,
 Urbino, as derived from a Parisian legend of ca. 1290. This
 panel also partly reflects Parisian mystery plays and theatri-
 cal devices.

2108 FRY, ROGER. "Three Pictures in the Jacquemart-André Collec-
 tion." Burlington Magazine 25, no. 134 (1914):78-85, 3
 illus.
 Lengthy discussion of Uccello's St. George and the
 Dragon. Also publishes Madonna and Child attributed to
 Baldovinetti.

2109 GOUKOVSKJ, M.A. "A Representation of the Profanation of the
 Host: A Puzzling Painting in the Hermitage and Its Possible
 Author." Art Bulletin 51, no. 2 (1969):170-73, 6 illus.
 Identifies subject of panel on basis of woodcut with
 similar composition. Connects to Uccello or his shop. Dates
 ca. 1470-80.

Paolo Uccello

2110 GRIFFITHS, GORDON. "The Political Significance of Uccello's
 Battle of San Romano." Journal of the Warburg and Courtauld
 Institutes 41 (1978):313-16, 4 illus.
 On basis of contemporary humanist accounts, interprets
 panels as honoring Niccolo Tolentino as a Florentine hero and
 as a Medici instrument.

2111 GRONAU, [GEORG]. "Zu Paolo Uccellos Schlachtenbildern."
 Pantheon 9 (May 1932):176.
 Dates Paolo's battle scenes in 1450s.

2112 HORNE, HERBERT. "The Battle Piece by Paolo Uccello in the
 National Gallery." Monthly Review 5 (October 1901):114-38,
 5 illus.
 Identifies subject of this and panels in Uffizi,
 Florence, and Louvre, Paris, as battle of San Romano, done for
 palace of Cosimo de' Medici in 1450s. Examines documents and
 Vasari's text. Appends documents.

2113 JOOST-GAUGIER, CHRISTIANE L. "Un'eco veneziana nell'opera
 di Paolo Uccello?" Arte illustrata 7, no. 59 (1974):350-52,
 2 illus.
 Postulates detail of thirteenth-century mosaic, S. Marco,
 Venice, of crow pecking at dead body, as source for same motif
 in Uccello's Flood. Evidence of Uccello's response to Venice.

2114 _____. "Uccello's 'Uccello'": A Visual Signature." Gazette
 des beaux arts 84, no. 1269 (1974):233-38, 4 illus.
 Panel of Founders of Florentine Art, Louvre, Paris, in-
 cludes figure resembling Noah in Uccello's Flood. Argues that
 both are self-portraits and attributes Louvre painting to
 Uccello.

2115 KERN, G.J. "Der Mazzocchio des Paolo Uccello." Jahrbuch
 der preussischen Kunstsammlungen 36, no. 1 (1915):13-38, 18
 illus.
 Detailed analysis of perspective systems in Uccello's
 works, particularly drawings. Relationship to ideas of Piero
 della Francesca.

2116 LAVIN, MARILYN ARONBERG. "The Altar of Corpus Domini in
 Urbino: Paolo Uccello, Joos van Ghent, Piero della
 Francesca." Art Bulletin 49, no. 1 (1967):1-24, 31 illus.
 Exploration of levels of meaning in altar. Uccello's
 predella linked to wave of anti-Semitism and formation of
 Christian banks. Main panel includes references to contempo-
 rary history as well as to death of Battista Sforza. Parallels
 drawn to Piero's altar, Brera, Milan. Appendix suggests iden-
 tification of courtiers in main panel.

2117 LLOYD, CHRISTOPHER HAMILTON, ed. Paolo Uccello's "Hunt in
 the Forest." Essays by Sheila McCrann, Joanna Walton, and

Sallyann Kleibel. Oxford: Ashmolean Museum, 1981, 28 pp., 20 b&w and 1 color illus.
Analyzes various aspects of work, on occasion of exhibition of work and comparative material. Essays on artist, physical nature of work, perspective system, and subject. Diagrams.

2118　LOESER, CHARLES. "Paolo Uccello." Repertorium für Kunstwissenschaft 21 (1898):83-94.
Essay on nature of Uccello's art, traces development. Asserts importance and calls to scholars' attention.

2119　LONGHI, ROBERTO. "Un ritratto di Paolo Uccello." Vita artistica 2, no. 3 (1927):45-48, 2 illus.
Attribution of painting, Museum, Chambéry.

2120　MARANGONI, MATTEO. "Gli affreschi di Paolo Uccello a San Miniato al Monte a Firenze." Rivista d'arte 12 (1930):403-17, 7 illus.
Discovery of fragments of frescoes in cloister of S. Miniato. Affirms attribution to Uccello, dates earlier than Chiostro Verde.

2121　　　　. "Osservazioni sull'Acuto di Paolo Uccello." L'arte 22 (1919):37-42, 3 illus.
Discusses relation of fresco in Duomo, Florence, to Donatello, Castagno, and others. Compares to drawing in Uffizi, Florence.

2122　　　　. "Una predella di Paolo Uccello." Dedalo 12, no. 5 (1932):329-47, 14 b&w and 1 color illus.
Attribution of predella from S. Bartolommeo a Quarata, Bagno a Ripoli, Florence, now Museo Diocesano di Castello, Florence, ca. 1426-32. Reviews other attributed works. Considers questions of changing stylistic tendencies in Uccello.

2123　MAZZONI, GUIDO. "Un epigramma per un dipinto di Paolo Uccello." Vita d'arte 1, no. 1 (1908):35-37.
Examines history of inscription added to Uccello's fresco of Cain and Abel, Chiostro Verde, Sta. Maria Novella, Florence, as described by Baldinucci (entry 7).

2124　MEISS, MILLARD. "The Original Position of Uccello's John Hawkwood." Art Bulletin 52, no. 3 (1970):231, 2 illus.
Publishes engraving indicating that Uccello's fresco, and Castagno's, in Duomo, Florence, were originally higher than present installation.

2125　MELONI, TRKULJA SILVIA. "Vicende ignorate della 'Battaglia di San Romano.'" Paragone 26, no. 309 (1975):108-11.
Indicates that the panels are mentioned in Medici records. Traces their locations.

Paolo Uccello

2126 MITTIG, HANS-ERNST. "Ucellos Hawkwood-Fresko: Platz und
 Wirkung." Mitteilungen des kunsthistorischen Institutes in
 Florenz 14, no. 2 (1969):235-39, 2 illus.
 Determines that present placement of fresco on interior
 wall of Duomo, Florence, is too low, as indicated by distortion
 of perspective.

2127 MURARO, MICHELANGELO. "L'esperienza veneziana di Paolo
 Uccello." In Venezia e l'Europa. Atti del XVIII Congresso
 internazionale di storia dell'arte, Venice, 1955. Venice:
 Casa editrice arte veneta, 1956, pp. 197-99, 6 illus.
 Several works in Venice attributed to Uccello, including
 fresco fragment of a man, Palazzo Ducale; decorative bits in S.
 Marco, and from later time, mosaic fragments now in Museo di S.
 Marco.

2128 PAATZ, WALTER. "Una Natività di Paolo Uccello e alcuni
 considerazioni sull'arte del maestro." Rivista d'arte 16
 (1934):111-48, 19 illus.
 Publication of much damaged Nativity, S. Martino alla
 Scala, Florence (now Soprintendenza alle Gallerie). Essay on
 the dramatic character of Uccello's work.

2129 PARRONCHI, ALESSANDRO. "Cammello per camaleonte." Paragone
 13, no. 153 (1962):64-67, 2 illus.
 Drawing in Codex Rustici, Seminario di Castello, Florence,
 identified as a copy of Uccello's lost ceiling, Casa Peruzzi,
 Florence, because uses camel instead of chameleon to represent
 "air," as Uccello is said to have done.

2130 _____. "Il 'dossale di San Cosimo e Damiano.'" Arte antica
 e moderna 33 (January-March 1966):45-57, 21 illus.
 Thebaid in Uffizi, Florence, often attributed to
 Starnina, identified with work mentioned by Vasari as by
 Uccello. Supports attribution to Uccello.

2131 _____. "Le fonti di Paolo Uccello." Paragone 8, no. 89
 (1957):3-32, 18 illus.; no. 95 (1957):3-33, 10 illus.
 [Reprinted in Studi su la dolce prospettiva (Milan:
 Martello, 1964), pp. 468-532.]
 Seeks to define Uccello's art, primarily in terms of
 perspective. Sees artist as still medieval, because represents
 various moments rather than a unified view. Distinguishes
 between his visual "perspectiva naturalis" and the Renaissance
 codified "perspectiva artificialis."

2132 _____. "Una nunziatina di Paolo Uccello." Ricostruzione
 della Cappella Carnessecchi." Studi urbinati 36, no. 1
 (1962):93-130, 28 illus. [Reprinted in Studi su la dolce
 prospettiva (Milan: Martello, 1964), pp. 182-225.]
 Reconstruction of complex of works in Carnesecchi Chapel,
 Sta. Maria Maggiore, Florence, mentioned by Vasari and others

as involving Uccello and Masaccio. Postulates that included Annunciation, National Gallery, Washington, which attributes to Uccello (instead of Masolino). Also attributes several other works.

2133 _____. "Paolo Uccello." In Encyclopedia of World Art. Vol. 11. London: McGraw Hill, 1966, col. 87–95, 7 b&w and 3 color illus.
 Reviews career, attributions, and critical judgments. Lengthy bibliography.

2134 _____. "Paolo Uccello im Grünen Kreuzgang." In Santa Maria Novella: Kirche, Kloster und Kreuzgänge. Edited by Umberto Baldini. Stuttgart: Urachhaus, 1982, pp. 134–55, 2 b&w and 17 color illus.
 Brief text accompanying photographs of Chiostro Verde, Sta. Maria Novella, Florence. Includes details and sinopie, and newly restored portions.

2135 POGGI, GIOVANNI. "Paolo Uccello e l'orologio di S. Maria del Fiore." Miscellanea di storia dell'arte in onore di Igino Benvenuto Supino. Florence: Olschki, 1933, pp. 323–36, 4 illus.
 Publication of photos and documents of four heads at cornes of clock, Duomo, Florence, 1443. Also documents and information regarding Uccello's other projects for the Opera del Duomo, particularly the Hawkwood fresco.

2136 POPE-HENNESSY, JOHN. Paolo Uccello: The Rout of San Romano in the National Gallery, London. London: Percy Lund Humphries & Co., 1945, 24 pp., 17 illus.
 Brief introductory essay on subject, function, details, and style of work. Good black-and-white illustrations, including details.

2137 PUDELKO, GEORG. "The Early Works of Paolo Uccello." Art Bulletin 16, no. 3 (1934):230–59, 22 illus.
 Discusses influences on style and earliest paintings. Defends monumental, rather than fanciful character, rejecting conception of Lionello Venturi (entry 2154).

2138 _____. "Paolo Uccello peintre lunaire." Minotaure 7 (1935):33–41, 9 illus. Reprint. New York: Arno, 1968.
 Analysis of fantastic and mathematical in Uccello.

2139 _____. "An Unknown Holy Virgin Panel by Paolo Uccello." Art in America 24, no. 3 (1936):127–34, 3 illus.
 Attributes Madonna and Child in National Gallery, Dublin. Dates ca. 1435–40.

2140 RAGGHIANTI, C[ARLO] L[UDOVICO]. "Casa Vitaliani." Critica d'arte 2, no. 5–6 (1937):236–50, 30 illus.

Paolo Uccello

> Lost frescoes by Uccello of "giganti," in Casa Vitaliani,
> Padua, may have been copied in fifteenth-century chronicles and
> may have been used by Filarete, Ferramola, and particularly by
> Mantegna in the Ovetari Chapel, Eremitani, Padua.

2141 ROSSI, PAOLO ALBERTO. "Il calice di Paolo Uccello."
 Critica d'arte 44, no. 166-68 (1979):35-46, 4 illus.
 Study of drawing of chalice, Uffizi, Florence, on basis
of photographs in raking light, which indicate elaborate proce-
dure for perspective construction. Diagrams.

2142 SAALMAN, HOWARD. "Paolo Uccello at San Miniato."
 Burlington Magazine 106, no. 140 (1964):558-63, 7 illus.
 New document establishes date of cycle of Uccellesque
frescoes in cloister of S. Miniato, Florence, as ca. 1448.
Second document of 1455 concerns lost major work by Uccello,
probably of Christ on the Cross.

2143 SALMI, MARIO. "Per Paolo Uccello." In Studies in Late
 Medieval and Renaissance Painting in Honor of Millard Meiss.
 Edited by Irving Lavin and John Plummer. New York: New
 York University Press, 1977, pp. 373-76, 8 illus.
 Uccello's geometric designs and ideas seen in various
mosaics and intarsia patterns.

2144 _____. "Riflessioni su Paolo Uccello." Commentari 1, no. 1
 (1950):22-33, 29 illus.
 Considerations on various lost and damaged works by
Uccello, reconstructed through copies or related works: Saint
Peter mosaic for facade of S. Marco, Venice; frescoes in clois-
ter of S. Miniato, Florence; frescoes of Saint Benedict,
Chiostro degli Angeli; animal representations.

2145 SCHMITT, ANNEGRIT. "Paolo Uccellos Entwurf für das
 Reiterbild des Hawkwood." Mitteilungen des
 kunsthistorischen Institutes in Florenz 8, no. 3 (1959):125-
 30, 4 illus.
 Reconstructs drawing for Hawkwood, Uffizi, Florence, to
its original state. Reveals closer correspondence to fresco,
Duomo, Florence.

2146 SEIDEL, CURT. "Paolo Uccello." Arte e storia 32
 (15 April 1913):97-102.
 Essay on nature of Uccello's art, its unique and innova-
tive features.

2147 SINDONA, E[NIO]. "Una conferma uccellesca." L'arte no. 9
 (1970):66-107, 36 b&w and 2 color illus.
 Asserts Uccello's authorship of Madonna and Child, ca.
1445-50, in National Gallery, Dublin, after recent cleaning.
Relates to Donatello and to frescoes in Chapel of Assumption,

Duomo, Prato, in which Piero may have participated. Numerous
illustrations, including diagrams. English summary.

2148 _____. "Elementi critici e fantastici nell'arte di Paolo
Uccello." L'arte 58, no. 4 (1959):293-97, 4 b&w and 1 color
illus.
St. George, National Gallery, London, recently cleaned,
discussed in terms of Gothic and scientific aspects. Dates
1455-60.

2149 _____. "Introduzione alla poetica di Paolo Uccello."
Relazioni tra prospettiva e pensiero teoretico." L'arte,
no. 17 (1972):7-99, 45 illus.
Investigates relation of new artificial perspective and
quattrocento philosophy, especially in the work of Uccello.
Crisis between orthodox adherence to Brunelleschi's ideas and
digressions from it paralleled to struggle between Platonism
and Aristotelianism. Extensive appendix with perspectival
analyses of Uccello's works, edited by Paolo Alberti Rossi with
collaboration of Massimo Becattini and Roberta Lauri Gherardi.
English summary.

2150 SOUPAULT, PHILIPPE. "Les prolongements de Paolo Uccello."
Cahiers belgique 1 (1928):205-14, 7 illus.
Traces historical fluctuations in appreciation of
Uccello. Defends the lasting qualities of his art.

2151 TOESCA, ILARIA. "Gli 'uomini famosi' della Biblioteca
Cockerell." Paragone 3, no. 25 (1952):16-20, 6 illus.
Publishes set of drawings, Cockerell Collection, Kew.
Suggests connection to Uccello's lost series for Casa
Vitaliani, Padua. Compares style to Piero.

2152 VAN MARLE, RAIMOND. "Eine Kreuzigung von Paolo Uccello."
Pantheon 1 (May 1928):242, 1 illus.
Attribution of small work in private collection (now
Thompson Collection, Lugano). Dates ca. 1425-30.

2153 _____. "Eine unbekannte Madonna von Paolo Uccello."
Pantheon 9 (March 1932):76-80, 5 illus.
Attribution of Madonna, private collection. English
summary.

2154 VENTURI, LIONELLO. "Paolo Uccello." L'arte 33, no. 1
(1930):52-87, 15 illus.
Survey of critical attitudes to artist, many of them
negative. Lists works. Interprets as artist not just of
science, but of lyrical fantasy. Includes discussion of charac-
ter of portraits.

2155 VOLPE, CARLO. "Paolo Uccello a Bologna." Paragone 31, no.
365 (1980):3-28, 27 b&w and 2 color illus.

Paolo Uccello

Adoration, S. Martino, Bologna, recently restored, attributed to Uccello and dated 1437. Discusses artist's chronology.

2156 WACKERNAGEL, MARTIN. "Paolo Uccello." Pantheon 27 (May 1941):102-10, 8 illus.
Reviews artist's career, referring frequently to Boeck (entry 2073). Emphasizes realistic approach to space.

2157 WAKAYAMA, EIKO M.L. "Per la datazione delle storie di Noé di Paolo Uccello: Un'ipotesi di lettura." Arte lombarda 61 (1982):93-106, 17 illus.
Hypothesizes that Noah scenes, Sta. Maria Novella, Florence, were commissioned 1424-25, and given over to other artists when Uccello went to Venice in 1425. Suggests stories of Noah were perhaps repainted in 1447, in relation to Eugene IV and the acts of the Council of Florence.

UGOLINO DI VANNE (act. 1420s)

2158 CROCETTI, GIUSEPPE. "Gli affreschi di S. Maria a Piè di Chienti." Notizie da Palazzo Albani 7, no. 2 (1978):39-45, 6 illus.
Considers documentation and inscription on fresco cycle, which can now be attributed to Ugolino di Vanne, with date of 1420.

TURINO VANNI (doc. 1390-1438)

2159 B[ACCI], P[ELEO]. "Schede d'archivo." Bullettino pisano d'arte e di storia 1, no. 3 (1913):82.
Publishes document regarding Turino di Vanni's catasto of 1427.

2160 LAVAGNINO, EMILIO. "Pittori pisani del XIV secolo." L'arte 26 (1923):33-43, 72-85, 25 illus.
Includes discussion of career of Turino Vanni and several works attributed to him, particularly in Pisa and vicinity.

BARTOLOMMEO VARNUCCI (act. mid-fifteenth century)

2161 DAL POGGETTO, MARIA GRAZIA CIARDI DUPRÉ. "Un 'offiziolo' camereccio ed altre cose di Bartolommeo Varnucci." Antichità viva 10, no. 5 (1971):39-48, 25 b&w and 1 color illus.
Attributes group of codices. Earliest, Museum, Empoli, dates 1444. Sees artist as very close to Andrea di Giusto and suggests some collaboration.

LORENZO VECCHIETTA (ca. 1412-80)

Books

2162 OS, H.W. VAN. Vecchietta and the Sacristy of the Siena
 Hospital Church: A Study in Renaissance Religious
 Symbolism. Translated by Eva Biesta. Kunsthistorische
 Studiën van het Nederlands Instituut te Rome, 2. 's-
 Gravenhage: Staatsuitgeverij, 1974, 121 pp., 107 b&w and 8
 color illus.
 Publishes little-known frescoes, 1446-49, in sacristy.
 Analyzes iconography of reliquary formerly in same room. Dis-
 cusses overall program, historical background. Appendix with
 inventory of 1575. Index.
 Review: B.B. Frederickson, Art Bulletin 59, no. 1
 (1977):139-41.

2163 VIGNI, GIORGIO. Lorenzo di Pietro detto il Vecchietta.
 Florence: Sansoni, 1937, 95 pp., 40 illus.
 Monograph with separate chapters on paintings and sculp-
 ture. Biographical and critical notices. Chronological list
 of works. Bibliography.
 Review: John Pope-Hennessy, Burlington Magazine 73, no.
 428 (1938):228.

Articles

2164 CAGNOLA, GUIDO. "Siena: Un recente acquisto dell'Accademia
 delle belle arti." Rassegna d'arte 4, no. 2 (1904):29-30, 1
 illus.
 Panel of St. Lawrence, attributed to Vecchietta.

2165 CARLI, ENZO. "Un affresco sconosciuto del Vecchietta." In
 Scritti di storia dell'arte in onore di Mario Salmi. Vol.
 2. Rome: DeLuca, 1962, pp. 291-97, 6 illus.
 Attribution of scenes of Christ's life from S. Marziale,
 Colle di Val D'Elsa. Dates ca. 1435.

2166 CLAPP, FREDERICK MORTIMER. "Vecchietta." Art Studies 4
 (1926):41-55, 31 illus.
 Traces artist's career, first in painting and then in
 sculpture, noting a variety of influences, and mentioning some
 documentation.

2167 DE NICOLA, GIACOMO. "Un affresco del Vecchietta nella
 chiesa di S. Francesco a Siena." Rassegna d'arte senese 6,
 no. 4 (1910):74-77, 1 illus.
 Attribution of recently uncovered Pietà, ca. 1448. Cites
 documents regarding Vecchietta's activity at time.

Lorenzo Vecchietta

2168 EDGELL, GEORGE HAROLD. "An Unpublished Fresco by Lorenzo
 Vecchietta." Art Studies 5 (1927):53, 1 illus.
 Publishes lunette with fresco of St. Christopher over
 doorway in Hotel Continental, Siena. Dates ca. 1450.

*2169 OS, H.W. VAN. "Lorenzo Vecchietta und seine soziale
 Stellung als Kunster." Mitteilungen, Gesellschaft fur
 vergleichende Kunstforschung, Vienna 30, no. 2 (1978):5-6.
 Source: Répertoire d'art et d'archéologie (1978).

2170 _____. "Vecchietta and Blessed Sorore: A Vexed Question in
 the Iconography of the Saints in Sienese Painting." In
 Festschrift Wolfgang Braunfels. Tübingen: Ernst Wasmuth,
 1977, pp. 281-87, 4 illus.
 Interpretation of Vasari's fresco, Pellegrinaio, Siena,
 as an allegory of the Blessed Sorore, founder of the hospital,
 and the education of the Foundlings.

2171 _____. "Vecchietta and the Franciscan Predella: A Renais-
 sance Artist and His Workshop." In Festoen: Opgedragen an
 A.N. Zadoks-Josephus Jitta bij haar zeventigste verjaardag.
 Translated by Eva Frans-Biesta. Scripta archaeologica
 groningana, 6. Groningen: H.D. Tjeenk Willinck; Bussum:
 Fibula--Van Dishoeck, [1977], pp. 451-64, 12 illus.
 Publishes three predella scenes of Franciscan Saints
 (Munich, Liverpool, and Vatican). Attributes to different
 (anonymous) students of Vecchietta and associates with lost
 altarpiece from S. Francesco, Siena.

2172 _____. "Vecchietta and the Persona of the Renaissance
 Artist." In Studies in Late Medieval and Renaissance
 Painting in Honor of Millard Meiss. Edited by Irving Lavin
 and John Plummer. New York: New York University Press,
 1977, pp. 445-54, 18 illus.
 Vecchietta studied as a case history of interrelation
 between artist and works of art. Notes consciously displayed
 versatility, new self-awareness.

2173 PERKINS, F. MASON. "Un altro dipinti ignorato del
 Vecchietta." Rassegna d'arte senese 17, no. 1-2 (1924):
 3-5, 1 illus.
 Attribution of Nativity of Virgin, Louvre, Paris.

2174 _____. "Un dipinto dimenticato del Vecchietta." Rassegna
 d'arte senese 2, no. 2 (1906):52.
 Attribution of fresco in S. Ansano, Castelvecchio, repre-
 senting Saint Ansano.

2175 RAND, OLAN A., Jr. "A Problem in Iconography." Record of
 the Art Museum, Princeton University 16, no. 2 (1957):26-35,
 1 illus.

Discusses unusual features of Crucifixion from Platt Collection sometimes attributed to Vecchietta, with half-figures of Paul and the four Doctors of the West. Analyzes insects, bones, and hoofprints on Golgotha as well as inscription extending from Christ's mouth.

2176 VAN MARLE, RAIMOND. "Ancora quadri senesi." La Diana 6, no. 3 (1931):168-76, 34 illus.
Publishes a variety of little-known works by important artists, including Vecchietta's S. Bernardino, on art market.

VENTURA DI MORO (1395/1402-1486)

2177 CARLI, ENZO. "Chi e lo 'Pseudo Ambrogio di Baldese.'" In Studi dell'arte Valerio Mariani. Naples: Libreria scientifica editrice, 1971, 109-112, 2 illus.
Reads inscription on Madonna, Pinacoteca, Siena, as Ventura di Moro.

Index of Artists

Alberti, Leon Battista, 4, 11,
 19, 44-45, 50, 58, 152, 169,
 426-27, 430, 432, 491, 495,
 497-98, 501, 504, 506-7,
 509-10, 513, 516, 520, 557-
 619, 696, 840, 853, 936,
 1365, 1426, 1518, 1607,
 1623, 1741, 1755, 1758,
 1820, 2084, 2104
Alcañiz, Miguel, 2028, 2030,
 2036, 2048, 2052
Ambrogio di Baldese, 127, 180,
 215
Amedei, Giuliano, 620
Andrea dell'Aquila, 1632
Andrea di Bartolo, 359, 362, 410
Andrea del Castagno. See
 Castagno, Andrea del
Andrea di Giusto, 104, 115,
 212, 216, 529, 621, 651,
 1165, 1435, 1491, 1523,
 1916, 2161
Andrea del Sarto, 84
Angeli di Lippi, 122
Angelico, Fra, 6, 51, 77, 116,
 137-38, 170, 172, 189, 193,
 197-98, 201, 220-21, 227,
 326, 357-58, 361, 365, 393-
 94, 396-97, 416, 430, 446,
 622-728, 746, 813, 973, 993-
 94, 1212, 1226-27, 1232,
 1269, 1311, 1323-24, 1326,
 1474, 1491, 1601, 1642,
 1874, 1960, 2061-62, 2065
Angelo da Camerino, 323, 330
Angelo del Maccagnino, 729-30
Angelo di Pietro da Siena.
 See Angelo del Maccagnino

Angelo Parrasio. See Angelo
 del Maccagnino
Antonello da Messina, 116, 1834
[Soror] Antonia, 194
Antoniazzo Romano, 1372
Antonio di Anghiari, 1799
Antonio de Calvis, 281
Antonio di Domenico, 124
Antonio da Fabriano, 1100, 1172
Antonio da Firenze, 731-33, 894, 927
Antonio di Nicolo, 322
Antonio da Viterbo, 280
Antonio Veneziano, 1417, 2026
Apollonio di Giovanni, 405, 549,
 734-40
Arcangelo di Cola da Camerino,
 309, 311, 345, 347, 381,
 741-51, 867, 1047, 1139,
 1491

Baldovinetti, Alesso, 119-20,
 204, 358, 380, 393, 401,
 521, 539, 752-78, 890, 901,
 968, 2108
Bartolomeo, Fra, 1307
Bartolomeo di Fruosino, 446,
 779-80
Bartolomeo di Tommaso da
 Foligno, 286, 326, 339, 350,
 781-89, 867, 1698
Battista di Gerio, 790-92, 1653
Battista da Pisa. See Battista
 di Gerio
Bedi, Jacopo, 793
Bellini, Giovanni, 71, 1195,
 1834

Index of Authors, Editors, and Reviewers